THE ART OF CONVERSION

THE ART OF

CÉCILE FROMONT

CONVERSION

*Christian Visual
Culture in the
Kingdom of Kongo*

Published for the Omohundro Institute of Early
American History and Culture, Williamsburg, Virginia,
by the University of North Carolina Press, Chapel Hill

Publication of this book has been aided by a grant from the
Millard Meiss Publication Fund of the College Art Association.

MM

The Omohundro Institute of
Early American History and Culture
is sponsored jointly by the College
of William and Mary and the
Colonial Williamsburg Foundation.
On November 15, 1996, the Institute
adopted the present name in honor
of a bequest from Malvern H.
Omohundro, Jr.

Designed and set in Minion and
Trajan types by Rebecca Evans.
Manufactured in the United States
of America.

Library of Congress Cataloging-in-Publication Data
Fromont, Cécile, author.
The art of conversion : Christian visual culture in
the Kingdom of Kongo / Cécile Fromont.
 pages cm
Includes bibliographical references and index.
ISBN 978-1-4696-1871-5 (cloth : alk. paper)
ISBN 978-1-4696-1872-2 (ebook)
1. Christianity—Kongo Kingdom. 2. Kongo
Kingdom—Church history. 3. Kongo Kingdom—
Religious life and customs. 4. Christian art and
symbolism—Kongo Kingdom. I. Title.
BR1470.K66F76 2014 276.75106—dc23
2014034799

18 17 16 15 14 5 4 3 2 1

The paper in this book meets the guidelines for
permanence and durability of the Committee on
Production Guidelines for Book Longevity of the
Council on Library Resources. The University of
North Carolina Press has been a member of the
Green Press Initiative since 2003.

Jacket illustration: Detail of Albert Eckhout,
Portrait of a Kongo Ambassador to Recife, Brazil.
Circa 1637–1644. Oil on paper, 30 x 50 cm. Libri
Picturati A 34, fol. 1. Jagiellonian Library, Krakow.
Photograph courtesy of the Jagiellonian Library
Photographic Services.

To my parents,
 to Louis and Héloïse,
and to Grant

Acknowledgments

Research for this book has taken me to four continents and would not have been possible without the generous support of Harvard University's Department of History of Art and Architecture, the Région Martinique, the Center for Advanced Study in the Visual Arts (CASVA), the Arquivos Nacional da Torre do Tombo, the Fundação Luso-Americana, the University of Michigan's Society of Fellows, Yale University's Institute of Sacred Music, and the University of Chicago's Division of the Humanities and Department of Art History.

I am indebted to the archivists, curators, and librarians with whom I have worked over the years and from whom I have learned the art and joy of conducting research. Thank you to the staff of the Capuchin General Archives and Franciscan Museum in Rome-Bravetta; the Capuchin Provincial Archives in Florence, Genoa, and L'Aquila; the Biblioteca del Clero in Bergamo; the Biblioteca Civica Centrale in Turin; the Biblioteca Civica Gambalunga in Rimini; the Archivio di Stato in Milan; the Biblioteca Ambrosiana in Milan; the Biblioteca Angelica in Rome; the Biblioteca Universitaria Alessandrina in Rome; the Archivio dell'Ordine dei Padri Carmelitani Scalzi in Rome; the Biblioteca Universitaria Urbaniana in the Vatican; the Archivio Storico de Propaganda Fide in the Vatican; the Biblioteca Apostolica Vaticana; the Archivio Segreto Vaticano; the British Library; the Jesuit general archives in Rome; the Archives des Missions Étrangères in Paris; the Archives Générales de la Congrégation du Saint-Esprit in Chevilly-la-Rue; the Biblioteca Nacional in Madrid; the Biblioteca del Palacio in Madrid; the Arquivo Nacional da Torre do Tombo in Lisbon; the Biblioteca Nacional de Lisboa; the Biblioteka Jagiellońska in Krakow; the Biblioteca Nazionale Centrale in Rome; the Arquivo Histórico Nacional de Angola; the Arquivo Nacional in Rio de Janeiro; the Melville J. Herskovits Library of African Studies at Northwestern University; the KADOC in Leuven; the Biblioteca Estense in Modena; the Bibliothèque Nationale de France; the Leiden University Library; the Nationaal Archief in The Hague; the Arquivo Histórico Militar in Lisbon; the Arquivo Histórico Ultramarino in Lisbon; the Biblioteca da Ajuda in Lisbon; the Academia das Ciênciais in Lisbon; the Sociedade de Geografia in Lisbon; the Gabinete de Estudos Arqueológicos da Engenharia Militar in Lisbon; the Museu Antropológico da Universidade de Coimbra; the Metropolitan Mu-

seum of Art in New York; the Museu Nacional de Etnologia in Lisbon; the Vatican Ethnological Museum; the Paul Raymaekers Foundation; the Royal Library of Belgium in Brussels; the Museum Aan de Stroom in Antwerp; the Afrika Museum in Berg en Dal; the Krannert Art Museum in Urbana-Champaign; the Musée du Quai Branly in Paris; the Royal Museum for Central Africa in Tervuren; the National Museum for African Art and the Eliot Elisofon Photographic Archives, Smithsonian Institution, in Washington D.C.; the Chrysler Museum in Norfolk; the Jamestown-Yorktown Foundation in Williamsburg; the Loyola University Archives in New Orleans; the Anthropos Institute and Haus Völker und Kulturen in Sankt Augustin; and the Yale–Van Rjin Archive of African Art at Yale University.

I am also fortunate to have received thoughtful comments on this material from Suzanne P. Blier, Claudia Brittenham, Thomas B. F. Cummins, Paul Kaplan, Webb Keane, Megan Luke, Pierre de Maret, Steven Nelson, Emily Osborn, Francesco Pellizzi, Allen Roberts, Ray Silverman, John Thornton, Kristina Van Dyke, Jelmer Vos, Robert J. C. Young, Rebecca Zorach, the members of the African Studies Workshop and of the Material Archeology Workshop at the University of Chicago, my colleagues in the Department of Art History at the University of Chicago and the University of Michigan, the fellows and staff in residence at the CASVA in 2007–2008, and the insightful audiences at events where I presented material from this book.

My most heartfelt thanks go to the many other friends, colleagues, and generous people who helped move the project along in small, big, and sometimes unknowing ways: Carlos Almeida, Yohannes Taklemariam Bache, Michiel Bernardus, Koen Bostoen, Giacomo Carlini, Audrey Celestine, Sabine Cornelis, Els Cornelissen, James Denbow, David Easterbrook, Chelsea Foxwell, Susan Fritz, Susan Gagliardi, Michael Gallis, Antonella Ghassi, Servus Gieben, Ingrid Greenfield, Geoffroy Heimlich, Maria de Lurdes Henriques, Linda Heywood, Irene Hübner, Maaike Kool, Aden Kumler, Katherine McAllen, Luigi Martignani, Marina de Mello e Souza, Maria do Rosário Martins, Emily Osborn, Catalina Ospina, Els de Palmenaer, Joachim Piepke, Alysson Purpura, Patricia Quaghebeur, Paul Raymaekers, Juliana Ribeiro, Gemma Rodrigues, Father Mantovi Romano, Chantal da Silva, Chris Smith, Louis de Strycker, Bertrand and Véronique Teboul-Bonnet, Manuela Tenreiro, Carlo Toso, Hein Vanhee, Gerard Vieira, Anne and Louis-Carl Vignon, Molly Warsh, Boris Wastiau, Pierre Wauters, Tamara Wiesebron, and others who wish to remain anonymous.

Thank you to Nadine Zimmerli, Virginia Montijo Chew, and the staff at the Omohundro Institute of Early American History and Culture for making a book out of the manuscript I first sent them.

I have received financial and technical support for the publication of this book, and in particular for its illustrations, from the University of Chicago's Division of the Humanities, Department of Art History, Visual Resources Center, and the Committee on African Studies, and from the College Art Association's Millard Meiss Publication Fund. I am also grateful for the generosity of many image depositories, whose understanding of the financial challenges of academic publishing and willingness to waive or lower their fees was immensely helpful.

It has been my great luck that Tom Cummins and soon after Suzanne Blier gave me a chance to try my hand at research and writing. I discovered art history in their classes, and I became the scholar I am today thanks to their support of my decision to embark on a research path firmly wedged in the exciting but rough waters that run between well-defined fields. The biggest lesson they taught me was to march to the beat of my own drum.

I am also grateful that Suzanne taught me to pursue provocative ideas, to confront established notions with a genuinely open mind, that good scholarship comes from hard work and a good laugh, and, of course, that there are no problems that cannot be solved with a big pot of coffee. I thank Tom for showing me the thrill of stretching ideas further than I imagined possible, for the excitement that comes from rigorous analytical thinking, for demonstrating that the English language is full of colorful phrases, and, of course, for reminding me to go back to work.

Finally, none of the research and writing for this book could have happened without the love and support of my parents, Francis and George Lucy Fromont, my siblings, Henri and Sophie, their spouses, Chrystelle and Alexandre, my grandparents as well as the many, many members of my extended family, especially *mes taties* and Lynda, Jim, Garrett, and Angie Calderwood.

Thank you to Louis and Héloïse for bringing me joy and perspective. And thank you to Grant Calderwood for everything.

Contents

Illustrations

FIGURES

THE ART OF CONVERSION

Introduction

Central African warriors stage a martial dance in the shadow of a church and a monumental cross (see Figure 2, Plate 1). Mourners at a funeral surround a catafalque with incense, Catholic hymns, and animal offerings (see Figure 18, Plate 10). A friar blesses a wedding under a veranda in front of an African crowd dressed in luxurious textiles and garments imported from around the globe (see Figure 56). Early modern Kongo Christianity comes to life in the watercolors of the "Missione in prattica," an illustrated manuscript composed around 1750 by Bernardino d'Asti, a veteran of the Capuchin order's central African mission. The friar's vivid images present unexpected tableaus in which Christian objects, rituals, and symbols seamlessly meld with African imagery, practices, and emblems. The characters in the watercolors inhabit a space that, for friar Bernardino's audience in eighteenth-century Italy and viewers of his works today, challenges preconceptions about Africa. Instead of a strange land alien to European ideas, objects, and practices, a cosmopolitan, visibly Christian landscape opens up before our eyes. This is the kingdom of Kongo, a realm that at the time of the paintings had professed Christianity and engaged with the visual and material cultures of Europe and the Atlantic world at large for nearly 250 years. From their king's decision to embrace Catholicism at the turn of the sixteenth century to the time of Bernardino and beyond, elite men and women of the Kongo creatively mixed, merged, and redefined local and foreign visual forms, religious thought, and political concepts into a novel, coherent, and continually evolving worldview that I call Kongo Christianity.

Drawing from a surprisingly broad and rarely published set of objects, images, and written documents, I analyze the advent of Kongo Christian visual culture circa 1500, follow its evolutions for three centuries within the political, religious, and commercial context of the early modern Atlantic world, and finally study its unraveling in the wake of the colonial era, fully inaugurated in Africa with the 1885 Berlin Conference. Explored is the way in which the elite of the kingdom used narratives, artworks, and visual culture at large as conceptual spaces of correlation within which they recast heterogeneous local and foreign ideas and forms into newly interrelated parts of the evolving worldview that was Kongo Christianity. These spaces of correlation demonstrate that the newly minted Kongo Christian discourse did not

1

merely combine disparate elements but also transformed and redefined them into the constitutive and intimately linked parts of a new system of religious thought, artistic expression, and political organization. The sources newly assembled here make possible a historically grounded account of Kongo Christian visual culture that acknowledges continuity but also highlights chronological specificities and examines change.[1]

Historical Background

The kingdom of Kongo, founded in the thirteen hundreds according to oral history and archaeological evidence, was at the outset a highly centralized polity. Located in west central Africa south of the Congo River, it extended over the western part of today's Democratic Republic of the Congo and northern Angola (Map 1). Its political organization centered on the person of the king, who ruled with absolute power from his capital city over large territories through governors, or *mani,* he sent from his court to provincial capitals. The regal function was not hereditary; rather, a group of qualified electors chose the new king from a pool of eligible candidates. This system of transition rendered royal successions delicate political affairs and placed a high value on the ability of the chosen candidate to assert his rule and establish his legitimacy in political, military, and supernatural terms. Kongo monarchs therefore depended heavily on a range of regalia, myths, and ritual apparatus to demonstrate their power and naturalize their rule.

1. This study builds upon but also challenges past approaches to Kongo Christian visual and material culture. Objects and images linked to the Christian Kongo came to the attention of scholars in the early twentieth century from the works of Catholic priests active in central Africa who first recognized and collected them. Since then, both lay and religious researchers have studied only a fraction of the corpus, relying primarily on the interpretations of a small group of modern consultants and scholars from regions once part of the historical kingdom. This approach yielded the seminal works of anthropologist Wyatt MacGaffey and art historian Robert Farris Thompson, whose arguments posit a "substantial continuity . . . between sixteenth and twentieth century Kongo cosmology, cultic practice, and social structure." Although my study does not contradict this premise, and in many regards helps establish its general validity, I do not take that proposition as a given. Rather, I introduce visual and archival material that enables inquiry based on the careful analysis of objects, narratives, and documents within their specific social and historical contexts.

See Wyatt MacGaffey, "Dialogues of the Deaf: Europeans on the Atlantic Coast of Africa," in Stuart B. Schwartz, ed., *Implicit Understandings: Observing, Reporting, and Reflecting on the Encounters between Europeans and Other Peoples in the Early Modern Era* (Cambridge, 1994), 255 (quotation). See also Robert Farris Thompson and Joseph Cornet, *The Four Moments of the Sun: Kongo Art in Two Worlds* (Washington, D.C., 1981). Anthropologist John M. Janzen is also a key figure for the study of west central Africa; see Janzen, *Lemba, 1650–1930: A Drum of Affliction in Africa and the New World,* Critical Studies on Black Life and Culture, XI (New York, 1982); and Janzen and Wyatt MacGaffey, *An Anthology of Kongo Religion: Primary Texts from Lower Zaïre,* University of Kansas Publications in Anthropology, no. 5 (Lawrence, Kans., 1974).

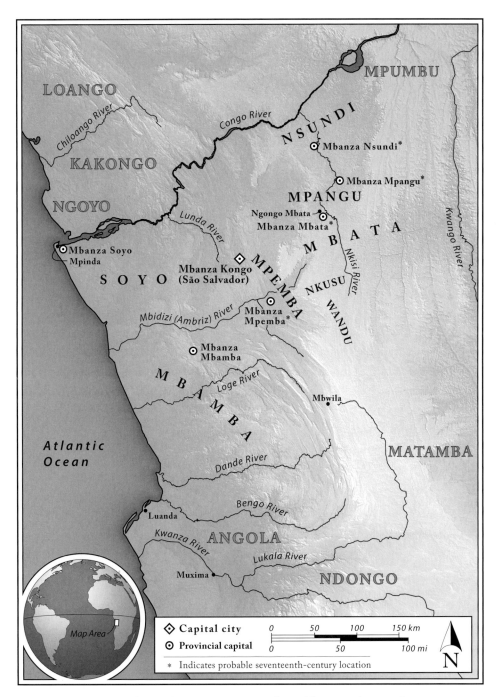

MAP 1 The Kingdom of Kongo's Main Provinces and Neighboring Polities in the
Seventeenth Century. Drawn by James DeGrand. The Kongo's provinces are labeled
in black; neighboring polities, in gray

The kingdom entered European history in 1483 with the arrival on its shores of Portuguese explorers and clerics, led by Diogo Cão, in search of the maritime passage to India and of new allies for Christendom. In the first decade of contact, Kongo and Portugal exchanged hostages, dispatched embassies, and established a cordial diplomatic relationship. The result of these early encounters with Europeans was the willful conversion of the Kongo monarch, Nzinga a Nkuwu (r. 1470–1509), who celebrated his baptism with great pomp on May 3, 1491, and took the name of João I after the king of Portugal. The newly Christian ruler instigated large-scale reforms in his kingdom, based on the technological, cultural, and religious knowledge that Portuguese emissaries and Kongo men who had returned from long stays in Europe brought to his court.[2]

The changes initiated by João blossomed under the leadership of his son and successor Afonso I Mvemba a Nzinga (r. 1509–1542), who imposed Christianity as the kingdom's state religion and integrated it into the symbolic and historical fabric of the Kongo. The official adoption of the new faith was met with a mix of enthusiasm and opposition, but Christianity soon prevailed as the state religion and opened a new era in the history of central Africa, defined by its people's growing involvement in the commercial, political, and religious networks of the early modern Christian Atlantic world. From this time to the era of nineteenth-century colonial imperialism, through centuries of dense history marked by periods of great stability and prosperity as well as by profoundly transformative events such as civil and foreign wars and the drain of the Atlantic slave trade, Christianity continued to play a prominent role in shaping the political and religious life of the Kongo.[3]

The reasons behind the Kongo elite's rapid and enthusiastic decision to independently embrace Christianity remain unclear. It is beyond doubt, however, that by adopting Christianity the central African monarchy benefited

2. For a discussion of Portugal's overseas explorations, see Francisco Bethencourt and Diogo Ramada Curto, *Portuguese Oceanic Expansion, 1400–1800* (Cambridge, 2007), 200. The early history of the encounter between Portugal and the Kongo is told, for example, in the early-sixteenth-century texts of Rui de Pina, chronicler for the royal house of Portugal. See the critical edition by Carmen M. Radulet, *O cronista Rui de Pina e a "Relação do Reino do Congo": Manuscrito inédito do "Códice Riccardiano 1910,"* Mare liberum (Lisbon, 1992), 121–123.

3. A documentary history of Christianity in central Africa based on careful study of the primary sources may be found in Graziano Saccardo, *Congo e Angola con la storia dell'Antica missione dei Cappuccini,* 3 vols. (Venice-Mestre, 1982–1983). The history of the kingdom of Kongo has been discussed for the early period in Jean Cuvelier, *L'ancien royaume de Congo: Fondation, découverte, première évangélisation de l'ancien royaume de Congo, règne du grand roi Affonso Mvemba Nzinga (1541)* (Bruges, 1946). For the seventeenth century, see John K. Thornton, *The Kingdom of Kongo: Civil War and Transition, 1641–1718* (Madison, Wis., 1983). For a later period, see Kabolo Iko Kabwita, *Le royaume kongo et la mission catholique, 1750–1838: Du déclin à l'extinction,* Mémoire d'églises (Paris, 2004). Anne Hilton considers the kingdom from the fifteenth to the twentieth century in *The Kingdom of Kongo,* Oxford Studies in African Affairs (Oxford, 1985).

from the powerful support of the papacy against the territorial claims of Portugal. Portugal, in turn, hoped to find in the development of the Catholic Church in the Kongo under its patronage both international prestige and a means to exercise control over the great kingdom. The Kongo's conversion fulfilled the duty of the Iberian realm to bring Catholicism to overseas territories under the *padroado régio,* a set of ecclesiastical rights and responsibilities over newly claimed territories the papacy bestowed to Portugal in the fifteenth century. The padroado granted the Iberian crown control over the clergy and, later, bishops of central Africa—and therefore the possibility of holding sway over the spiritual and secular affairs of the African kingdom. These rights, in fact, did not allow Portugal much power in the Kongo; throughout the period, the local crown maintained financial responsibility for and de facto authority over the priests active in the region. Yet, from the baptism of the king in 1491 to the 1620s, the Kongo and Portugal maintained a relatively amicable relationship.[4]

The budding Christianity of the Kongo immediately caught the attention of several missionary orders functioning outside Portugal's patronage. There are indications that the Lóios, or Canons Regular of Saint John the Evangelist, were among the first religious groups to arrive from Europe, but no documentation remains of their stay. The new Company of Jesus (later called the Society of Jesus), founded in 1540, rushed to the Kongo as early as 1548 and established an ambitious but short-lived mission that had failed by 1555. During that time, the Jesuits nonetheless produced the first catechism dedicated to the Kongo, published in Lisbon in 1556 and probably redacted in both Portuguese and Kikongo, the language of the Kongo. The author likely was Cornelio Gomes, a man born in the African kingdom to Portuguese parents, who became a priest, served as an ambassador of the king of Kongo in Europe, and eventually joined the Society to serve in its central African missions. Unfortunately, no copies of the book have been located yet. Franciscans followed soon after the Jesuits in 1557 for another short-lived enterprise that closed by 1564. Four Dominicans arrived in central Africa in the 1570s, but two of them died almost immediately, and the remaining two went back to Portugal soon after, defeated by disease. Finally, Discalced Carmelites, a 1562 reform community of the thirteenth-century Carmelite rule, officiated in the

4. For a discussion of the *padroado régio,* or royal patronage, see Antonio da Silvo Rego, *Le patronage Portugais de l'Orient, un aperçu historique* (Lisbon, 1957); Isabel dos Guimarães Sa, "Ecclesiastical Structures and Religious Action," in Francisco Bethencourt and Diogo Ramada Curto, eds., *Portuguese Oceanic Expansion, 1400–1800* (New York, 2007), 257–259. For documents and analysis of this period, see, for example, Willy Bal, *Le royaume du Congo aux Xve et XVIe siècles; documents d'histoire choisis et présentés en traduction française, avec annotations* (Léopoldville, 1964); J. Cuvelier and L. Jadin, *L'ancien Congo d'après les archives romaines (1518–1640)* (Brussels, 1954).

Kongo for two years starting in 1584. The interest that the various missionary groups showed in the Kongo came without a doubt from the prestige they hoped to derive by associating their order with the great apostolic success that the nascent African Catholic Church promised to represent.[5]

Afonso I, the inventor of Kongo Christianity, passed away in 1542, and his long reign was followed by several more decades of stability under Diogo I Nkumbi a Mpudi (r. 1544–1561), Álvaro I Nimi a Lukeni lua Mbemba (r. 1568–1687), and Álvaro II Mpanzu a Nimi (r. 1587–1614). Succession struggles nonetheless occasionally arose, and between 1561 and 1568 the kingdom, paralyzed by internal conflict, fell to the Jagas, bellicose invaders coming from regions east of its limes. In the face of the invasion, the realm regrouped around Álvaro I, who was able to overrun the intruders with the help of the Portuguese in 1568. Taking advantage of the weakened Kongo, the Iberian realm then founded the colonial city of Luanda at the southern frontier of the kingdom in the aftermath of the battles in 1575. By the 1620s, the increasingly strained relationship between the Kongo and Portugal started to unravel. In 1622, Portugal invaded the south of the kingdom from what had become their colony of Angola. In 1624, it permanently called back the bishop of Kongo and Angola, seated in the kingdom's capital, São Salvador do Congo, since the foundation of the bishopric in 1596, to Luanda, chief city of colonial Angola.[6]

A new phase thus opened in the relationship between the Kongo and the Catholic Church, marked by the kingdom's will to maintain its religious independence from Portuguese clerical hierarchy. In 1619, the Jesuits, not allied with the Portuguese crown, returned to the Kongo and in 1625 opened a college in the capital to educate the royal elite. The Society's efforts yielded the second and oldest extant Kikongo catechism, published in 1624. In addition, and in direct response to the departure of the bishop, the king of Kongo ob-

5. Pedro Vilas Boas Tavares, "Participação dos Lóios nas primeiras 'missões' africanas" (paper presented at the Congresso Internacional Bartolomeu Dias e a sua Época, 1989). For the first Jesuit mission, see Saccardo, *Congo e Angola*, I, 50–52; and François Bontinck and D. Ndembe Nsasi, *Le catéchisme kikongo de 1624: Réédition critique*, Mémoires—Académie Royale des Sciences d'Outre-Mer (Brussels, 1978), 17–23. For the early Franciscan presence, see Saccardo, *Congo e Angola*, I, 53–55. On the Dominicans, see António Brásio, ed., *Monumenta missionaria africana: África ocidental*, 15 vols. (Lisbon, 1952–1988), IV, 273–275. For a summary of the Discalced Carmelite mission and its documents, see François Bontinck, "Les Carmes Déchaux au royaume de Kongo (1584–1587)," *Zaïre-Afrique*, no. 262 (February 1992), 112–123. The documents concerning their mission are in MS 2711, fols. 108–133, Biblioteca Nacional de España, Madrid.

6. The origin and identity of the Jagas is a controversial question among historians of central Africa. A good summary of the literature on the problem is found in Paulo Jorge de Sousa Pinto, "Em torno de um problema de identidade: os 'Jagas' na História de Congo e Angola," *Mare Liberum*, nos. 18–19 (1999–2000), 193–243, as well as in the notes to the French edition of [Duarte Lopes and Filippo Pigafetta], *Relatione del reame di Congo et delle circonvicine contrade: Tratta dalli scritti e ragionamenti di Odoardo Lopez Portoghese per Filippo Pigaffetta* . . . (Rome, 1591): Duarte Lopes and Filippo Pigafetta, *Le royaume de Congo et les contrées environnantes, 1591*, trans. and ed. Willy Bal, Collection Magellane

tained from the papacy the dispatch of Capuchin missionaries from nations outside Portugal, who would work in the capital as well as in the provinces under the direct control of the Kongo crown and elite. The mendicants of the Order of Friars Minor Capuchin, a 1558 reform community of the thirteenth-century Franciscan rule, arrived in the Kongo in 1645 in the wake of the Dutch-Portuguese wars in which the Kongo allied with the Dutch, who took control of Angola in 1641 for a brief period. Increased territorial pressures from Portugal immediately followed the restoration of Portuguese Angola in 1648. Tension between the Kongo and the Iberian kingdom culminated in the 1665 Battle of Mbwila, a disastrous defeat for the central Africans that opened a forty-year period of civil wars in the kingdom. Relative stability returned to a permanently weakened realm around 1700 with a creative political compromise designed by King Pedro IV Agua Rosada (r. 1696–1718) that was based on rotating succession between the major lineage groups pretending to the throne. The reoccupation and reconstruction of the capital of São Salvador in 1709 symbolized the return of peace. The new system functioned moderately well throughout the seventeen hundreds. What had been a centralized kingdom in the preceding centuries became increasingly fragmented, united by an attachment to the capital but divided by the growing independence of the individual provinces, in particular Soyo and Nsundi in the northern parts of the realm. The rotational truce ended in 1764. From that time to the gradual annexation of the kingdom into colonial Angola between 1859 and 1914, a series of generally long reigns afforded stability to kings who established their rule by force. The Capuchins continued their work in the region for most of the period, with increasingly reduced numbers and geographic coverage until the last friars left Luanda in 1834 after the general dissolution of the male regulars in Portugal and its overseas dominions.[7]

(Paris, 2002), 291–295. For a discussion of the creation of the city of Luanda, see Cécile Fromont, "A Walk through the City: Stories and Histories of Luanda, 1575–1975," *Ellipsis: Journal of the American Portuguese Studies Association,* IV (2006), 49–77. See a description of the period in John Thornton and Andrea Mosterman, "A Re-interpretation of the Kongo-Portuguese War of 1622 according to New Documentary Evidence," *Journal of African History,* LI (2010), 235–248. For the history of the bishopric of Kongo and Angola, see Chantal da Silva, "L'évêché du Congo et de l'Angola (1596–1760)," *Anais de História de Além-Mar,* IV (2003), 295–334. This period also saw the union of the crowns of Portugal and Spain between 1580 and 1640.

7. Jorge, Bontinck, and Nsasi, *Le catéchisme kikongo de 1624,* 17–36. For an account of the Dutch presence in central Africa, see Klaas Ratelband and Carlos Pacheco, *Os Holandeses no Brasil e na costa africana: Angola, Kongo, e São Tomé, 1600–1650* (Lisbon, 2003). On Mbwila, see John K. Thornton, *Warfare in Atlantic Africa, 1500–1800* (London, 1999), 103–107; and Gastão Sousa Dias, *A batalha de Ambuíla* (Lisbon, 1942). On the rotating truce, see Thornton, *Kingdom of Kongo,* 97–121. For the suppression, see William J. Callahan, "Spain and Portugal: The Challenge to the Church," in *The Cambridge History of Christianity,* VIII, *World Christianities, c. 1815–c. 1914,* ed. Sheridan Gilley and Brian Stanley (Cambridge, 2006), 383.

From the sixteenth to the nineteenth century, the kingdom of Kongo actively participated in the commercial, diplomatic, and religious networks of the Atlantic world. The elite of the Kongo, in addition to their involvement in the slave trade, imported and exported metals, textiles, and luxury goods, working with merchants from a range of European nations. The kingdom also maintained an active diplomatic agenda, reaching out and negotiating with European governments through correspondence and ambassadors, whose visits engendered great interest and celebration not only in Iberia but also in Rome and in Dutch territories. These diplomatic missions dealt with political and commercial matters, but they also asserted the kingdom's place in Christendom and allowed the kingdom to seek from its European partners and allies, in particular the papacy and selected religious orders, the resources—chiefly clerics and devotional objects—to ensure the continued promotion of Christianity in its territories. The written and artistic traces of these transactions form the core of the documentary corpus on the kingdom of Kongo between 1500 and 1885.[8]

The Atlantic Dimension of Kongo Christianity

The impact of Kongo Christianity extended far beyond the boundaries of the African kingdom. The active diplomatic endeavors of the Kongo elite on the international scene and the strategic interests of European powers in the region placed the central African Christian land in a position of some influence in the commercial and geopolitical transactions of the early modern world. Over the centuries, the Kongo implemented and reaped the rewards of ambitious diplomatic missions that left a rich documentary and artistic record. The Christian kingdom helped to shape, for example, the emergence and organization of the papacy's own global missionary program and took part in the unfolding of the struggle between Portugal and the Low Countries in the southern Atlantic in the mid-seventeenth century. Considering

8. For documents on trade in the Kongo, see Louis Jadin, "Rivalités luso-néerlandaises au Sohio, Congo, 1600–1675: Tentatives missionaires des récollets flamands et tribulations des capucins italiens, 1670–1675," *Bulletin de l'Institut Historique Belge de Rome,* XXXVII (1966), 137–337; E. G. Ravenstein, ed., *The Strange Adventures of Andrew Battell, of Leigh, in Angola and the Adjoining Regions . . .* (1901; rpt. Nendeln, Liechtenstein, 1967). Studies of Kongo diplomatic missions include F. Bontinck, "Jean-Baptiste Vivès: Ambassadeur des Rois de Congo auprès du Saint-Siège," *Revue du clergé Africain,* VII (1952), 258–264; Bontinck, "La première 'ambassade' congolaise à rome (1514)," *Etudes d'Histoire Africaine,* I (1970), 37–73; Luis Martínez Ferrer and Marco Nocca, *"Coisas do outro mundo": A missão em Roma de António Manuel, Príncipe de N'Funta, conhecido por "o Negrita" (1604–1608), na Roma de Paulo V: Luanda, exposição documental* (Vatican City, 2003); Richard Gray, "A Kongo Princess, the Kongo Ambassadors, and the Papacy," *Journal of Religion in Africa: Special Issue in Honour of the Editorship of Adrian Hastings, 1985–1999, and of His Seventieth Birthday, 23 June 1999,* XXIX (1999), 140–154.

the story of Kongo Christianity both in and out of Africa thus brings a fuller understanding of early modern Europe's engagement with other parts of the globe, beyond a narrow focus on colonial endeavors, and enlarges our knowledge of the cross-cultural transactions that shaped the early modern world. Kongo Christianity indeed emerged and endured during the same period that saw the birth and solidification of the European colonial presence in the Americas. But, unlike the cross-cultural interactions that occurred under colonial domination, this new system of thought in the Kongo derived from independent reflection on the part of central Africans about the innovations that an expanding world brought to their shores.

Although it is crucial to highlight the Kongo and its people as independent, influential actors in the early modern Atlantic, it remains indisputable that it was the Atlantic slave trade that made central Africans a significant presence first in Europe and later in the Americas. The commerce in enslaved men and women was in many ways the price the Kongo elite paid for their involvement in long-distance diplomatic and trade networks. From the outset, acquiring the foreign goods the Kongo elite so eagerly sought and also showcasing diplomatic munificence involved both the transfer of slaves from the central African realm to its European partners and the opening of its land to foreign slave traders. Social categories of servitude, free citizenry, and aristocracy existed in the kingdom before the arrival of Europeans and allowed for an easy translation of the foreigners' demand for enslaved workers into the export of slaves, a practice that, in turn, reinforced and sharpened distinctions between the different social strata. The Kongo's overseas trade in slaves thus developed in the first decades of contact with Europe as a form of international currency, complementing the kingdom's other exports in ivory, copper, and cloth.[9]

The pernicious effects of the kingdom's involvement in the slave trade soon became apparent to its rulers. Afonso I, who in earlier decades had used slaves as gifts and payments for overseas transactions, in 1526 vehemently condemned the vicious effects of the trade on his kingdom. He denounced in particular the unlawful enslavement of his subjects and the anarchical involvement of Portuguese and central Africans alike in the lucrative commerce. This new economic system challenged his authority, evaded his fiscal policy, and diminished his ability to fulfill his role as protector of his people.

9. For the early trade, see Linda M. Heywood, "Slavery and Its Transformation in the Kingdom of Kongo, 1491–1800," *Journal of African History*, L (2009), 2–3. See also Duarte Pacheco Pereira's 1506 merchant report in Pereira, *Esmeraldo de situ orbis,* ed. Raphael Eduardo de Azevedo Basto, Edição comemorativa da descoberta da América por Christovão Colombo no seu quarto centenário (Lisbon, 1892), 84.

His successors continued to raise similar objections. They were not opposed to the principle of enslavement or to the existence of the transatlantic commerce, but they strongly criticized the trade's practices and fretted over its consequences.[10]

The ability of the Kongo elite to mitigate the extent and effects of the slave trade on their region has been the subject of much scholarly debate. Clearly, however, the trade contributed to the political instability that plagued the kingdom from at least the era of the civil wars of the late seventeenth century, increasing the wealth and independence of some of its provinces, for example. In turn, internal strife at different points in time, often derived from fraught rules of royal succession, fed the trade. War produced captives, and rebellion was an offense punishable by enslavement, sending people of all standing to the Middle Passage. During the course of the seventeen hundreds, rivalry between factions led to an increase in both internal and external slavery as power in the Kongo came to increasingly depend on enslaved armed guards. This situation created small and large chieftains and bandits who sought and made their fortune capturing and selling slaves in and out of the kingdom. Other policies of the realm also paradoxically undermined the kings' efforts to protect their own people, such as forced deportation for crimes against the church, lèse-majesté vis-à-vis the Order of Christ, or witchcraft.[11]

As a result, from as early as the beginning of the sixteenth century and well into the second half of the eighteen hundreds, thousands of men and women enslaved in and around the kingdom were displaced to all corners of the Atlantic. Central African slaves first reached the Iberian Peninsula and then, from the middle of the sixteenth century on, made up a significant portion of the enslaved manpower imported into the Americas. There they participated in the shaping of what would become a truly new world, molded

10. See Afonso to King João of Portugal, July 6, 1526, in Brásio, ed., *Monumenta*, I, 468–471, Oct. 18, 1526, I, 488–491.

11. Some historians, such as Ann Hilton and Joseph Inikori, argue that the transatlantic slave trade's unprecedented structures and patterns ravaged the kingdom. Others, like John Thornton and Linda Heywood, maintain that the Kongo's rulers retained substantial control over the commerce and its effects in their land, at least until the end of the sixteen hundreds. Each side brings a complementary perspective on the issue, as slavery's relevance varied at different points in the kingdom's history. See Heywood, "Slavery and Its Transformation in the Kingdom of Kongo," *Journal of African History*, L (2009), 1–22; Thornton, *Kingdom of Kongo*; Hilton, *Kingdom of Kongo*; Joseph E. Inikori, "Slavery in Africa and the Transatlantic Slave Trade," in Joseph E. Harris et al., *The African Diaspora*, ed. Alusine Jalloh and Stephen E. Maizlish (College Station, Tex., 1996), 39–72. The penalty for insults against the Order of Christ, an order of knighthood the Kongo elite adopted from Portugal, is mentioned in António Brásio, "Raimondo da Dicomano, Informazione 1798: Documentario," *Studia*, XLVI (1987), 326. On witches sent into slavery, see Girolamo Merolla da Sorrento and Angelo Piccardo, *Breve, e succinta relazione del viaggio nel regno di Congo nell' Africa meridionale, fatto dal P. Girolamo Merolla da Sorrento . . . Continente variati clima, arie, animali, fiumi, frutti, vestimenti con proprie figure, diversità di costumi, e di viveri per l'uso humano* (Naples, 1692), 105–106.

by the profound and enduring interactions between the people indigenous to the land, the Europeans who claimed control over these territories, and the men and women from Africa and Asia who arrived in their midst as a result of the new economic system implemented in the region. Ever more precise and sophisticated demographic information about the movement of people between Africa and the Americas is becoming available thanks to records of transatlantic slave ship voyages compiled in the slave trade database and the innovative analysis historians derive from its data. Cultures, however, are not easily measured with the yardstick of numerical analysis, and the impact of enslaved Africans on the religious, artistic, linguistic, and philosophical life of the regions to which they were brought becomes apparent only when such quantitative data is enriched with a range of other sources.[12]

Inquisition records, naming patterns, warfare techniques, religious sensibilities, and language as well as visual and material forms create a vivid record of the presence of central Africans in general and people of the Kongo in particular in Europe and the Americas and the impact they had on their new environment. Even if the meaning and use of ethnic labels among the enslaved remained fluid, people claiming central African origins and their descendants crafted specific responses to their new life in enslavement, some of which called upon, transposed, and used aspects of the Christian background of their region of origins. In Portugal and Brazil, men and women from central African "nations" formed confraternities in the orbit of the church. There they elected and crowned kings and queens with pomp and pageantry inspired by Kongo coronations. The fierce central African soldiers of the South Carolinian 1739 Stono Rebellion, who rallied around a common Catholic identity, garnered strength and courage on a feast day dedicated to the Virgin Mary. They staged a typical central African *sangamento,* a martial performance in preparation for battle, in a manner similar to that used by contemporary Kongo armies. Kongo religious and political ideology—and military training—also loomed large in the worldview of Haitian revolutionary leaders.[13]

12. For quantitative data and analysis of the slave trade, see David Eltis et al., eds., *The Trans-Atlantic Slave Trade: A Database on CD-ROM* (Cambridge, 1999); David Eltis and David Richardson, *Atlas of the Transatlantic Slave Trade* (New Haven, Conn., 2010).

13. For confraternities, see Didier Lahon, "Esclavage et confréries noires au Portugal durant l'Ancien Régime (1441–1830)" (Ph.D. diss., École des hautes études en sciences sociales, 2001); Célia Maia Borges, *Escravos e libertos nas irmandades do Rosário: Devoção e solidariedade em Minas Gerais, séculos XVIII e XIX* (Juiz de Fora, 2005); Lucilene Reginaldo, *Os Rosários dos Angolas: Irmandades de africanos e crioulos na Bahia setecentista* (São Paulo, 2011); Patricia Ann Mulvey, "The Black Lay Brotherhoods of Colonial Brazil: A History" (Ph.D. diss., City Univeristy of New York, 1976); Elizabeth W. Kiddy, *Blacks of the Rosary: Memory and History in Minas Gerais, Brazil* (University Park, Pa., 2005). For the coronations, see Marina de Mello e Souza, *Reis negros no Brasil escravista: História*

More than any other emblems, the sign of the cross, in all its ambivalence as a symbol of both Christian and non-Christian Kongo religious thought, has been recognized as the preeminent signature of central African heritage in American visual, material, and religious culture. Drawing from the exegesis of Congolese philosopher Fu-Kiau Bunseki, Robert Farris Thompson brought the cross to the limelight as the fundamental symbol of Kongo cosmology in Africa as well as in the Americas in his influential essays for the 1981 exhibition catalog, *The Four Moments of the Sun*. Since then, archaeologists, historians, and art historians have found written, material, and oral traces of the Kongo cosmogram and its associated philosophies from the era of the slave trade to contemporary times in Haitian *vévé* ground paintings, Brazilian *puntos risgados,* Cuban *firmas,* and in artifacts from the southern United States.[14]

My analysis of the Kongo in the era of the slave trade thus sheds light not only on the kingdom but also on developments that unfolded well beyond west central Africa in all corners of the Atlantic world. By establishing the nature, form, and manifestations of Kongo's religious, artistic, and political engagement with Christianity in Africa, it provides an essential background for understanding cultural transmissions across the Middle Passage. Even the most influential studies of the visual and material culture of the historical African diaspora appeal in their arguments to broad parallels between the era of slavery and more recent practices in the Americas and twentieth-century ethnographies of central Africa. The corpus and history presented in this study now make possible the formulation of other, historically grounded arguments about cultural continuity and change across the Atlantic.[15]

da festa de coroação de Rei Congo (Belo Horizonte, 2002); Cécile Fromont, "Dancing for the King of Congo from Early Modern Central Africa to Slavery-Era Brazil," *Colonial Latin American Review,* XXII (2013), 184–208. On the Stono Rebellion, see John K. Thornton, "African Dimensions of the Stono Rebellion," *American Historical Review,* XCVI (1991), 1112; Mark M. Smith, "Remembering Mary, Shaping Revolt: Reconsidering the Stono Rebellion," *Journal of Southern History,* LXVII (2001), 513–534. For Haiti, see John K. Thornton, "I Am a Subject of the King of Kongo: African Political Ideology and the Haitian Revolution," *Journal of World History,* IV (1993), 181–214; Terry Rey, "The Virgin Mary and Revolution in Saint-Domingue: The Charisma of Romaine-la-Prophétesse," *Journal of Historical Sociology,* XI (1998), 341–369.

14. Thompson and Cornet, *The Four Moments of the Sun,* 43–46. For the Kongo cosmogram in United States archaeology, see Christopher C. Fennell, *Crossroads and Cosmologies: Diasporas and Ethnogenesis in the New World* (Gainesville, Fla., 2007). In Cuba, see Bárbaro Martínez-Ruiz, *Kongo Graphic Writing and Other Narratives of the Sign* (Philadelphia, 2013). In Haiti, see Robert Farris Thompson, "Translating the World into Generousness: Remarks on Haitian Vèvès," *RES: Anthropology and Aesthetics,* no. 32 (Autumn 1997), 19–34.

15. Other studies not primarily concerned with visual and material culture have established the connection between central Africa and specific cultural and religious manifestations among enslaved people from other, more rigorously historical perspectives. James H. Sweet described rites and beliefs present across the African-Portuguese world from central Africa to Brazil; Jason Young considered the close religious links that tied the Kongo and the United State Lowcountry in the era of slavery;

The Conversion Debate

For decades, scholars have interrogated the reasons that led Kongo rulers to independently adopt and promote Christianity in their realm and debated the extent to which the new faith affected the worldview of the realm's inhabitants beyond the elite. Diverging opinions on these questions have shaped Kongo historiography. Early scholarship on the kingdom from religious historians, such as the Jesuit V. Baesten, the Franciscan Eucher de Roy, or anonymous Capuchin authors, was typically published by their orders. Conversion was not a problematic term in these works, the main aim of which was to document and celebrate the particular group's past achievements. For most of the twentieth century, historical inquiry on the Kongo remained the territory of missionary-scholars such as Louis Jadin, Jean Cuvelier, Hildebrand de Hooglede, Carlo Toso, Graziano Saccardo, Francisco Leite de Faria, and António Brásio, who collectively paved the path for later studies through their tireless and extremely diligent collection, analysis, and publication of the documents relating to the region. Because they were often missionaries to central Africa themselves and so deeply invested in the success of their predecessors, their otherwise sophisticated works did not adopt a critical stance vis-à-vis the question of conversion, which they presented as a continuing, but mostly uncomplicated, process.[16]

In contrast, the conversion debate took center stage in the investigations of lay scholars in the second half of the century. In dated studies tinted with ethnocentrism, W. G. L. Randles and Georges Balandier in the 1960s considered Christianity as a feeble presence in the Kongo, perhaps best encapsulated

and Thornton and Heywood drew the contours of seventeenth-century central African influence in the shaping of the Americas at large. Maureen Warner-Lewis, Monica Schuler, and Ras Michael Brown discussed the same connections in a broader chronological lens, looking at the early modern period as well as recent times. Opinions vary among these authors about the specific role of Christianity in Kongo life on both continents, but together they draw a vivid portrait of the transmission of central African worldviews from one context to the next. See James H. Sweet, *Recreating Africa: Culture, Kinship, and Religion in the African-Portuguese World, 1441–1770* (Chapel Hill, N.C., 2003); Maureen Warner-Lewis, *Central Africa in the Caribbean: Transcending Time, Transforming Cultures* (Kingston, Jamaica, 2003); Monica Schuler, *"Alas, Alas, Kongo": A Social History of Indentured African Immigration into Jamaica, 1841–1865* (Baltimore, 1980); Jason R. Young, *Rituals of Resistance: African Atlantic Religion in Kongo and the Lowcountry South in the Era of Slavery* (Baton Rouge, La., 2007); Ras Michael Brown, *African-Atlantic Cultures and the South Carolina Lowcountry* (New York, 2012); Linda M. Heywood and John K. Thornton, *Central Africans, Atlantic Creoles, and the Foundation of the Americas, 1585–1660* (Cambridge, 2007).

16. V. Baesten, "Les Jésuites au Congo (1548–1759)," *Précis Historiques: Bulletin mensuel des missions Belges de la Compagnie de Jésus,* XLI (1892), 529–546, XLII (1893), 55–75, 101–122, 241–258, 433–457, XLIV (1895), 465–481, XLV (1896), 49–60, 145–157; Eucherius de Roy, *Le Congo: Essai sur l'histoire religieuse de ce pays depuis sa découverte (1484) jusqu'à nos jours* (Huy, 1894). See also the works by Capuchin Dieudonné Rinchon, such as *Les missionaires Belges au Congo: Aperçu historique, 1491–1930* (Brussels, 1931); and studies in *Analecta Ordinia Fratrum Minorum Capuccinorum* (Rome, 1940–).

in Balandier's phrase, "failed acculturation." More recent studies by anthropologist Wyatt MacGaffey, historian Anne Hilton, and historian James Sweet all argue that, if Christianity had a lasting presence in central Africa, Kongo cosmology wholly took over the new religion. In contrast, John Thornton, Richard Gray, and Jason Young argue that the people of the Kongo adopted Christianity, albeit to varying degrees, according to the church's standards of the time and followed their own interpretation of the new religion.[17]

Scholars on both sides of the debate have in common a focus on textual sources, whether written or oral. They all derive their interpretations from the rich archival collections that make the Kongo the best-documented area of Africa before the colonial period or from the equally impressive set of ethnographies gathered in the region since the early twentieth century. As an art historian, I bring to the debate new evidence that complements these sources. Visual and material cultures, considered on their own but also in conjunction with word-based documentation, offer crucial insights into the perspective of central Africans on the changes they faced in the early modern period and, by extension, into the nature and form of conversion. Crucifixes and figures of saints as well as architecture, regalia, and sartorial practices materialized the reflection through which Kongo men and women brought together and redefined central African and Euro-Christian concepts and forms into a coherent set of ideas and practices that I collectively refer to as Kongo Christianity. This term acknowledges that new and influential beliefs, political discourses, and social organizations emerged in the region as a result of its engagement with the precepts and symbolism of Christianity. Whether individual, sincere change of heart consistently took place among large sections of the population—that is, conversion in the modern sense—the visual culture of central Africa between 1500 and 1885 amply demonstrates that its people profoundly and lastingly relied on Christianity and its imagery in their social, political, and spiritual life. In turn, the recognizable Christian visual culture that developed in the kingdom ensured its place in the realm of Christendom, a status European powers acknowledged throughout the period.

17. W. G. L. Randles, *L'ancien royaume du Congo des origines à la fin du XIXe siècle* (Paris, 1968); Georges Balandier, *La vie quotidienne au royaume de Kongo du XVIe au XVIIIe siècle* (Paris, 1965); Balandier, "Le royaume de Kongo et l'acculturation ratée," *XIIème Congrès des Sciences Historiques* (Vienna, 1965), 95–102; Hilton, *Kingdom of Kongo*, 62–64; MacGaffey, "Dialogues of the Deaf," in Schwartz, ed., *Implicit Understandings*, 249–267; Wyatt MacGaffey, *Religion and Society in Central Africa: The BaKongo of Lower Zaire* (Chicago, 1986), 189–216; Sweet, *Recreating Africa*, 113–117; John Thornton, "Perspectives on African Christianity," in Vera Lawrence Hyatt and Rex Nettleford, eds., *Race, Discourse, and the Origin of the Americas: A New World View* (Washington, D.C., 1995); Richard Gray, "'Come vero Precipe Catolico': The Capuchins and the Rulers of Soyo in the Late Seventeenth Century," *Africa: Journal of the International African Institute*, LIII, no. 3 (1983), 39–54; Young, *Rituals of Resistance*, 46–64.

The extant visual and material evidence from the period consists primarily of prestige items and elite representations. The nature of this archive creates a focus on the upper class in this and other studies of Kongo Christianity. The prominent men of the Kongo and the equally powerful women of their entourage derived their elite status from the often interrelated attributes of descent from eminent lineages, control over large demographic groups and natural resources, and appointment in political positions of power. The rest of the population, however, even if leaving little trace in the historical record, did not dwell outside the realm of Kongo Christianity. They lived in an environment molded by the visual and material culture the elite created around the new religion, and, in turn, contributed to shaping this new world, albeit in ways not yet fully understood.

A linear narrative cannot adequately articulate the nature, mode, and means of Kongo's artful adoption of the new religion and its imagery nor properly outline how Kongo Christianity evolved over time and in response to changing historical conditions in the region. Rather than following a strictly chronological course, I will focus on a series of cultural objects—narratives, images, visual practices—that each played a critical role in the emergence and sustained importance of Christianity in the Kongo. The five interrelated chapters follow a roughly chronological order from the advent of Christianity circa 1500 to the unraveling of the kingdom in the late nineteenth century, but they primarily present a diachronic thematic analysis, each building upon preceding sections to offer an increasingly complex perspective on Kongo Christianity.

Spaces of Correlation

Kongo Christianity emerged from an encounter between central African and European religious thought, visual forms, and political systems that channeled through a set of cultural objects to form "spaces of correlation," a concept that encapsulates the central analytical proposition of this study. Spaces of correlation are cultural creations such as narratives, artworks, or performances that offer a yet unspecified domain in which their creators can bring together ideas and forms belonging to radically different realms, confront them, and eventually turn them into interrelated parts of a new system of thought and expression. In the *atopia*, the creative domain offered by the space of correlation, local and foreign thought can evolve into a single, novel worldview, new notions can transform old concepts, and attributes of the other can transfigure definitions and representations of the self. As an analytical tool, the idea applies to a variety of concrete or abstract objects

characterized by a range of historically and culturally specific paradigms of change. Creole languages merging local grammar and foreign vocabulary, hybrid art from colonial contexts that use strategically the ambiguity of visual representation to express a subaltern point of view, or revolutionary narratives reformulating the past from a radical, novel perspective could all be analyzed as spaces of correlation. In each of these examples, a different process of cultural change is at play, from syncretism to appropriation and innovation. Yet, in all instances, the product of the confrontation does not merely form a new entity; it also creates new and strong links between its original components.[18]

Interest in the mutually transformative impact of cross-cultural interactions on the elements in contact has been at the core of analysis of cultural convergence since Fernando Ortiz's 1940 formulation of transculturation and, in late-twentieth-century postcolonial studies, was reflected in concepts such as Homi Bhabha's "third space" and the related idea of hybridity. These notions were coined to make sense of cross-cultural interactions in contexts that Mary Louise Pratt called *"contact zones,"* or "social spaces where cultures meet, clash, and grapple with each other, often in contexts of highly asymmetrical relations of power, such as colonialism, slavery, or their aftermaths"—that is, the postcolonial world in which and about which these terms emerged.[19]

Using any of these concepts to analyze Kongo Christianity gives me pause. The art of conversion did not emerge from a situation devoid of power struggles, conflict, and inequality; it was in many regards intricately linked to securing and enacting power and legitimacy. But these tensions took place at the margin of the cross-cultural encounter rather than at its core. The imposition of Christianity as a state religion was an internal matter spearheaded by the kingdom's own elite who conversed freely and on their own terms with foreigners and independently considered the ideas and forms they introduced. Neither the adoption of Christian imagery and thought nor their redefinition in a central African light followed a pattern of foreign oppression and local resistance or emerged in response to "conditions of coercion,

18. Here I use the term *space* in the sense of *espace,* in French referring to an area, extent, or domain that is both localized and defined but not assigned to any specific use. The phrase is partly inspired by Tom Cummins's discussion of images as "sites of correlation" in colonial legal and religious contexts. See Thomas Cummins, "From Lies to Truth: Colonial Ekphrasis and the Act of Crosscultural Translation," in Claire J. Farago, *Reframing the Renaissance: Visual Culture in Europe and Latin America, 1450–1650* (New Haven, Conn., 1995).

19. Fernando Ortiz, *Contrapunteo cubano del tabaco y el azúcar (advertencia de sus contrastes agrarios, económicos, históricos y sociales, su etnografía y su transculturación)* (Havana, 1940); Homi K. Bhabha, *The Location of Culture* (London, 1994); Mary Louise Pratt, "Arts of the Contact Zone," *Profession* (1991), 34.

radical inequality, and intractable conflict" between natives and outsiders, to further quote Pratt.[20]

Rather than using the language of postcolonial theory, I propose instead turning to spaces of correlation to consider the diverse faces of cross-cultural interaction and convergence across time and geographies. After all, these encounters often took a form that differed strikingly from twentieth-century colonial systems and the postcolonial world in which the most prominent tools used to analyze cross-cultural change were honed. In the early modern world, some of the most spectacular moments of generative interaction between peoples took place outside the paradigms of colonization—such as sixteenth-century Japanese Christianity and the conversion of the Kongo— and colonization itself in this era took on many different guises. The systems of political control and economic exploitation the Hispanic monarchy sought and often failed to implement in vice-regal Mexico, for instance, had little to do in nature, scope, and aims with the practices and policies the French or English set up elsewhere in North America, although all projects have been glossed as colonial.

As an analytical tool, the space of correlation centers on the syntactic strategies employed in a cultural object—artwork, discourse, text—through which change is shaped, expressed, and enacted. It does not presume the political tenor of these strategies, which in some contexts can be empowering responses to oppression but in others are the result of simple curiosity or opportunism. Looking at specific forms of cultural production and interrogating their historical genealogies and the aesthetic choices of their makers allows us to consider the transformative power of choice and contingency, in contrast to the often agentless and teleological perspectives of syncretism and acculturation. Focusing on the space of correlation also avoids the pitfall of creating broad and artificially coherent groups without considering social diversity such as class and gender; it singles out only the relevant traits from each group that actors call upon and put into play in the objects they create in the process of change.

Shortly after the establishment of Iberian rule in Peru, for example, Andean metalworkers crafted a bracelet for a member of their elite that featured a horse and rider among other animals emblematic of power and status in the Andes (Figure 1). The gold band formed a space of correlation in which artists and patrons appealed to specific European and local symbolism and imagery and recast them in a way that articulated the changing face of prestige and privilege in their emerging colonial world. In his new role as indigenous

20. Mary Louise Pratt, *Imperial Eyes: Travel Writing and Transculturation* (London, 1992), 6.

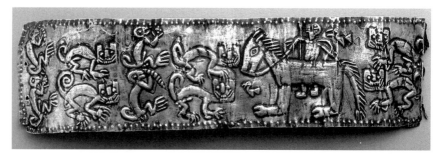

FIGURE 1 Inca (Probably Vicinity of Cuzco, Peru) Armband Depicting Horse and Rider with Animals. Sixteenth century, after 1532. Gold, 25 × 6.2 cm. The Art Institute of Chicago, Kate S. Buckingham Endowment, 1955.2608. Photograph courtesy of The Art Institute of Chicago

ruler within a colonial society, the wearer of the band could own a horse, a European attribute of power and a novelty in the Americas. The horse appears with the camelid feet of a llama rather than equid hooves, hovering in nature and status between the two worlds its original viewers were learning to straddle. The bracelet carefully correlates the new symbol and its image with Andean emblems of power and status, integrating novelty into local epistemologies and simultaneously extending precontact symbolism to the new social order. In this example of correlation, unnamed but specific actors strategically called upon specific local and foreign, old and new traits to make sense of their changing world and to voice their own perspective on the emerging colonial society. The bracelet, considered as a space of correlation, illustrates not only an instance of subaltern resistance in the face of imposed change but also demonstrates how Andeans participated in the shaping of colonial discourse.[21]

The spaces of correlation discussed here in the context of the advent of Kongo Christianity unfolded outside such colonial situations; yet, if they are not instances of subversion or resistance, they are also not the result of a passive merging of cultures. The cultural objects highlighted in this volume are carefully crafted creations in which authors, artists, and patrons confronted and rearticulated sameness and difference into the newly interrelated parts of a new, cohesive whole. In the space of correlation of the Kongo Christian foundation myth discussed in Chapter 1, for example, a gifted central African king transformed Christian lore into a version of central African mythology

21. This interpretation of the bracelet is that of Tom Cummins, used here in terms of the concept of "spaces of correlation." See Tom Cummins, "The Madonna and the Horse: Becoming Colonial in New Spain and Peru," in Emily Good Umberger and Cummins, eds., *Native Artists and Patrons in Colonial Latin America,* special issue of *Phoebus: A Journal of Art History,* VII (1995), 52–83.

and transfigured local narratives of the Kongo's origins into proto-Christian stories. Similarly, in Kongo crucifixes, discussed in Chapter 2, metal casters and elite patrons created lasting links between ideas about death and regeneration associated with Christian as well as non-Christian thought and practices. In doing so, the Kongo worldview changed to recognize Christianity's potential as a means to reach invisible powers, and Christendom broadened its horizons by acknowledging the Kongo as a Christian land and by approving as orthodox at least some of its idiosyncratic modes of interactions with invisible powers.

Visual Sources

This study relies on two main visual corpuses: Capuchin didactic watercolors and Kongo Christian art. Italian Capuchin friars with firsthand experience of the Kongo composed the first group of images between 1650 and 1750 as both promotional material for the order's central African mission and as a practical guide for the education of future missionaries. The watercolors and ink drawings are part of a genre of Capuchin central African works in which full-page images, glossed by a few lines of text, describe the natural, cultural, and religious environment of the region. Accuracy and detail are crucial to the images' didactic purposes of description of the exotic environment and prescription for the proper behavior novices should adopt. Bernardino d'Asti presents the watercolor in Figure 18 (Plate 10), for example, as a matter-of-fact rendering of a Kongo Christian ritual, intended mostly to warn future missionaries against the theft of offerings. "The Father Missionary," he cautions in the caption, "must be careful to collect all [the offerings] as they are more than necessary to his sustenance and that of the Blacks at its service." The central African Capuchin corpus that I have identified and defined consists of five richly illustrated manuscripts ranging in size from one to more than one hundred pages created between approximately 1650 and 1750. These eyewitness images provide a detailed view of the religious, social, and political organization of the kingdom of Kongo. As missionary images, they conform to a well-defined and clearly stated agenda that make their biases and inaccuracies easily navigated.[22]

22. Bernardino Ignazio da Vezza d'Asti, "Missione in prattica: Padri cappuccini ne' Regni di Congo, Angola, et adiacenti," circa 1750, MS 457, fol. 8r, Biblioteca Civica Centrale di Torino. On the Capuchin watercolors, see Cécile Fromont, "Collecting and Translating Knowledge across Cultures: Capuchin Missionary Images of Early Modern Central Africa, 1650–1750," in Daniela Bleichmar and Peter C. Mancall, eds., *Collecting across Cultures: Material Exchanges in the Early Modern Atlantic World* (Philadelphia, 2011).

The other set of visual materials essential to my argument are the artworks and objects of Christian form created in central Africa. Christian paraphernalia such as crucifixes and medals clearly arrived in the Kongo as early as the new religion itself, and local production likely followed soon after. This book presents the textual, visual, and archeological evidence that informed the creation, use, and meaning of Christian visual forms in the Kongo between the sixteenth and the nineteenth centuries. The scant data available today does not yet allow for diachronic or geographic considerations of the corpus; archeological work currently under way may soon provide further information. Nevertheless, I am able to establish dates for some of the objects and offer interpretations on the sources and historical significance of the iconography of the corpus at large.[23]

The images, objects, and practices brought together here showcase how, from the sixteenth to the nineteenth century, through times marked by profoundly transformative events such as civil and foreign wars and the traumatic population drain of the transatlantic slave trade, Christianity and its visual manifestations remained prominent forces in the shaping of political and religious life in the kingdom of Kongo. Whether the Kongo elite converted in the modern sense, they and many of the people under their rule actively engaged with Christianity and its imagery during this period. New art forms, religious conceptions, and social practices emerged and evolved from these transactions that collectively molded Kongo Christianity.

23. Early records of Christian art in the Kongo appear, for example, in [Duarte Lopes and Filippo Pigafetta], *Relatione del reame di Congo et delle circonvicine contrade: Tratta dalli scritti e ragionamenti di Odoardo Lopez Portoghese per Filippo Pigafetta . . .* (Rome, 1591), 54. New linguistic and archaeological evidence about the Kongo kingdom is coming to light thanks to the project "KONGOKING: An Interdisciplinary Approach to the Origins of the Kongo Kingdom," which unites researchers from Ghent University, Brussels University, and the Royal Museum for Central Africa in Tervuren; see http://www.kongoking.org. In addition, another project based in Angola called "Projecto Mbanza Kongo, cidade a desenterrar para preservar" is conducting archaeological research in the ancient capital of the kingdom Mbanza Kongo.

Sangamentos

Performing the Advent of Kongo Christianity

A vociferous crowd of men armed with swords and shields march across an open plaza toward a modest church (Figure 2 [Plate 1]). The beat of a long drum, the chime of a marimba, and the blow of two ivory horns orchestrate the group's acrobatic steps. In rhythm, the bare-chested dancers swing large swords, raise shields of different shapes, shout out loud, and flash wide-open eyes in an awesome display of strength and determination. At the head of the group, a richly dressed man kneels in the shadow of a monumental cross. He wears a *mpu* cap enhanced with a red feather, a long crimson coat embroidered with a white design, a *nkutu* shoulder net, a colorful wrapper, and rows of anklets. He holds in his hands a European-looking sword and a shield, as do the other dancers. Down on one knee, he pays his respects to a Capuchin friar quietly sitting in front of the church, giving his blessing to the assembled men. Next to the priest, a *mestre,* a church leader and interpreter for the friar, watches the dancers while holding the attributes of his office, a long staff and a white cloth loosely wrapped on his left arm. Above the two men, overlooking the scene, is a painting of the Virgin pinned on the building's facade and a cross attached to the church's rooftop.

In this lively watercolor, painted around 1750, the Capuchin Bernardino d'Asti depicts the impressive staged assaults of the *sangamento,* a prominent performance that gave rhythm to public life in the kingdom of Kongo. The word *sangamento* is a lusitanism derived from the Kikongo verb *ku-sanga,* itself stemming from the widespread Bantu root *càng,* meaning "to be pleased." The Kikongo-language dictionary "Vocabularium Latinum, Hispanicum et Congense" (written circa 1650) recorded the term as *cuangalala* (plural *yangalele)* in translation for both the Latin *exultare* and *gaudere,* meaning "to rejoice." French missionary R. F. Cuénot similarly defined the word in his 1775 dictionary of the northern dialect of Kikongo as "to jump or leap alone or in a crowd with certain prescribed gestures in manifestation of joy or congratulations," a definition that captured the characteristic moves and mood of the dance. In the Christian Kongo, sangamentos served dual purposes. On the one hand, they acted as preparatory martial exercises for soldiers and as demonstrations of might and determination in formal declarations of

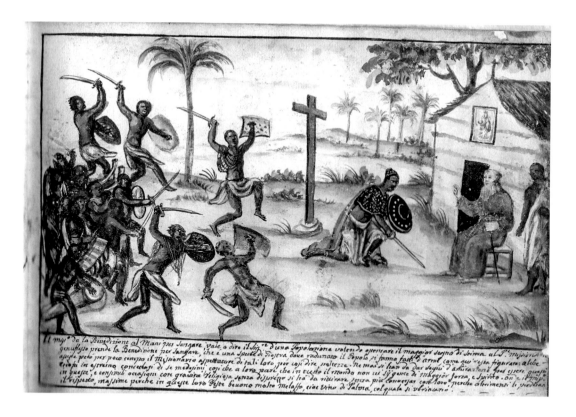

FIGURE 2 Bernardino d'Asti, *The Missionary Gives His Blessing to the Mani during a Sangamento.* Circa 1750. Watercolor on paper, 19.5 × 28 cm. From "Missione in prattica: Padri cappuccini ne Regni di Congo, Angola, et adiacenti," MS 457, fol. 12r., Biblioteca Civica Centrale, Turin. Photograph © Biblioteca Civica Centrale, Turin

war. On the other hand, they accompanied joyful celebrations of investiture, complemented courtly and diplomatic pageants, and lent their pomp to pious celebrations on the feast days of the Christian calendar. During the dances, the sitting king or ranking ruler, members of the elite, and common soldiers each took the stage in order of precedence. With spectacular simulated assaults, feints, and dodges, each man showcased his dexterity with weapons and his physical agility and asserted his place in the kingdom's political hierarchy. The fake but awe-inspiring ritual assaults were the occasion for members of the elite to reinforce their prestige by inviting—and theatrically defeating—challenges to their power.[1]

1. See an earlier description of the sangamento in Gio[vanni] Francesco da [Roma], *Breve relatione del successo della missione de Frati Minori Cappuccini del Serafico P. S. Francesco al regno del Congo e delle qualità, costumi, e maniere di vivere di quel regno, e suoi habitatori* (Rome, 1648), 126–127; "Vocabularium Latinum, Hispanicum et Congense," [1652], MSS Varia 274, Fondi minori 1896, Biblioteca

Sangamentos existed in central Africa before European contact and re-
mained a widespread practice into the twentieth century within and beyond
the boundaries of the Kongo. The kingdoms of Loango to the north and
Ndongo to the south also staged their own variants of the ritual. With the
advent of Catholicism at the turn of the sixteenth century, the Kongo sanga-
mento evolved in form, nature, and purpose. New choreographies, regalia,
and weapons in the dances reflected the broad changes to the kingdom's
political and religious life brought about by its participation in the religious,
diplomatic, and commercial networks of the Atlantic world. The dances can
thus be used to consider the mythological, religious, and political redefini-
tions that allowed the Kongo elite to reinvent the nature of their rule in this
new context. Sangamentos and their visual and material symbolism illustrate
how the rulers of the kingdom employed mythology and its visual and ma-
terial manifestations as generative spaces of correlation within which they
merged and transformed Christian lore and central African tradition into a
novel Kongo Christian discourse.[2]

The Two Parts of the Sangamento

Friar Girolamo Merolla da Sorrento described sangamentos in the late
seventeenth century as performances staged in two parts. In the first act,
the dancers dressed "in the way of the country," wearing feathered head-
dresses and using bows and arrows as weapons. In the second act, the men
changed their outfits, donning feathered European hats, golden crosses,
necklace chains, knee-length strings of corals, and red coats embroidered
with gold thread. They also traded in their bows and arrows for firearms,

Nazionale Vittorio-Emmanuele II di Roma; R. F. Cuénot, "Dictionnaire Congo et françois," 1773, MS
524, 294, Bibliothèque municipale de Besançon. Many thanks to Jacky Maniacky for clarifying the
etymology of the word. There is no indication that the term *sangamento* was associated during that
period with the Latin root carrying sharply different connotations, *sanguis-inis:* blood. For the use
of the sangamento as a declaration of war, see John K. Thornton, "African Dimensions of the Stono
Rebellion," *American Historical Review,* XCVI (1991), 1112. See also the Jesuit records of 1622, Lus. T. 55,
fol. 115v, Archivum Romanum Societatis Iesu, Rome, published in António Brásio, ed., *Monumenta
missionaria africana: África ocidental,* 15 vols. (Lisbon, 1952–1988), XV, 537. Lorenzo da Lucca also
mentions the use of the sangamento in diplomatic receptions; see Lorenzo da Lucca and Filippo da
Firenze, "Relazioni d'alcuni Missionari Capp[ucci]ni Toscani singolarmente del P. Lorenzo da Lucca
che due volte fù Miss:io Apotol:co al Congo; parte seconda," 1700–1717, fols. 99–100, 186, Archivio
Provinciale dei Frati Minori Cappuccini della Provincia di Toscana, Montughi Convent, Florence.

2. For Loango, including a print illustration, see L. de Grandpré, *Voyage à la côte occidentale
d'Afrique fait dans les années 1786 et 1787 . . . suivi d'un voyage fait au cap de Bonne-Espérance contenant
la description militaire de cette colonie* (Paris, 1801), I, 126–129. For Ndongo, see Giovanni Antonio
Cavazzi da Montecuccolo, "Missione evangelica al regno del Congo: Araldi Manuscript," 1665–1668,
Araldi Collection, vol. A, book 1, Modena.

imported weapons echoing the European-style swords depicted in the 1750 watercolor. Merolla noted plainly the binary structure of the performances he observed, but sangamentos often intertwined the two parts rather than clearly delineated them. The watercolor in Figure 2 (Plate 1), for instance, captures the event in a manner that both stresses and merges the two sides. In a didactic, synthesized depiction, it collapses the two moments of the ceremony into a single scene but maintains a marked distinction between the two in the spatial arrangement of the figures. The left side of the vignette focuses on Kongo elements, while the right side of the image, beyond the threshold of the monumental cross, presents a scene anchored in Christian attitudes and symbols. In spite of this arrangement, central African regalia figures prominently in the Catholic blessing and European-style swords in the Kongo dance. Fundamentally, the image emphasizes how the two parts of the sangamento seamlessly articulated disparate objects, symbols, and practices into a meaningful, coherent whole.[3]

The correlation of heterogeneous parts at the core of the Christian era's sangamentos reflects the operations through which the Kongo elite created a novel Kongo Christian myth of the origins of the kingdom that drew from and redeployed both Catholic and central African lore. The early part of the show staged the founding of the kingdom—centuries before the advent of Christianity—by Lukeni, the original civilizing hero of the Kongo's creation myth. Accordingly, primarily local regalia and weaponry that symbolized central African notions of might and prestige appeared in the first act. King Nzinga a Nkuwu used similar props in a sangamento he led in 1491 before the advent of the Christian era. According to oral tradition, Lukeni, a young foreign prince of extraordinary military skill, leaves his homeland north of

3. Girolamo Merolla da Sorrento and Angelo Piccardo, *Breve, e succinta relatione del viaggio nel regno di Congo nell' Africa meridionale, fatto dal P. Girolamo Merolla da Sorrento . . . Continente variati clima, arie, animali, fiumi, frutti, vestimenti con proprie figure, diversità di costumi, e di viveri per l'vso humano* (Naples, 1692), 157 ("all'uso del paese"). All translations are mine unless otherwise noted. For other descriptions of sangamentos not cited elsewhere in this chapter, see the account of the Dominican mission to the Kongo in 1610 in Brásio, ed., *Monumenta*, V, 608. See also Mateo de Anguiano, *Misiones capuchinas en África*, Biblioteca "Missionalia Hispanica," VII (Madrid, 1950), 77, 279; François Bontinck, ed. and trans., *Diaire congolais (1690–1701), de Fra Luca da Caltanisetta*, Publications de l'Université Lovanium de Kinshasa (Leuven, 1970), 5; Giuseppe Monari da Modena, "Viaggio al Congo, fatto da me fra Giuseppe da Modena Missionario Apostolico, e predicatore Capuccino, incomentiato alli 11 del mese di Novembre del anno 1711, e terminato alli 22 di Febraro del anno 1713 etc. . . . ," 1723, Manoscritti Italiani 1380, Alfa N. 9–7, fol. 148, Biblioteca Estense, Modena (Monari's account is published in Calogero G. Piazza, "Una relazione inedita sulle missioni dei minori Cappuccini in Africa degli inizi del Settecento," *Italia Francescana*, XLVII, nos. 4-5 [1972], 222); Louis Jadin, "Andrea de Pavia au Congo, à Lisbonne, à Madère: Journal d'un missionnaire capucin, 1685–1702," *Bulletin de l'Institut Historique Belge de Rome*, XLI (1970), 444; António Brásio, *História do Reino do Congo: Ms. 8080 da Biblioteca Nacional de Lisboa* (Lisbon, 1969), 61.

the Kongo, marches south with an army of followers, and conquers the lands of his future kingdom in a great military feat made possible, the narratives suggest, by his command of iron technology, until then unknown to the people of the southern shore. In addition to military skill and iron smelting, he brings to the Kongo new wisdom that forms the basis of the kingdom's organization.[4]

The subsequent performance in the sangamento, in which the dancers appeared in a mix of local and foreign attire, referred to the second founding of the kingdom in 1509 by Afonso, son of Nzinga a Nkuwu and first great Christian king of the Kongo. According to oral histories recorded in the seventeenth and eighteenth centuries, Afonso was an early supporter of Catholicism and ascended to the throne after a bitter battle against one of his brothers, who, in contrast, opposed the new religion. As noted previously, wars of succession were common in the Kongo, where the crown was not hereditary but was bestowed by a group of electors upon one of a number of eligible nobles. Afonso, with the help of the miraculous apparition of Saint James the Apostle leading an army of horsemen, and under the cross of Constantine that appeared in the central African sky on his behalf, was able to defeat his brother and win over the Kongo to Catholicism. The second act of the performance featured insignia and emblems inspired by both central Africa and Europe. Dancers appeared in what had become the characteristic regalia of the Kongo Christian elite, an intricate mix of swords, mpu caps, crosses, nkutu shoulder nets, imported coral necklaces, and European cloaks. No longer were they simply powerful heirs to Lukeni's feat; they were also mighty Christian knights emulating the example of their first Catholic king. Merolla himself suggests in his description the link between the dances and the second founding, explaining that the kingdom's main sangamento takes

4. See the account of the 1491 sangamento in Rui de Pina's untitled chronicle, in Carmen M. Radulet, *O cronista Rui de Pina e a "Relação do Reino do Congo": Manuscrito inédito do "Códice Riccardiano 1910," Mare liberum* (Lisbon, 1992), 122. Andrea da Pavia describes the founding smith king of the Kongo in Scritture referite nei Congress, Africa, Angola, Congo, Senegal, Isole dell'Oceano Atlantico, I (1645–1685), fol. 141r, Archivio Storico de Propaganda Fide, the Vatican: "La Casa Reale trahendo la sua origine da un Fabro sagacissimo et asuto." Giovanni Antonio Cavazzi da Montecuccolo also notes the connection in Kongo and Dongo, respectively; see Cavazzi and Fortunato Alamandini, *Istorica descrizione de' tre' regni Congo, Matamba, et Angola sitvati nell' Etiopia inferiore occidentale e delle missioni apostoliche esercitateui da religiosi Capuccini* (Bologna, 1687), 169, 290. In fact, the Iron Age in central Africa clearly predates the creation of the Kongo. Creation myths in related central African kingdoms have been discussed in Luc de Heusch, *Mythes et rites bantous: Le roi ivre; ou L'origine de l'État* (Paris, 1972); Jan Vansina, *Kingdoms of the Savanna* (Madison, Wis., 1966); De Heusch, *Mythes et rites bantous: Rois nés d'un cœur de vache* (Paris, 1982). Further linguistic evidence for the link between smithing, kingship, and the origins of the kingdom of Kongo is outlined in Koen Bostoen, Odjias Ndonda Tshiyayi, and Gilles-Maurice de Schryver, "On the Origin of the Royal Kongo Title *ngangula," Africana Linguistica,* XIX (2013), 53–83.

place on the feast day of Saint James as a tribute to the holy warrior that helped secure the victory for Afonso.[5]

Creation Myth of the Christian Kongo

The creation myth celebrated in the second part of the sangamento originated from a series of letters Afonso wrote around 1512 to the elite of his kingdom. Thirty years after the arrival of Europeans on the central African coast and twenty years after the baptism of his father, Nzinga a Nkuwu, as João I in 1491, the young monarch lived in a world with rapidly expanding horizons. Since the first landing of Portuguese explorers and clerics on Kongo shores in 1483, a sustained flow of people, objects, and ideas circulated and wove ties between the Kongo and Portugal. In the early decades of contact between the two realms, selected Kongo youth traveled to Lisbon, where they received a formal European Christian education; Portuguese clerics, merchants, and craftsmen, on the other hand, sojourned in central Africa to practice their trade. The exchange emerged from the Europeans' interest in the Kongo as a commercial partner. In the words of explorer and chronicler Duarte Pacheco Pereira, writing around 1506, they sought copper, ivory, "beautiful" and "peerless" raffia-palm cloth, and "some slaves in small quantity." After the baptism of the central African king, Portugal could also boast that the Kongo was a Christian ally and shining proof of the successes of their overseas proselytizing efforts. Reciprocally, the Kongo elites found in their relationship with the faraway land a source of new wares, technologies, and philosophies that they selectively welcomed according to their own aesthetics, needs, and curiosity. Intrigued at first by a range of novelties, they soon dismissed the ones they deemed unfit for their needs, such as European farming techniques, and received others, such as textiles and clerics, with great enthusiasm. In this context of rapid change and broad experimentation with novelties, Afonso formulated and promoted, in letters addressed to the kingdom's elite, the story of his rise to power as the second founding of the Kongo.[6]

5. Merolla and Piccardo, *Breve, e succinta relatione,* 156. For biographical information on Afonso I, see Graziano Saccardo, *Congo e Angola con la storia dell'Antica missione dei Cappuccini,* 3 vols. (Venice-Mestre, 1982–1983), I, 24–43. I am interested here in oral tradition as narrative rather than as historical document. However, John Thornton has argued in favor of the accuracy of early modern oral histories with regard to the early history of the kingdom of Kongo; see Thornton, "The Origins and Early Hisotory of the Kingdom of Kongo, c. 1350–1550," *International Journal of African Historical Studies,* XXXIV (2001), 89–120.

6. Afonso's letters are published in Brásio, ed., *Monumenta,* I, 256–273, XV, 24. Clerks, such as the Kongo man João Teixeira, worked for the king as scribes; see John K. Thornton, *Africa and Africans in*

The correspondence presented a narrative that performed a symbolic reformulation of select elements of Kongo history and Christian lore that allowed Afonso to naturalize Christianity into a central African phenomenon while simultaneously inscribing his kingdom in the larger realm of Christendom. The new king intended this story to become the official narrative of his accession to the throne and of the advent of Christianity in the Kongo. The letters explained how he, oldest son of king Nzinga a Nkuwu, had been among the first in the Kongo to champion the new faith. After the death of his father, he dutifully traveled with a small retinue of professed Christians to the capital of the kingdom, Mbanza Kongo. European Christian rules made the crown rightfully his as firstborn son of the deceased ruler; Kongo law, however, only saw him as one of several eligible successors. The people of the capital, led by his brother Mpanzu a Kitima, who refused conversion, thus took up arms to oppose his presumptuous plans. Overpowered in the ensuing battle and soon on the verge of defeat, Afonso and his companions shouted out to Saint James the Apostle as they rallied for the final and surely fatal assault. At that very moment, against all odds, enemy lines broke in panic. As the few survivors in the brother's faction later explained, an army of horsemen led by Saint James himself appeared in the sky under a resplendent white cross and struck scores dead.[7]

The letters also encompassed a core visual dimension. One of them included a painting, now lost, of the new coat of arms of the kingdom of Kongo that Afonso presented to and interpreted for his vassals. The king of Portugal, as a gift to his overseas counterpart, had commissioned the arms from a Portuguese herald who based his work on a written account of the battle that Afonso had sent to Europe in 1509. The African king's narrative directly inspired the design of the coat of arms, which strikingly differed, for example, from the plain blazon that a Wolof prince received upon his baptism in Lisbon in 1488. Unlike the elaborate Kongo escutcheon, the emblem presented to the west African man merely featured a generic golden cross on a red background surrounded by a border of Portuguese blazons that did not encode any complex cross-cultural reflection between the herald and the Wolof prince. Afonso might have directly requested the coat of arms in

the *Making of the Atlantic World, 1400–1800*, 2d ed. (Cambridge, 1998), 213–214. Pereira's manuscript appeared in print form in the late nineteenth century; see Duarte Pacheco Pereira, *Esmeraldo de situ orbis, sob a direção Raphael Eduardo de Azevedo Basto* (Lisbon, 1892), 84. For the early dispatches from Portugal to the Kongo, see Brásio, ed., *Monumenta*, I, 112–115.

7. Here I use the term *Christendom* as a concept that defines a geographical space of its own, in the manner suggested by Allan Greer and Kenneth Mills, "A Catholic Atlantic," in Jorge Cañizares-Esguerra and Erik R. Seeman, eds., *The Atlantic in Global History, 1500–2000* (Upper Saddle River, N.J., 2007), 3–20.

the now lost 1509 letter, but, regardless of the origins of the design's commission, he presented its adoption as his own decision in later correspondence. "It seemed to Us a most deserved thing," he wrote, "that, in addition to the many graces and praises we give to Our Lord . . . we would keep the record and memory of such a clear and obvious miracle and complete victory in our [coat of] arms, so that the kings that will follow Us in our kingdom and lordship of the Kongo would not be able at any time to forget such great grace and favor."[8]

The escutcheon, depicted in António Godinho's 1548 Portuguese manuscript armorial, formalized Afonso's story of accession in the typically European format of heraldry (Figure 3 [Plate 2]). Following the African king's own reading detailed in the letters, the arms show a silver cross on a chief azure above a red shield that respectively memorialize the luminous apparition of the cross in the central African sky and the bloodshed of the battle. On either side of the cross, two sets of scallop shells stand for Saint James, "whom We called upon and who helped Us," alongside a battalion of knights, represented in the shield by five armored human arms, each brandishing a sword. The two-one-two placement of the swords, derived from the arms of Portugal, should be read, the Kongo king specified, as a reference to the five wounds of Christ. At the bottom, the escutcheon of Portugal itself, featured as Kongo's benefactor and ally, accompanied two "idols" broken at the waist. The 1548 armorial gives a full version of the arms, complete with a gold helm facing left, appropriately crowned as a royal emblem. A crest of five sword-carrying armored limbs echoes the main design and tops a torse and a mantling of red and gold. The vignette is labeled "Rei de Manicongo" after the Kikongo-language title for the kings, or *mani* (lords), of the Kongo.[9]

8. Brásio, ed., *Monumenta,* I, 263. The coat of arms has been briefly discussed in F. Bontinck, "Les armoiries de l'ancien Royaume de Congo," *Antennes: Chroniques culturelles Congolaises,* II (1962), 555–566. The now missing 1509 letter is mentioned in a 1512 letter by Afonso printed in Brásio, ed., *Monumenta,* I, 232; it is also mentioned in a subsequent document dated Oct. 5, 1514, printed in I, 295. For more on the missing letter, see John K. Thornton, "Elite Women in the Kingdom of Kongo: Historical Perspectives on Women's Political Power," *Journal of African History,* XLVII (2006), 443 n. 421. See the description of the Wolof coat of arms by chronicler Garcia de Resende in Brásio, ed., *Monumenta,* I, 548. An image is published in A. Teixeira da Mota, *D. João Bemoim e a expedição portuguesa ao Senegal em 1489* (Lisbon, 1971), fig. 9. For Afonso's quote, see Brásio, ed., *Monumenta,* I, 268. The coat of arms was used in the coronation rites, as witnessed in 1622 by Mateo Cardoso and in 1775 by Cherubino da Savona; see Louis Jadin, "Aperçu de la situation du Congo et rite d'élection des rois en 1775, d'après le P. Cherubino da Savona, missionaire au Congo de 1759 à 1774," *Bulletin de l'Institut Historique Belge de Rome,* XXXV (1963), 400, 407.

9. António Godinho, "Livro da nobreza e da perfeição das armas dos reis cristãos e nobres linhagens dos reinos e senhorios de Portugal," MS Casa Forte 164, 1528–1541, fol. 7, Arquivo Nacional da Torre do Tombo, Lisbon. The coat of arms of the king of Kongo also appears in a later armorial; see Francisco Coelho, "Tombo das armas dos reis e titulares intitulado . . . tesouro da nobreza," Casa Real, Cartório da Nobreza, livro 21, 1675, fol. 55, Arquivo Nacional da Torre do Tombo.

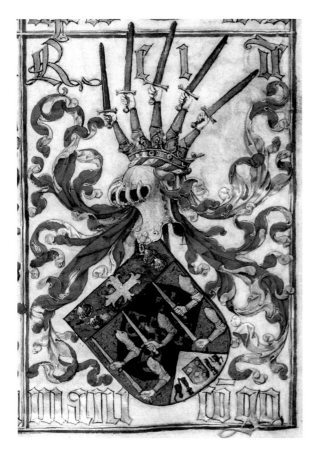

FIGURE 3 António Godinho, *Coat of Arms of the Manicongo Kings*. 1528–1541. Ink on parchment, 43 × 32 cm. (full page). Detail from "Livro da nobreza e da perfeição das armas dos reis cristãos e nobres linhagens dos reinos e senhorios de Portugal," fol. 7, PT/TT/CR/D-A/001/20, Arquivo Nacional da Torre do Tombo, Lisbon. Photograph courtesy of the Arquivo Nacional da Torre do Tombo

Afonso keenly perceived the potential of his narrative and emblem as tools to insert his rule and his realm in the historical and symbolic space of Christendom. "The arms," he wrote, "are for us [Kongo nobles] to carry on our shields, as the Christian Kings and Princes of [Europe] have the custom to do, as signs of whom and whence they are [and come] and so that by them they should be known by all." In word and image, Afonso of Kongo heralded himself as a Christian prince, companion in arms to Saint James, and one for whom the cross of Constantine appeared. The direct inspiration for this story was Afonso Henriques (r. 1139–1185), the self-proclaimed first king of Portugal who, according to Portuguese lore, defeated the Almoravids at the 1139 Battle of Ourique thanks to the miraculous apparition of the cross and of Saint James, *matamoros,* or "Moor Slayer."[10]

Afonso of Kongo wove a narrative that presented him in very clear terms as the heir to a European—specifically, Ibero-Portuguese—tradition of legitimacy honed on the battlefield and sealed by supernatural approval. Herald

10. Brásio, ed., *Monumenta*, I, 264.

Miguel Seixas sees in the composition of the Kongo coat of arms an "obvious mythical and heraldic chain linking Constantine, D. Afonso Henriques [of Portugal], D. Manuel I [of Portugal] and, eventually, D. Afonso of Congo." The close kinship between the two realms was not only claimed and promoted by the Kongo but also by Portugal. The 1548 Portuguese armorial featured the African kingdom among independent Christian realms and on the page immediately preceding the arms of Portugal. The inclusion of the escutcheon of Portugal at the bottom of the arms of the Kongo, in juxtaposition to what Afonso described as "broken idols," represented the role that Portugal could advantageously claim in the conversion of a faraway kingdom to Catholicism. The deed was momentous because it represented a significant achievement in the fulfillment of the *padroado* agreements in which the pope granted Spain and Portugal political control over their so-called overseas discoveries in exchange for their shouldering the financial and logistical costs of conversion.[11]

In turn, Afonso continued to cultivate his kingdom's affinity with Portugal and Europe. He enthusiastically embraced European political symbolism and demonstrated a keen understanding of how this strategy could move him closer to his overseas counterparts. In addition to adopting the coat of arms, he accompanied his signature in official correspondence with a full seal, an impression of which is still extant in a 1517 letter he sent to the king of Portugal. A thick layer of wax enriched with two thin strips of paper was applied to the document and then covered with another diamond-shaped piece of paper that received the imprint of Afonso's royal seal. The design of the stamp centered on a Greek cross enclosed in a circle, a motif that would become ubiquitous in Kongo elite regalia as the emblem of the prestigious Order of Christ. Around the perimeter of the seal, an inscription in Latin characters cannot be deciphered, apart from a few letters—in particular "N," "O," and, possibly, "C." These letters might have spelled the name and title of Afonso in Latin. They also might have repeated the Constantinian motto, "In hoc signo vinces" ("In this sign [the cross] you shall conquer"). The motto appeared on the coins of Portuguese king Manuel I (r. 1495–1521), the obverse of which closely matches the design of the seal. Afonso might have used one such coin here as an improvised stamp, or he could have commissioned a local artist to

11. Miguel B. A. Metelo de Seixas, "As armas do rei do Congo," in *Os descobrimentos e a expansão Portuguesa no mundo—Curso de verão de 1994: Actas* (Lisbon, 1996), 319–346. See also the similar analysis in Luis Felipe Alencastro, *O trato dos viventes: Formação do brasil no Atlântico Sul, séculos XVI e XVII* (São Paulo, 2000), 71. The arms of Kongo and Portugal are on either side of the same page; see Godinho, "Livro da nobreza perfeição das armas," MS Casa Forte 164, 1528–1541, fol. 7r–v. About the padroado, see note 4 in the Introduction, above.

create a new seal, using the coin as an inspiration and a model. In either case, the Kongo monarch capably used European conventions and visual tools to assert his status as a Christian ruler in a seal that evoked the narrative of his accession to the throne, victorious and divinely sanctioned by the miraculous apparition of the sign of the cross. Afonso used the cross motif insistently in his visual and narrative formulations, employing it in conjunction with the foundation story as two interrelated and powerful devices that allowed him to articulate and eventually merge European and central African ideas.[12]

Afonso's astute adoption and promotion of the foundation narrative and of the sign of the cross underscores the fundamental difference between the advent of Catholicism in central Africa and the almost contemporaneous European attempts at the spiritual conquest of the Americas. Whereas in the Kongo the apparition of Constantine's cross and Saint James enabled the triumph of the local ruler as Christian prince, the same emblem and saint came to the Americas as signs of the supposedly divinely sanctioned Iberian overrule of the indigenous populations. In Mexico, the cross of Constantine accompanied the conquistador Hernán Cortés. It floated on his standard, alongside the inscription, "Let's follow the sign of the Holy Cross . . . since by It, we shall conquer." Similarly, in Peru, during the 1536 siege of Cuzco, Saint James provided his miraculous and decisive assistance to the Spaniards in their fight against Andean troops. In the Kongo, however, decades before he became "Indian Slayer" in the Americas, Saint James the "Moor Slayer" of the Iberian *Reconquista* was summoned by Afonso as "Heathen Slayer" and proof that his accession to the throne was indeed providential in the strong Christian sense of the term.[13]

It is crucial to understand that the cross-cultural interactions between the kingdom of Kongo and Europeans were not ruled by colonialism or unfolding under dynamics of oppression and resistance. Instead, owing to the successful intervention of Afonso and his successors, the Kongo enjoyed a rare status among non-European polities in the early modern era, one de-

12. Although the seal may not be viewed in person today because of the document's state of conservation, the image on microfilm nevertheless allows an analysis of salient characteristics of this early document of Kongo Christian political imagery. Direct observation, however, would determine whether the inscription is reversed in the wax, which would indicate that the seal was made directly from the imported coin. Afonso's 1517 seal is in Corpo Cronológico, parte I, maço 21, doc. 109, Arquivo Nacional da Torre do Tombo.

13. For Cortés's banner, see Bernal Díaz del Castillo, *Historia verdadera de la conquista de la Nueva España*, 2d ed. (Madrid, 1968), I, 84. On the siege of Cuzco, see Carolyn Dean, "The Renewal of Old World Images and the Creation of Colonial Peruvian Visual Culture," in Diana Fane, ed., *Converging Cultures: Art and Identity in Spanish America* (New York, 1996), 171–172. For a study of the transformation of Saint James from "Moor Slayer" to "Indian Slayer" in New Spain, see Javier Domínguez García, "Santiago Mataindios: La continuación de un discurso medieval en la Nueva España," *Nueva revista de filología Hispánica*, LIV (2006), 33–56.

fined by its independence and its standing as a Christian land. Until well into the nineteenth century, when attitudes toward Africa dramatically changed under the influence of the pseudoscientific racial and social theories of the time, no European government seriously questioned the status of the Kongo as an independent Catholic polity. Ambassadors from the kingdom received a sumptuous welcome in European courts, and their visits occasionally warranted the commission of celebratory artworks, such as the bust of António Manuel still standing today in Rome's Santa Maria Maggiore. The Kongo's position in Christendom may also be judged by considering the full page in the 1548 Godinho manuscript on which the arms of the African kingdom appear alongside the emblems of other Christian nations, such as Poland and Bohemia. Portugal alone occasionally denounced a backsliding of Christianity in the Kongo to justify its expansionist plans to overtake part of the kingdom from its neighboring colony of Angola, a project that, aimed at a Christian land, would be unlawful in the eyes of the papacy. The need for such loud pronouncements demonstrates the status quo against which Portugal ran.[14]

Ironically, even in the hostile intellectual context of the nineteenth century, at least part of the derisive comments expressed by mostly Protestant Anglo-Saxon travelers to the Kongo focused on the "Romish" superstitions of the central Africans. For these travelers, the multisensory rituals of the Roman Catholic Church, its images and beliefs in the power of saints and sacramental objects, formed a kind of idolatry similar to what they fully expected to find among the "primitive" people of "darkest Africa." British Officer James Tuckey, for example, noted in 1816 the continuing use of Catholic objects and rites in the coastal region of Soyo. "All these converts," he wrote, "were loaded with crucifixes, and satchels containing the pretended relics of saints, certainly of equal efficacy with the monkey's bone of their pagan brethren." Before that period, however, from the fifteenth to the eighteenth century, the Kongo negotiated treaties, drew up alliances, and maintained diplomatic relationships with several European nations as a sovereign, Christian kingdom.[15]

14. For the bust, see Chapter 3, below, and Oreste Ferrari and Serenita Papaldo, *Le sculture del seicento a Roma* (Rome, 1999), 240. Paul Kaplan discussed the visit and related artworks in David Bindman and Henry Louis Gates et al., eds., *The Image of the Black in Western Art*, III, *From the "Age of Discovery" to the Age of Abolition*, part 1, *Artists of the Renaissance and Baroque* (Cambridge, Mass., 2010), 160–165. See also Luis Martínez Ferrer and Marco Nocca, *"Coisas do outro mundo": A missão em Roma de António Manuel, príncipe de N'Funta, conhecido por "o Negrita" (1604–1608), na Roma de Paulo V: Luanda, exposição documental* (Vatican City, 2003). See the full armorial page in Godinho, "Livro da nobreza perfeição das armas," MS Casa Forte 164, 1528–1541, fol. 7.

15. *Narrative of an Expedition to Explore the River Zaire, Usually Called the Congo, in South Africa, in 1816 under the Direction of Captain J. K. Tuckey, R. N.; to Which Is Added, the Journal of Professor Smith* . . . (London, 1818), 80. See also Chapter 5, below.

In an era otherwise defined in many ways by European colonial expansion and the Atlantic slave trade, this distinction accorded to the African realm was significant. As the king of an independent, Christian realm, Afonso and his successors endeavored to protect their freeborn population against enslavement, making diplomatic appeals to the king of Portugal and to the pope to stop Europeans from illegally capturing Kongo men and women. Their efforts, however, offered their subjects only limited security in prosperous times, and even less protection in periods of political instability, such as during the Jaga invasions of 1568–1570 and the civil wars of 1665–1709 and their long aftermath in the eighteenth century. Many inhabitants of the kingdom, including high-ranking, influential leaders, fell victim to the slave trade. Occasionally, Kongo captives overseas were sent for and ransomed by their kings, but the overwhelming majority remained abroad. The exact number of Kongo men and women among the estimated 5.6 million people who were forced to participate in the Middle Passage is unclear. Yet, their contribution to the formation of African diasporic cultures is easily discernible, for example, in the sangamento-like performances their descendants continued to stage all over the Americas.[16]

Christian History as Kongo Myth

Afonso's new foundation narrative and accompanying imagery not only propelled the Kongo kingdom into the realm of Christendom, they also inscribed Christianity into central African mythology. In the same manner as they evoked, quoted, and enlarged Christian lore to frame Afonso's accession to the throne, the story and emblems emulated, echoed, and reiterated the foundation myth of the kingdom of Kongo, presenting Afonso as a new Lukeni. No versions of the founding myth were recorded before the Christian era, but the oral traditions transcribed during the early modern

16. See, for instance, Afonso's pleas for the return of overseas captives in Brásio, ed., *Monumenta,* I, 468–471. For the return of slaves to Kongo, see, for example, [Duarte Lopes and Filippo Pigafetta], *Relatione del reame di Congo et delle circonvicine contrade: Tratta dalli scritti et ragionamenti di Odoardo Lopez Portoghese per Filippo Pigafetta . . .* (Rome, 1591), 62; Brásio, ed., *Monumenta,* VII, 220. For the impact of men and women of the Kongo in the making of the Americas, see, among others, James H. Sweet, *Recreating Africa: Culture, Kinship, and Religion in the African-Portuguese World, 1441–1770* (Chapel Hill, N.C., 2003); Linda M. Heywood and John K. Thornton, *Central Africans, Atlantic Creoles, and the Foundation of the Americas, 1585–1660* (Cambridge, 2007); Jason R. Young, *Rituals of Resistance: African Atlantic Religion in Kongo and the Lowcountry South in the Era of Slavery* (Baton Rouge, La., 2007). For sangamento-derived performances, see the discussion of the African king festivals in Brazil in this chapter and in Jeroen Dewulf, "Pinkster: An Atlantic Creole Festival in a Dutch-American Context," *Journal of American Folklore,* CVI (2013), 245–271; Marina de Mello e Souza, *Reis negros no Brasil escravista: História da festa de coroação de Rei Congo* (Belo Horizonte, 2001), 208–216.

period enounced the narrative of Lukeni's first creation of the kingdom with great consistency. Duarte Lopes recorded fragments of the stories as early 1588 in a lost report that served as the basis for cosmographer Filippo Pigafetta's influential *Relatione del Realme di Congo* (1591). Mateus Cardoso in 1624, Giovanni Antonio Cavazzi in the 1660s, and Bernardo da Gallo and Francesco da Pavia around 1710 recorded in writing fuller versions of the traditions they had heard during their stays in central Africa. Shorter references to the myth also appeared in many other accounts, providing numerous versions and iterations of the story over time.[17]

In these accounts, Lukeni, a young man foreign to the Kongo homeland, founded the kingdom of Kongo. Ambition in some versions or a gruesomely transgressive act of matricide in others drove him from his birth country to seek his fortune. After gathering an army of followers, he marched south, in some versions of the story crossed a river, and, in a great military feat, won his future kingdom from an indigenous population. He then organized his realm, dividing power between provincial rulers chosen among his followers while assigning token roles to the indigenous elite. The new system prospered thanks to the balance it achieved between a narrative of conquest and complementary genealogical traditions stressing alliance and intermarriage as central to the consolidation of the kingdom. Andrea da Pavia's late-seventeenth-century versions also attributed the introduction of smithing in the Kongo to Lukeni, who then, in addition to being a gifted warrior, became "a very sagacious and astute smith." Iron technology existed in the region for centuries before the consolidation of the kingdom, yet its association with the origins of kingship formed a powerful topos there, as in central Africa at large. The image of the blacksmith king and that of the conquering king functioned together as two complementary aspects of royal power: conciliation and force.[18]

17. [Lopes and Pigafetta], *Relatione*. Mateus Cardoso's 1624 manuscript appeared in António Brásio, *História do reino do Congo: Ms. 8080 da Biblioteca Nacional de Lisboa* (Lisbon, 1969); and in French translation in François Bontinck, trans., *Histoire du Royaume du Congo (c. 1624)*, IV, Etudes d'Histoire Africaine (Paris, 1972). See also Girolamo da Montesarchio, "Viaggio al Gongho," circa 1668, fol. 38, Fondo Missioni Estere, Archivio Provinciale dei Frati Minori Cappuccini della Provincia di Toscana, Montughi Convent, Florence, published in Calogero Piazza, *La prefettura apostolica del Congo alla metà del XVII secolo: La relazione inedita di Girolamo da Montesarchio* (Milan, 1976). These myths were recorded from both independent accounts and occasional cross-referencing between authors.

18. Thornton sees the river crossing topos as a seventeenth-century innovation, but the north to south movement is a constant in the stories. See Thornton, "The Origins and Early History of the Kingdom of Kongo," *International Journal of African Historical Studies*, XXXIV (2001), 108. The crucial role of the first king as the unifying figure of disparate, mostly independent provinces appears as early as [Lopes and Pigafetta], *Relatione*. See also Thornton, "Origin Traditions and History in Central Africa," *African Arts*, XXXVII (2004), 32. About the system's balance, see Thornton, "Origins and Early History," *International Journal of African Historical Studies*, XXIV (2001), 110. For Andrea da

In Afonso's letters, the seamless rendering of the events of the succession battle in Christian terms also allowed the episode to be easily interpreted as a mirror event to the first foundation of the kingdom. The origin myth as well as the narrative of the succession struggle each presented a civilizing hero—Lukeni in the earlier case and Afonso later—who was able to seize leadership of the Kongo through military might. Both men thus inaugurated a new era for the kingdom, based on a new political organization rooted in the novel forms of wisdom and social norms the hero brought with him. In the first case, Lukeni instituted a balance between local and exogenous powers through justice and lineage control, and, in the second case, Afonso imposed Christianity and its new social and moral rules. The power of Afonso's accession story thus resided in its ambivalence. It ably presented the prince's rise in the form of a Kongo tale with deep historical and mythological roots, and it also painted the coup in light of age-old Christian lore. The bold and innovative reformulation proved successful, and the story became an integral part of Kongo traditions, narrated for centuries after the reign of Afonso.[19]

Andrea da Pavia, for instance, recorded from a local ruler in the late seventeenth century the oral tradition that accompanied the sangamento staged during the feast day of Saint James in his coastal province of Soyo. In this version of the story, Europeans landed first in Soyo, and before long the people of the region adopted the foreigners' new faith. Soon the son of the king of Kongo, the future Afonso, governor of the distant inland Nsundi province, heard about the newcomers and their religion and was eager to learn more. He traveled to the coast to see the white men, studied the new doctrine, and converted to Catholicism before returning home. Experiencing the positive impact of the new faith on his life, he attempted without success to convince his father, the king, to convert. Eventually, bringing with him an army of faithful followers, the prince marched to the capital to confront the reluctant monarch in person. In the face of yet another refusal from the old man, the Christian son called upon Saint James, drew his sword, and decapitated his

Pavia's accounts, see Scritture referite nei congressi, Africa, Angola, Congo, Senegal, Isole dell'Oceano Atlantico, I (1645–1685), fol. 141r; for a modern edition, see Carlo Toso, *Una pagina poco nota di storia Congolese* (Rome, 1999), 21. Thornton discusses the binary between blacksmith and warrior as it appeared in the seventeenth- and eighteenth-century sources in Thornton, "The Regalia of the Kingdom of Kongo 1491–1895," in *Kings of Africa—Art and Authority in Central Africa* (Maastricht, 1992), 57–63. For the link between smithing and kingship, see Bostoen, Ndonda Tshiyayi, and De Schryver, "On the Origin of the Royal Kongo Title *ngangula*," *Africana Linguistica*, XIX (2013), 53–83.

19. See, for example, Andrea da Pavia's 1685–1702 account in Jadin, "Andrea de Pavia au Congo," *Bulletin de l'Institut Historique Belge de Rome*, XLI (1970), 452–453. See also the variation on the story recorded by Capuchin Cherubino da Savona in 1775 in Jadin, "Aperçu de la situation du Congo," ibid., XXXV (1963), 407.

father. At that fatal moment, the warrior saint propitiously appeared in the sky. His father dead, the prince was acclaimed master of the kingdom.[20]

Although the details of the events vary from the version first enounced in Afonso's letters, the structure of all the narratives is essentially similar. The key elements are unchanged—from the apparition of Saint James to the prince's unavoidable struggle against heathen members of his own family, either his brother or his father. Later versions recorded in the eighteenth century are similar but included new details such as the matricide of Afonso, presented as a necessary deed. The mother appeared in these narratives unable or unwilling to repudiate her old beliefs. Bernardo da Gallo recorded an iteration of the myth around 1710, also from Soyo inhabitants, that presented Afonso as the first one to receive baptism at the demand of his elderly father, the king. The story reported the apparition of Saint James in the battle between Afonso and his brother and described how Afonso buried alive his mother in the church of Saint Michael in the capital of the kingdom. Lorenzo da Lucca in 1706 and Cherubino da Savona in the 1770s also mentioned the murder. Finally, the matricide played a large part in the history of the advent of Christianity that was put to paper by a Kongo courtier in 1782 and kept in the archives of the kingdom until it was copied in 1844 by cleric António Francisco das Necessidades. In this version, the murder of the idolatrous mother formed the occasion for the miraculous apparition of the cross. The emblem glowed in the sky as Afonso, under attack by his brother's camp for murdering the queen, retreated to a church. Eventually, the Christian God sent five angels to defeat the heathen army. This addition to the original chronicle endowed the Kongo king with the ability to ignore even the closest family ties where the good of the kingdom was concerned. This innovation appropriately appeared around 1700, during an era defined by fierce civil wars induced by dynastic competition, and resurfaced at the end of the century, when renewed internal strife would lead to the gradual dismantling of the kingdom and, with it, the centralized power of the king by the 1780s.[21]

20. Jadin, "Andrea de Pavia au Congo," ibid., XLI (1970), 452–453.

21. See the version recorded by Bernardo da Gallo in Louis Jadin, "Le Congo et la secte des Antoniens: Restauration du royaume sous Pedro IV et la 'saint Antoine' congolaise (1694–1718)," ibid., XXXIII (1961), 468–474. See also Cherubino da Savona, "Rito della elezione de re del Congo," in Borgiano Latino 269, fols. 47–49, Biblioteca Apostolica Vaticana; Lorenzo da Lucca and Filippo da Firenze, "Relazioni," 1700–1717, 296, published in Teobaldo Filesi, *Nazionalismo e religione nel Congo all'inizio del 1700: La setta degli antoniani,* Quaderni della rivista Africa, 1 (Rome 1972), 108; Francisco das Necessidades, "Memoria de como veio a nossa christianidade de Portugal (1844)," *Factos memoraveis: Boletim oficial da Provincia de Angola,* no. 642 (1858), 1–3, no. 643 (1858), 1–3. The later aspect of the story remained important into the twentieth century and still appears in the clan mottos recorded in the first decades of the twentieth century; see Jean Cuvelier, *Nkutama a Mvila za Makanda* (Tumba, 1934). Thornton has discussed the evolution of the creation myth from another perspective in Thornton, "Origin Traditions and History in Central Africa," *African Arts,* XXXVII (2004), 32–37.

At a basic level, these accounts testify to the enduring currency of Afonso's narrative, owing in part to its historical adaptability. They also further establish the link between Afonso's story and that of Lukeni in a manner that gives substance to the otherwise elusive older myth. In other words, Afonso's narrative highlights the structural affinity between a pre-European contact Kongo creation myth and its reformulation after the arrival of the Christian element. In Claude Lévi-Strauss's structuralist sense, the two enunciations form but two variants of the same broadly defined myth. The two stories indeed fit well within the corpus of Bantu mythology studied in the essential works of Luc de Heusch and Jan Vansina. They are parallel narratives that both describe how an uncouth and imperfect civilization accepts the arrival of exogenous divine kingship. The Kongo narratives present the two foundations in interrelated and, to a large extent, inseparable stories—almost always told in tandem. Cardoso, Cavazzi, and Bernardo da Gallo all paired the description of the first foundation of the kingdom with that of Afonso's second, Christian inauguration. This successful and lasting relocation of the advent of Christianity and of Christian kingship into Kongo mythical terms allowed Catholicism to enter seamlessly into central African historical, ritual, and mythical thought.[22]

Correlation

The letters of Afonso and the mythological narrative they inaugurated demonstrate that the adoption of Christianity in the Kongo resulted as much from deep, inward-looking reflection on the part of the kingdom's elite as from a strategic plan to deal with European powers. The sophisticated cultural work that the letters performed was not merely a one-way translation of Kongo events into Christian terms. If the letters successfully positioned the Kongo as part of the realm of Christendom, they also inscribed Christianity into central African mythology. The king's personal knowledge and particular life experience allowed him to produce this exceptional cross-cultural manipulation of symbols and narratives. He was well educated in central African mythology from his childhood as a Kongo prince and studied Christian theology with the first European priests present in the region during his father's reign. According to the Portuguese vicar and resident of

22. "If a myth is made up of all its variants, structural analysis should take all of them into account": Claude Lévi-Strauss, "The Structural Study of Myth," *Journal of American Folklore*, LXVIII (1955), 435. Both stories maintain the fundamental core present in all the iterations of central Africa's foundation myths. See also Vansina, *Kingdoms of the Savanna*; and the summary of central African foundation myths in Heusch, *Le roi ivre*, 276.

the Kongo Rui de Aguiar, Afonso assiduously learned the history and the teachings of the church. "I certify to your Highness," the cleric wrote in 1516 to the king of Portugal, "that [Afonso] teaches us and knows more than we do about the Prophets, the Gospel of our Lord Jesus Christ and all the lives of the Saints and everything about the Holy Mother Church . . . he does not do anything but study and often he falls asleep on top of his books."[23]

With his ambivalent story, Afonso crafted a space of correlation in which he merged and redeployed central African myth and Christian lore. His narrative is a compelling account of the continuity between the history of the Christian church and that of the Kongo. What a European would consider a pagan people enters into Christendom ushered by the miraculous intercession of God's mighty crusader Saint James. In turn, the tale of conversion also took the form of a new iteration of central African myth. But the correlation established in the story also has a generative effect that gives new form to both past and present. With Afonso's narrative, Christianity began a new era of central African history, and, in turn, Kongo assumed its place within the universal history of the church. In central African myths, Lukeni and Afonso are both civilizing heroes. From the perspective of Christian history, the coming of Lukeni in ancient times takes on the guise of a foreshadowing of Afonso's reign, a form of antiquity that prepared and announced the Christian era. Indeed, the cross of Constantine, whose apparition marked the very moment when the Roman emperor and his realm turned away from their gods to embrace Christianity, returned for Afonso.

The European missionaries working in central Africa easily embraced the view of a propitious history of the Kongo that paralleled Europe's own pagan past. The author of the "Missione in prattica" himself, Bernardino d'Asti, commented several centuries after the time of Afonso that, "contrary to the heathens of Brazil in the Americas who wander without Chief and without Law, the Congo . . . people in Africa have always been governed by their . . . King." The phrase "without Chief and without Law" refers to the Portuguese rhyme "sem fé, sem lei, sem rei" that European commentators used to describe the perceived linguistic and social inadequacy of Brazil's indigenous populations. In contrast, Europeans such as Friar Bernardino embraced Afonso's correlation and saw the Kongo's past as a time of law and order, a sure sign for them, in retrospect, that it was destined for a Christian future.[24]

23. Brásio, ed., *Monumenta*, I, 361.

24. Bernardino Ignazio da Vezza d'Asti, "Missione in prattica de RP cappuccini italiani ne regni di Congo, Angola, et adiacenti," circa 1750, MS Borg. Lat. 316, fol. 67, Biblioteca Apostolica Vaticana (in Latin in the text: "sine Duce et sine Lege"). See John Manuel Monteiro, "The Heathen Castes of

The remarkable nature of this perception of the kingdom by European observers is best measured when contrasted with the idea of *fetishism,* a term Europeans coined elsewhere on the continent during the same period to qualify African religion, political organization, and economic values. The idea of *fetishism,* which would eventually become the prominent European descriptive and analytical term for African culture in the nineteenth century, encapsulated the perceived inability of the inhabitants of the region to produce elaborate forms of social organization, conduct rational economic transactions, or develop sophisticated religions. If European accounts of the Kongo could be very stark and critical, the objections they raised were not those encompassed by the newly developed term *fetishism.* Far from these prejudiced views, the numerous descriptions of the Kongo as an eminent realm of ancient wisdom testify to the success of Afonso's cross-cultural invention.[25]

Iron Kingdom and Iron King

The Kongo Christian discourse that Afonso created functioned equally well in both European and African contexts owing in large part to the two visual and symbolic hinges that anchored it: the motif of iron and the image of the cross. Kongo myths of creation recorded in the seventeenth and eighteenth centuries associated the foundation of the kingdom with the arrival of a civilizing hero and founding king who brought with him knowledge of iron technology. Since ironworking had been practiced in the region for at least several centuries before the emergence of the kingdom, the association was not grounded in historical fact; rather, it reflected the fundamental significance of the link between kingship and the metal in the political worldview that the myths expressed. The mythical and ritual pairing of iron and leadership is a shared feature of many central African polities both in the past as well as in recent times. Twentieth-century Bakongo consultants from the region that once formed the core of the Kongo kingdom expressed the connection with the term *ngangula a kongo,* or "smith of the Kongo," which they used as a royal title. Early modern sources do not mention the

Sixteenth-Century Portuguese America: Unity, Diversity, and the Invention of the Brazilian Indians," *Hispanic American Historical Review,* LXXX (2000), 703–704.

25. See the discussion of the term in William Pietz, "The Problem of the Fetish, I," *RES: Anthropology and Aesthetics,* no. 9 (Spring 1985), 5–17; and Pietz, "The Problem of the Fetish, II: The Origin of the Fetish," ibid., no. 13 (Spring 1987), 23–45. Italian and Portuguese cognates of *fetishism, feitiçaria* and *fattucchieria,* appear in the historical sources on the Kongo but with the different meaning of "witchcraft."

phrase, but they describe at length ceremonial performances and elements of regalia that proclaimed and extolled the connection. The Jesuit Mateus Cardoso's description of the coronation of King Pedro II (r. 1622–1624) in 1622, for example, details the rituals that molded a king out of the man chosen for the office.[26]

In the days following the elaborate funeral of his predecessor, the newly elected Pedro II became king of Kongo on the *mbazi,* or central plaza, of the capital, Mbanza Kongo. A rich soundscape created a special atmosphere for the ceremony. Three men standing by the incoming king struck together iron handheld anvils called *zundu,* "royal and very old insignia," the rhythmic thud of which re-created the sound of the smithy. Another, probably masked, figure blew the *sembo ausuri,* or "blacksmith whistle"; the use of this instrument was a royal privilege, and thus the sound was exclusively linked to royalty. Ivory horns and several types of drums joined the iron tools in a succession of somber tunes, solemn silences, and formal hymns. In this ambience, the newly elected monarch received the key emblems of his function, the "ancient" iron *simba* chain and the *malunga* bracelet. The gilded iron malunga, Cardoso explained, stands "for the kingdom that is given to [the king] which is whole and should remain whole, and just as the malunga is of iron, so the kingdom is of iron, and for this reason it is called *Congo riactari* that is to say Congo of Iron." The malunga armlet metaphorically endowed the king with attributes derived from a rich web of semantic and visual associations linked to its name, material, and form. The word *malunga* belongs to a large lexical group in central Bantu languages that encompasses ideas of divinity, infinity, perfection in the sense of completion as well as notions of might and fortitude. The endless shape of the circular malunga, the strength of its metal, and the suggestive power of its name formed a circle of mutually reinforcing metaphors that strengthened the royal person and office.[27]

26. King as conqueror and king as smith have two different connotations. See the discussion of Kongo kingship ideologies in John K. Thornton, "'I Am the Subject of the King of Congo': African Political Ideology and the Haitian Revolution," *Journal of World History,* IV (1993), 181–214. For the iron age in the Kongo, see Pierre de Maret and G. Thiry, "How Old Is the Iron Age in Central Africa?" in Peter R. Schmidt, ed., *The Culture and Technology of African Iron Production* (Gainesville, Fla., 1996); Brásio, ed., *Monumenta,* XV, 482–497. The ceremony is also discussed in Pierre de Maret, "The Smith's Myth and the Origin of Leadership in Central Africa," in Randi Haaland and Peter Shinnie, eds., *African Iron Working: Ancient and Traditional* (Bergen, 1985), 73–87. See also Thornton, "The Regalia of the Kingdom of Kongo," in *Kings of Africa,* 57–58. Note that the term *ngangula* figured in the 1652 "Vocabularium," but without mention of its use in royal titles.

27. See Thornton, "The Regalia of the Kingdom of Kongo," in *Kings of Africa,* 57. Cardoso mentions the whistle twice as a royal attribute, in the royal funeral and in the subsequent investiture; see Brásio, ed., *Monumenta,* XV, 486 (whistle), 490 (whistle, zundu), 492 (malunga quotation). *Congo riactari* should be read here as *Kongo dia ntadi; sembo ausuri,* as *sembo dia mufuri.* João de Barros already mentioned the bracelet as part of the regalia of the king of Kongo in his description of Nzinga

The multiple connotations of the malunga also resounded in the chime of the *lunga,* the iron double gong that accompanied the steps of the incoming king and endowed the abstract ideas of royal fortitude and vigor with a pragmatic martial dimension. Lunga bells not only preceded kings and rulers in ceremonies but also led military bands used in battle. Such "military bells," although in single form, appear in Pigafetta's 1591 edition of Duarte Lopes's eyewitness accounts. Cavazzi's 1687 *Istorica descrizione* also describes the multivalent significance of the double bell as musical instruments, attributes of the "great Lords," tools of "military officials," but, above all, as emblematic of the fearsome Jagas who cast them, he writes, using iron and human blood. The fierce Jaga warriors, an elusive people who sporadically appear in early modern documents, had, Cavazzi continued, great faith that the lunga could "have when played in battle (they say) a great ability to make them courageous and invincible." A print repeated twice in the *Istorica descrizione* depicts the bell to the right of a scene in which it chimes along a *ngamba* drum and two scrapers, a *quilondo* and a *cassuto,* animating the steps of an elegant dancer (Figure 4).[28]

Several early modern documents provide remarkable visual pendants to Cardoso's description of the regalia of Kongo kings and echo its emphasis on iron emblems. A drawing composed in the early 1650s, now in the Museo Francescano dei Frati Minori Cappuccini in Rome, captures Garcia II (r. 1641–1660) seated in majesty on the European throne Cardoso mentions with his iron chains and bracelets and accompanied by a royal band of ivory horns, marimbas, harpsichords, tambourines, and an iron bell (Figure 5). An engraving accompanying Dutch compiler Olfert Dapper's description of a Kongo coronation also convincingly echoes Cardoso's account and must have relied on precise eyewitness sources (Figure 6). An empty, ornate European throne placed on a podium covered with carpets awaits the new king, to whom the officiating attendants to the left will present the regalia of kingship displayed in the foreground on a large pillow: a European-style crown, a velvet bag containing a papal bull, and three bracelets reminiscent of the

a Nkuwu (the future João I) in 1491. See Barros, "Ásia de Joam de Barros," book 3, chap. 9, fol. 34v, published in Brásio, ed., *Monumenta,* I, 82. For a discussion of words and ideas associated with *malunga* in the larger Bantu area, see Rik Ceyssens, *Balungu: Constructeurs et destructeurs de l'Etat en Afrique centrale,* Collection Congo-Zaïre—histoire et société (Paris, 1998), 126–133.

28. Cardoso talks about the use of the lunga in battle: "Pungues e chocalhos e bungas e tudo o mais que se usa na paz e na guerra"; see Brásio, ed., *Monumenta,* XV, 490. See also [Lopes and Pigafetta], *Relatione,* plate 4; Cavazzi and Alamandini, *Istorica descrizione,* 217, 332. See the summary of the long debate surrounding the Jagas in Duarte Lopes and Filippo Pigafetta, *Le royaume de Congo et les contrées environnantes, 1591,* ed. and trans. Willy Bal, Collection Magellane (Paris, 2002), 291–295. Merolla describes the central African instruments in Merolla and Piccardo, *Breve, e succinta relatione,* 170–173, plate 113.

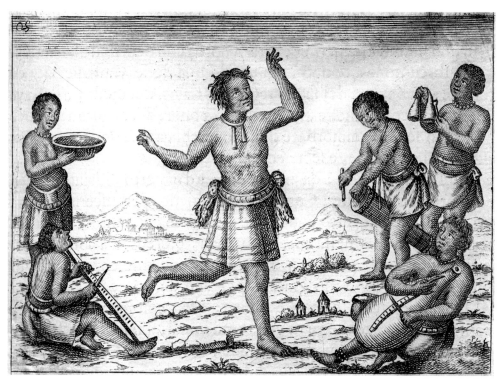

FIGURE 4 Dance Scene with Local Instruments. From Giovanni Antonio Cavazzi and Fortunato Alamandini, *Istorica descrizione de' tre' regni Congo, Matamba, et Angola sitvati nell' Etiopia inferiore occidentale e delle missioni apostoliche esercitateui da religiosi Capuccini* (Bologna, 1687), 333. Photograph courtesy of the Melville J. Herskovits Library of African Studies, Northwestern University

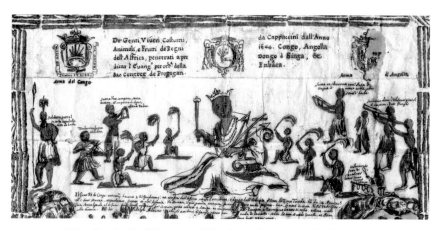

FIGURE 5 King Garcia II of Kongo and His Attendants. Detail of Anonymous, *People, Victuals, Customs, Animals, and Fruits of the Kingdoms of Africa*. Circa 1652–1663. Ink on paper, 73 × 40 cm. (full page). Rome, Franciscan Museum of the Capuchin Historical Institute, MF 1370. Courtesy of the Capuchin Historical Institute

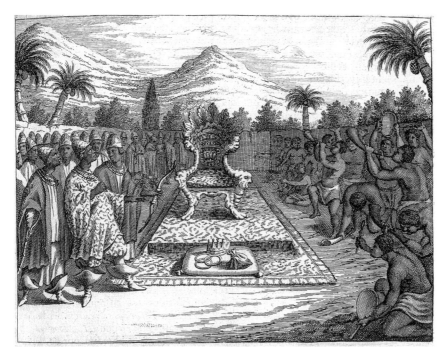

FIGURE 6 Throne of the King of Kongo. From Olfert Dapper, *Naukeurige beschrijvinge der afrikanensche eylanden: Als Madagaskar, of Sant Laurens, Sant Thomee, d'eilanden van Kanarien, Kaep de Verd, Malta en andere, vertoont in de benamingen, gelegentheit, steden, revieren, gewassen . . .* (Amsterdam, 1668), 583. Photograph courtesy of the Melville J. Herskovits Library of African Studies, Northwestern University

malunga. To the right, ivory horns, drums, scrapers, tambourines, and clapping hands fill the coronation enclosure with celebratory tunes. The throne in the middle heralds on the lower part of its back the coat of arms of the Kongo. The engraver might not have recognized the escutcheon from the sources he used to compose his print, but he nonetheless rendered the emblem in a recognizable manner. He outlined its general shield-like shape, the crown at its top, and the light border with evenly spaced designs surrounding it. The four feather-like shapes grouped at the center of the design approximately render the bundle of five swords that sometimes occupied the main part of the Kongo shield, as seen at the top left of the Museo Francescano's drawing in Figure 5. European-inspired heraldic swords as well as central African iron rings are ready to empower the new king.[29]

29. Cardoso describes the bag containing the bull in Brásio, ed., *Monumenta*, XV, 482–497.

Iron, in fact, expressed ideas of nobility and prominence beyond the figure of the king. Knowledge and practice of iron technology was a defining attribute as well as a privilege of the Kongo elite at large. Smiths, friar Lorenzo da Lucca noted around 1700, "are all Figalghi, that is to say nobles, this art being exercised among [the central Africans] by the nobility." Thus, the chime of the double gong that accompanied royal investitures and led soldiers into war also resounded during elite functions and festivities, as seen in Figure 4. A close cognate to this print from a late-seventeenth-century manuscript describes the dance in its accompanying text as the Angolan "maquina mafuete, which in our language means royal ball which is solely for the elite *[I grandi]* or at court." In Merolla's *Breve, e succinta relatione del viaggio nel regno di Congo nell' Africa meridionale* (1692), lunga bells are similarly described as aristocratic instruments, companions to the prestigious ivory horns, that "belong[ed] only to King, Princes and other people of royal blood."[30]

A strong, widespread, and enduring link between iron and might in political, military, and supernatural terms existed in the Kongo as well as in neighboring lands. To the north of the Kongo, the ruler of Baka needed but two handheld anvils for all to recognize him. To the south, the "Linguá" was not only a prominent military instrument but also the "principal insignia" of the mighty Jaga, without which no one among them could form an army nor "be legitimate and true lord." More broadly, the power of iron derived from its mythological associations but also from the power it wielded over invisible forces. The smith and his tools performed important apotropaic or curative functions for their communities, where they were called upon to chase away disease and restore health. They also took part in ritual tests during which a suspect's reaction to a drink of water used in the smithy or to the touch of red-hot metal could establish guilt or innocence.[31]

30. Lorenzo da Lucca and Filippo da Firenze, "Relazioni," 1700–1717, 187. The word *fidalghi* is a lusitanism used by the friar with an Italian plural form and spelling; it is from the Portuguese word *fidalgo,* the lowest title of nobility in Portugal. After the adoption of the Portuguese administrative and aristocratic organization and titles in the Kongo, the term *fidalgo* was used to designate members of the aristocracy in central Africa. For the "maquina mafuete," see "Parma Watercolors," Private Collection, 1663–1687, 73, Parma; Merolla and Piccardo, *Breve, e succinta relatione,* plate 13 (between 170 and 171). In Merolla's example, lunga bells are used by the ruler of the province of Soyo, illustrating his ambitions to become a prince in his own right, independent from the king of Kongo.

31. Pierre de Maret, "Ceux qui jouent avec le feu: La place du forgeron en Afrique centrale," *Africa: Journal of the International African Institute,* L (1980), 263–279. For Baka, see Bontinck, ed. and trans., *Diaire congolais,* 163. For the Jaga and "essere legitimo, e vero Signore," see Cavazzi, "Missione evangelica," vol. A, xxxiii (front matter); see also the drawing on xxxii. Cavazzi also calls it *gongo* or *gonghe* in book 3, chapter 1 of the same manuscript. Another double bell is depicted on page lviii of the front matter: a Jaga leader in a mpu cap holds a double gong as he looks at a crucifix on the floor. About iron's curative function, see Lorenzo da Lucca and Filippo da Firenze, "Relazioni," 1700–1717, 187. See also the edited translation by J[ean] Cuvelier, *Relations sur le Congo du père Laurent de Lucques (1700–1717)* (Brussels, 1953), 140, 149. For ritual tests, see Corella in Vittorio Salvadorini,

FIGURE 7 Giovanni Antonio Cavazzi, *First King of Dongo*. Circa 1665–1668. Watercolor on paper, 17 × 23 cm. (page), 13 × 15 cm. (watercolor). "Missione evangelica al regno del Congo," circa 1665–1668, Araldi Collection, vol. A, book 1, fol. XXI. Photograph, V. Negro, courtesy of the Araldi Collection, Modena

A painting from the front matter of Cavazzi's manuscript "Missione evangelica al regno del Congo," composed between 1665 and 1668, gives visual form to ritual manifestations of the three-way link (Figure 7 [Plate 3]). In a watercolor on a draft of the opening page of the book he planned, the friar depicted a central African king at work at the anvil. The image is titled *First King of Dongo* and opens the chapter "On the Lineage of the Ancient Kings of the Kingdom of Dongo, Commonly Called Kingdom of Angola of Whom Descends the Queen Njinga." The mythical first king, iron bracelets on his wrists, iron chain around his neck, and woven cap on his head, shapes a red-hot metal blade between a large stone and a handheld anvil. Nearby, an attendant heightens the fire with a central African *Y*-shaped bellows. He firmly holds the large tool in place with one foot while carefully turning his face away from the heat of the strengthened flame. As the king, he sits on an

"La relazione sul Congo di Bonaventura da Corella, 1654," *Annali della Facoltà di Scienze Politiche dell'Università degli Studi di Pisa*, III (1973), 441. See also Cavazzi and Alamandini, *Istorica descrizione*, 103; Cherubino da Savona, Letters, 1769–1770, docs. 1–3, Condes de Linhares, Arquivo Nacional da Torre do Tombo.

elaborate stool and wears an iron necklace chain. The two men have created a variety of objects arranged on the floor between them: a fan-shaped ax similar to the one still in the making as well as two blades—one curved and one straight—elements of a scimitar and a sword. In the distance, a small crowd sits around two musicians playing *nsambi* pluriarcs. A third man watches over a large woven box. An ornate headdress and a bow placed on its top endow the receptacle with emblems of royal authority. The container, made in the elaborate central African textile technique so admired in Europe at the time, is likely the *misseto* royal reliquary. The box contained remains of royal ancestors that lent their cumulated prestige to the current holder of the regal office. The reliquary, which also served as a throne, complements the cap of status and the bow as royal regalia. A bowl of palm wine lies on the ground at the center of the image between the smiths and the crowd.[32]

The sound of the string instruments, the murmur of the bellows, and the beat of the anvil create a rich aural environment akin to that of the coronation rites. The suggestive presence of the reliquary box, the bowl of palm wine awaiting libations, and the musical background confer a ritual dimension on the rhythmic labor of the smith and his assistant. Both the coronation and the scene of the watercolor stage the transformative power of smithing as an activity that literally transforms softened metal into hard, powerful weapons and metaphorically forges the chosen man into a king whose fortitude, sharpness, and strength will match that of his predecessors on the throne of the iron kingdom or one of its neighbors. Whether Cavazzi attempted to capture a particular ceremony he witnessed or whether he invented the scene altogether as an illustration of the myths he recorded in his manuscript is unclear. In either case, the image incorporates eyewitness accounts of central African smithing, regalia, and ceremonial pomp and is a vibrant representation of the multivalent visual, ritual, and symbolic elements associated with the figure of the central African smith-king. It simultaneously depicts the practice of the technology, attributed to the arrival of the founding king and since that time linked to royalty and nobility, and records the ruler's symbolic

32. Cavazzi, "Missione evangelica," vol. A, fol. xxi. The manuscript also includes a second version of the painting at the opening of book 2 in vol. A. The string instruments are identified in Merolla and Piccardo, *Breve, e succinta relatione,* plate 13. See other examples of central African basketry in Ezio Bassani, *African Art and Artefacts in European Collections, 1400–1800,* ed. Malcolm McLeod (London, 2000), 394, 450. On various occasions, Cavazzi describes the reliquary and its role as foremost regalia of kingship in Dongo in Angola (Cavazzi, "Missione evangelica," vol. A, book 1, chap. 5, 52, vol. A, book 2, chap. 10, 118). In the second version of the painting, Cavazzi labels the box as "sedia reale." The same reliquary depicted in both images appears as the throne in Cavazzi's painting of Queen Njinga elsewhere in the codex; see the published image in Ezio Bassani, *Un Cappuccino nell'Africa nera del seicento: I disegni dei Manoscritti Araldi del Padre Giovanni Antonio Cavazzi da Montecuccolo,* Quaderni Poro, 4 (Milan, 1987), 26.

identity as smith expressed in the forging act and in his regalia. The axes and blades produced by the king and prominently displayed in the foreground of the image further encapsulate the bond linking iron with political and military might.

The Motif of the Iron Sword

In the second Christian founding of the Kongo kingdom, the potent political symbolism of iron crystallized in the form of European-shaped swords. Afonso's tale of the advent of Kongo Christianity that correlated central African foundation myth and Christian lore hinged to a large extent on the figure of the iron sword. In late medieval Iberia, the weapon was one of the principal attributes of knighthood and encapsulated ideas of military and political might similar to commensurate concepts in the Kongo. In Afonso's visual and narrative formulations, iron, in the form of the swords prominently carried by Saint James and his miraculous army of knights, created a space of correlation within which the two conceptions of power and legitimacy merged. The regalia of the dancers of the sangamentos in Figure 2 (Plate 1) are vivid visual manifestations of this correlation. Re-enacting the second, Christian founding of the kingdom, the men wear what had become the characteristic regalia of Kongo Christian nobility—a combination of insignia rooted in local symbolism with swords, crosses, and cloaks inspired by imported European objects. The particular items adopted from Europe—notably the red cape and the swords—were, not co-incidentally, central to the iconography of Saint James, as seen, for example, in the early-sixteenth-century Iberian depiction of the saint as moor slayer in Figure 8 (Plate 4). The elite performers were no longer simply powerful men in the terms established by Lukeni; they were also mighty Christian nobles emulating the example of Afonso and, through him, of Saint James.

First appearing in Afonso's letters, the motif of the iron sword took center stage in oral histories of the founding event iterated throughout the following centuries. Versions of the narrative varied, but all showcased the miraculous weapons. In 1591, Duarte Lopes gave a variant of the story featuring five swords that appeared, not during, but before the battle and that gave the Christian troops the confidence to attack and rout their robust enemies. The story Mateus Cardoso recorded in 1622 as a gloss of Pedro II's coat of arms emphasized the role of iron weapons as the locus of supernatural intervention, attributing Afonso's victory to a rain of innumerable swords. In Bernardo da Gallo's 1710 account, the victory came from the powerful lance of Saint James, a close visual and material cognate for the smaller weapon. And,

FIGURE 8 School of Juan de Flandes, *Saint James Matamoros at the Battle of Clavijo*. Early sixteenth century. Oil on panel, 96.5 × 68.3 cm. Museo Lázaro Galdiano, inv. 3025. Photograph courtesy of the Fundación Lázaro Galdiano, Madrid

in 1775, Cherubino da Savona heard about "five swords that appeared in the sky of the battle at the time of Afonso I to defend him against his enemies."[33]

The swords were not merely a narrative motif; they were also a visual one that was articulated in the coat of arms of the Kongo, a ubiquitous royal emblem that the kings used to seal correspondence and that was carved on their thrones, displayed on their royal caps, worn on their rings, and heralded in their standards. The swords appeared prominently on the original coat of arms Afonso described in 1512 and remained the focus of the emblem over time. The coat of arms recorded in the António Godinho armorial (1521–1541), composed during Afonso's lifetime, centered on five swords brandished by armored arms (see Figure 3 [Plate 2]). Álvaro I (r. 1568–1587) used a closely related seal featuring five freestanding swords, seen in an original document

33. [Lopes and Pigafetta], *Relatione,* 48–55. Lopes also notes that Afonso takes the swords as his emblem. See references to the swords in Cardoso, in Brásio, ed., *Monumenta,* XV, 489; Bernardo da Gallo in Toso, *Una pagina poco nota di storia Congolese,* 50; Cherubino da Savona in Jadin, "Aperçu de la situation du Congo," *Bulletin de l'Institut Historique Belge de Rome,* XXXV (1963), 406: " . . . armes du royaume du Congo, à savoir les cinq épées qui apparurent en l'air au temps du roi Afonso Ier pour le défendre contre ses ennemis."

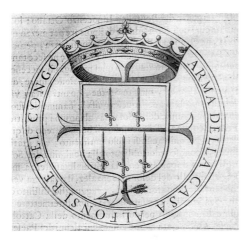

FIGURE 9 Coat of Arms of the
Kings of Kongo. From Giovanni
Antonio Cavazzi and Fortunato
Alamandini, *Istorica descrizione
de' tre' regni Congo, Matamba,
et Angola sitvati nell' Etiopia
inferiore occidentale e delle missioni
apostoliche esercitateui da religiosi
Capuccini* (Bologna, 1687), 274.
Photograph courtesy of the
Melville J. Herskovits Library of
African Studies, Northwestern
University

in the Portuguese national archives of the Torre do Tombo from circa 1580.
His slightly simplified design probably omitted the limbs holding the swords
shown in the earlier design for the sake of visual clarity. It also appeared in
the foldout map of Lopes's influential 1591 *Relatione*. In 1615, his grandson,
Álvaro III (r. 1612–1622), still used the same seal or a very similar one, also
found in the Torre do Tombo. The design of the coat of arms, at first serving
as a visual embodiment of the second founding story, became an influential
source for oral traditions. If the original version of the escutcheon featured
five swords in reference to the five wounds of Christ and in emulation of the
quinas (fives) on the coat of arms of Portugal, the number heralded on the
emblem soon acquired canonical status in local histories, as recorded in the
1591 and 1775 accounts mentioned above.[34]

The iconography of the seal evolved to include a cross with hollow and
equal-length branches, the emblem of the Order of Christ, another attribute
of European knighthood that became an integral part of the expression of
Kongo nobility. The new escutcheon, first described in 1622, appears in a
1649 seal impression on a letter signed by Garcia II. It shows the five swords
within an escutcheon superimposed on a large cross of the Order, with an
arrow transpiercing its bottom branch. This design endured throughout most
of the seventeenth century and appears with a stylized cross in the 1687 edi-
tion of Giovanni Antonio Cavazzi's *Istorica descrizione* as the "arms of the
house of Afonso, king of Congo" (Figure 9). The inclusion of the cross is a

34. For the seal of Álvaro I, see Tribunal do Santo Ofício, Inquisição de Lisboa, 5328, fols. 8v, 15v,
Arquivo Nacional da Torre do Tombo. The coat of arms appears in the foldout map of the kingdom
in [Lopes and Pigafetta], *Relatione*. For the seal of Álvaro III, see Corpo Cronológico, parte I, maço
116, doc. 28, Arquivo Nacional da Torre do Tombo. Cardoso described the coat of arms of Pedro II
in 1622; see Brásio, ed., *Monumenta*, XV, 489.

testament to the increased importance of the Order in the Kongo, where it was eagerly adopted.[35]

The arrow piercing the cross in versions of the coat of arms linked to Garcia II, however, is a more intriguing innovation. Images of the piercing dart might have referred to Christian figures of martyrdom such as Saint Sebastian or Christ himself, whose heart a Roman soldier pierced on Calvary, or to the Virgin of sorrows and her metaphorically pierced heart. The arrows were probably linked to Sebastião I of Portugal (r. 1554–1578). A 1622 description of a coat of the Order of Christ the Portuguese king sent to the Kongo mentions the presence of the arrow in the emblem. Coins from this monarch's reign that could have circulated in central Africa before and during Garcia's time also might have inspired the design of his arms. The millenarian movement of Sebastianism was, furthermore, very popular in the Lusophone Atlantic during Garcia II's reign. Jesuits such as Padre António Vieira promoted the movement, and members of the company active in the Kongo court could have promoted the motif. The portrait of Garcia II in Figure 5 juxtaposes the arrow with the cross in the hand of the seated monarch and may refer to the symbol's prominent role in a personal motto of Garcia II that the arms would also illustrate.[36]

The addition of the cross to the coat of arms remained secondary to the swords themselves, however, which continued to appear bundled in the simplified version recorded in the 1650s drawing in Figure 5, carved on the throne in Figure 6, and etched on the ring of the king in 1775 according to Cherubino da Savona. The starring role of the iron weapons in the emblem continued into the nineteenth century up to the reign of Pedro V (r. 1859–1891). Under his rule, the status of the Kongo changed from an independent, if greatly weakened, kingdom to a polity in the orbit of Portugal, but not yet fully a colonial possession. Pedro V assured his accession to the throne at the expense of his rivals through what he perceived as an alliance with Portugal but that to the Europeans appeared as an act of vassalage. The strategic if ill-fated ambivalence of Pedro V with regard to the oath appears in a comparison of the two seals he used simultaneously. A document dated 1859 in the British Library showcases the "sello do Rey do Congo," a modern version of the sixteenth-century emblem, including the five swords design, the cross

35. Seal of Garcia II, box 5, doc. 26, Arquivo Historico Ultramarino, Lisbon; Cavazzi and Alamandini, *Istorica descrizione,* 274. For the Order of Christ, see Chapter 3, below, and André L'Hoist, "L'ordre du Christ au Congo," *Revue de l'Aucam,* VII (1932), 258–266.

36. Jacqueline Hermann, *No reino do desejado: A construção do sebastianismo em Portugal: Séculos XVI e XVII* (São Paulo, 1998). For the coat of the Order of Christ sent by Sebastião I, see Brásio, ed., *Monumenta,* XV, 486.

and shells on the chief, and the royal crown at the helm. Another letter from 1860, in contrast, displays a Portuguese-designed seal that identifies the new monarch and his kingdom as part of Portugal's colonial empire. From that time on, the kings of Kongo continued to pass down and jealously preserve both seals, which were still extant in the twentieth century and maybe are the ones today in the Mbanza Kongo Museum.[37]

The symbolic potential of the sword to articulate ideas of might and prestige from both local and Christian traditions was keenly understood by the central African elite who adopted large iron swords shaped in the European fashion of the early Renaissance as integral parts of their regalia (Figures 10 [Plate 5] and 11). The swords were straight or curved, reminiscent in their shape of fifteenth- and sixteenth-century Iberian examples characterized by the alignment of guard and blade in the same plane and notably lacking the coiled hilt of later examples. They completed, for example, the funerary regalia of King Álvaro III in 1622 and were found in the elite tombs of the eighteenth-century Ngongo Mbata cemetery, where they expressed the social position of their owner as a member of the Kongo Christian elite. The weapons also carried in their material, in their form, and in their decorations key features grounded in local imagery that referred to central African ideas of might and prestige. The expression of these two sides, the Christian and the central African, materialized in the sangamentos.[38]

In the sangamentos, acrobatic steps, martial tunes, and spectacular regalia enacted Afonso's elaborate mythical transposition visually and materially through evocative objects and gestures. The swaying swords of the performers, their flashing eyes and formidable attitudes articulated the multiple interventions through which the Kongo reinvented itself as a Christian land. The large iron swords used in the dances heralded the re-creation through which

37. Savona in Jadin, "Aperçu de la situation du Congo," *Bulletin de l'Institut Historique Belge de Rome,* XXXV (1963), 406. On the reign of Pedro V and the incorporation of the Kongo into Angola, see François Bontinck, "Pedro V, roi de Congo face au partage colonial," *Africa: Rivista trimestrale di studi e documentazione dell'Istituto italiano per l'Africa e l'Oriente,* XXXVII (1982), 1–53. Compare the seal of the king of Kongo, 1859, in Additional Manuscripts 29960 D, fol. 22, British Library, London, with the one in Secretaria do Estado da Marinha e do Ultramar, Direção Geral do Ultramar, box 628, 1860, Arquivo Histórico Ultramarino. For the treaty, see José Heliodoro de Faria Leal, "Memórias d'África (Part 1)," *Boletim da Sociedade de Geografia de Lisboa,* XXXII (1914), 330. John Thornton saw the seals in the Mbanza Kongo Museum in September 2002, personal communication.

38. See, for example, Rob L. Wannyn, "Les armes ibériques et autres du Bas-Congo," *La Revue Coloniale Belge,* VI (1951), 428–430. The watercolor in Figure 2 (Plate 1) depicts two sorts of swords, scimitars with curved blades and straight baldes; I focus here on examples of the latter type. Curved swords are mentioned in Cavazzi and Alamandini, *Istorica descrizione,* 157. For the coronation, see Brásio, ed., *Monumenta,* XV, 489. The findings of Ngongo Mbata were briefly published in G. Schellings, "Oud Kongo: Belangrijke Ontdekking uit de eerste beschaving," *St. Gerardusbode: Maandschrift der paters Redemptoristen,* LIII, no. 8 (1949), 10–13.

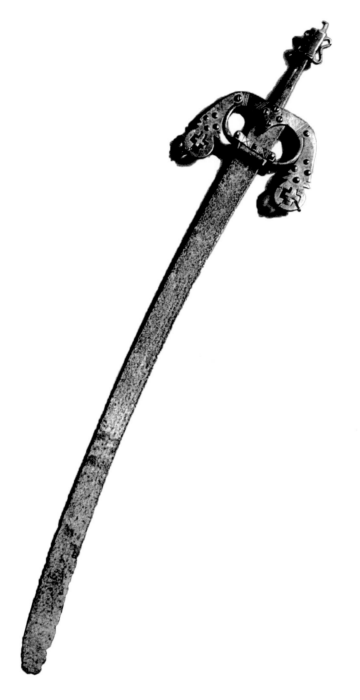

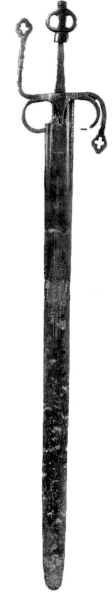

FIGURE 10 Sword of Status. Kongo kingdom, sixteenth to nineteenth century. Iron, height 55 cm. Ethnological Museum—Staatliche Museen zu Berlin, inv. III C 44945. From Jill R. Dias, *Africa: Nas vésperas do mundo moderno* (Lisbon, 1992), 141

FIGURE 11 Sword of Status. Kongo kingdom, sixteenth to nineteenth century. Iron, 90 × 4.5 cm. Royal Museum for Central Africa, Tervuren, Belgium, inv. HO.1955.9.20. Photograph, J. Van de Vyver, Royal Museum for Central Africa, Tervuren ©

Kongo warriors became Christian knights and political and military might derived from central African mythology became imbued with additional powers drawn from Christianity. The central African elite borrowed from their Portuguese counterparts key attributes of the noble man, such as the sword and the red coat and insignia of the Order of Christ, and transposed them into elements reflecting their own political and religious worldview. The swords, of course, referred to the story of Afonso that was captured in the Kongo coat of arms and, through the narrative, arched back to the significance of iron in central African mythology.

Kongo ceremonial swords represented in seventeenth- and eighteenth-century sources, excavated in Ngongo Mbata, and collected in the twentieth century consistently resembled the types used in late-fifteenth-century Portugal. The wide, double-edged blade built in the same plane as the hilt and the loops and waves of the guard are characteristics of the Manueline weapons that early Portuguese travelers would have brought to central Africa. Kongo ceremonial swords included straight blades as well as curved scimitars, but all known examples follow the template of turn-of-the-sixteenth-century Portuguese weaponry. Over centuries of interactions with Europe, Kongo nobles observed generations of new European weapons and, in the case of firearms, included them in their ceremonial attire. Yet the type of swords they used in their regalia did not change. They continued to follow the pattern introduced around 1500, a form through which they visually evoked the rule of Afonso and the moment of conversion.[39]

The historical dimension of the swords of status remained clear into the twentieth century. In the 1930s and 1940s, rulers of regions once part of the kingdom continued to hold in high esteem the ceremonial swords of Manueline style they called *mbele a lulendo,* literally "blade of power." These swords, they explained, unlike other kinds of blades, came from the *mafulamengo* people, a term that evoked, in one of the many word games used in Kikongo, both the verb *fula,* "to forge," and the term *Flamengo,* Portuguese for "Flemish," probably referring to the seventeenth-century Dutch presence in central Africa. Their oral tradition linked the mafulamengo as well as the founding forging gesture to times immemorial in the Kongo. In the twentieth century, as in the Christian period, swords of status linked the elite who carried them to the foundation myth that legitimized their rule.[40]

39. See Manueline swords in "A mão que ao occidente o véu rasgou: armaria," *Os descobrimentos portugueses e a Europa do Renascimento* (Lisbon, 1983), 57. See firearms used in regalia in Figure 42 (Plate 17), below.

40. *Mbele* appears as the translation for *gladius* in "Vocabularium," [1652], MSS Varia 274, 41v, Fondi minori 1896. The words *inbele* and *fula* are both in Cuénot, "Dictionnaire Congo et françois," 1773,

The narrative of Afonso laid out the political foundation of the kingdom but also legitimized conversion, and the swords contributed to establishing the link between religion, power, and legitimacy. In addition to their role as political regalia, they served an official function at Christian liturgies and festivities. At the end of the seventeenth century, during the processions honoring the Corpus Christi, members of the Christian elite raised their swords as a sign of their dedication to the defense of the faith and flashed them around as they danced the sangamento at each station of the Eucharistic sacrament. Here, the local significance of the iron weapon joined multifarious Christian associations. Instrument of the Passion, the sword also was an attribute of many saints, including Saint James and, in the Portuguese world, Saint Anthony. For instance, an eighteenth-century statue of Saint Anthony imported from Brazil that featured a menacing sword graced the church of Muxima, a northern Angola town with ties to the Kongo. The Virgin also often appeared in conjunction with the weapon, for instance in images of the Mater Dolorosa. In an example from the late-seventeenth-century Kongo, a Capuchin, during a theatrical sermon, pierced the chest of a statue of the Virgin with a dagger. The association of the swords with otherworldly intercession, beginning with the apparition of Saint James, received continual reinforcement in the imagery of the church.[41]

The decoration on the swords also strongly connected them to other Kongo Christian objects. Engraved motifs, cruciform elements, and the decorative use of nails cast the weapons as close cognates to the crucifixes, rosaries, medals, and embroidered coats commonly worn by the Kongo elite on solemn occasions. Decorative nails and engraved incisions and openwork enhance the guard of a sword of status in the Berlin Ethnology Museum (Figure 10 [Plate 5]), for example, in a manner that echos the techniques and motifs seen on crucifixes of the kind illustrated in Figure 19 (Plate 11). Four

MS 524, fols. 35, 98. See Wannyn, "Les armes ibériques et autres du Bas-Congo," *La revue coloniale Belge,* VI (1951), 428–430; Cécile Fromont, "By the Sword and the Cross: Power and Faith in the Arts of the Christian Kongo," in Susan Cooksey, Robin Poynor, and Hein Vanhee, eds., *Kongo across the Waters* (Gainesville, Fla., 2013), 28–34.

41. For the use of swords in liturgy, see Jadin, "Andrea de Pavia au Congo," *Bulletin de l'Institut Historique Belge de Rome,* no. XLI (1970), 447. For the Corpus Christi celebration, see Lorenzo da Lucca and Filippo da Firenze, "Relazioni," 1700–1717, 169–170; Cuvelier, *Relations sur le Congo,* 122. Saint Anthony had a strong military side in the Portuguese world and often appeared with a large sword; see, for example, José Carlos de Macedo Soares and Orlando Guerreiro de Castro, *Santo Antonio de Lisboa, militar no Brasil* (Rio de Janeiro, 1942); Santos Furtado, "Uma imagem de Santo António em Angola (Santo António da Muxima): Breve estudo e apontamentos," *Boletim do Instituto de Angola,* no. 14 (July–December 1960), 41–51. The Virgin pierced by a large sword was used by the Capuchins in a theatrical sermon by Merolla; see Merolla and Piccardo, *Breve, e succinta relatione,* 148.

pegs, each with a single slit, attach the guard to the blade and form a lozenge that recalls the designs on the crosses. On this broadly anthropomorphic object, the diamond also protectively clads the chest of the figure where handle and blade meet, over a triangular shape suggesting a *nkutu* net. From there, broad shoulders turn into thin arms with fists planted on hips at the level of a sash attached with high pegs. A thick strip of metal hangs over the arms of the figure as a heavy coat, embellished with undecorated nails arranged in a diamond pattern. On either side, the coat ends in decorative openwork forming two medallions, each pierced with a cross. The cross is effectively rendered with its bi-colored design, resembling that on an eighteenth-century medallion unearthed in Ngongo Mbata. This detail is a particularly elaborate example of a motif present in many Kongo swords as a single cross opened at the ends of the guards, as in Figure 11. The design also brings to the coat of the anthropomorphized sword the sign of the Order of Christ often embroidered on the cloaks of the highest-ranking elite of the Kongo, as seen in fading white paint on Figure 2 (Plate 1) and Figure 42 (Plate 17). Fishbone patterns and *X*-shaped crosses decorate the shoulders and the belt. The decorations on the swords of status thus close the loop that linked—through design and a common underlying political, mythical, and religious message—the swords, crucifixes, and their elite Kongo Christian owners.[42]

The might and fortitude encoded in the swords' material and in their historical and mythological valence also transpired from their shape. The end of the pommel, often pierced with two holes, resembled a human head and face and, as noted above, conferred on the swords a distinct anthropomorphic look (see Figure 11). Directly under the handle, the guard protecting the blade suggests the arms of a human figure, one arm down and the other up above the head. This attitude directly reflects the use made of the weapons in the ritual dances of the sangamento in which the dancers brandished the swords, stretching their arms up and down to convey physically an intimidating message of strength, power, and aggression (Figure 12). The martial exercises of the sangamentos were, after all, a means for central African men to hone their skills and demonstrate their value as warriors as well as to prove the aggression they could muster in battle. Marcellino d'Atri vividly captured the intimidating use of the swords in a performance staged at the turn of the seventeenth century:

42. See the medallion in Schellings, "Oud Kongo," *St. Gerardusbode*, LIII, no. 8 (1949), 12. Other examples are the sword in the Afrika Museum Berg en Dal, Netherlands, inv. 29–692, or those in the Musée Royal de l'Afrique Centrale in Tervuren, Belgium, inv. 55 95 67 and 55 95 65. See the discussion of Kongo regalia in Chapter 3, below.

FIGURE 12 Sangamento Dancer. Detail of Bernardino d'Asti, *The Missionary Gives His Blessing to the Mani during a Sangamento*. Circa 1750. Watercolor on paper, 19.5 × 28 cm. From "Missione in prattica: Padri cappuccini ne Regni di Congo, Angola, et adiacenti," MS 457, fol. 12r, Biblioteca Civica Centrale, Turin. Photograph © Biblioteca Civica Centrale, Turin

Finally, the Prince himself, who wore as uniform a spring coat, crimson velvet boots, holding a crucifix in the left hand and a sword in the right [started dancing. He] jumped and moved with a range of gestures and attitudes of the head, swaying his sword now to the right, now to the left, now in the air above the head, now hitting it to the ground. Here he struck it to his chest, there to his back, and now pretending to assault and wound the crowd that followed him.[43]

The same gestures continued to express ideas of aggression and might in the nineteenth and twentieth centuries in central African visual culture. Carvers from regions close to the territories of the old kingdom shaped menacing *minkisi minkondi* (sing. *nkisi nkondi*) power figures in formally similar attitudes, looming against traitors and transgressors, one arm up with a weapon, the other down on the hip (Figure 13 [Plate 6]). Wide-open, beaming eyes—as those of the dancers—complete their ominous look. In some

43. Robert Farris Thompson noted the anthropomorphic look and gesture of the pommels and related them to *niombo* reliquary figures; see Thompson and Joseph Cornet, *The Four Moments of the Sun: Kongo Art in Two Worlds* (Washington, D.C., 1981), 62–63, 65. See also Fu-Kiau Bunseki-Lumanisa, *N'kongo ya nza yakun'zungidlia; nza-Kôngo* (Kinshasa, 1969). John K. Thornton underlines the role played by the dances as military training; see Thornton, *Warfare in Atlantic Africa, 1500–1800* (London, 1999), 105. See the late-sixteenth-century description of "sanguar" as a defensive technique in Brásio, ed., *Monumenta*, IV, 563. For Marcellino d'Atri's account, see Carlo Toso, *L'anarchia congolese nel sec. XVII: La relazione inedita di Marcellino d'Atri*, Studi di storia delle esplorazioni, 15 (Genoa, 1984), 229.

instances, the arms of the minkisi and of the swords are akimbo, fists planted on the hips in a related stance of strength and determination. The affinity between the swords and the minkondi is, in fact, more than formal. Nails or sharp pieces of metal driven into the flesh activated the wooden figures, and, in at least one instance, a sword of status served as an activating metal piece that was plunged into the heart of a large and mighty nkondi (Figures 14 [Plate 7] and 15 [Plate 8]). Similarly, a shell, reminiscent of the type emblematic of Saint James and prominently featured in the coat of arms of the Kongo, tops the nkondi in Figure 13 (Plate 6). These two details offer an evocative demonstration of how central African and European visual and symbolic syntaxes met over centuries in complex interlacing streams, from the first moments of contact with Christianity circa 1500 into the eighteen and nineteen hundreds.[44]

There are no extant examples of nkondi from the early modern period; however, the characteristic Kongo position of the arms identifies two "broken idols" depicted in the coat of arms of Afonso as representations of this category of menacing objects. The painting shows two statues that are broken at the waist into two pieces (Figure 16). Their bottom halves stand in the center as two pairs of legs resting on a base or pedestal. The top parts of the "idols" appear as two upper bodies with their arms in the pose witnessed in the swords, the sangamento dancers, and the minkisi minkondi, one arm up and the other down in a menacing stance. The European painter of the coat of arms might have worked from actual figures brought to Portugal by travelers or from eyewitness descriptions, as the characteristic position of the arms compellingly suggests. If the artist is not representing objects from central Africa but simply a generic depiction of pagan idols, he presents a much less sinister view of non-European objects of worship than the large catalog of European imaginative renderings of exotic "idols" in the sixteenth century demonstrates. Kongo religious objects depicted in the fanciful engraving of the "burning of the idols" in Lopes's 1591 *Relatione,* for instance, take the more common shape of winged snakes, dragons, and monstrous horned figures.

44. Robert Farris Thompson, drawing from Congolese scholar Fu-Kiau Bunseki-Lumanisa's teachings, proposed a reading of the first gesture, one arm up and the other one down, as an expression of the Kongo cosmogram, conveying ideas of death and regeneration; see Thompson and Cornet, *Four Moments of the Sun;* Fu-Kiau Bunseki-Lumanisa, *N'kongo ya nza yakun'zungidlia.* He also discussed Kongo gesture at large in his essays in Christiane Falgayrettes-Leveau and Musée Dapper, *Le geste kôngo* (Paris, 2002). See also Bárbaro Martínez-Ruiz, "Kongo Atlantic Body Language," in *Performance, art et anthropologie* (2009), http://actesbranly.revues.org/462. Note that the name *nkisi nkondi* (pl. *minkisi minkondi),* which has become the canonical term for these figures, belongs to a northern dialect of Kikongo. Observation about the presence of the sword in Figure 14 is drawn from a personal study of the object in June 2007 in the reserves of the Royal Museum for Central Africa in Tervuren, Belgium.

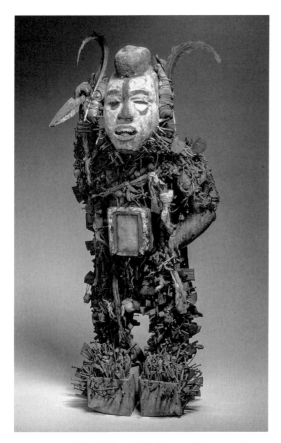

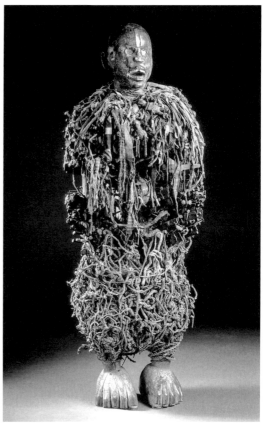

FIGURE 13 Nkisi Nkondi. Bakongo, Democratic Republic of the Congo, before 1914. Wood, metal, cloth, shell, other material, height 85 cm. Royal Museum for Central Africa, Tervuren, Belgium, inv. EO.0.0.22438. Photograph, Schneebeli, Royal Museum for Central Africa, Tervuren ©

FIGURE 14 Nkisi Nkondi. Bakongo, Democratic Republic of the Congo, before 1878. Wood, metal, fabric, pigment, fibers, glass, 115 × 45 × 33 cm. Royal Museum for Central Africa, Tervuren, Belgium, inv. EO.0.0.7943. Photograph, R. Asselberghs, Royal Museum for Central Africa, Tervuren ©

Moreover, the images of the escutcheon were unquestionably recognized by Afonso as Kongo "idols" and must have been a convincing depiction of local objects. In the narrative of Afonso, the idols of the coat of arms are destroyed as vestiges of the Kongo's pagan past, yet the gesture with which they signified their power endured in swords and sangamentos as attributes of the Christian elite.[45]

45. There is a considerable literature on late-nineteenth- and twentieth-century minkisi minkondi, but not an earlier form, as presented here. For discussion of minkondi in modern times, see Chapter 5, below, and Wyatt MacGaffey, "Complexity, Astonishment, and Power: The Visual Vocabulary of Kongo Minkisi," *Journal of Southern African Studies,* XIV (1988), 188–203. See also Zdenka Volavkova, "Nkisi Figures of the Lower Congo," *African Arts,* V, no. 2 (Winter 1972), 52–59. The print in Lopes

FIGURE 15 Detail of a Sword of Status in the Chest of a Nkisi Nkondi. Bakongo, Democratic Republic of the Congo, before 1878. Wood, metal, fabric, pigment, fibers, glass, 115 × 45 × 33 cm. Royal Museum for Central Africa, Tervuren, Belgium, inv. EO.0.0.7943. Photograph, J. M. Vandyck, Royal Museum for Central Africa, Tervuren ©

FIGURE 16 Broken Idols on the Coat of Arms of the Kings of Kongo. Detail of António Godinho, *Coat of Arms of the Manicongo Kings*. 1528–1541. Ink on parchment, 43 × 32 cm. (full page). From "Livro da nobreza e da perfeição das armas dos reis cristãos e nobres linhagens dos reinos e senhorios de Portugal," fol. 7, PT/TT/CR/D-A/001/20, Arquivo Nacional da Torre do Tombo, Lisbon. Photograph courtesy of the Arquivo Nacional da Torre do Tombo

is discussed in Suzanne Preston Blier, "Capricious Arts: Idols in Renaissance-era Africa and Europe (The Case of Sapi and Kongo)," in Michael W. Cole and Rebecca Zorach, eds., *The Idol in the Age of Art: Objects, Devotions, and the Early Modern World* (London, 2009), 11–29 (discussion of the print is on 18–21).

From Sangamento to Congada

Afonso's reinvention of the founding of the Kongo and its enactment in the sangamento's choreography and regalia became essential parts of the Kongo elite's definition of itself. The dance and its associated insignia endured through the centuries and across the Middle Passage as a standard of collective identity and a tool of political and social empowerment. Forty years after the Italian friar painted the sangamento vignette in Figure 2 (Plate 1), another Italian, Carlo Giuliani, better known as Carlos Julião, captured in a series of watercolors the elaborate black kings festivals he had observed in Brazil in the last quarter of the eighteenth century (Figure 17 [Plate 9]). Although no original titles or text accompany Julião's watercolors, there is little doubt that the festivities he depicted were celebrations staged around the kings and queens of black brotherhoods on the feast days of their patron saints. The watercolors in Rio de Janeiro depict elaborately attired black dancers in animated processions. In Figure 17 (Plate 9), a kingly figure, stately dressed with a long red coat and crimson wrapper, staff in hand and a dagger at the waist, wears a golden crown on his head and embroidered anklets. Two young men attend him. One holds a red umbrella above his crowned head, and the other carries his red coat decorated with stars. They, too, are richly dressed with colorful wrappers, anklets, and silver crowns adorned with feathers. Five musicians sporting similar outfits dance and play a combination of central African and European instruments: a marimba, a guitar, a *reco-reco,* a boxlike scraper, and a tambourine. A sixth man is pirouetting in the foreground, twirling a staff and castanets in the air. A single female bystander stands to the right of the page, taking in the spectacle.

Although the painting styles of the two Italian observers are strikingly different, points of comparison between the scenes Julião and Bernardino d'Asti captured readily arise. On both sides of the Atlantic, similar musical instruments create the soundtrack to which a leader solemnly processes, clad in a red coat and a decorated fabric wrapper and holding a staff or a sword. The animated attitudes and arm gestures of the attendants seem to carry over from one side to the other. The staff and castanets twirling on the Brazilian page echo the awe-inspiring swoops of swords in the Kongo watercolor. The necklace chains, anklets and bracelets, crosses, and medals of the American dancers also recall elements of Kongo elite regalia seen in Figure 2 (Plate 1).[46]

46. See also the broader discussion of Kongo regalia in Chapter 3.

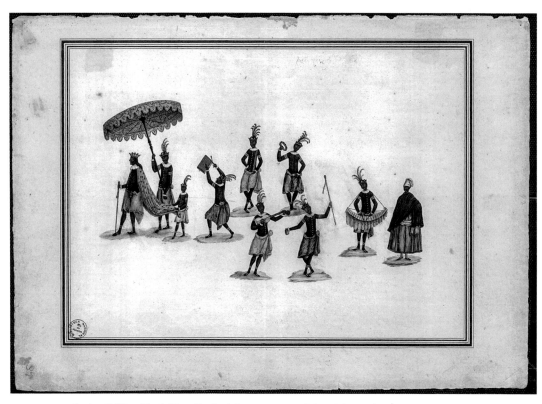

FIGURE 17 Carlos Julião, *Black King Festival*. Last quarter of the eighteenth century. Watercolor on paper, 45.5 × 35 cm. (album). Iconografia C.I.2.8, drawing 49, Collection of the Fundação Biblioteca Nacional—Brazil

Bringing these images together highlights visual, gestural, and material resonances that give substance to the central African dimension of black festivals in Brazil. Point-by-point correspondences in the regalia, musical instruments, and choreographies deployed in contemporaneous performances on either side of the Atlantic offer an evocative portrait of cultural continuity. The occasion for the Brazilian festival likely depicted here, the election of a king within a confraternity identifying with central African ethnicity, also echoes the celebration of mythical and real kings in the sangamentos. Precise gestures, objects, and ceremonies traveled with enslaved men and women and took on new life in the Americas. Yet, beyond transfers of single objects or rituals, a significant point of connection between American practices and African precedent resides in the use and articulation of European and African elements as a means for central Africans to express independent thoughts and to respond to social challenges. In the Kongo, the elite strategically combined local and foreign elements into a discourse of power through which

they managed the changes brought about by their entrance into the religious, commercial, and political networks of the Atlantic world. The independent and inward-looking combination of local and foreign formed the core of Kongo discourses of political power and social prestige that were expressed in central African regalia and ceremonies such as the sangamentos. In turn, in the Americas and Iberia, the black kings festivals that could be seen as subaltern emulations of Iberian political pomp, or carnivalesque reversals, also formed a central African response to the radically new circumstances of life in slavery. In election festivals, men and women of central African origin or heritage, including occasional members of the Kongo elite brought into the slave trade through wars and political turmoil, used insignia and ceremonials according to the well-established and deeply meaningful practices of combination and reconfiguration that characterized the Kongo visual vocabulary of power and prestige. They used European emblems and symbolism as standards of collective identity and tools of social expression. The combination functioned at two levels. First, it re-created the mix of European and African items that already existed in the Kongo. Second, following the combinative logic honed in Africa, it operated a further synthesis specific to the new context of enslavement within colonial Latin America. Black kings festivals and their characteristic regalia, hierarchies, and choreographies testify not only to cultural transmission but also and significantly to epistemological continuity across the Middle Passage.[47]

Conclusion

Sangamentos encapsulate the elaborate operations through which the rulers of the Kongo kingdom recast the nature and expression of their political power and legitimacy as they chose to embrace Christianity, the new religion that came to their shores as they became actors within the early modern Atlantic world. In the dances, the elite of the kingdom enacted a set of mythological, religious, and symbolic redefinitions through which ideas and emblems from abroad met and merged with local conceptions and imagery to form a new Kongo Christian discourse. The central African elite, following their first great Christian king Afonso, used mythology, in particular, as a generative space of correlation that allowed them to combine

47. Linda M. Heywood describes the circumstances in which members of the Kongo elite became caught in the slave trade in Heywood, "Slavery and Its Transformation in the Kingdom of Kongo, 1491–1800," *Journal of African History*, L (2009), 1–22. I develop further the link between sangamentos and black king festivals in Cécile Fromont, "Dancing for the King of Congo from Early Modern Central Africa to Slavery-Era Brazil," *Colonial Latin American Review*, XXII (2013), 184–208.

and transform Christian history and central African traditions into a novel Kongo Christian lore. The multivalent reinvention hinged on the imagery of iron and ironworking as potent symbols of political might and spiritual fortitude in both early modern Europe and pre-contact central Africa. The miraculous iron weapon of Saint James, for example, gave visual form to the mythological, religious, and political reformulations that European-style swords of status, in turn, continued to evoke as they became emblematic attributes of the Kongo Christian elite.

Under the Sign of the Cross in the Kingdom of Kongo

Religious Conversion and Visual Correlation

At the feet of a monumental cross installed in front of a church, a Capuchin friar, in full ecclesiastical garb, presides over the office of the dead in eighteenth-century Kongo (Figure 18, Plate 10). The friar and two *mestres,* interpreters for the Capuchins and local leaders of the church, sing the service from a book, accompanied by two children carrying the incense and the holy water. A fifth man is holding a ceremonial cross at the head of the tomb. A black pall inscribed with a white cross covers the grave around which all are gathered, and a candle is burning at each of its corners. The congregation has brought offerings—small animals, pots, and food—which are disposed on the ground in front of the burial place.[1]

What emanates from the scene presented in the watercolor is the superposition of two different orders that cohabitate in the space of the image. On the one hand, we see the friar and his acolytes, Catholic hymnals in hand, bathed in the burning incense, practicing for the congregation in the orthodoxy of the Roman Catholic Church. On the other hand, the local community is gathered around the offerings they brought to the ceremony "in favor of the souls" at the foot of a cross, a symbol associated in the Kongo with the cyclical passage from life to death. The sign of the cross is at the center of the watercolor and at the crossroads of the symbolism and beliefs that infuse the image. In the vignette and in the scene it represents, two different sets of religious ideas as well as two modes of visual expression have converged and overlap. The monumental cross and smaller crucifixes serve for the Capuchins as univocal warrants of worship to the Christian God, but they also are the unifying signs under which Catholic and central African religious traditions join in a single ritual. A univocal European or Kongo reading of the ceremony depicted does not exhaust the religious significance of the scene, of the ritual practices it

1. For the monumental cross, see François Bontinck, "Les croix de bois dans l'ancien royaume de Kongo," *Dalla chiesa anticha alla chiesa moderna: Miscellanea per cinquantesimo della facoltà di storia ecclesiastica della Pontificia Università Gregoriana,* Miscellanea Historiae Pontificiae, no. 50 (1983), 199–213; and Chapter 4, below.

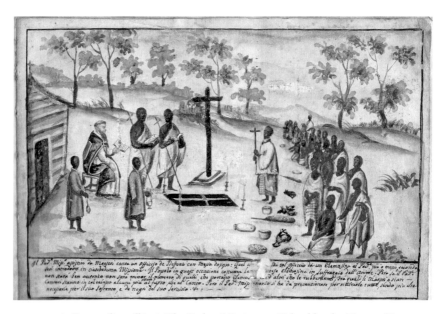

FIGURE 18 Bernardino d'Asti, *The Father Missionary Helped by the Mestres Sings an Office of the Dead*. Circa 1750. Watercolor on paper, 19.5 × 28 cm. From "Missione in prattica: Padri cappuccini ne Regni di Congo, Angola, et adiacenti," MS 457, fol. 8r, Biblioteca Civica Centrale, Turin. Photograph © Biblioteca Civica Centrale, Turin

portrays, and of the objects it describes. Rather, the sensuous Christianity of the Capuchins, rendered in the theatrical staging of the ceremony, complete with music and perfume, here engages in a dialogue—in the shadow of the monumental cross—with the devotions, Christian or otherwise, of the Kongo protagonists.[2]

For the men and women gathered around the tomb, the Christian and central African symbols and ideas that have merged in the ritual during which they celebrate the passing of their kin and kith form more than a discourse of political power and legitimacy. If the space of correlation created by Afonso's succession story, which redeployed central African myth and Christian lore, operated in the realm of political discourse and mythol-

2. The quoted text is from the image in Figure 18 (Plate 10). As discussed below, early modern sources establish the link between the cross and the belief in death and regeneration promoted by the Kimpasi association. The continued significance of the cross in twentieth-century Kongo as a cosmogram representing the cycle of life and death has been demonstrated by authors such as Robert Farris Thompson and Wyatt MacGaffey, drawing from the work of Congolese scholar Fu-Kiau Bunseki. See Thompson and Joseph Cornet, *The Four Moments of the Sun: Kongo Art in Two Worlds* (Washington, D.C., 1981), 43–46; MacGaffey, *Religion and Society in Central Africa: The BaKongo of Lower Zaire* (Chicago, 1986), esp. 44–46; Fu-Kiau Bunseki-Lumanisa, *N'kongo ya nza yakun'zungidlia; nza-Kôngo* (Kinshasa, 1969).

ogy, it also encompassed a deep religious dimension. The cross formed the nexus through which central African and Christian discourses of power and cosmological thought entered into dialogue. It appeared at key moments in the early history of Christianity in the Kongo. As a central symbol in both Kongo and European religious thought, it allowed the two sides to ascertain the religious significance of Afonso's gesture of conversion in their own terms as well as to establish epistemological common ground regarding the nature of the supernatural and its worldly manifestations. The cross formed a space of correlation where the perimeter of Christian orthodoxy widened to recognize and include what constituted in central Africa manifestations of immanence, and, in turn, where Kongo religious thought broadened to include the new invisible powers of Christianity. These ideas acquired visual and material form in portable, elaborately crafted crucifixes through which Kongo artists and patrons articulated their new Kongo Christian worldview.

Under the Sign of the Cross

On the sails of caravels, on the chests of noblemen, in the hands of clerics, and on the stone landmarks proudly erected along newly reached shores, the sign of the cross accompanied every move of the Portuguese explorers as a banner of conquest and a standard of proselytism. Yet, when Iberians and their crosses reached central Africa in 1483, their presence resulted neither in colonial conquest nor forceful conversion. Rather, Christianity entered into the political, social, and religious realm of the kingdom of Kongo at the demand of its own rulers and without foreign coercion, and a lasting relationship was established between Europeans and central Africans without colonization. In contemporary chronicles describing the early relationship between Portugal and the Kongo, the Christian cross appeared repeatedly not only in the hands of Portuguese men but also was put to work by central Africans in powerful gestures demonstrating their control over the real and symbolic terms of their encounter with Europe and Christianity.

Chronicler Rui de Pina recorded the first moments of the advent of Catholicism in the Kongo, writing in Portugal at the time of the events from eyewitness accounts and official correspondence. On May 3, 1491, he reports, the king of Kongo, Nzinga a Nkuwu, received baptism along with six of his courtiers and took the Christian name of João I. The king celebrated the event with great pomp and immediately declared Catholicism the state religion, ordering that clerics be well received in all his provinces and that all local idols, altars, and temples be destroyed. A few days after the ceremony, two of the men baptized with him experienced a vision in their sleep. They were visited

by a resplendent Virgin Mary, who asked them to congratulate João on her behalf for the conversion of his kingdom. The next morning, as he stepped out of his house, one of the two men found a cross carved in a strange black stone. It was two palms high with smooth, rounded branches, as if "worked with great industry." "I found a holy thing made of a stone I have never seen before," he reported to the king and the clerics, "and it is shaped as the object that the Friars held when we became Christian and that they called *the Cross.*" Showing the stone to the European priests, the king asked, "What do you think this is?" "Sir," answered the clerics, moved to tears, "these things [that is, the visions and the cross] are signs of grace and salvation that God sent to you and your kingdom, and for this we give him and you also should give him infinite thanks." And they took the cross in procession to a newly built church where it was prominently displayed as a relic of the great miracle. Memory of the wondrous event endured for centuries. A now unknown local author wrote in 1782 an account of the advent of Christianity in the Kongo that still centrally featured the miraculous apparition of the stone at the moment of João's baptism. Once the old king decided to accept Christianity, this later story recalled, "God judged good to show [to the clerics sent from Portugal] the place or the location where the sacrament [of baptism] should be performed; a large stone fell from the sky, and the friars understood that God by his power revealed this sign as a relic *[lembrança]* of this sacrament and they built on this site a church called the True Cross where the friars celebrated the saint baptism."[3]

In this context of early contact between two radically different worldviews, it is significant that the original moment of conversion would include a core material and visual dimension. At a time wrought with ambiguity and uncertainty about the possibility and efficiency of communicating religious ideas across cultures, the stone provided common ground on which Europeans and Africans could engage in dialogue. Although skilled interpreters trained in nearly a decade of contact between Portugal and Kongo facilitated the conversation, the miraculous object took precedence over linguistic communication in this key moment of cross-cultural exchange. In the story,

3. Rui de Pina "Baptismo do Rei do Congo, 3-5-1491," in António Brásio, ed., *Monumenta missionaria africana: África ocidental (1471–1531)* (Lisboa, 1952), I, 124–125. See also the account of the event by another Portuguese chronicler, Garcia de Resende "Baptismo do Rei do Congo, 3-5-1491," in Brásio, ed., *Monumenta*, I, 127–128 (quotation on 124; emphasis mine). The story of the apparition also figures in Mateus Cardoso's 1624 history of the kingdom; for a modern edition, see *Histoire du Royaume du Congo (c. 1624),* trans. François Bontinck, IV, Études d'Histoire Africaine (Paris, 1972), 106–108. See the 1782 story in Francisco das Necessidades, "Memoria de como veio a nossa christianidade de Portugal (1844)," *Factos memoraveis: Boletim oficial da Provincia de Angola,* no. 642 (1858), 2.

the stone cross was the pivotal element through which central Africans and Europeans were able to ascertain a mutual understanding of the significance of the king's decision to turn to the new faith and to establish a common understanding of the invisible world and its tangible manifestations.

When the newly baptized nobleman came across the black stone, he immediately recognized it as a "holy thing," "cousa sancta" in the text, a phrase that missionary literature would later convey in the Kongo language with the word *nkisi.* From the seventeenth century onward, the word *nkisi* appears in missionary literature as a translation for the word and concept *holy.* For example, in a circa 1650 Latin-Kikongo dictionary, the entry for the adjective *sanctus-a* is translated as *quianquissi,* or "of the *nkisi,*" and the entry for the substantive *sanctitas* ("sanctity," "holiness"), as *uquissi,* or "having the nature of the *nkisi.*" The connection made by the early modern translators between the idea of the holy and that of the nkisi suggests that the central African term already carried at least part of its modern meaning of a material object in which otherworldly forces dwell and act in this world. At a time of great symbolic violence marked by the king's order to destroy local objects of worship, the stone was, for the nobleman and Kongo observers at large, a key, reassuring manifestation of the reality of the supernatural forces that were invoked in baptism. From a Kongo perspective, the discovery of the stone was a revelation that legitimized the act of conversion. At the demand of the king, this Kongo understanding of the cross as a nkisi was validated by the foreign clerics as they answered his request to identify the stone with the question, "What do you think this is?" In their response, the priests indeed recognized the cross as a sign, as a manifestation of God in the world, as a nkisi, and as a holy thing. In turn, for the European clerics, the miraculous apparition of the Virgin and the discovery of the stone were clear demonstrations of the will of the Christian God to see the Kongo converted. Thus, the stone cross created a space where Europeans and Africans could size up their religious conceptions and reach agreement on the authenticity and perceptibility of supernatural forces.[4]

4. See the definitions in "Vocabularium Latinum, Hispanicum et Congense," [1652], MSS Varia 274, 94v, Fondi minori 1896, Biblioteca Nazionale Vittorio-Emmanuele II di Roma. The term is discussed in John Thornton, "Perspectives on African Christianity," in Vera Hyatt and Rex Nettleford, eds., *Race, Discourse, and the Making of the Americas* (Washington D.C., 1995), 183. See also Thornton, "Afro-Christian Syncretism in the Kingdom of Kongo," *Journal of African History,* LIV (2013), 53–77. The modern understanding of nkisi is discussed at length in Wyatt MacGaffey, "Complexity, Astonishment, and Power: The Visual Vocabulary of Kongo Minkisi," *Journal of Southern African Studies,* XIV (1988), 188–203. The idea of revelation plays an important role in Thornton's discussion of Christian conversion in the Kongo; see, for instance, Thornton, *Africa and Africans in the Making of the Atlantic World, 1400–1800,* 2d ed. (Cambridge, 1998), 235–236.

In this regard, the stone cross was a space of correlation in which Kongo and Christian views of revelation and the supernatural met and merged. It became a cultural object in which heterogeneous conceptions could be approximated in a generative process creating new ideas that both encompassed and surpassed the original inputs. A Kongo nkisi became a Christian sign, and a Christian cross, a Kongo power object. The perimeter of Christian orthodoxy widened to recognize and include Kongo ideas of immanence and, in turn, the acknowledgment of new forms of supernatural powers transformed Kongo religious thought. Kongo Christianity emerged at the crux of these two trends in a form that was both recognized by the Catholic Church and enthusiastically embraced by many in the Kongo, as demonstrated by their elaborate and lasting engagement with Christian rituals, objects, and thought.[5]

The space of correlation here, the stone cross, owed its compelling role as an agent of cross-cultural communication not only to its miraculous nature but also to its specific form. In the early modern Christian Kongo, the cross, as a sign, a symbol, and an object, provided a domain in which central Africans could articulate Christian and Kongo ideas of the supernatural and related concepts of power, history, and legitimacy. If João I was the first king to receive baptism, it was his son Afonso who initiated the crucial symbolic reformulation that naturalized Christianity into a central African religion while integrating the Kongo into the larger realm of Christendom. In Afonso's series of letters discussed previously, he outlined what he intended to become the official narrative of his ascension to the throne. In his telling, the young Christian prince seized the crown after a bitter succession struggle against his heathen brother in which he emerged victorious thanks to the providential apparition of Saint James and a prodigious cavalry under the sign of the cross miraculously branded in the sky of the decisive battle. The story proved successful in establishing Afonso both as a Christian prince in the eyes of Europeans and as a potent founding hero from the perspective of central African tradition; it became an integral part of Kongo oral tradition and recorded history.[6]

5. John Thornton has underlined the fluidity of Catholic orthodoxy in the early modern period, which allowed it to recognize Kongo Christianity, in contrast to the modern tendency for a closed, exclusive understanding of Christian dogma. See Thornton, "The Development of an African Catholic Church in the Kingdom of Kongo, 1491–1750," *Journal of African History*, XXV (1984), 147–167.

6. See later iterations of the story, for example, in Louis Jadin, "Andrea de Pavia au Congo, à Lisbonne, à Madère: Journal d'un missionnaire capucin, 1685–1702," *Bulletin de l'Institut Historique Belge de Rome*, XLI (1970), 452–453. See also Jadin, "Aperçu de la situation du Congo et rite d'élection des rois en 1775, d'après le P. Cherubino da Savona, missionnaire au Congo de 1759 à 1774," ibid., XXV (1963), 407.

The cross conspicuously appears in Afonso's story, at a foundational moment, and serves as a key point of correlation for central African and Christian perspectives. Its prominence in the advent of Catholicism in central Africa derived from its concomitant significance as a sign for European travelers and clerics and as a key motif in Kongo visual culture. Drawing on this ambivalence, Afonso made the design the visual cornerstone of his reinvention of the Kongo's mythological foundation. His narrative not only mobilized the miraculous imagery of the Constantinian cross but also monumentalized the sign as a cornerstone of the kingdom's coat of arms. In oral history, and in the Christian Kongo's new foundation myth, the miraculous cross apparition became a trope for the supernatural endorsement of Afonso's support of the kingdom's conversion. In the 1782 version of the myth, a second stone cross appears minutes after the key moment in which the young king finds himself forced to kill his mother for refusing to abandon her old "idols." After burying the woman alive, Afonso, enraged, "grabbed his sword, walked to the church, and, stepping on a stone, drew his sword and struck [the stone] in defense of the Faith of Our Lord Jesus Christ." A miracle ensued; at that very moment, "the sign of the Cross" appeared and instantaneously "molded" *(lavrou)* the stone. This story explains why, the author added, "all the royal people, dukes, counts, marquis, and other noblemen take the habit of [the Order of] Christ." Centuries after the first enunciation of the miraculous story, the idea of the cross apparition continued to serve as a central hinge for the articulation and justification of the advent of Christianity in the Kongo.[7]

The great Christian king also inaugurated his reign with the erection of a monumental cross in front of the principal church in his capital to commemorate the momentous celestial apparition at the time of his ascension to the throne. All across the kingdom, under his impetus, provincial rulers built churches at the center of their towns and in front of them placed large crosses, grand and permanent visual manifestations of the mythological and historical innovations Afonso formulated. The monuments, such as the one depicted in Figure 18 (Plate 10), stamped the Kongo landscape as Christian. They were imposing markers that celebrated Afonso's triumph as the legitimate king, memorialized the miraculous advent of Christianity in the kingdom, and in effect enacted the Kongo crown's adoption of Catholicism.[8]

7. Necessidades, "Memoria," *Factos memoraveis,* no. 642 (1858), 3.

8. The Portuguese traveler Duarte Lopes, who lived in the Kongo around 1580, mentions the monumental cross in Mbanza Kongo and Afonso's order to the provincial ruler to erect their own; see [Lopes and Filippo Pigafetta], *Relatione del reame di Congo et delle convicine contrade: Tratta dalli scritti et ragionamenti di Odoardo Lopez Portoghese per Filippo Pigafetta* . . . (Rome, 1591), 50, 55. Carmelite missionaries saw one of the monumental crosses in a provincial capital in 1584; see Brásio,

Kongo Crucifixes

The sign of the cross in the Kongo encompassed more than a narrative of power, triumph, and legitimacy that operated merely at the level of political rule. Kongo Christian crosses also took the form of portable, elaborately crafted objects used by individuals and small communities. The hundreds of Kongo crucifixes that are still extant today form a coherent corpus, ranging in size from a few inches to a couple of feet. As a group, they are remarkable in their complex yet consistent iconography that grew at the crux of Christian and Kongo religious and visual syntax. European devotional objects imported en masse by Portuguese and later Italian missionaries provided the original paradigms for Kongo crucifixes, but central elements of the African objects' iconography also firmly characterized them as local visual expressions, such as the ancillary figures, the geometric designs, and the etched borders seen in Figure 19 (Plate 11).

From the rare written sources documenting the production of the crosses, we know that Kongo artists made them from local and imported brass in workshops without European supervision. There is no evidence that European laymen or missionaries set up metalworking operations in the region after the initial arrival of Portuguese tradesmen in the first years of contact. On the contrary, foreigners avidly and unsuccessfully sought information about local mining and metalworking because central Africans believed that the two activities required great ritual discretion. Hopeful reports of hidden mines appear in most European accounts of the region, starting with the earliest news of the land, as the one found on the 1502 Cantino Map, whose depiction of the region is dominated by the Montes de Luna, the marvelous silver mountains. The inhabitants of the Kongo indeed had access to copper deposits, but most surviving crucifixes are made of yellow brass of high zinc content—often misidentified by European observers as gold rather than copper. Dutch merchant F. Cappelle wrote that only small amounts of such "a metal looking like bronze"—probably a local, naturally occurring brass—existed in the area. Although the Kongo and nearby kingdoms exported red copper to Europe, Europeans brought "yellow copper" to the region. Metals of both origins would have been used in the manufacture of

Monumenta, IV, 364. See also the discussion in Bontinck, "Les croix de bois dans l'ancien royaume de Kongo," *Dalla chiesa anticha alla chiesa moderna,* no. 50 (1983), 199. The location marked by the crosses served as burial grounds for the local population, as depicted in Figure 18 (Plate 10); see Rafael Castelo de Vide, "Reino do Congo; Relação da Viagem, que fizeram os padres missionarios, desde a cidade de Loanda, d'onde sahiram a 2 de agosto de 1780, até á presença do rei do congo, onde chegaram a 30 de junho de 1781," *Annaes do Conselho Ultramarino; parte não official,* 2d Ser. (1859), 65, 70.

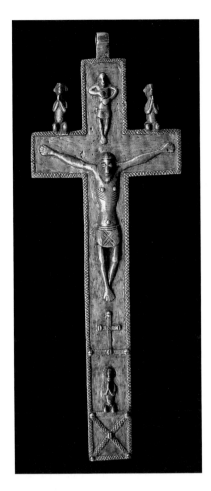

FIGURE 19 Kongo Crucifix. Kongo kingdom, possibly eighteenth century. Brass, 40 × 15 cm. Collection Albert Cochaux, Ohain. Photograph, Cécile Fromont

the crosses. Luxury goods from central Africa, including ivory crucifixes, also circulated between the Kongo and the neighboring Portuguese colony of Angola. According to Inquisition inquiries conducted in Luanda in 1598, Aires Fernandes, a trader working between Angola and Kongo and identified as a New Christian (a Portuguese of Jewish descent), acquired crucifixes and rosaries from the Kongo, some of which were made of ivory or "hippopotamus tooth" and almost certainly of local facture. Aires also exported to the kingdom black beads and brass medals. The merchant's activities outline the fluid circulation of Christian imagery between Kongo and Angola, in elite as well as possibly in more modest circles and, most notably, outside missionary or clerical purview.[9]

9. Dutch merchant F. Cappelle, for instance, writes in 1642 about the "chains, crosses and other things that are made in the [Congo]"; see Louis Jadin, "Rivalités luso-néerlandaises au Sohio, Congo, 1600–1675: Tentatives missionaires des récollets flamands et tribulations des capucins italiens, 1670–1675," *Bulletin de l'Institut Historique Belge de Rome*, XXXVII (1966), 226. It is likely that the crucifixes

It is significant that Christianity developed in central Africa at the demand and under the control of the Kongo crown itself. The discourse of Christianity that emerged in this context grew from within the central African worldview. Although the adoption of the new faith was from the outset accompanied by great symbolic duress with the the newly converted elite's forceful destruction of local objects and places of devotion, it entered into the intellectual realm of the Kongo without overarching epistemic violence or epistemological rupture between what became a pagan past and a Christian present. In this regard, the advent of Kongo Christianity took on a radically different form from the cross-cultural conversion in colonial contexts that unfolded in the Americas during the same period and in which rupture in the nature and modes of knowledge between native past and colonial present was at the core of an evangelization project. William F. Hanks has described, for instance, the conversion to Catholicism of the Maya of Yucatán in the sixteenth century under Spanish rule. Following the military subjugation of the region, Franciscan friars embarked on the spiritual conquest of its inhabitants, a goal they hoped to achieve by remaking every aspect of indigenous life, from the reorganization of social and lived spaces and the modification of everyday behavior to the refashioning of the indigenous "heart, soul, and mind." In practice, this entailed relocating the population to new towns, or *reducciones,* and transforming the Maya language into a tongue fit for a Christian community. Even though this, as any, colonial project remained incomplete, the profound transformations in social life and discursive practices it did implement created a real rupture in the nature and form of Maya religious—and also nonreligious—thought. In contrast, the first Christian kings successfully naturalized Christianity as

were created from both local and imported brass. Metal analysis will provide further information on these issues. For early artisans and objects in the Kongo, see Brásio, ed., *Monumenta*, I, 223. For references to mines, see, for example, the eighteenth-century report by the Capuchin Cherubino da Savona commissioned by the governor of Angola, in Cherubino da Savona, Letters, 1769–1770, docs. 1–3, Condes de Linhares, Archivo Nacional da Torre do Tombo, Lisbon (my thanks to John Thornton for advising me of this source). In the seventeenth century, Cappelle noted the presence of mines, as well as of locally produced crosses, in Jadin, "Rivalités luso-néerlandaises au Sohio," *Bulletin de l'Institut Historique Belge de Rome*, XXXVII (1966), 226. Copper ore is also mentioned in Mateus Cardoso's 1624 manuscript; see António Brásio, *História do Reino do Congo: Ms. 8080 da Biblioteca Nacional de Lisboa* (Lisbon, 1969), 39. The Cantino Map is in the Biblioteca Estense, Modena, Italy; for a facsimile, see *Carta del Cantino: Charta del navicare per le isole novamente trovate in la parte de l'India,* (Modena, 2004). For archaeological evidence of copper mining north of the Congo River, see Nicolas Nikis et al., "Projet KONGOKING; prospections en République du Congo (Brazzaville): Le cuivre et l'origine des anciens royaumes Kongo et Teke," *Nyame Akuma*, LXXX (2013), 32–42. The indicative list of Dutch imports was recorded by Capelle; see Jadin, "Rivalités luso-néerlandaises au Sohio," *Bulletin de l'Institut Historique Belge de Rome,* XXXVII (1966), 229, 236. The inquiry is in Inquisição de Lisboa, Processo 13087, fol. 2v, Arquivo Nacional da Torre do Tombo; see José da Silva Horta, "Africanos e Portugueses na documentação inquisitorial de Luanda a Mbanza Kongo (1596–1598)" (paper presented at the Seminário Encontro de Povos e Culturas em Angola, Lisbon, 1997), 311–312.

 FIGURE 20 Mbafu Rock Design. Detail of figure 6 from Georges Mortelmans and R. Monteyne, "La grotte peinte de Mbafu, témoignage iconographique de la première évangélisation du Bas-Congo," *Annales du MRAC Actes du IV Congres Panafricain de préhistoire et de l'étude du quaternaire*, XL (1962), between 468 and 469. Photograph, The University of Chicago Visual Resources Center

an expression of a Kongo worldview while simultaneously integrating the central African kingdom into the realm of Christendom. Underlining this key characteristic of the advent and development of Kongo Christianity does not downplay the brutal changes that conversion brought to central African society—or the violence and disruptive effects of the Atlantic slave trade, the other phenomenon brought to the Kongo by the Europeans. It is crucial, however, to shed the misleading conception that European cultural assaults were the predominant motor of change in pre-colonial and colonial Africa.[10]

The Cross in the Kongo

At the time of the advent of Christianity in the Kongo, and independent from any European influence, the cross was a predominant motif of central African art. Cruciform designs appeared in rock paintings, textiles, and engravings—in their simplest expression as two intersecting lines as well as in elaborate geometric derivations inspired by weaving patterns (see, for example, Figure 20). Archaeological material along with complex textiles and carved ivory tusks eagerly collected by the early modern European elite for their cabinets of curiosity illustrate the Kongo's visual syntax when the kingdom entered into European history. In the 1990s, archaeologist James Denbow excavated a corpus of decorated terracotta vessels on the northern

10. Ideas about colonial impositions on the nature and condition of knowledge in subjugated regions have been expressed at length, for example, by Nicholas Dirk as part of the "cultural technologies of rule" necessary to the colonial project. See also Dirks, *Castes of Mind: Colonialism and the Making of Modern India* (Princeton, N.J., 2001), 9. See William F. Hanks, *Converting Words: Maya in the Age of the Cross* (Berkeley, Calif., 2010), 6–7. For the process of conversion in colonial Latin America, see also Serge Gruzinski, *La colonisation de l'imaginaire: Sociétés indigènes et occidentalisation dans le Mexique espagnol, Xvie-Xviiie siècle* (Paris, 1988); Carolyn Dean, *Inka Bodies and the Body of Christ: Corpus Christi in Colonial Cuzco, Peru* (Durham, N.C., 1999). I am not suggesting that the colonial evangelization project wholly took over indigenous worldviews but that the nature of the cross-cultural encounter and power relationship was strikingly different in the context of the Kongo than in that of areas under colonial rule. For the impact of the slave trade on the kingdom, see Linda M. Heywood, "Slavery and Its Transformation in the Kingdom of Kongo," *Journal of African History*, L (2009), 1–22; Joseph E. Inikori, "Slavery in Africa and the Transatlantic Slave Trade," in Joseph E. Harris et al., *The African Diaspora*, ed. Alusine Jalloh and Stephen E. Maizlish (College Station, Tex., 1996), 39–72.

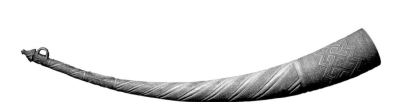

FIGURE 21 Carved Elephant Tusk. Kongo kingdom, early sixteenth century. Ivory, length 83 cm. Museo degli Argenti, Florence, inv. Bargello no. 2. Photograph courtesy of the Ministero per i Beni e le Attività Culturali. Reproduction or duplication by any means prohibited

FIGURE 22 Potsherd from Loubanzi (archeological site near Bwali, capital of the Loango kingdom). Circa 1450. Terracotta, 4 cm. Photograph courtesy of J. Denbow

shore of the Congo River, the dates of the pieces ranging from the eleventh to the sixteenth century. The objects' decorations remained stylistically consistent over the entire period and closely resemble the Kongo visual productions from the following two centuries considered here. Across different mediums, design patterns articulate lines, intersections, and overlaps in varied knotlike motifs organized around a central focus point and ultimately suggesting a diamond shape. The exquisite designs of the Kongo tusk that entered the Medici collection in the early decades of the sixteenth century and the potsherd excavated by Denbow, circa 1400–1600, showcase the pattern (Figures 21 and 22). Ezio Bassani's evocative juxtaposition of early modern Kongo textiles and the early-twentieth-century scarification pattern on the back of a woman from the Yombe people provides a compelling example of the persistence of these designs through time, also suggested by Robert Farris Thompson and Wyatt MacGaffey. Continuity in form does not necessarily entail continuity in meaning, however. A historically grounded analysis of the material is essential for establishing the significance of these designs from the sixteenth through the eighteenth century.[11]

11. The description of the design variations of the Kongo cross stems from a studious visual analysis of photographs or direct observation of central African rock painting, ceramics, ivories, and textiles dated between the eleventh and the eighteenth centuries. See also Ezio Bassani, "Kongo Art," in *African Art and Artefacts in European Collections, 1400–1800,* ed. Malcolm McLeod (London, 2000), 277–284; James Denbow, "Rapport des progrès obtenus au cours du projet archéologique au Congo de 1993," prepared for Congolaise de Développement Forestier, University of Texas, 1993; Denbow, "Pride, Prejudice, Plunder, and Preservation: Archaeology and the Re-invisioning of Ethnogenesis on the Loango Coast of the Republic of Congo," *Antiquity,* LXXXVI, no. 332 (June 2012), 402–404. For a comprehensive list of Kongo objects in European collections before 1800, see Bassani, *African Art and Artefacts,* ed. Mcleod, 283. The age of the Lower Congo rock paintings is not precisely determined, although it is generally thought that they date at least as far back as the era of early modern

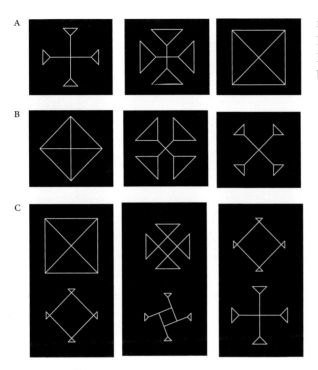

FIGURE 23 Schematics of Kongo Rock Painting and Engraving Designs. Drawn by Cécile Fromont

The schematic rendering of motifs taken from rock paintings and engravings in Figure 23 show the diamond and cross patterns as two parallel expressions of the same design. Each drawing depicts a singular motif observed in rock art. Organized here in sequence from left to right, the designs may be seen as different manifestations of a fluid visual continuity between cross and lozenge. The cross expands into a diamond shape (Figure 23a), and the diamond shape collapses into a cross (Figure 23b). Simple rotations articulate in Figure 23c some of the many design variations observed.

European contact; see Daniel Cahen and Pierre de Maret, "Recherches archéologiques récentes en République du Zaïre," *Forum ULB,* XXXIX (1974), 33–37. Geoffroy Heimlich published preliminary carbon fourteen results in Heimlich et al., "First Direct Radiocarbon Dating of Lower Congo Rock Art (Democratic Republic of the Congo)," *Radiocarbon,* LV (2013), 1383–1390. The designs illustrate the use of the motif of the cross in a Kongo context independent from direct European intervention. Rock paintings appear in Paul Raymaekers and Hendrik van Moorsel, *Lovo: Contribution à l'étude de la protohistoire de l'Ouest centrafricain* ([Léopoldville], 1964). The comparison appeared in Ezio Bassani et al., eds., *Africa and the Renaissance: Art in Ivory* (New York, 1988), 204–205. Wyatt Mac-Gaffey talked, for example, of a "substantial continuity" in the arts and religion of the Kongo from the sixteenth to the nineteenth century; see MacGaffey, "Dialogues of the Deaf: Europeans on the Atlantic coast of Africa," in Stuart B. Schwartz, *Implicit Understandings: Observing, Reporting, and Reflecting on the Encounters between Europeans and Other Peoples in the Early Modern Era* (Cambridge, 1994), 255. Robert Farris Thompson considers Kongo visual culture across centuries in Thompson and Cornet, *Four Moments of the Sun.* For a survey and analysis of graphic expressions in the region once under the rule of the Kongo kingdom and Cuba, considering material from the perspective of contemporary ethnologies, see Bárbaro Martínez-Ruiz, *Kongo Graphic Writing and Other Narratives of the Sign* (Philadelphia, 2013).

According to early modern accounts, the motif of the cross in its diverse guises carried great significance in the Kongo even independently from its Christian symbolism; in particular, it appeared in the visual lexicon of the religious system promoted by the Kimpasi, a ritual association that heavily influenced the social and political organization of the region. The elite members of the group were extremely powerful, inspiring fear even among the highest-ranking Kongo political leaders, and they fiercely and successfully defended their association against the assaults of Christian proselytism. The defining rite of the Kimpasi was its initiation ceremony, which staged the symbolic death and resurrection of the candidate. The novice, chosen among the Kongo elite, was, upon his or her admission into the group, induced to lose consciousness and later brought back to his or her senses on the grounds of the secret ritual enclosure as a new member and initiate of the society.[12]

The Capuchins in charge of the Kongo mission in the seventeenth and eighteenth centuries focused much of their efforts on uprooting the Kimpasi, whose prominent use of the cross in its rituals and paraphernalia particularly preoccupied the friars. Girolamo da Montesarchio, missionary to the Kongo between 1648 and 1668, observed, puzzled, that "the members of the [Kimpasi] society had at the entrance of their meeting place a great portico with the sacred sign of the cross painted in diverse colors." In fact, the motif not only announced the entrance to the Kimpasi enclosure but also served as the ubiquitous sign for the association. Montesarchio's colleague and contemporary Giovanni Antonio Cavazzi also saw the cross used in the association's rituals. He wrote: "The devil had taught [the Kimpasi initiates] that to entice new Christians, . . . they should paint on their idols the venerable sign of the cross . . . so as to hide their pernicious sentiments and their sacrilegious impiety." "One would not believe," he lamented, "how many people were seduced by this ruse."[13]

The clerics' concern here is with idolatry, or misplaced devotion, but their observations highlight the fluidity between Christian and non-Christian

12. I only consider here the Kimpasi in the seventeenth and eighteenth centuries as outlined in the historical documents. Early modern sources on the Kimpasi include Girolamo da Montesarchio, "Viaggio al Gongho," circa 1668, Fondo Missioni Estere, fols. 61–66v, Archivio Storico dei Frati Minori Cappuccini della Provincia di Toscana, Florence (this work is published with original pagination in Calogero Piazza, *La prefettura apostolica del Congo alla metà del XVII secolo: La relazione inedita di Girolamo da Montesarchio* [Milan, 1976]); Giovanni Antonio Cavazzi and Fortunato Alamandini, *Istorica descrizione de' tre' regni Congo, Matamba, et Angola sitvati nell' Etiopia inferiore occidentale e delle missioni apostoliche esercitateui da religiosi Capuccini* (Bologna, 1687), 85–87. For a description of twentieth-century Kimpasi, see Joseph van Wing, *Études Bakongo; sociologie, religion, et magie,* 2d ed. (Brugge, 1959), 420–489.

13. Girolamo da Montesarchio, "Viaggio al Gongho," circa 1668, Fondo Missioni Estere, fols. 61v–62. Note that the crosses in Congo rock paintings are also polychromatic, mixing red, white, and black pigments. See Cavazzi and Alamandini, *Istorica descrizione,* 85.

symbols and ideas. It is not possible to determine whether the use of the cross by the Kimpasi—or even the existence of the association itself—predated the introduction of Christianity in the region. Regardless of the chronology, the two interpretations of the motif coexisted in the early modern Kongo, and central Africans acutely perceived the kinship between Kimpasi and Christian ideas of death and regeneration expressed in both cases by the cross. In one of many similar instances, villagers from a remote region of the Kongo, less familiar with Catholicism than people in the larger population centers, greeted Friar Girolamo as a *nkita,* the word used for Kimpasi initiates and literally meaning someone who has come back from the otherworld. The image of the cross prompted the association of the crucifix-bearing missionary with a local narrative of death and resurrection. The link between the missionary and the nkita was also reinforced by the pale skin of the friar, an indication in the Kongo visual syntax of an individual's ability to access supernatural powers. This particular talent was enjoyed, for example, by the albino men and women born in the region. One could interpret such episodes as evidence that Christianity was from the outset wholly taken over by Kongo cosmology. A more nuanced reading of the period, however, suggests that Christianity became a Kongo phenomenon that called upon local thought and forms of representation to express its ideas and anchor its message. The same evidence suggests that the Kimpasi, as it existed in the early modern period, was touched by the Kongo's continuing cross-cultural dialogue with Christianity. The Kimpasi's rituals and symbolism were at least in part formulated as a resistance to the presence of Christianity in the region but also clearly echoed and even emulated those of the church.[14]

In this episode involving Friar Girolamo, and in a wider Kongo Christian context, the encounter between Christian and local religious thought centered on the key visual cue of the sign of the cross. The cross allowed Europeans and central Africans to recognize and acknowledge shared conceptions about unseen supernatural forces, common beliefs in the possibility to communicate with the otherworld, and a mutual understanding of immanence. As a space of correlation, the cross expressed a new worldview in which local and foreign, old and new ideas met and blurred.[15]

14. Girolamo da Montesarchio, "Viaggio al Gongho," circa 1668, Fondo Missioni Estere, fol. 39r. The special status of albino men and women is discussed, for example, in François Bontinck, ed. and trans., *Diaire congolais (1690–1701) de Fra Luca da Caltanisetta,* Publications de l'Université Lovanium de Kinshasa (Leuven, 1970), 152. See also Mateo de Anguiano, *Misiones capuchinas en África,* Biblioteca "Missionalia Hispanica," VII (Madrid, 1950), 75. The drawing in the Museo Francescano Cappuccino, MF 1370, fig. x, also mentions albinos in the paragraph under the representation of the king of Kongo.

15. See also Chapter 4, below.

Kongo Symbol and Christian Icon

An exceptional object showcases the organic process through which Kongo Christian thought emerged from the local religious and symbolic syntax. In 1937, Redemptorist Father Georges Schellings and Maurice Bequaert, a Belgian civil servant attached to the Tervuren Museum of the Belgian Congo, excavated the ruins of a Kongo church and cemetery in Ngongo Mbata that were in use in the seventeenth and eighteenth centuries. Their exploration yielded more than six hundred artifacts, which were a mixture of local pottery, European ceramics, and Kongo art objects of Christian forms. During the excavations, they uncovered several tombstones, some engraved with the Latin cross, others with what they identified as a stylized cross of the Knights Templar or the Order of Christ. The uncommon iconography of one of the markers especially caught their attention, shown here in a photograph of the stone reset in the façade of the Redemptorist church at Kimpangu after the excavation (Figure 24). The stone articulated, Schellings explained with difficulty, a "Navigator Cross (or Cross of the Order of Christ) sculpted in relief and at the same time a Latin Cross in one of the triangles formed by the former cross."[16]

The European viewers identified the *X* shape as a stylized representation of the Maltese cross, the emblem of the Portuguese Order of Christ, heir to the Knights Templar. Upon the suppression of the medieval order under the influence of Philippe IV of France, King Dinis of Portugal obtained from the pope the right to institute the Order of Christ in 1319 as another military order that would inherit the assets of the Portuguese Knights. The insignia of the new order derived from the emblem of the Templars, with the addition of a white center within the well-known crimson cross. The new sign, sometimes simplified as an octagonal red cross, became famous for its presence on the sails of the caravels that made Iberia's great discoveries, voyages that the order supported both financially and with manpower. The insignia became known as the "Cross of the navigator" in reference to the Infante Henrique the Navigator, who reformed the order and obtained immense privileges for its members from Pope Calixtus III in the bull "Inter caetera quae" of

16. On the stone and the excavation, see G. Schellings, "Oud Kongo: Belangrijke ontdekking uit de eerste beschaving," *De Standaard*, July 24–25, 1949. See also Schellings, "Oud Kongo: Belangrijke ontdekking uit de eerste beschaving," *St. Gerardusbode: Maandschrift der paters Redemptoristen*, LIII, no. 8 (1949), 10–13; Schellings, "Importante découverte au Bas-Congo: Les ruines de la première église congolaise construite au XVIe siècle, à Mbanza Mbata dia Madiadia," *Le courrier d'Afrique*, Aug. 19–20, 1950, 13. The quote is taken from the French publication. See also the short article by Maurice Bequaert that presented one plate of the excavation report, Bequaert, "Fouille d'un cimetière du XVIIe siècle au Congo Belge," *L'Antiquité Classique*, IX (1940), 127–128.

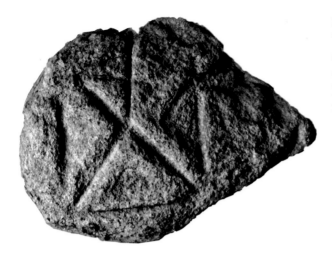

FIGURE 24 Ngongo Mbata Tombstone. Kongo kingdom, seventeenth or eighteenth century. Stone, 28 × 37 cm. Photograph, B. Clist, 2012, KONGOKING Project

March 13, 1496; in exchange for the privileges, the king and the order committed to winning over Africa to Christianity. The frontispiece of a 1504 rule of the order published in Lisbon illustrates the design (Figure 25 [Plate 12]). By the sixteenth century, the monastic order had become secularized; knights were noblemen that no longer took religious vows. The two men in charge of the Ngongo Mbata excavation were also without a doubt aware that, since the sixteenth century, the order had been adopted by the early modern kings of Kongo, who bestowed the distinction to members of their own elite. The cross of the order became a ubiquitous insignia of the Kongo Christian elite.[17]

The reference to the Order of Christ, although apt and most likely accurate, does not wholly explain the engraved signs on the tombstone, which articulate two different and interrelated designs in an elaborate play of positive and negative space. Simply put, two intersecting lines inside a square form a Kongo *X*-shaped cross of the kind shown in Figure 23. The center of the *X* is also the apex of three triangles whose bases form the left, bottom, and right edges of the square. The three arrow-like shapes in high relief have thick, rounded sides and hollowed centers. In place of a fourth triangle at the top, a set of intersecting lines, one vertical and the second horizontal, occupy the area defined by the two main diagonals. From the photograph alone, this top part seems to consist of a vertical line intersecting a horizontal segment at a

17. On the Order of Christ, see Francis A. Dutra, "Membership in the Order of Christ in the Seventeenth Century: Its Rights, Privileges, and Obligations," *The Americas*, XXVII (1970), 3–25; André L'Hoist, "L'ordre du Christ au Congo," *Revue de l'Aucam*, VII (1932), 258–266. The mythical origin of the Order of Christ in the Kongo is also linked in the 1782 history of Kongo Christianity to the miraculous apparition of a stone cross in front of Afonso; see Necessidades, "Memoria," *Factos memoraveis*, no. 642 (1858), 3.

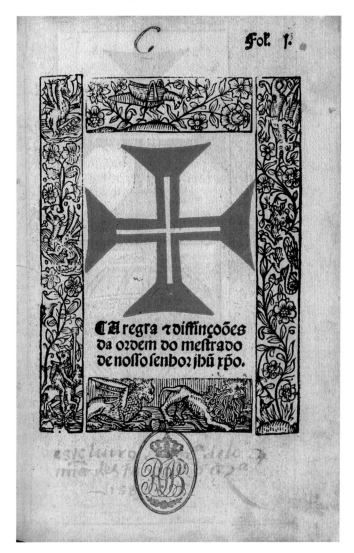

FIGURE 25 Cross of the Order of Christ on the first page of a 1504 printed Rule of the Order. From "A Regra et Diffinçoões Da Ordem Do Mestrado De Nosso Senhor Ihũ Xp̄o," circa 1504, RES 127 V. fol. 1, Biblioteca Nacional de Portugal, Lisbon. Photograph courtesy of the Biblioteca Nacional de Portugal

right angle, forming the diagonals of a diamond and a Greek cross. Schelling's quotation above and the sketch of the stone labeled "Pierre A" in Figure 26 clarify the details of that upper quadrant. They point, in particular, to the "Latin Cross" that emerges from the center of the design in juxtaposition with the *X*-shaped motifs.[18]

The geometry of the design is complex but thoroughly thought through, as presented in the diagram in Figure 27 that exposes the underlying construction of the engraved stone. Overall, the figure emerges from intersecting

18. The original orientation of the stone is unclear, but I follow here that suggested by Bequaert's excavation drawing in Figure 26.

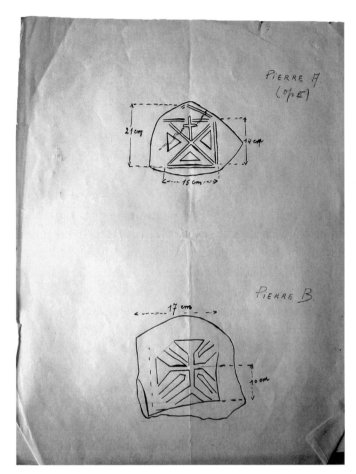

(left) FIGURE 26 Drawing of Ngongo Mbata Tombstones. By M. Bequaert. Ink on paper, 21 × 30 cm. Royal Museum for Central Africa, Tervuren, Belgium, File MRAC 260-102, Prehistory Section, n.p. Image courtesy of the Royal Museum for Central Africa, Teruven ©

(right) FIGURE 27 Diagram of a Ngongo Mbata Tombstone. Drawn by Cécile Fromont

lines and imbricated motifs, centered on a single focal point and broadly encompassed by the organizing figure of a modified diamond shape. In this regard, the design is typical of Kongo motifs. Yet its structure has been reworked to include a Latin cross. The tombstone as a space of correlation combines motifs and symbolism that can be traced back to distinct central African and European-Christian visual and religious traditions but that now function together in a fully accomplished Kongo Christian object.[19]

A visual analysis of the tombstone alone may not be sufficient evidence that the designs are indeed combinations of Christian and Kongo crosses, but the context of the discovery makes the connection clear. The cemetery

19. I am grateful to Bernard Clist and the KONGOKING project for providing me with a photograph of the tombstone; I am now able to refine the analysis I previously presented of the stone, which was based on old, low-quality photographs. See Cécile Fromont, "Under the Sign of the Cross in the Kingdom of Kongo: Religious Conversion and Visual Correlation in Early Modern Central Africa," *RES: Anthropology and Aesthetics*, nos. 59–60 (Spring–Autumn 2011), 109–123.

of Ngongo Mbata was a Catholic burial ground associated with a church. On a tombstone carved for a Christian patron, the maker of the engravings depicted the Kongo sign for the belief in an open channel between life and death as a Christian plea for salvation and resurrection. This vibrant profession of faith marked the tomb of a member of the Kongo elite, who was put to rest in a wooden coffin decorated at each of its corners with brass plates bearing the cross of the Order of Christ, echoing the design of the tombstone. He could also count on the comforting presence of a small pectoral crucifix wrapped in fabric and beads as well as a second, large one beside him.[20]

The line drawing, labeled "Pierre B," of another tombstone found at Ngongo Mbata in the excavation files held at the Royal Museum for Central Africa in Tervuren further illustrates the correlation operating in the funerary monuments of the elite men of the Kongo (Figure 26). Both "Pierre A" and "Pierre B" articulate rhombuses, X shapes, and crosses recalling the emblems of the Order of Christ in thoroughly resolved designs. They are part of a larger genre of two-dimensional designs typical of Kongo Christianity, designs the elite of the kingdom used as insignia on their swords, coats, and seals and that were also common on the medals and crucifixes they carried as emblems of status and markers of devotion.[21]

Most of the objects Schellings and Bequaert unearthed in the excavation of Ngongo Mbata disappeared from public and scholarly view in the aftermath of the Congo's independence. An article from *De Standaard* announcing the excavation's findings, however, includes a photograph of one of the crucifixes that accompanied the Kongo nobles in their tombs. The quality of the newspaper image is poor, but there is a photograph in the archives in Tervuren depicting another cross also collected in the twentieth century in the region of Mbata and almost identical to the one found in the excavation (Figure 28). These two crosses, as well as most of the crucifixes unearthed at Ngongo Mbata, belong to a large, closely knit group of Kongo crucifixes that share almost identical iconography and style. I have identified about twenty examples of this group as well as at least half a dozen Christ figures without wooden crosses that also pertain to the same stylistically related group of objects. The crucifix from the Tervuren photograph in Figure 28 is one of the few complete examples of the group. It features all the ancillary figures

20. J. Vandenhoute, "De Begraafplaats van Ngongo-Mbata (Neder-Zaire)" (licentiate's thesis, Rijksuniversiteit Gent Hoger Instituut voor Kunstgesischiedenis on Oudheidkunde, 1972–1973), 47–48. The content of the tomb is also described in Schellings, "Importante découverte au Bas-Congo," *Le courrier d'Afrique,* nos. 19-20 (August 1950), 47–48.

21. The two stones are discussed in Vandenhoute, "De Begraafplaats van Ngongo-Mbata," 149. See the discussion of Kongo regalia in Chapter 3, below.

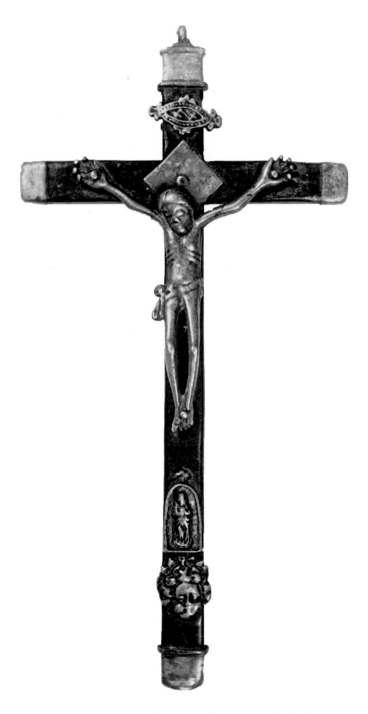

FIGURE 28 Kongo Crucifix. Kongo kingdom, second half of the
seventeenth century or eighteenth century. Brass and wood, 26 × 13.2
cm. Current location unknown. Inv. RP.2011.6.1 (51.14.9), Ethnography
Section, Royal Museum for Central Africa, Tervuren ©

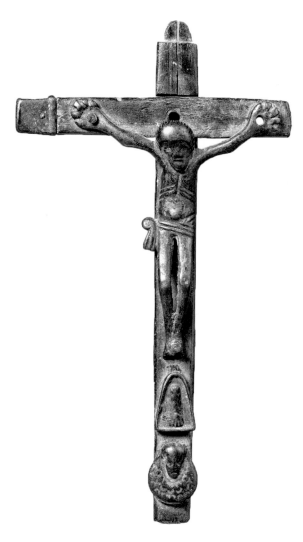

FIGURE 29 Kongo Crucifix. Kongo kingdom, likely second half of the seventeenth century or eighteenth century. Wood and copper alloy, 20 × 11 cm. Afrika Museum, Berg en Dal, Netherlands, inv. 29-381. Photograph, Studio Herrebrugh, © Afrika Museum, Berg en Dal

originally placed around the body of Christ. Another example, from the Afrika Museum in Berg en Dal, shown in Figure 29 (Plate 13), also carries the patina of many years of use.[22]

Mixing dark wood and yellow brass, the crucifix in Figure 28, twenty-six centimeters high and thirteen centimeters wide, is an exquisite artifact reflecting the prestige of its owner. The black wooden cross is glistening from

22. The similarity between the two crosses was also noted by Alphonse Marie Van den Bosch, the bishop of Matadi, to whom the excavated objects from Ngongo Mbata were entrusted; see the typescript kept in the excavation file at the Royal Museum for Central Africa at Tervuren, "Verzameling kruisbeelden gefotografeerd oop 10-2-1950," n.p. These excavated crosses are described in Vandenhoute, "De Begraafplaats van Ngongo-Mbata," 128. Examples in varying states of conservation are in Afrika Museum, Berg en Dal, Netherlands, inv. 29–381; Museu de etnologia de Lisboa, Portugal, inv. D4.1; Metropolitan Museum of Art, New York, United States, inv. 1999.295.11.

heavy patina, and its edges have been smoothed by repeated use, particularly in the space between the body of Christ and the figure under its feet, where the wood slightly curves inward from wear. White metal covers embellish the four ends of the cross. The top cover received particular attention; it is ornate with two architectural cornices and is topped with a suspension loop. At the intersection of the wooden branches, a diamond-shaped metal plate has been affixed with a single nail placed in its exact center. As with most Kongo crucifixes, this metal plate, echoing the halos gracing the heads of saints in Christian imagery, does not embellish the head of the dying Christ but marks the precise meeting point of the two segments of the cross. This special place of intersection is also emphasized on the back of the object, as it is in other examples. The diamond-shaped halo, centered on a single central nail and juxtaposed with the Latin cross, links the crucifix to the larger genre of Kongo Christian designs found, for example, on the tombstones. As in the grave markers, locally rooted Kongo visual syntax and religious thought are here called upon and put to work in the Christian object.

The emaciated figure of Christ is attached to the wood by three pegs piercing his oversized hands and his crossed feet. His head is wrapped by a stylized representation of his coiffure and bends to the right. He is ready to expire. The limbs are thin and elongated, the ribs represented by a few simple lines. Across the hips, the dying Christ wears a short rope-like loincloth. Above him, a decorated oval plate bears, in lieu of the INRI inscription, a zigzag line. Under his feet are two ancillary metal elements. First, a medal of the Immaculate Conception depicts the Virgin carried by a crescent moon in a decorated niche topped with a cross. Then, a chubby, curly haired head of an angel seemingly supports the higher medal. In Figure 29 (Plate 13), the same iconography unfolds in a worn cross that has lost three of its metal decorative ends. The lozenge halo remains centered on the intersection. The Virgin and angel head still remain but are almost unrecognizable from wear; the cherub's head has turned upside down.

The juxtaposition of the Virgin and angel echoes the representations of the Immaculate Conception, a devotion ardently promoted by the Capuchin friars in Europe as well as in Africa, and is a reminder of the influential presence in the region of the order and of its Franciscan imagery from the mid-seventeenth century to the early nineteenth century. The friars championed the very controversial idea and dedicated their order to the Immaculate Conception in 1621. The iconography of the new devotion only stabilized at the end of the sixteenth century when the image of the woman of the Apocalypse, carried by a crescent moon, often supported by cherub heads, became its main representation. An Italian medal depicting the Immaculate,

also excavated from Ngongo Mbata, illustrates the type of objects that the Capuchins imported en masse in the region and that inspired examples seen on the crucifixes.[23]

The presence of these images of the Immaculate Conception thus anchor the crucifixes in the period when the Capuchin friars were in central Africa, starting around 1650. Since the excavation of Ngongo Mbata indicates that they were in use in the eighteenth century, the crosses may be dated to the late seventeenth and eighteenth century. This period was characterized by civil wars, then by the diminished power of the kings, and overall by the presence and gradual withdrawal of the Capuchins. The crucifixes discussed here are therefore late creations in the Christian history of the kingdom. Yet, as with the story of Afonso that local rulers retold and appropriated over centuries, the crucifixes conveyed a cultural narrative that could be traced back to the first moments of contact between the Kongo and Christianity but that also took on, over the decades, new meanings anchored in the issues of their own time and place of creation.[24]

Several crucifixes similar to those unearthed in the excavation were collected in the twentieth century in the former powerful Kongo province of Mbata, in which the town of Ngongo Mbata thrived in the seventeenth and eighteenth centuries. Even such tenuous evidence suggests that, at a time in Kongo's history of weakened centralized power, a local style emerged that represented a consistent and elaborate expression of the significance of Christianity and its imagery in a specific province. This hypothesis raises the crucial question of how the crucifixes changed in form and significance throughout the history of the Kongo kingdom as well as over the expanse of its geographical territory. Answering this question will require further research informed by material analysis and new archaeological and archival findings.[25]

23. See Mirella Levi D'Ancona, *The Iconography of the Immaculate Conception in the Middle Ages and Early Renaissance* (New York, 1957); Victor Tourneur, "Médailles religieuses du XVIIIe siècle, trouvées au Congo," *Revue Belge de Numismatique et de Sigillographie*, XCI (1939), 21–26.

24. The history of the period was studied in John K. Thornton, *The Kingdom of Kongo: Civil War and Transition, 1641–1718* (Madison, Wis., 1983). See also Chapter 5, below, and, for the later era, Kabolo Iko Kabwita, *Le royaume Kongo et la mission catholique, 1750–1838: Du déclin à l'extinction*, Mémoire d'églises (Paris, 2004).

25. A similar cross was published in Josef Franz Thiel and Heinz Helf, *Christliche kunst in Afrika* (Berlin, 1984), fig. 84. The history of Mbata is known through the reports of Capuchins and secular clergy, who were present intermittently in the region, which is summarized in Graziano Saccardo, *Congo e Angola con la storia dell'Antica missione dei Cappuccini*, 3 vols. (Venice-Mestre, 1982–1983), I, 408–410, II, 345.

European Realism as Kongo Stylization

With the design of the crucifixes, central African artists not only performed an iconographic synthesis anchored in the motif of the cross but also conducted an elaborate cross-cultural reflection on style. Formally, the Kongo crucifixes are unlike European or Kongo objects; rather, they draw from both traditions in a creative way and merge the visual discourses of Baroque Europe and the Kongo, as described in sources of the same era. The main tension at play is the contrast between Kongo modes of representation and the predominant naturalism of European devotional images. Early modern observers described both figurative and abstract central African artworks but in all cases insisted on what they perceived as the composite nature of their representation. The missionaries, for instance, often described central African "idols" as deformed and misshapen images bedecked with horns or even wholly abstract amalgams put together, in the words of Cavazzi, "according to each person's kind of madness." The idols of these testimonies combined visual elements following a logic that was conceptual rather than aimed at rendering the world through a mimetic depiction of its appearance. They articulated parts into a whole to express ideas metaphorically.[26]

The tall brass crucifix in Figure 30 (Plate 14) is a masterpiece born from this tension between Kongo and European forms of artistic representation. The artist disposed protagonists and motifs along the surface of a yellow brass cross, bordered with incisions on a slightly elevated band. At the center of the Latin cross, where the vertical and horizontal branches meet, he incised a diamond, checkered in crisscrossing lines and surmounted by a small cross at its upper corner. The left and right extremities of the design are finished in triangular forms that create two additional *X*-shaped crosses. The incised diamond is the only two-dimensional element of the crucifix and serves both as center and background of the group. The rhombus, just above the head of the corpus, is reminiscent of a saint's halo, but, again, as in most Kongo crucifixes, it is not positioned in reference to the head of Christ but is placed to monumentalize the exact location where the two branches of the cross

26. A Capuchin specifically mentions in 1680 seeing "statues of dead wood with human faces, and also of stone"; see Giovanni Belotti da Romano, "Giornate apostoliche con varii, e dilettevoli successi: Descritte dal P. F. Giovanni Belotti da Romano predicatore Cappucino della Provincia di Brescia, 23 novembre 1680," 1680, AB 75, 149, Archivio Generale Cappuccini, Rome. Giovanni Antonio Cavazzi describes here Mbundu objects from Angola; see Cavazzi, "Missione evangelica al regno del Congo: Araldi Manuscript," 1665–1668, Araldi Collection, vol. A, book 2, chap. 13, 171, Modena. See the translation in John Thornton, "African Texts," accessed January 2014, http://www.bu.edu/afam/faculty/john-thornton/john-thorntons-african-texts.

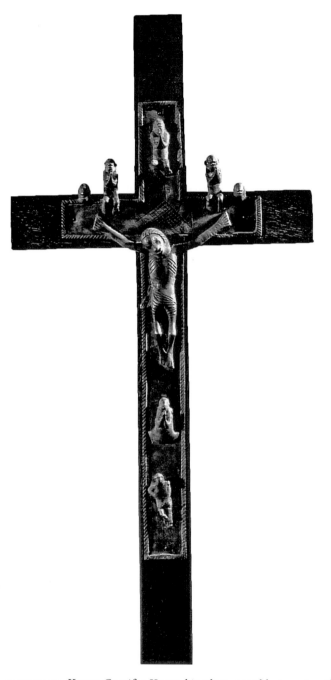

FIGURE 30 Kongo Crucifix. Kongo kingdom, possibly seventeenth
to nineteenth century. Brass and wood, 64 × 27 cm. Current location
unknown. Image from Josef Franz Thiel, *Christliches Afrika: Kunst
und Kunsthandwerk in Schwarzafrika* (Sankt Augustin, 1978), plate
87. Photograph courtesy of the Anthropos Institute, Sankt Augustin,
Germany

come together. As with the tombstones of Ngongo Mbata or the crucifixes in Figures 28 and 29 (Plate 13), Kongo cross and Latin cross merge and unite their symbolic powers for the benefit of the worshiper.[27]

At the fourth corner of the etched diamond, the artist placed the figure of Christ, head fallen on his right shoulder, arms extended, belly caved in, and knees bent, in an attitude inspiring compassion. Anatomical details such as ribs, toes, and fingers are indicated in a stylized manner, as are the drapes of the loincloth. The coiffure of the corpus is also rendered with simple parallel incisions, maybe suggesting hair braiding. The stylization of the traits of the body, including that of the anatomical details, falls between European-inspired realism and abstracted, symbolic renderings associated at the time with Kongo artistic forms. This play of naturalism and stylization would become a salient trait of central African artworks of the nineteenth century, as seen, for example, in the juxtaposition of the finely modeled faces with the summarily carved limbs and feet in Figures 13 (Plate 6) and 14 (Plate 7).

Under the dying body of Christ in this crucifix, the artist placed a small depiction of the Immaculate Conception, also stylized. The simple figure, represented by a head and two arms folded on the chest, hands joined in prayer, is recognizable as the Virgin thanks to the crescent moon at the bottom of her body. This type of representation of the Madonna, present on many of the crucifixes, illustrates how artists reinterpreted in Kongo Christian motifs the predominant naturalism of imported objects, turning them into stylized designs that nevertheless retained key attributes of their original composition. In Figures 28, 29 (Plate 13), 30 (Plate 14), and 31 (Plate 15), the Immaculate appears in various degrees of stylization while retaining central elements of proportion and iconography that allow for her identification, such as the crescent moon under her feet and her flowing garment.

On the crucifix from the Afrika Museum in Figure 31 (Plate 15), two different interpretations of the Madonna appear in three ancillary pieces placed below Christ. The artist who composed the cross placed two identical brass plates on either side of the crucified man's feet. The nearly identical figures clearly come from a set produced in a series and hint at the mode of production of the crucifixes. Underneath the two Virgins, the maker of the cross included a larger plate resembling a human figure standing inside a small architectural structure. A similar plate belongs to a closely related cross now

27. The crucifix in Figure 29 (Plate 13) is not dated, but its iconography, including the inclusion of the Virgin, links it to the early modern period. The monumental crosses also received a similar treatment. For instance, the large cross found at the site of Ngongo Mbata had its central nail, at the crux of its branches, embellished with a copper cover. See Schellings, "Importante découverte au Bas-Congo," *Le courrier d'Afrique,* nos. 19-20 (August 1950), 13.

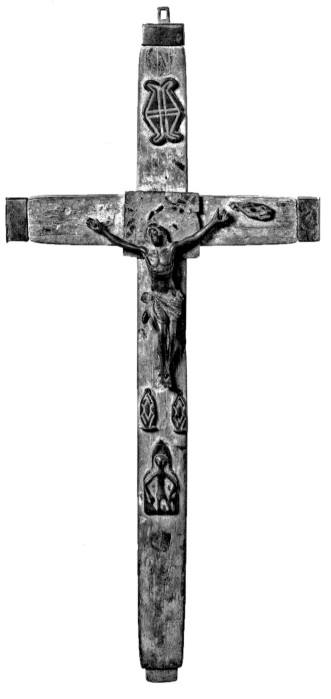

FIGURE 31 Kongo Crucifix. Kongo kingdom, possibly seventeenth to nineteenth century. Wood and copper alloy, 54 × 26 cm. Afrika Museum, Berg en Dal, Netherlands, inv. 29-377. Photograph, Studio Herrebrugh, © Afrika Museum, Berg en Dal

FIGURE 32 Stylized Kongo Rendering of the Virgin. Detail of Kongo Crucifix. Kongo kingdom, possibly seventeenth to nineteenth century. Wood and copper alloy, 54 × 26 cm. Afrika Museum, Berg en Dal, Netherlands, inv. 29-377. Photograph, Studio Herrebrugh, © Afrika Museum, Berg en Dal

in Fátima, Portugal (Figure 33 [Plate 16]), that articulates the same iconography, including a reinterpretation of the Virgin figure that draws the link between the enigmatic plate at the bottom of the Afrika Museum crucifix in Figure 31 (Plate 15) and other images of the Madonna (seen, for example, in Figures 28 and 29 [Plate 13]). On Figure 31 (Plate 15) and previous examples, medals of the Immaculate that are closer to European templates stand on top of a crescent moon, hands joined in prayer, surrounded by a glowing halo, the whole figure enclosed in a cartouche topped with a cross. On the Fátima cross, two worn, small Virgins stand between Christ and a larger Madonna plate. In this larger Virgin, the cross has become a head from which shoulders clothed in a broad robe emerge; forearms and hands are visibly joined in front of the chest, an identifying gesture also depicted in the almost abstract Figure 32. Viewers can alternatively read the bottom Fátima plate as a full figure standing within a house, a perspective close to that of the bottom design in Figure 31 (Plate 15). The saint garbed in flowing clothes seen on other crucifixes thus in the Afrika Museum cross turns into a body wrapped in textiles or enclosed in the woven walls of a Kongo building, both cognates of reliquaries and funerary bundles. Successive recasting of the crucifixes' components partly explains the formal changes in the images. Yet, such complete, well-balanced designs (particularly of the Virgin in Figure 32) do not come from haphazard, increasingly blurry castings; rather, the more abstract representations demonstrate how Kongo metalworkers carefully studied imported motifs, pondered on their design and iconography, and, eventually, produced wholly new, stylized forms.[28]

The central element of the crucifixes, the dying corpus of Christ, was similarly redesigned yet never stylized to the point of abstraction; it always remained readily recognizable as a human figure. This seeming restraint in the treatment of Christ may be grounded in theological considerations about the role of God's human form in the crucifixion narrative. Formally, the figure of Christ is the point on the crucifixes where the impact of European and Kongo images and forms of representation on each other appear most clearly. The depictions of the body of Jesus demonstrate the interest of central African artists in the foreign modes of representation and in the counterpoint it presented to their own formal vocabulary. The corpuses they created responded to these artistic differences with thoughtful quotations and bold transpositions of elements of style hailing from the two traditions. For instance, the

28. There are at least two other crucifixes of the same genre still extant in addition to the crosses in Figures 30 (Plate 14) and 32. One is published in Thiel and Helf, *Christliche Kunst in Afrika*, 89. Another is in the William W. Brill Collection, sold at Sotheby's in New York, Nov. 17, 2006 (NO8287), as lot 126.

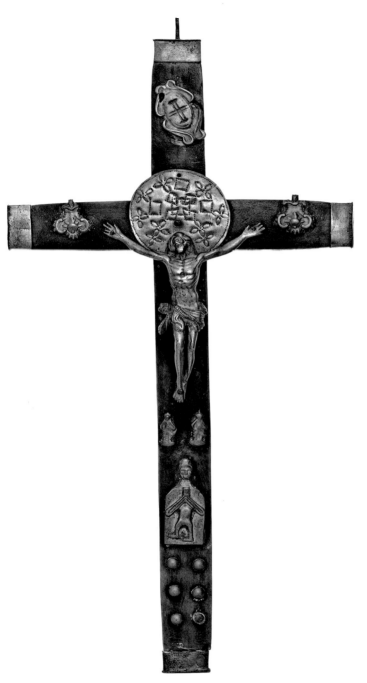

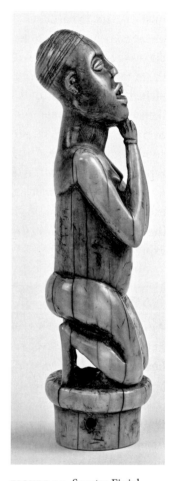

FIGURE 33 Kongo Crucifix. Kongo kingdom, possibly seventeenth or eighteenth century. Wood and brass, 52 × 25 cm. Museu de Arte Sacra e Etnologia, Missionários da Consolata (Fátima, Portugal), inv. SMP 601. Photograph, Ana Paula Ribeiro, 2012, Museu de Arte Sacra e Etnologia, Fátima, Portugal

FIGURE 34 Scepter Finial with Kneeling Figure. Kongo, nineteenth century. Elephant ivory, 16.2 × 4.3 × 4.5 cm. Robert and Lisa Sainsbury Collection, University of East Anglia, United Kingdom, inv. UEA 252. Photograph, James Austin, courtesy of the Robert and Lisa Sainsbury Collection, University of East Anglia, United Kingdom

deep lines incised on the chest of the Christ figures in Kongo crosses are not only a stylized rendering of the anatomy of a dying body but also an expression of European illusionistic representations of the bodily features of the crucified man. The detailed rendering of ribs on Iberian and Baroque Christ figures that reached central Africa in the hands of merchants and missionaries, in particular the Capuchins from the mid-seventeenth century on, became one of the central elements in the construction of the Kongo crucifixes. Looking at European models, central African artists reflected upon the nature of representation. They considered, for instance, the deep grooves etched on the chests of the crucified men and systematically used them in their own figures, not as a means to suggest flesh in a metal object, but as tropes quoting the naturalism observed in imported artworks. The beguiling combination of naturalism and abstraction in the crucifixes echo later Kongo artistic forms from the nineteenth and twentieth centuries, admired for their ambivalent representation of the human figure, depicted in a single piece in exquisite lifelike renderings as well as bold, minimalist strokes. In this regard, the crucifixes deepen our historical understanding of central African artistic expressions at large.[29]

A Space between Life and Death

Although it is stylized, the Christ of the crucifix in Figure 30 (Plate 14) is nevertheless expressive and conveys through gesture—the position of his head, the bend of his knees—the imminence of death. Seven protagonists are gathered around him. On the transversal bar, two figures kneel, hands joined in prayer, in a stance typical of attendants on crucifixes. The attitude is also common in other artworks from the region, for example, in scepter finials, where similar characters, down on their knees with toes planted on the ground in a dynamic stance, seemingly pay their respects to the ruler holding the staff. An ivory figure now in the Sainsbury Centre for Visual Arts in England models the pose (Figure 34). The likely female character wears a *mpu* cap of status as her only clothing. Her hands joined under the chin delicately tilt up her striking, glowing face. She is in an attitude similar to that of the attendants perched on the transversal bars of the crucifixes in Figures 19 (Plate 11) and 30 (Plate 14). It is unclear whether the finial's gesture

29. To my knowledge, there are no extant examples of Kongo anthropomorphic artwork that can be dated to the early modern period. However, two small female wooden busts created by neighbors of the kingdom in the seventeenth century, now in the Museo Preistorico Etnografico "L. Pigorini" in Rome (inv. 4525 and 4526), show an artist's stylized rendering of the human figure from that period in a cultural area related to the Kongo. See Bassani, *African Art and Artefacts*, ed. McLeod, 269–275.

refers to Christian prayer, as do those of the small figures on the crosses, who echo—perhaps among other things—the attitudes of the Madonnas alongside which they appear.[30]

Another attendant on the crucifix in Figure 30 (Plate 14) kneels above Christ in the same position. Under the Virgin at the feet of Christ, a fifth character lies lifeless on the cross, arms wrapped around the upper body, legs crossed, head tilted to the right in the image of Christ. A frequent addition to the crucifixes, the idiosyncratic figure seems to encapsulate the idea of imminent or recent death. Cavazzi's depiction of Angolan Queen Njinga on her catafalque in the "Missione evangelica" manuscript presents the deceased queen in a similar position, arms crossed over the chest (see Figure 77 [Plate 34]). Such elaborate public displays of the dead bodies of prominent members of society was typical in central Africa in the Christian era and beyond. The bottom figure in the crucifixes might have recognizably referred to some deceased member of the elite.[31]

The last two figures on the crucifix are simple heads emerging from the etched border of the cross bar, just to the side of the kneeling figures. These frequent components of Kongo crosses have no European precedents. Rather, the enigmatic bodiless heads evoke a different set of central African funerary practices. French traveler Louis Ohier de Grandpré witnessed in the 1780s a burial ceremony for a prominent man from Loango, north of the Congo River. The body of the high-ranking official had been wrapped in a monumental bundle of textiles over the course of a year, topped, for the funeral, with a small carved head "that stood for that of the dead man" (Figure 35). The heads of the transversal bar, emerging from the cloth-like patterns of the border's etchings, might have echoed this neighboring practice. The material of the crosses, copper alloy, also contributes to this interpretation, as it evokes the use of the material in the larger central African cultural area—for instance, in the reliquary figures of the Kongo's northern neighbors of Gabon, the Kota.[32]

The juxtaposition of dead bodies with the textile-like borders of the crucifixes placed the crosses within a widespread and lasting funerary tradition. The centuries-old practice, already described in the sixteen hundreds, continued into the nineteenth century and beyond. James Tuckey, for example,

30. For a discussion of kneeling ivory finials from the Kongo, see Marc Leo Felix, *White Gold, Black Hands: Ivory Sculpture in Congo* (Qiquhar, Heilungkiang, China, 2010), 142–158.

31. Cavazzi, "Missione evangelica," vol. A, book 2, after 210.

32. L[ouis Marie Joseph Ohier] de Grandpré, *Voyage à la côte occidentale d'Afrique fait dans les années 1786 et 1787 . . . suivi d'un voyage fait au cap de Bonne-Espérance, contenant la description militaire de cette colonie* (Paris, 1801), 152–153. On central African reliquaries, see Alisa LaGamma et al., eds., *Eternal Ancestors: The Art of the Central African Reliquary* (New York and New Haven, Conn., 2007).

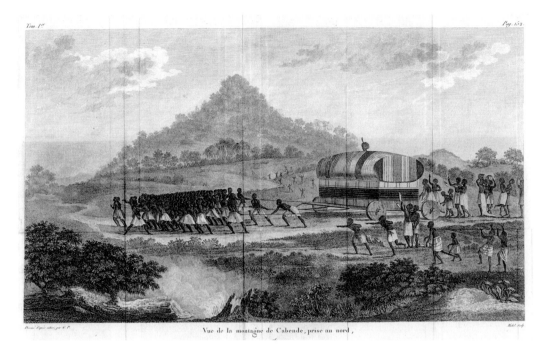

FIGURE 35 Burial Bundle of a Prominent Man from Loango. From L. de Grandpré, *Voyage à la côte occidentale d'Afrique fait dans les années 1786 et 1787 . . . suivi d'un voyage fait au cap de Bonne-Espérance contenant la description militaire de cette colonie* (Paris, 1801), 152–153. Photograph courtesy of the Melville J. Herskovits Library of African Studies, Northwestern University

saw in 1816 the corpse of a prominent Kongo figure honored with layers and layers of "cloth money of the country" and European cottons. David Livingstone also observed the practice in a Christian context during his visit to the capital city of São Salvador in the 1850s. "When a King of Congo dies," he reported, "the body is wrapped up in a great many folds of cloth until a priest can come from Loanda to consecrate his successor." The crucifixes' etched borders that enclosed the entire body of Christ as if in a textile bundle or in a box thus recalled the cloth wrappings of prestige funerals or the royal *misseto* reliquary case. The image of Angola's Njinga shrouded in Capuchin vestment on her bier in Figure 77 (Plate 34) is evidence of the broad geographical extent of the practice of wrapping prominent bodies in rare textiles that occurred from north to south of the Kongo as well as its fluid transposition to Christian contexts. Crucifixes themselves have been found wrapped in layers of textiles in funerary settings as well as in everyday use.[33]

33. The wrapping of the cadavers of high-ranking rulers in precious textiles is reported in Cavazzi and Alamandini, *Istorica descrizione*, 116, 117; and J[ean] Cuvelier, *Documents sur une mission française au Kakongo 1766–1776: Avec introduction et annotations* (Brussels, 1953), 49. See also *Narrative of an*

Notably, in brass crucifixes the body of Christ is nearly always entirely contained within the bounds of the cross. Only the tips of Christ's wrappers sometimes stretch over the etched border, at times awkwardly but always distinctly. In addition to the etched or actual textile coverings, metal crosses were sometimes inlaid within a wood casing, in a shallow niche carved to fit closely their contours (see Figure 89). This arrangement reinforces the overall effect of enclosure. A cross contains the body of Christ, a textile border encloses the cross, and a wooden casing further confines the entire object. In this reading of the crucifixes, the intriguing figures laying with their arms wrapped around their chest on the vertical bars easily become dead bodies metaphorically at rest with Christ in the shared burial space of the crucifix, as their flesh-and-bone owners would be in the company of precisely such crosses in their actual tombs.[34]

The other figure present in the space defined by the textile border is the Virgin, fittingly dwelling in the realm of the otherworld. In this reading of the crucifixes, the ancillary figures on the transversal bars take on a distinctly liminal character. Perched on the horizontal bar, their toes or legs sometimes pass the etched border, timidly or boldly crossing the boundary between the enclosed space of cadavers and the outside world of the living. Hands joined in a gesture of respect and devotion, legs bent in a dynamic kneeling position, they are alert intercessors. In more elaborate crosses, such as the one in Figure 19 (Plate 11), they also appear within the space enclosed by the textile border, on the vertical bar, next to geometric constructions designed with etched strips of brass in the shape of *X*s, squares, and Latin crosses. In these arrangements, these creatures of the threshold lend three-dimensional depth to the crosses. Here, the praying figure kneels in an ambivalent space between the surface of the cross that recedes behind him and the etched line that supports his body. Within the crosses, as on the transversal bars, the praying figures blur the distinction between inside and outside that the etched border of the crucifixes creates. The kneeling figure on the vertical

Expedition to Explore the River Zaire, Usually Called the Congo, in South Africa, in 1816 under the Direction of Captain J. K. Tuckey, R. N.; to Which Is Added, the Journal of Professor Smith . . . (London, 1818); David Livingstone, *Missionary Travels and Researches in South Africa: Including a Sketch of Sixteen Years' Residence in the Interior of Africa, and a Journey from the Cape of Good Hope to Loanda on the West Coast: Thence across the Continent, Down the River Zambesi, to the Eastern Ocean* (New York, 1858), 464. For a discussion of misseto, see Chapter 1, above. The etched border of crucifixes was sometimes suggested in summary form by engraved strips attached to the four ends of the cross rather than a full contour. We also know from the excavations of Ngongo Mbata that crucifixes were sometimes wrapped in textiles in funerary contexts; see Vandenhoute, "De Begraafplaats van Ngongo-Mbata," 130–131. See also Poussot in António Brásio, *Angola* (Pittsburgh, Pa., 1966), I, 520.

34. Some brass crucifixes do not have an etched border, but these examples are consistently less elaborate.

bar dwells ambivalently both in the area contained within the cross and in a volumetric space that surpasses the two-dimensional confines of the crucifix's flat surface. These ideas of boundary crossing and fluid interrelation between connected but distinct realms are in line with the larger significance of the crucifixes. With their liminal position and breaching stance, the ancillary figures give form and substance to abstract notions of the permeability between this world and the other. They also give literal form to the idea of the cross as the precise point where the realms of life and death connect.[35]

Accumulation

If the iconography of the Kongo crucifixes is not entirely decipherable, it is clear that accumulation was central to their composition. Just as the ruler of the Bamba province wore around his neck "more than fifty medals," the crosses collected and displayed a quantity of iconographic elements. Only in rare and perhaps incomplete examples was Christ alone on the cross. Symbolically, the accumulation of ancillary characters created elaborate objects combining motifs into a complex visual text tailored to a particular owner, function, or devotion. Materially, the value of the cross increased with the added weight of each figure, crafted in precious material such as ivory (according to textual evidence and a few examples of uncertain date) or brass (in the case of the majority of pieces that have survived to this day). Material analysis of two crucifixes conducted in the 1950s by the Laboratoire Central des Musées de Belgique reported that the brass on the crosses was an alloy of 90 percent copper and 10 percent zinc. Spectrometric studies of three other objects conducted in 2010 and 2012 found ratios between 70 percent copper to 30 percent zinc and 80 percent copper and 20 percent zinc. Anthropologist R. Ceyssens and geologist J. Navez found 5 percent and 7 percent zinc in two other crucifixes. The crucifixes' metal composition thus varied widely. The ones with a high copper to zinc ratio have a rich yellow hue that European observers in the early modern period routinely described as gold. The color coincidence between brass, particularly with a high copper content, also known as gilding metal, and gold made the Christian objects as precious in the eyes of Europeans as in those of Africans, for copper and its alloys in Africa were the economic, political, symbolic, and magical equivalents to gold in Europe.[36]

35. Another crucifix closely related to Figure 19 (Plate 11) presents a similar iconography. See Christiane Falgayrettes-Leveau et al., *Brésil: L'héritage africain* (Paris, 2005), 93.
36. For the duke of Bamba's medals, see Michele Angelo Guattini and Dionigi Carli, *Viaggio del p. Michael Angelo de Guattini et del p. Dioniggi de Carli, predicatori nel regno del Congo descritto per*

The material and symbolic worth of the crucifixes, which in some cases measured more than fifty centimeters long and included more than seven ancillary figures, were interrelated. The crosses required access to brass, a rare and costly material the circulation of which was closely controlled by the political hierarchy of the Kongo. In turn, their molding was a prestigious activity that involved metalworking, a privilege of the elite. Moreover, the secondary figures on the crucifixes belonged to a finite set of motifs. If a varying number, combination, and style of Christ and ancillary figures seemingly created a great diversity in the crosses, closer examination reveals that each component of the cross belonged to a limited repertoire of types and was featured only in a specific location on the cross, as outlined in Figure 36. The consistent use and placement of a limited range of figures suggest that invention played a smaller role in their creation than emulation. The accumulation of motifs on a crucifix thus not only denoted the owner's economic and social status through access to brass and casting; it also expressed his or her involvement in the exclusive networks that brought access to motif prototypes.[37]

A visual analysis of the crucifixes indeed indicates that figures attached

lettere (Reggio di Calabria, 1672), 193. Girolamo Merolla da Sorrento, for example, saw the king wearing an ivory crucifix mounted on ebony, and Serafino da Cortona described another ivory cross made "al torno" that he sent back to Europe as a gift to his sisters; see, respectively, Girolamo Merolla and Angelo Piccardo, *Breve, e succinta relazione del viaggio nel regno di Congo nell' Africa meridionale, fatto dal P. Girolamo Merolla da Sorrento . . . Continente variati clima, arie, animali, fiumi, frutti, vestimenti con proprie figure, diversità di costumi, e di viveri per l'vso humano* (Naples, 1692), 319; Filippo da Firenze, "Ragguagli del Congo," 1711, 157, Archivio Provinziale dei Cappuccini, Florence. Another ivory crucifix was seen in 1858 according to Louis Jadin, "Les survivances chrétiennes au Congo au XIXe siècle," *Etudes d'histoire Africaine*, I (1970), 181. Note that no mention was made of other materials, such as wood. A number of ivory crucifixes are today in private collections, and some of them echo the iconography of brass crosses discussed here. This metallographic analysis considered two crosses (number 55 9 2 and 55 9 3) from the Musée Royal de l'Afrique Centrale at Tervuren, collected in the Congo by Robert Wannyn. The report may be found in the Department of History at the museum. Dr. John Mansfield conducted the analysis at the Electron Microbeam Analysis Laboratory (EMAL) at the University of Michigan. Another series of tests of two crucifixes in the Krannert Art Museum (number 2001-16-21 and 1968-2-5) were performed at the University of Illinois at Urbana Champaign, in part in the Frederick Seitz Materials Research Laboratory Central Facilities, which is partially supported by the U.S. Department of Energy under grants DE-FG02-07ER46453 and DE-FG02-07ER46471. The research was also made possible thanks to Sarah Wisseman and the Illinois State Archaeological Survey. My thanks to Allyson Purpura for her collaboration on the analysis of the objects from the Krannert. For further analysis, see R. Ceyssens and J. Navez, "Origine des masques en cuivre martelé du Haut-Kasayi," *Arts d'Afrique noire*, XCI (1994), 8–13. The significance of copper in Africa has been discussed in Eugenia W. Herbert, *Red Gold of Africa: Copper in Precolonial History and Culture* (Madison, Wis., 1984).

37. Anne Hilton discusses the role of copper in the structures of the kingdom of Kongo in Hilton, *The Kingdom of Kongo*, Oxford Studies in African Affairs (Oxford, 1985), 32–34. For metalworking, see Chapter 1, above, and Lorenzo da Lucca and Filippo da Firenze, "Relazioni d'alcuni Missionari Capp:ni Toscani singolarmente del P. Lorenzo da Lucca che due volte fù Miss:io Apotol:co al Congo; parte seconda," 1700–1717, fol. 187, Archivio Provinciale dei Frati Minori Cappuccini della Provincia di Toscana, Montughi Convent, Florence. Men and women owned crucifixes, but metalworking was a male, elite activity. Some who owned the crucifixes must have also made them.

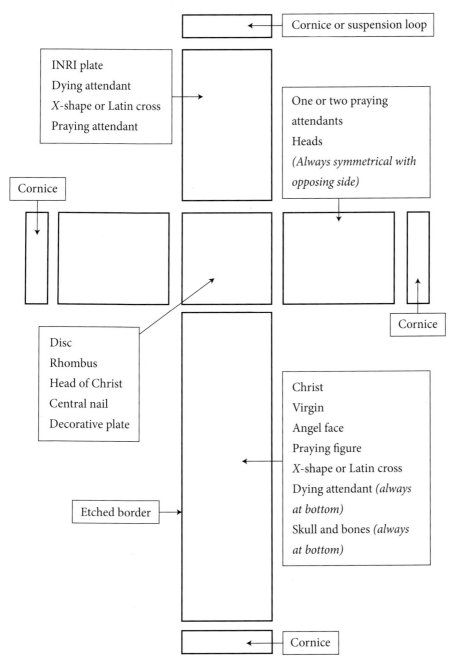

Cornice or suspension loop

INRI plate
Dying attendant
X-shape or Latin cross
Praying attendant

One or two praying
attendants
Heads
*(Always symmetrical with
opposing side)*

Cornice

Cornice

Disc
Rhombus
Head of Christ
Central nail
Decorative plate

Christ
Virgin
Angel face
Praying figure
X-shape or Latin cross
Dying attendant *(always
at bottom)*
Skull and bones *(always
at bottom)*

Etched border

Cornice

FIGURE 36 Diagram of the Organization of Motifs on a Kongo Crucifix. Drawn by Cécile Fromont

to different crucifixes were cast in a series from one mold or recast or copied freehand from older crosses, as the Virgin plates discussed above. Direct observation of most of the Kongo Christian objects still extant today and limited spectroscopic analysis indicate that artists used open molds of fine riverine sand and, in some cases, lost wax or lost wood casting. Material analysis conducted in the Electron Microbeam Analysis Laboratory (EMAL) at the University of Michigan found silica on the surface of the cross consistent with the presence of sand in the molding process. Open molds contributed to creating thinly cast pieces, a characteristic of the figures found on Kongo crosses, including the Christ, and were probably used to conserve precious material. Additional metal was spared by hollowing the backs of the pieces. Etching later added surface detail. As copies became prototypes in successive generations, series of Christs, ancillary figures, and crucifixes emerged. The individual parts were then arranged on wooden or brass crosses in fixed combinations. The crucifixes unearthed at Ngongo Mbata or those in Figures 31 (Plate 15) and 33 (Plate 16) are examples of such a series in which Christ figures of a closely related type are juxtaposed with a fixed kind and arrangement of ancillary figures. Overall, the distinct iconography of the different types of crucifixes might have been linked to a particular devotion or to one of the many Christian confraternities active in the region. Pendants worn by the knights of the Order of Christ and the staffs carried by the mestres, for instance, also functioned emblematically in this manner.[38]

If large and elaborate crucifixes were precious and prestigious possessions, diminutive pieces such as the undated cross now in Antwerp's Museum aan de Stroom probably belonged to a modest patron with limited access to brass and to prototypes of Christian images (Figure 37). The metalworker who created the cross nevertheless eloquently collapsed the different parts present in larger crucifixes into a minute piece. A kneeling figure, hands joined in prayer, single-handedly plays the role of all the elements present in larger crucifixes. He is simultaneously the central body of the scene, the praying attendant, and the vertical bar itself. The large loop at the top indicates that the object is in fact a fragment from the top part of a large crucifix. An enterprising artisan, perhaps, broke apart a large, pricey cross into smaller pieces fit for a modest clientele. This small piece offers a significant backdrop to the study of the large and precious crucifixes presented here. It is a useful reminder of the plurality of points of views, social situations, and personal responses to the advent and development of Christianity in the Kongo.

38. Analysis conducted by Dr. John Mansfield at EMAL, University of Michigan. For the use of crosses in sartorial practices, see Chapter 3, below.

FIGURE 37 Cross. Kongo kingdom, undated. Brass, 6.7 × 2.2 cm. MAS (Museum aan de Stroom), Ethnographic Collections, Antwerp, inv. AE 1959.0015.0011, purchased from Jan Vissers, 1959. Photograph, Museum and Heritage, Antwerp, Bart Huysmans and Michel Wuyts

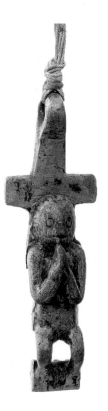

Numerous reports of collective baptisms and other mass sacraments in the missionary texts testify to the large number of people touched by Kongo Christianity. These examples of collective rituals are often used to support arguments about the religion's superficial foothold in the Kongo because they cast doubt on the depth of the religious experience that such events could offer participants. The same scenes during which missionaries also distributed paraphernalia, however, testify to the exposure of broad segments of the population to Christianity, beyond the elite and their direct entourage. Even in remote regions far from the established parishes and missionary covents, and even outside the territories controlled by the kingdom, crowds of men and women could experience memorable, if few, Christian rituals and see or own modest Christian images. Within the kingdom, networks of schools and mestres organized in the sixteenth century and still active in the eighteen hundreds brought the Christian doctrine and traditions to a large public, beyond the elite, even if little material evidence remains of these humble devotees. Christianity, then, was part of the world of many central Africans. It was an everyday reality for some and, for most others, took the form of rare yet notable experiences and objects. In both cases, it provided to the men and women captured in the slave trade some familiarity with the Christian rituals and objects they would witness in the Americas.[39]

Beyond the Sign of the Cross

Kongo crucifixes mobilized more than the potent symbolism of the sign of the cross. They also participated in the wider visual culture that emerged in central Africa with the advent of the new religion and the involvement of the kingdom in the artistic, commercial, intellectual, and religious networks of the Atlantic world. The cross entered into dialogue in particular with the multivalent visual categories of graphic and textile design, two genres deeply rooted in central African visual and material culture that dy-

39. For numerical records of sacraments, see, for example, Antonio Zucchelli da Gradisca, *Relazioni del viaggio e missione di Congo nell'etiopia inferiore occidentale del P. Antonio Zucchelli Da Gradisca, predicatore Capuccino della Provincia di Stiria, e gia missionario apostolico in detto regno . . .* (Venice, 1712), 251, 300. For the schools and mestres, see Chapter 5, below. On Christianity and the enslaved from the Kongo in the Americas, see, for example, Soi-Daniel W. Brown, "From the Tongues of Africa: A Partial Translation of Oldendorp's Interviews," *Plantation Societies*, II (1983), 51.

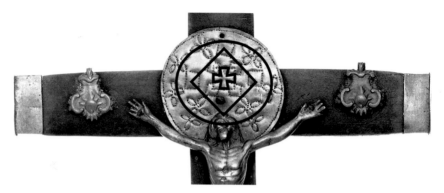

FIGURE 38 Detail of Kongo Crucifix. Kongo kingdom, possibly seventeenth or eighteenth century. Wood and brass, 52 × 25 cm. Museu de Arte Sacra e Etnologia, Missionários da Consolata (Fátima, Portugal), inv. SMP 601. Photograph, Ana Paula Ribeiro, 2012, Museu de Arte Sacra e Etnologia, Fátima, Portugal

namically engaged with the innovations brought about by the region's new cosmopolitan horizons. Elaborate two-dimensional etchings on the halo of the wood and metal crucifix in Fátima illustrate how such designs featured on crucifixes echo a broad repertoire of motifs that appear in other media of the Kongo Christian period, such as rock paintings and ink on paper. The halo in Figure 38 (a detail of the Fátima crucifix in Figure 33 [Plate 16]) attaches to the cross with a single nail placed at the intersection of the two branches. Two types of designs, lozenges and four-petal flowers, surround the head of Christ, which is positioned in the lower third of the round metal plate, directly under the central nail. Seven flowers or stars crown the head from ear to ear, in a circle just inside the circumference of the disk. The two stars on the sides of the head of Christ are doubled into two quatrefoils sharing a common branch. The doubling allows them to interact with both the outer ream of stars and the inner circle of diamonds slightly within that wider ark. These three large diamonds outline, along with the head of Christ at its fourth tip, the corners of an invisible square, or the ends of a cross similar to the ones sketched in Figure 23. Stars are rhythmically interspersed between the diamond shapes. The innermost design, competing with the nail as the center of the halo, forms a complex shape made of four lozenges pointing toward the center so that they overlap a fifth, larger diamond in their middle. The four smaller lozenges are arranged in a cruciform pattern, as if marking the ends of the diagonals of the larger diamond. The line contour of the intersection of the four small diamonds and one large diamond creates a cross reminiscent of that of the Order of Christ. The schematics in Figure 33 outline a small number of the geometric variations embedded in the brass plate. It is striking that the halo and its seemingly

free-floating decorations using seemingly ornamental motifs form a com-
pletely thought-through and elaborate geometric design akin to the ones on
the tombstones in Figures 24 and 26. This form of geometric patterning is
also closely linked to rock painting, a contemporaneous medium in which
similar integrations of European motifs within elaborate Kongo geometic
patterns appear. Although it is impossible to ascertain the age of the Fátima
crucifix, its careful composition and ordering of ancillary figures places it
at the center of the corpus, a classic example that clearly engages not only
with seventeenth- and eighteenth-century Christian iconography but also
with core Kongo forms of abstract geometric patterning.

Members of the Kongo elite who owned and commissioned the elaborate
crucifixes also signed their correspondence with similar graphic elaborations.
Dom Manuel, the brother of Afonso I, for instance, used ornate signatures on
his letters, still visible on two briefs he sent to the king of Portugal in 1543 (for
one, see Figure 39). His signature is not unusual from a European perspective,
and similar examples by European hands in contexts completely independent
from the Kongo exist in the archives. It nonetheless offers another example
of two-dimensional elaborations of linear patterns of the sort seen on the
tombstones and on the halo. Dom Manuel's signature, which, incidentally,
demonstrates his literacy and trained penmanship, consisted of his name and
title written in three parts, dom-ma-nuel. Over the three parts, the prince
drew a square with four loops at its corners. Additional doodles completed
the signature on either side. The motif itself is hardly exceptional, but it still
links the letter to a broader range of graphic expressions in Kongo visual
culture and, in turn, literally inscribes this written text as well as alphabetic
literacy in general into the realm of Kongo graphic systems.[40]

The geometric motifs of the signatures, the tombstones, and the cruci-
fixes should be considered alongside the significant corpus of graphic signs
painted or engraved in caves, escarpments, and other natural landmarks
across central Africa, dating back to the era of the Kongo kingdom. In all
media, local and foreign designs, abstract symbols, and human forms come
together in elaborate compositions. The visual inventions linked to the ad-
vent and development of Christianity in the region thus did not manifest
themselves merely in new genres but also became a part of age-old and emi-
nently local visual practices. Among the graphic formulations in the parietal
art appear some representations of scenes and objects recognizably linked
to the Kongo Christian era. On the remote, sometimes almost inaccessible
walls in locations chosen for the ritual modesty they offered, Kongo image

40. Corpo Cronológico, parte I, maço 73, docs. 41, 122, Arquivo Nacional da Torre do Tombo.

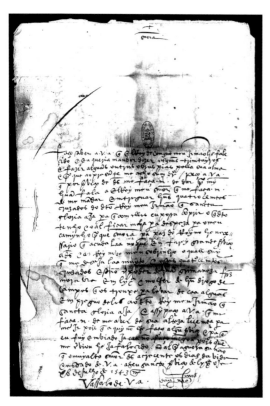

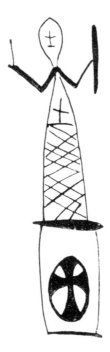

FIGURE 39 "Letter of Dom Manuel, brother of the King of Kongo, announcing to the queen [of Portugal] the death of the king of Kongo. Asking the same lady to obtain from the king an order that be returned to him 400 cruzados which were in the hands of Grimaneza Fernandes, wife of Diogo de Campos and resident in Lisbon," July 15, 1543," PT/TT/CC/1/73/122, Arquivo Nacional da Torre do Tombo, Lisbon. Photograph courtesy of the Arquivo Nacional da Torre do Tombo

FIGURE 40 Mbafu Rock Design. Detail of figure 6 from Georges Mortelmans and R. Monteyne, "La grotte peinte de Mbafu, témoignage iconographique de la première évangélisation du Bas-Congo," *Annales du MRAC Actes du IV Congres Panafricain de préhistoire et de l'étude du quaternaire*, XL (1962), between 468 and 469. Photograph, The University of Chicago Visual Resources Center

makers crafted visual chronicles of the kingdom's conversion. Photographs document, for example, what can be interpreted as sword- or bow-carrying figures in acrobatic stances that may be a record of *sangamentos,* or they could be individual figures with one arm raising a cross in a stance suggestive of predication.[41]

Belgian researchers Georges Mortelmans and Roger Monteyne surveyed in 1957 the intricate combinations of motifs in the Mbafu cave that served as

41. For the dating of Kongo rock painting, see Geoffroy Heimlich et al., "First Direct Radiocarbon Dating of Lower Congo Rock Art (Democratic Republic of the Congo)," *Radiocarbon,* LV (2013),

FIGURE 41 Staff with Saint Anthony Figure. Kongo kingdom, possibly eighteenth century. (Listed by the Metropolitan Museum of Art as Prestige Staff: Saint Anthony [Toni Malau], Kongo peoples, Northwestern Angola, nineteenth century.) Brass and wood, height 105.4 cm. Gift of Ernst Anspach, 1999, inv. 1999, 295.2, The Metropolitan Museum of Art, New York, NY, USA. Image copyright © The Metropolitan Museum of Art. Image source: Art Resource, New York

a burial site and still received votive offerings in the twentieth century. The designs recorded there depict abstract signs and human figuration drawing from the same visual lexicon as the crucifixes. Greek crosses, grids, and hatchings combine in enigmatic groupings. At times, an eye trained in the visual production of the Kongo kingdom can decipher particular motifs, such as the intricate knot based on a combination of cross and lozenge, as in Figure 20. The designs in the halo in Figure 33 (Plate 16), in the tombstones in Figures 24 and 26 as well as the ones formulated in this motif at Mbafu all originated in a similar process of thought and design. A human figure on a pedestal, at the center of the wall panel on which it appeared, emerges among the desgins in the Mbafu cave (Figure 40). It stands hieratically, wrapped in a long loincloth on a platform stamped with a variation on the Greek cross enclosed in a circle. Its two raised hands hold a large stick on the left side and a smaller object on the right. It sports a cross on its possibly bare torso. The speculative interpretation of this painting as a clerical figure, proposed by Mortelmans and Monteyne, gains substance when considered within the corpus of crucifixes and saint figures with which it shares key features.[42]

A staff now in the Metropolitan Museum of Art offers a close comparison and a possible reading key for the design (Figure 41). This type of staff, decorated with bulbous rosettes, would have been used by mestres, church guardians, catechists, and translators, a group that formed the backbone of Kongo Christianity. As will be discussed below in Chapter 3, these men ensured the continuity of Christian knowledge in the absence of priests and, in their presence, served as cultural and linguistic go-betweens who enabled their missionary work. Here, the staff of office is topped with a brass figure of Saint Anthony standing on a circular platform. A rectangular piece

1383–1390. For photographs of Kongo rock art, see Geoffroy Heimlich, "L'art rupestre du massif de Lovo (République démocratique du Congo)" (Ph.D. diss., Université Paris 1 Panthéon Sorbonne—Université Libre de Bruxelles, forthcoming).

42. Georges Mortelmans and R. Monteyne, "La grotte peinte de Mbafu, témoignage iconographique de la première évangélisation du Bas-Congo," *Annales du MRAC Actes du IV Congrès Panafricain de préhistoire et de l'étude du quaternaire*, XL (1962), 457–488 (the interpretation of the human figure appears on 469–470). The Mbafu cave has not been dated and, unfortunately, has been destroyed by quarrying.

decorated with two diamonds connects the metal figurine to the wooden part. To viewers familiar with Kongo Christian objects and insignia, whether in the Christian era or in the twentieth century when they were still used, wall painting and finial figure easily echoed each other. The hatched treatment of the loincloth on the wall recalled the draping of the saint's habit, the raised arms and pectoral cross paralleled the attributes held high by the saint, and the pedestal engraved with the Greek cross lent to the two-dimensional motifs the same proportions and composing parts as the finial. As with many examples of saint figures from central Africa, the man's attributes invite ambivalent readings that would see him either as a cleric or as a member of the Kongo Christian elite.

If the staffs and the crucifixes served as ostentatious markers of status for all to behold, the rock paintings and engravings often remained in remote locations, hidden caves, riverbeds, escarpments, and cliffs, only to be seen by those with knowledge of their existence. There, they served a purpose very different from that of regalia and testified to the diverse role that central Africans expected Kongo Christian motifs and symbolism to play. If crosses worn as insignia conspicuously heralded the link between Christianity and elite status, remote wall paintings expressed more discreet, secluded reflections on the new religion, its images, and the place of those icons within local systems of expression. The graphic designs of the rock paintings are key to grasping the full significance of the crucifixes, not only as insignia but also as media for two-dimensional Kongo signs.

Conclusion

As a genre, Kongo crucifixes formed a space of correlation in which Kongo artists and patrons brought together central African and European artistic categories, approximated heterogeneous visual syntaxes, and bridged the gap between distant forms of beliefs. In the crucifixes, the meeting of Kongo cross and Christian cross naturalized Christianity into a local discourse about the nature of the supernatural and the cycle of life and death and, in turn, transposed Kongo religious signs into visual expressions of Catholic thought. Much is still to be discovered about Kongo crucifixes, but, as a group, they demonstrate how the adoption of Catholicism in central Africa was, in contrast to the outcome of the coercive proselytism exercised elsewhere by Europeans—especially in the Americas—an independent development. Crucifixes were not tools of resistance against foreign influences; they were the result of an independent process of cross-cultural inclusion and reinvention.

The Fabric of Power, Wealth, and Devotion
Clothing and Regalia of the Christian Kongo

A crowd of men clad in colorful fabrics, weapons held high, marches down-hill from the outskirts of a town toward a Capuchin friar and his retinue (Figure 42 [Plate 17]). Their richly attired leader walks one step in front of the group in the shade of a red umbrella that an attendant diligently holds above his head. The shade, the attentive servant, and elaborate items of re-galia and clothing set the man apart from the rest of the group. He wears a *mpu* (pl. *zimpu*) cap of status on his head and a *nkutu* (pl. *nkutu*) net over his shoulders; he carries a wooden staff in his left hand, and many bracelets and anklets adorn his arms and legs. As he steps, a fringed wrapper, made of thick and colorful fine raffia cloth or silk brocade, undulates around his legs, and a brilliant red coat embroidered with the insignia of the Order of Christ floats behind his back. The second man in command, under another crimson shade and also with a red coat draped on his left shoulder, has chosen a cotton wrapper checkered in blue and red. Each of the attendants grouped around the two men shows off a different combination of clothing and regalia according to his rank. Some wear nkutu nets, others, coats of various hues, and all carry different kinds of weapons. To the right of the image, the Capuchin friar coolly stands under a simple umbrella to face the welcoming party. Behind him, two *mestres,* interpreters and leaders of the church, wear their uniform, a white cloth draped over one shoulder. Members of the elite themselves, they are richly attired. One of them wears a white mpu cap of status appropriate to his social standing and a raffia wrapper, while the other has draped his ample white cloak over striped, possibly imported, fabric. They exchange a knowing glance as they observe the reception that the prince of the coastal province of Soyo organized for Friar Bernardino d'Asti, the author of the watercolor. The Capuchin and the Kongo prince stand face to face, measuring the other's demonstration of power, prestige, and determination.

The watercolor and the scene it records celebrate the return of the Capu-chin mission to Soyo a few years after a disagreement with the former ruler, Cosme Barreto da Silva, had driven the friars from the region in 1743. The dispute emerged around the prince's right to marry one of his nieces against

109

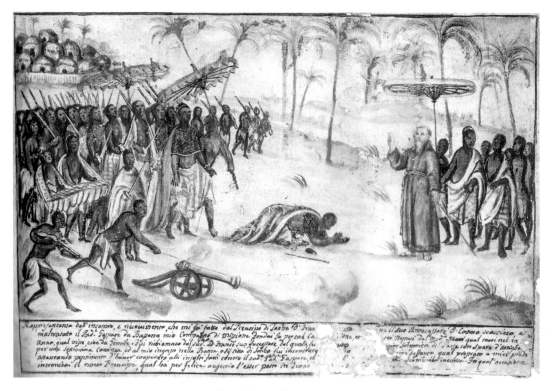

FIGURE 42 Bernardino d'Asti, *The Missionary Comes Back to Soyo*. Circa 1750. Watercolor on paper, 19.5 × 28 cm. From "Missione in prattica: Padri cappuccini ne Regni di Congo, Angola, et adiacenti," MS 457, fol. 9r, Biblioteca Civica Centrale, Turin. Photograph © Biblioteca Civica Centrale, Turin

Catholic kinship rules. In the image, the missionary gazes up at the prince with a gesture of blessing and salutation and conspicuously overlooks the man lying apologetically at his feet. The prostrated penitent is also richly outfitted in a thick blue coat and a nkutu net. He respectfully took off his mpu bonnet and dropped his wooden staff, now lying on the ground next to him. The prince, in turn, looks back at the priest but points to the man on the floor. The fragmentary text on the damaged page partly explains the exchange. Don Francesco, it tells us, the new ruler of Soyo, presents to Bernardino a repentant associate of the former prince as a token of his own dedication to the Capuchin mission and in a conspicuous display of might over his people, even those of the highest social rank. The friar, in turn, haughtily accepts the homage and apology.[1]

1. On the dispute between the former prince Cosme Barreto da Silva and the Capuchin missionaries, see Graziano Saccardo, *Congo e Angola con la storia dell'Antica missione dei Cappuccini*, 3 vols. (Venice-Mestre, 1982–1983), II, 307–308. See also Bernardino Ignazio da Vezza d'Asti's version in

No words are recorded for the encounter. Gestures, regalia, and gaze suffice to convey the stakes of the meeting and the position of its protagonists. The prince of Soyo appears grandly dressed in the cosmopolitan outfit of a Kongo Christian ruler, a mix of textiles and insignia derived from both local and foreign sources. His mpu cap and nkutu shoulder net draw from central African practices and symbolism, but his coat and insignia of the Order of Christ ultimately derive from a European imagery of nobility and prestige. Artillery fire also resoundingly showcases the prince's access to the commercial and technological networks of the Atlantic world as well as his conspicuous consumption of gunpowder, a most precious and sought-after commodity that he literally blows into smoke for show in the foreground of the watercolor. Meanwhile, two marimbas play a quieter local tune during this spectacular display of power, wealth, and devotion.

The watercolor functions as evidence, for the Roman hierarchy, of Bernardino's status as a respected missionary to a powerful, Christian realm. The scene appropriately presents Kongo nobles respectfully paying homage to the friar and, through him, the church. Yet, the vignette also captures how the Kongo Christian elite creatively mixed and seamlessly merged in their sartorial practices and insignia both local and foreign elements and transfigured them into the new outfits and regalia of Kongo Christianity. These sartorial practices and political insignia thus functioned as spaces of correlation through which the high-ranking men and women of the Kongo recast local and foreign materials, old and new ideas of luxury, and emblems of power into the visual and symbolic expressions of rank and status in the Christian Kongo.

The preceding chapters discussed the symbolic operations through which, from the beginning of the sixteenth century, the elite of the kingdom correlated central African and European religious thought, mythology, and political ideology into a novel and enduring Kongo Christian worldview. Similarly, the distinctive insignia and sartorial practices analyzed here became pivotal loci of the visual and symbolic expression of Kongo Christian political legitimacy and religious affiliation. The relationship inaugurated in the early years of contact between the kingdom and Europe evolved over

his Vatican manuscript, "Missione in prattica de RP cappuccini italiani ne regni di Congo, Angola, et adiacenti," circa 1750, MS Borgiano Latino 316, fol. 54, Biblioteca Apostolica Vaticana. For more details, see *Scritture originali riferite nelle congregazioni generali*, vol. 721, fols. 298, 301, Archivio Storico de Propaganda Fide, the Vatican. The text of the vignette is damaged, so the identity of the prostrated man is unclear, but it likely is a relative or close associate of the dead prince; see Bernardino Ignazio da Vezza d'Asti, "Missione in prattica: Padri cappuccini ne' Regni di Congo, Angola, et adiacenti," circa 1750, MS 457, fol. 12, Biblioteca Civica Centrale di Torino.

the centuries in response to changing historical circumstances and to the formative effects of the cross-cultural transactions brought about by the involvement of the kingdom and its people in the religious, commercial, and diplomatic networks of the early modern Atlantic world.

Kongo Christian Fashion

The defining trait of Kongo Christian regalia revolved around artful juxtapositions of local and foreign elements, combined and redefined into a new look. As early as 1491, Portuguese travelers noted upon their return to the Kongo that the king wore in conjunction with his local regalia a wrapper made of the damask cloth they had given him a few years earlier on their first visit. This combination of local and imported textiles observed by the travelers foretold a practice that would define the image of the Kongo noble throughout the Christian era as the kingdom's upper classes followed in the footsteps of their ruler. A century later, around 1580, the Portuguese Duarte Lopes noted that all of the Kongo elite had eagerly adopted clothing in the European style "since the kingdom received the Christian Faith." The prominent men of the Kongo wore "coats, capes, scarlet cloaks, and silk cloth, each according to his means." They also sported hats, shoes, golden chains, and large iron swords inspired by Europe. Only the "common people," he added, "who cannot make clothing in the Portuguese fashion for themselves, retained their unchanged customs." Lopes probably intended his list to demonstrate the wholesale adoption of Portuguese garb, but in fact his observations reveal a selective interest on the part of the inhabitants of the Kongo in specific foreign items. Two categories of imports are most often mentioned on the list, footwear and headgear, on the one hand, and large spans of untailored fabric used as coats, capes, cloaks, and cloth—that is, long textiles fit for draping—on the other. If shoes and hats functioned as exotic novelties, the textiles corresponded to a local predilection for cloth and immediately translated into existing practices. The king, and after him the entire upper class of a highly textile-literate society, readily recognized the imports' pliability to local conceptions of cloth use and value as well as their potential to express locally hewn ideas of prestige.[2]

2. [Duarte Lopes and Filippo Pigafetta], *Relatione del reame di Congo et delle circonvicine contrade: Tratta dalli scritti e ragionamenti di Odoardo Lopez Portoghese per Filippo Pigafetta* . . . (Rome, 1591), 67. The second meeting with the king of Kongo is recorded in João de Barros, "Primeira Missão Enviada ao Congo, 19-12-1490," in António Brásio, ed., *Monumenta missionaria africana: África ocidental*, 15 vols. (Lisbon, 1952–1988), I, 82. The Discalced Carmelite missionary Diego del Santissimo Sacramento also described Kongo elite outfits in 1584: "Chi ha maggiore facoltà, usa di una pezza di cotone con cui si copre le spalle" ("Who has more faculty, uses a piece of cotton with which he covers his back");

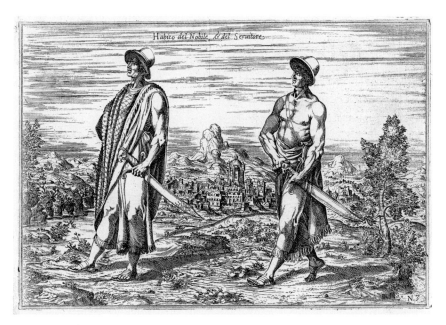

FIGURE 43 *Dress of the Noble and the Servant.* From [Duarte Lopes and Filippo Pigafetta], *Relatione del reame di Congo et delle circonvicine contrade: Tratta dalli scritti e ragionamenti di Odoardo Lopez Portoghese per Filippo Pigaffetta* . . . (Rome, 1591), plate 3. Photograph courtesy of the Melville J. Herskovits Library of African Studies, Northwestern University

Portuguese mapmaker Diogo Homem enhanced his 1558 map of Africa with a representation of the "Manicongo rex," or king of Kongo, but the prints published with Lopes's descriptions are the earliest surviving European visual representations of the Kongo elite (Figure 43). In the image titled *Dress of the Noble and the Servant (Habito del nobile e del servitore),* a prominent man and his attendant stroll in an imaginary landscape wearing a combination of loose, draped fabric, European-style bowler hats, and swords that, for the print's Italian audience, had a distinct oriental flair. The image belongs to a large corpus of European representations of exotic peoples drawn from imagination rather than observation. It borrows some of its details and composition from this genre, such as the fantastic townscape in the background and the Caucasian traits of the two men. The print nonetheless also demonstrates its maker's reliance on knowledgeable sources, most likely the eyewitness testimonies of Lopes himself. As fit for a wealthy, high-ranking Kongo

see "Lettera delli Padri Carmelitani Discalzi del Convento della Madonna della Concettion di Congo in Etiopia alli Padri et Fratelli della sua provincia scritta alii 14 Decembre 1584," *Il Carmelo,* I, nos. 3–9 (1902), 94.

noble, the man on the left sports great lengths of cloth, one of them possibly a nkutu shoulder net. The earliest mention of the net by name is in 1627 in the Jesuit annals, where it is called "encuta," translated as "clothing" or "vest," a word also recorded in 1651 as "ncutu" for the Latin *cucullus,* or "cowl," in the "Vocabularium Latinum, Hispanicum et Congense." In R. F. Cuénot's 1775 dictionary of northern Kikongo, the word *kinkutu* (pl. *binkutu*) is used for "clothing" ("habit"), and in W. Holman Bentley's 1887 *Dictionary and Grammar of the Kongo Language, as Spoken in São Salvador,* nkuta is used as the word for "cloth." The nkutu net is homonymous to the Kikongo term *nkutu,* or "bag," a word often recorded in anthropological writing since the late nineteenth century as referring to the small bag that served as insignia principally on the northern shore of the Congo River. Thin thread looped into delicate large stitches formed the circular or diamond-shaped garments known in the Christian era as *nkutu,* which elite men wore draped over the shoulders or passing over the head through an opening at the neck (Figure 44). In Lopes's print, only the *nobile* has a nkutu, but both men wear wrappers that, with their fine grain, light color, and characteristic decorative fringe, evoke central African cloth made of raffia or pineapple fiber. The surprising hats worn by the two men also echo uses of European headgear by other high-ranking Kongo men, such as the bridegroom in Figure 56 (Plate 27) and the ambassador in Figure 67 (Plate 31), below, who each holds a black hat in his hands. In the late eighteenth century, Raimondo di Dicomano observed that the elite of the Kongo—"but no others"—proudly wore, "when they had them," foreign hats, as they would a mpu.[3]

The consistent image of Kongo Christian nobility these documents record comes in sharp focus in a series of oil studies painted in Brazil around 1642. Images of five men of varying rank within the central African elite offer

3. The image of the king of Kongo appears in Diogo Homem, "Queen Mary Atlas," 1558, Department of Manuscripts, Add. MS 5415A, fol. 14r, British Library, London. See Antonio Franco, *Synopsis annalium Societatis Jesu in Lusitania ab anno 1540; usque ad annum 1725* (Augsburg, 1726), no. 11, 249; "Vocabularium Latinum, Hispanicum et Congense," [1652], MSS Varia 274, Fondi minori 1896, 26v, Biblioteca Nazionale Vittorio-Emmanuele II di Roma; José Troesch, "Le Nkutu du Comte de Soyo," *Aequatoria,* XXIV, no. 2 (1961), 42–49. Troesch calls the shoulder net worn in Soyo in the 1930s "nzemba" in "Le Royaume de Soyo," ibid., XXV, no. 3 (1962), 95–100. See also R. F. Cuénot, "Dictionnaire Congo et françois," 1775, MS 524, 188, s.v. "kinkutu," Bibliothèque municipale de Besançon; Cuénot, "Dictionnaire françois et Congo," 1773, MS 525, 339, s.v. "habit," Bibliothèque municipale de Besançon. *Binkutu* is also translated as "habit" in the Northern dialect in "Dictionnaire Kikongo Français," 1772, 22, Archivio dei Cappuccini di Genova. For *nkutu* used for "cloth," see W. Holman Bentley, *Dictionary and Grammar of the Kongo Language, as Spoken at San Salvador, the Ancient Capital of the Old Kongo Empire, West Afrika [and Appendix]* (London, 1887), 386. The word for "cloth" and the word for "bag," however, belong to a different noun class in the São Salvador dialect. See Raimondo di Dicomano's *Informazione* (1798), published with original pagination in António Brásio, "Domumentário: Informação de frei Raimundo de Dicomano," *Studia,* XLVI (1987), 303–330 (quotation on 326).

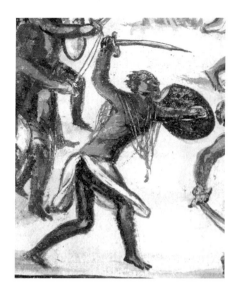

FIGURE 44 Sangamento Dancer with Sword and Nkutu Shoulder Net. Detail of Bernardino d'Asti, *The Missionary Gives His Blessing to the Mani during a Sangamento*. Circa 1750. Watercolor on paper, 19.5 × 28 cm. From "Missione in prattica: Padri cappuccini ne Regni di Congo, Angola, et adiacenti," MS 457, fol. 12r, Biblioteca Civica Centrale, Turin. Photograph © Biblioteca Civica Centrale, Turin

a comprehensive and detailed visual record of the clothing practices of seventeenth-century Kongo. Albert Eckhout, court painter for the governor of Dutch Brazil, Johan Maurits van Nassau, seized the likenesses of five diplomatic envoys sent to Recife around 1642 by the ruler of Soyo (Figures 45–49 [Plates 18–22]). The thirty-by-fifty-centimeter oil paintings on paper are now bound in the third volume of the "Theatri Rerum," a five-tome compilation of visual material from Dutch Brazil that German scholar Christian Mentzel edited between 1660 and 1664. Mentzel's titles for the five images (on pages 1, 3, 5, 9, and 11 of the album), such as *A Chilean Prince (Principum quidam Chilensium)* and *Another Chilean (Alius Chilensium),* do not reflect Eckhout's own observations but refer to an expedition conducted by Dutch naturalists to Chile, also illustrated in the volume, which Mentzel erroneously linked to the portraits. A sixth image probably completed the set, on page 7 of the album, now cut off.[4]

4. Several embassies were sent from the Kongo in 1642 by both the king of the kingdom and by the ruler of Soyo. See the description of the diplomatic visits in Caspar van Baerle, *História dos feitos recentemente praticados durante oito anos no Brasil e noutras partes sob o govêrno do ilustríssimo João Maurício . . .*, ed. and trans. Claudio Brandão (Rio de Janeiro, 1940), 272. Rebecca Parker Brienen, who wrote an important analysis of Eckhout's oeuvre, suggested that the oil paintings served as studies for one of his large 1641 canvases and could not represent the 1642 embassy. However, although adjacent images in the album inspired the paintings she mentions, no details of the five portraits appear in the large canvases. Brienen's misidentification of the younger ambassador in Figure 49 (Plate 22) as a preparatory study for a woman in the 1641 series derives from the lack of comparative material from the Kongo available to her. In light of the material presented here, the person in Figure 49 (Plate 22) is clearly not an enslaved African woman in Brazil; rather, he is a member of the central African elite, proudly clad in the prestigious shoulder net, raffia cloth wrapper, and animal skin appropriate to his social standing. See Brienen, *Visions of Savage Paradise: Albert Eckhout, Court Painter in Colonial Dutch Brazil* (Amsterdam, 2006), 149 and n. 81. The images are in Christian Mentzel, ed.,

In the five paintings, Eckhout unmistakably captured the appearance of three high-ranking Kongo nobles (Figures 45, 46, 47 [Plates 18, 19, 20]) and two men of their entourage (Figures 48, 49 [Plates 21, 22]). The African travelers, depicted individually on a full page, wore, each according to his rank and prestige, a combination of items of European and central African facture. The three eminent older men in rich outfits and colorful mpu caps appear along with two younger attendants in more modest clothing. One of the two attendants is possibly a mestre, characteristically outfitted with a light-colored cloak draped on one shoulder and here tellingly posed with finger pointed, in the attitude of speech (Figure 49 [Plate 22]). The three senior ambassadors are likely Miguel de Castro, Bastião de Sonho, and António Fernandes, the envoys from the count of Soyo that Dutch traveler and chronicler Johan Nieuhoff described as members of the educated Kongo elite who could converse with the Dutch officials in Latin. An important aspect of their mission, Nieuhof wrote, was to secure regalia, such as "a chair, a cape, war insignia, flags and other items of clothing." Another embassy from the king of Kongo sought similar gifts from the Dutch in the same year. These two visits took place at a time of conflict between the Kongo and Portugal and illustrate the central Africans' active search for other European allies and new sources of imported finery that they could no longer secure from their former friend and now rival, Portugal.[5]

The paintings of the "Theatri Rerum" did not stage the Kongo ambassadors in elaborate compositions; rather, they portrayed them in a documentary mode. The combination of Kongo and European elements captured in the five portraits reflected the envoys' sartorial practices as members of the central African elite, with a possible nod to the regional fashion of Soyo. The three high-ranking men wear colorful zimpu adorned with shells, a detail typical of the coastal region, as well as long metal chains, medals, crosses, and strings of coral beads that were favored across the kingdom. Two of the three men have draped extravagant lengths of heavy dark wools over their bare shoulders and combined them with wrappers of the same fabric (in Figure 45 [Plate 18]) or made of central African dark-dyed patterned cloth (in Figure 46 [Plate 19]). By the end of the eighteenth century, the Kikongo language in-

"Icones animalium Brasiliae: Theatri rerum naturalium brasiliae tomus III quo pronuntur icons animalium ad homine ad insecta usq iussu serenissimi ac potentissimi principis ac domini Dn Friderici Wilhelmi, marchionis brandeburgici, S R IMP archicamerarii atq electoris principis etc. etc. etc in ordinem redactus a Christiano Menszelio D.," 1637–1644, Libri Picturati A 34 (call number), Biblioteka Jagiellonska, Krakow.

5. Johan Nieuhof, *Johan Nieuhofs Gedenkwaerdige zee en lantreize door de voornaemste landschappen van West en Oostindien . . .* (Amsterdam, 1682), 56.

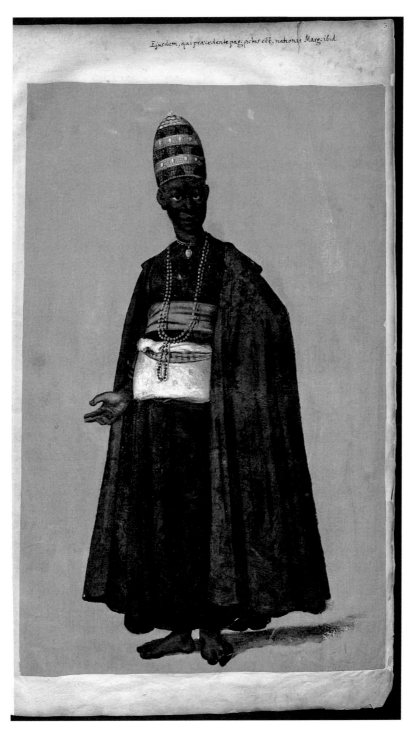

FIGURE 45 Albert Eckhout, *Portrait of a Kongo Ambassador to Recife, Brazil.* Circa 1637–1644. Oil on paper, 30 × 50 cm. Libri Picturati A 34, fol. 3, Jagiellonian Library, Krakow. Photograph courtesy of the Jagiellonian Library Photographic Services

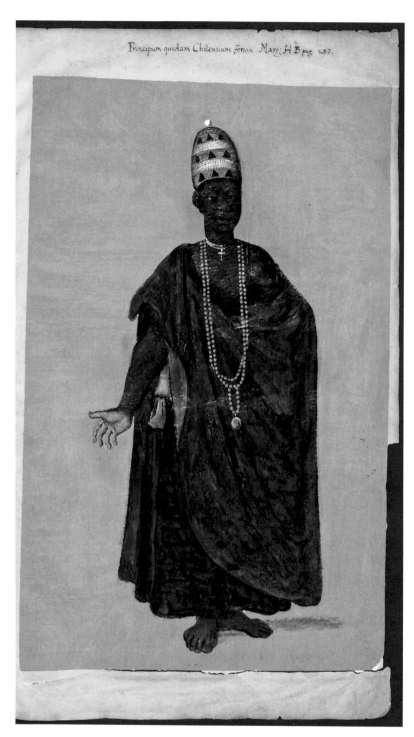

FIGURE 46 Albert Eckhout, *Portrait of a Kongo Ambassador to Recife, Brazil*. Circa 1637–1644. Oil on paper, 30 × 50 cm. Libri Picturati A 34, fol. 1. Jagiellonian Library, Krakow. Photograph courtesy of the Jagiellonian Library Photographic Services

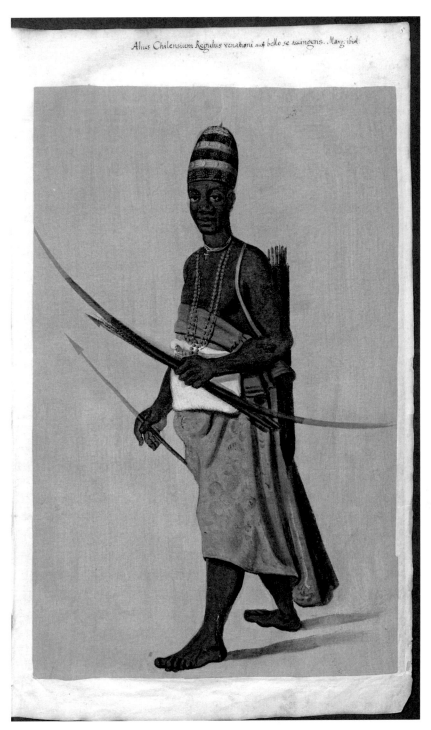

FIGURE 47 Albert Eckhout, *Portrait of a Kongo Ambassador to Recife, Brazil*. Circa 1637–1644. Oil on paper, 30 × 50 cm. Libri Picturati A 34, fol. 5. Jagiellonian Library, Krakow. Photograph courtesy of the Jagiellonian Library Photographic Services

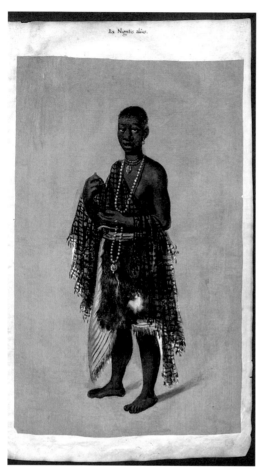

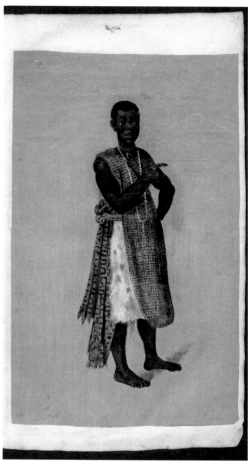

FIGURE 48 Albert Eckhout, *Portrait of a Kongo Youth in Recife, Brazil.* Circa 1637–1644. Oil on paper, 30 × 50 cm. Libri Picturati 34, fol. 11, Jagiellonian Library, Krakow. Photograph courtesy of the Jagiellonian Library Photographic Services

FIGURE 49 Albert Eckhout, *Portrait of a Kongo Youth in Recife, Brazil.* Circa 1637–1644. Oil on paper, 30 × 50 cm. Libri Picturati 34, fol. 9, Jagiellonian Library, Krakow. Photograph courtesy of the Jagiellonian Library Photographic Services

cluded a dedicated word for the dark imported wools illustrated here and in many other depictions of central African regalia. Cuénot recorded the name in the northern form of Kikongo as *livonga* (pl. *mavonga*), defined as "blue or red cloth that they wear on the shoulders" under the French heading for "habit" and as "woolen fabric" under the Kikongo entry "livonga."[6]

6. Although zimpu are often white, colored ones are also mentioned; see, for example, Giovanni Francesco da Roma, *La fondation de la mission des Capucins au Royaume du Congo (1648)*, trans. François Bontinck (Leuven, 1964), 105. Lopes mentions a yellow-and-red cap in [Lopes and Pigafetta], *Relatione,* 67. The duke of Bamba wears a red cap with strips of gold (probably brass) according to Michele Angelo Guattini and Dionigi Carli, *Viaggio del p. Michael Angelo de Guattini et del p. Dioniggi de Carli, predicatori nel regno del Congo descritto per lettere* (Reggio [Emilia], 1672), 193. For references

The third ambassador, probably ready to dance in the *sangamento* martial performance the men staged in Recife, sports a shorter, lighter wrapper of yellow brocade that leaves his bust and arms uncovered and ready to grab his bow and arrows in the course of the acrobatic martial dance (Figure 47 [Plate 20]). All three senior legates cinched their waist with a red sash, a neatly folded animal pelt, and in two cases a band of white-and-blue-checkered cotton (Figures 45 and 47 [Plates 18 and 20). Their bare-headed attendants draped on their shoulders net-like textiles resembling nkutu. Their jewels, while still opulent, are less exuberant than those of their senior counterparts. They wear simpler wrappers of Kongo cloth adorned with loosely hanging, rather than neatly folded, animal skins. Central African elite in the Kongo and surrounding countries—from the kingdom of Loango in the north to Angola in the south—wore animal pelts hung in front of the legs as a marker of status. Giovanni Belotti da Romano, who described "the customs of the kingdoms of Congo and Angola" in the late seventeenth century, remarked that the elite "like wearing around the waist some animal pelt with the tail hanging in front, . . . for great fast and pomp," an observation also illustrated in Girolamo Merolla da Sorrento's contemporary print in Figure 71, below. Several European accounts duly noted and depicted how the prominent pelt-wearers often cinched the fur with a red sash and a strip of imported checkered cloth, two visually striking foreign novelties.[7]

––––––––

to coral beads, see, for example, Calogero Piazza, *La missione del Soyo (1713–1716) nella relazione inedita di Giuseppe da Modena OFM Cap.* (Rome, 1973), 259; Girolamo Merolla da Sorrento and Angelo Piccardo, *Breve, e succinta relatione del viaggio nel regno di Congo nell' Africa meridionale, fatto dal P. Girolamo Merolla da Sorrento . . . Continente variati clima, arie, animali, fiumi, frutti, vestimenti con proprie figure, diversità di costumi, e di viveri per l'vso humano* (Naples, 1692), 174. Olfert Dapper also mentions the juxtaposition of metal chains and red coral or red beads in *Naukeurige beschrijvinge der afrikanensche eylanden: Als Madagaskar, of Sant Laurens, Sant Thomee, d'eilanden van Kanarien, Kaep de Verd, Malta en andere, vertoont in de benamingen, gelegentheit, steden, revieren, gewassen . . .* (Amsterdam, 1668), 572. Francesco da Roma in 1648 references coral beads as part of the royal regalia and describes the popular black dyeing process of Kongo local cloth; see Gio[vanni] Francesco da [Roma], *Breve relatione del successo della missione de Frati Minori Cappuccini del Serafico P. S. Francesco al regno del Congo e delle qualità, costumi, e maniere di vivere di quel regno, e suoi habitatori* (Rome, 1648), 173, 177. For black-dyed Kongo vegetal fiber cloth, see also Guattini and Carli, *Viaggio,* 193. The same volume also mentions dark-blue cloaks (198–199). For the Kikongo word for the dark imported wools, see Cuénot, "Dictionnaire Congo et françois," 1775, MS 524, 427; for the French, see Cuénot, "Dictionnaire françois et Congo," 1773, MS 525, 339.

7. For the sangamento staged in Recife, see Nieuhof, *Gedenkwaerdige,* 56. For the pelts, see Giovanni Belotti da Romano, "Giornate apostoliche con varii, e dilettevoli successi: Descritte dal P. F. Giovanni Belotti da Romano predicatore Cappucino della Provincia di Brescia, 23 novembre 1680," 1680, AB 75, 148, Archivio Generale Cappuccini, Rome; Merolla and Piccardo, *Breve, e succinta relatione,* 174 (the print is on 177, no. 14). See also the animal pelt in the watercolor attributed to Louis Marie Joseph Ohier de Grandpré in the Biblioteca Nacional de Lisboa published in Jill R. Dias, *Africa: Nas vésperas do mundo moderno,* trans. José Luís ([Portugal], 1992), 216. A similar image appeared as an engraving in De Grandpré's published account, *Voyage à la côte occidentale d'Afrique fait dans les années 1786 et 1787 . . . suivi d'un voyage fait au cap de Bonne-Espérance, contenant la description militaire de cette colonie* (Paris, 1801), I, facing 71. António de Oliveira de Cadornega's illustrated manuscript includes

A consistent image of the Kongo Christian elite regalia appeared across time, from Lopes's 1591 descriptions, to Eckhout's 1642 paintings, and up to Friar Bernardino's circa 1750 watercolor. These European depictions also closely correspond to the findings of the important archaeological exploration of the eighteenth-century elite burial ground of Ngongo Mbata in the 1930s and 1940s. The rich men interred at the site were luxuriously clothed, adorned, and outfitted with precious local and exotic objects. The excavation file records indicate the discovery of fine textiles, some woven with gilt thread, iron and silver swords, beads, chains of brass, gold, and silver, Christian medals and crucifixes of various precious metals as well as glassware and ceramics, all either locally made or imported from Europe or beyond, including chards of pottery from China.[8]

The combination of local and foreign elements in the regalia and sartorial practices of the Kongo endured in its main traits over the centuries. It encompassed a political and religious dimension that arched back to Afonso's reinvention of the Kongo kingdom as a Christian land. The 1650s Capuchin drawing of Garcia II (r. 1641–1660) recalls the political significance of the combination (Figure 5). Its gloss describes the king as wearing "an open shirt, and around the thighs a cloth that touches the ground; he wears socks and shoes and a coat in the European style, and a little white cap on the head; necklaces, armbands." The portrait in ink on paper, in turn, depicts the ruler in a white shirt, a long wrapper, with a large draped coat, a mpu, and many necklaces and bracelets. The drawing also includes the European throne, crown, and scepter that Kongo rulers had eagerly adopted. What could be an awkward juxtaposition of regalia of local and foreign origins here functions well together. The iron *simba* chain and *malunga* bracelets so crucial to the symbolism of central African rule, with their profound link to ideas of power, endurance, and fortitude, are combined with objects suggesting similar notions in a European visual syntax, such as the throne and the scepter. Less obvious but equally crucial points of connection are the European shirt and coat of the king, precious objects that encapsulate Kongo ideas of wealth and power but that also illustrate the ruler's connection to European emblems of nobility. The cross and arrows in his left hand are also linked to his coat of arms, which he inherited from Afonso but customized for his reign with a cross and arrow. The staff topped with a cross echoed the distinctive at-

several depictions of the catskin worn around the legs; see "Historia geral das guerras Angolanas," 1680, Manuscrito Vermelho 77, Academia das Ciências, Lisbon (see, for example, Figure 50 [Plate 23]).

8. J. Vandenhoute, "De Begraafplaats van Ngongo-Mbata (Nedcr-Zalre)" (licentiate's thesis, Rijksuniversiteit Gent Höger Instituut voor Kunstgesischiedenis on Oudheidkunde, 1972–1973), 56.

tribute of the powerful mestres, who controlled knowledge of Christianity and buttressed the independent Kongo Christian church on which the king's legitimacy partly depended.[9]

A depiction of the king of Kongo also appeared on one of the frontispieces of António de Oliveira de Cadornega's 1680 manuscript "Historia Geral das Guerras Angolana" (Figure 50 [Plate 23]). The Portuguese military man, veteran of central Africa, took on the task at the end of his life to write a comprehensive account of the history, geography, and people of Angola. In the painted opening to the first of the "Historia's" three volumes, the king of Kongo and the king of Angola stand in full regalia on an illusionistic architectural frontispiece, under the coat of arms of Portugal and two pineapples glossed as "fruits of Angola." The king of Angola pictures the leader of Ndongo and Matamba, two interconnected polities in almost constant conflict with Portugal. Bare-chested and barefoot, his skin is decorated with red marks on his face and dark patterns on his arms. Anklets, bracelets, white beads, a fly whisk slung over his left shoulder, and a cat pelt enrich his simple wrapper and red belt, possibly of foreign origin. In comparison to the barely clad Angolan armed with an African axe and spear, the king of Kongo appears cosmopolitan with his central African insignia, a mpu, and raffia-fiber wrapper combined with a European inspired sword, shirt, dark coat, red boots, and a typically Kongo Christian metal medallion of the Order of Christ. The king's cross, his foreign items of clothing, and their juxtaposition to local cloth and insignia demonstrate once more the specific and consistent look of the Kongo Christian elite. They also draw attention to the political significance of the outfits as emblems of the Kongo's status as a Christian kingdom and as evidence of its people's independent and singular adoption of religious and material novelties from abroad.

Hats, Power, and History

The combination of local and foreign elements articulated in the entire outfits of the Kongo elite was present also within individual pieces such as the different kinds of hats used as emblems of status. Mpu caps were the most important type of headgear in the Kongo and are among the best-documented objects of early modern central African material culture through written and visual descriptions as well as examples that arrived in Europe as early as the seventeenth century. In the first decades following the encounter between Europe and the Kongo, chronicler João de Barros

9. See the seal of Garcia II in Angola, caixa 5, doc. 26, Arquivo Histórico Ultramarino, Lisbon.

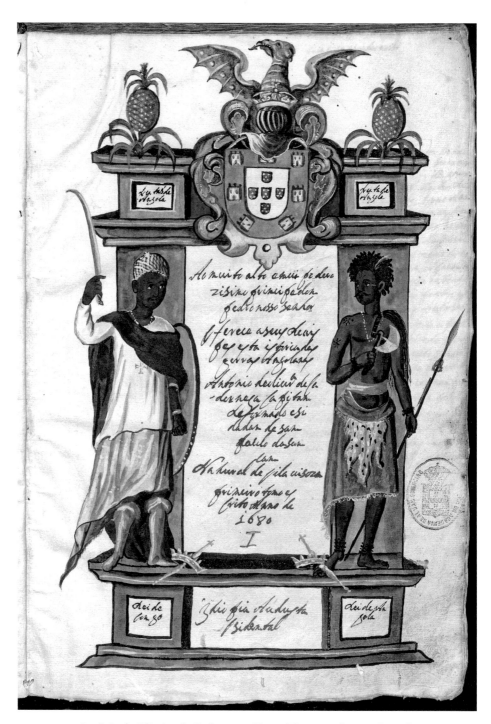

FIGURE 50 António de Oliveira de Cadornega, *King of Congo and King of Angola*. 1680. Watercolor on paper, 30 × 20.5 cm. (manuscript). Manuscrito Vermelho 77, frontispiece, Academia das Ciências de Lisboa, Portugal. Photograph courtesy of the Academia das Ciências de Lisboa

wrote a precise description of the caps, drawing from accounts of travelers and from other sources available to him as a prominent courtier and leading administrator of Portugal's overseas endeavors. He might even have seen a mpu in Lisbon, perhaps brought back from the Kongo by travelers or worn at court by a central African visitor. A mpu, Barros writes, is "a cap high as a miter, made of very fine and thin palm cloth, with high and low embellishments in the manner that around us pertains to the weaving of satin velvet." These words ably render the zimpu recorded in early modern images and the ones that entered European collections in the seventeenth and eighteenth centuries (Figure 51).[10]

The highly elaborate and idiosyncratic creation techniques of the zimpu consisted of successive looping and knotting of raffia or pineapple fiber in a spiral that grew from top to bottom and created a textile cone. Simple, small loops provided a plain background for patterns executed in low and high relief with larger, more elaborate knots. The orthogonal designs found on the caps were ubiquitous in Kongo visual culture and graced the surface of a wide range of objects from *misseto* reliquaries to ivory horns and architecture. The elaboration and sophisticated variations of the designs suggest that they visually encoded complex information we can no longer decipher today.[11]

The male artist who crafted the mpu in Figure 52 (Plate 24) used the knots-and-loops technique to create an unusual object, one among a handful set apart from the rest of the known corpus because of its peculiar design variations. The hat, now in Copenhagen's National Museum, arrived in Europe before 1674. A plain spiral at the top of the bonnet echoes a simple, large band at its bottom. Interlacing diamond-derived motifs occupy most of the main vertical part, forming a band of triangles at its top and bottom. In the lower part, five bold crosses appear above the textile ground in high relief. They stand in sharp contrast to the imbricate patterns in the rest of the hat that rise subtly above the main surface. The five crosses are repeated along the perimeter of the cap in a pattern that somewhat coordinates with

10. A letter sent from Lisbon in 1491 to an unknown party in Milan (probably at the Sforza court) remarked on the presence of a Kongo ambassador at court in Lisbon wearing one such cap; see "Vestirli de nigro, cioè manto e caputio," in Potenze Estere 649 (Misc. in cartolina "Guinea"), Archivio di Stato di Milano, transcribed in Kate Lowe, "Africa in the News in Renaissance Italy: News Extracts from Portugal about Western Africa Circulating in Northern and Central Italy in the 1480s and 1490s," *Italian Studies*, LXV (2010), 327. See João de Barros, *Décadas da Ásia* (1552–1613), decade I, book 3, chap. 9, in Brásio, ed., *Monumenta*, I, 82: "e na cabeça, hum barette alto como mitra, feito de panno de palma muito fino e delgado, com lavores altos, e baixos, a maneira que ácerca de nós hé a tecedura de cetim avelutado."

11. See Ezio Bassani, *African Art and Artefacts in European Collections, 1400–1800,* ed. Malcolm McLeod (London, 2000), 279–281; Gordon D. Gibson and Cecilia R. McGurk, "High-Status Caps of the Kongo and Mbundu Peoples," *Textile Museum Journal*, IV, no. 4 (1977), 71–96.

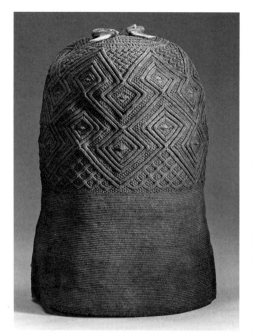

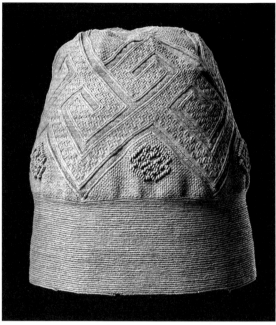

FIGURE 51 Mpu Cap of Status. Kongo kingdom, eighteenth century. Pineapple fiber and leopard claws, 25.5 × 24 cm (flat). National Museums Scotland, inv. A.1956.1153. Photograph © National Museums Scotland

FIGURE 52 Mpu Cap of Status. Kongo kingdom, before 1674. Vegetal fibers, height 18 cm. The National Museum of Denmark inv. no. Dc. 123 Hat. Photograph © The National Museum of Denmark, Ethnographic Collection

the rhythm of the interlacing designs, from which they otherwise differ in almost all aspects. Unlike the rest of the patterns, the crosses are raised, finite, individual, and free floating. This distinct treatment of crosses suggests that the hat appealed to and ostentatiously combined distinct visual lexica. On the one hand, it used geometric interlaces, a sophisticated and ubiquitous central African genre. On the other hand, it employed the singular motif of the cross, the significance of which we can, at least partly, understand.[12]

In 1696, the Capuchin Marcellino d'Atri saw during the coronation of Pedro IV Agua Rosada Nusamu a Mvemba (r. 1696–1718) a peculiar hat that functioned in a manner similar to the mpu in Figure 52 (Plate 24). Coming to power in the midst of a civil war, the new king ascended to a much-weakened Kongo throne in a modest ceremony conducted on the site of the abandoned capital of São Salvador. Unable to use the European-style crown of his predecessors (pictured in Figure 5), which was lost to the Portuguese

12. Weaving in central Africa is a male activity. For a discussion of the cap, see Bassani, *African Art and Artefacts,* ed. McLeod, 20.

in the disastrous Mbwila battle of 1665, Pedro was coronated instead with a makeshift crown on which featured the royal coat of arms of the Kongo, described by Marcellino d'Atri as five unsheathed swords of shiny silver hue embroidered or pinned on the front of the headgear. The crown crafted for the occasion, seemingly cut from a European hat, replaced the gold-plated silver crown the pope had offered to Kongo kings (a once-foreign object described in Olfert Dapper's 1668 *Naukeurige beschrijvinge* as "a crown decorated [gewerkt] with gold, silk and silver thread") that had become essential to the royal regalia of the Christian central African monarchs by at least 1651.[13]

The substitution of the hat for the crown relied on the Kongo Christian correlation of local and foreign conceptions and manifestations of power and prestige. It concurrently drew from the intrinsic symbolic value of prestigious headgear such as zimpu as a central African insignia of rulership and from the significance of the Kongo coat of arms as a potent emblem of royal power. Swords, as we recall, formed the central motif of the escutcheon adopted by the early Christian king Afonso circa 1500, when they evoked through heraldry the story of the triumph of Catholicism in the Kongo. Thereafter, Kongo rulers used the coat of arms on seals, regalia, and banners as symbols of their office. The five swords on Pedro IV's hat evoked through heraldry Afonso's reformulation of the nature and origins of Kongo rulership from a local narrative to one that encompassed a Christian dimension expressed through ideas and symbols introduced from Europe.

With the addition of the heraldic signs, Pedro IV's lowly hat became a valid insignia of Kongo Christian kingship. The swords on the surface of the

13. For the description of the crown-hat, see Marcellino Canzani d'Atri, "Giornate apostoliche fatte a me Fra Marcellino d'Atri predicatore Cappucino nelle missioni de regno d'Angola e Congo, nella Etiopia inferiore parte occidentale nell'Africa 1690," 1690–1708, 141, 518, Convento Santi Francesco e Chiara, L'Aquila, published with original pagination in Carlo Toso, *L'anarchia congolese nel sec. XVII: La relazione inedita di Marcellino d'Atri*, Studi di storia delle esplorazioni, 15 (Genova, 1984), 68, 276. The type of hat ("cappello") Pedro used as a crown is unclear from the description, although it seems to be a European-style hat extravagantly reworked ("sfoggiatamente ritagliato . . . con alcune curiosità") in the shape of a crown. For Dapper's description of the earlier crown, see *Naukeurige beschrijvinge*, 582. The sources Dapper used for this description are unknown, and it is unclear what period he describes. John K. Thornton gives a vivid portrait of the period and of Pedro IV's accession to the throne in *The Kongolese Saint Anthony: Dona Beatriz Kimpa Vita and the Antonian Movement, 1684–1706* (Cambridge, 1998). For the Battle of Mbwila (or Ambuila), see António de Oliveira de Cadornega, *História geral das guerras Angolanas, 1680[–1681]*, ed. José Matias Delgado ([Lisbon], 1940), II, 526. For discussion of the crown, see Giacinto Brugiotti da Vetralla in a 1655 account copied in the later manuscript by Giuseppe Monari da Modena, "Viaggio al Congo, fatto da me fra Giuseppe da Modena Missionario Apostolico, e predicatore Capuccino, incomentiato alli 11 del mese di Novembre del anno 1711, e terminato alli 22 di Febraro del anno 1713 etc. . . ," 1723, Manoscritti Italiani 1380, Alfa N. 9–7, 436, 440, 442, Biblioteca Estense, Modena. Luca da Caltanisetta also mentions the golden crown in a 1651 coronation in Scritture originali riferite nelle congregazioni generali, vol. 249, fols. 431v, 434r–435v, Archivio Storico de Propaganda Fide; see François Bontinck, ed. and trans., *Diaire congolais (1690–1701) de Fra Luca da Caltanisetta*, Publications de l'Université Lovanium de Kinshasa (Leuven, 1970), 101.

headgear functioned as other objects often attached to or designed on central African caps of status, such as claws, fangs, snakes, and feathers, which metaphorically attributed the skills of mighty animals to rulers. The ruler of Soyo, for example, greeted European visitors in 1491 wearing "on his head a cap on which slithered a very finely embroidered snake." Animal claws also enhance another mpu that arrived in Europe in the eighteenth century, which is now in the National Museum of Scotland (Figure 51). In a similar form of metonymy, the coat of arms on Pedro's hat linked its wearer to the supernatural powers of Saint James and his miraculous army of knights that enabled and sanctioned the rule of his Christian predecessors. The European-derived heraldic signs there became Kongo tropes. In other words, in Pedro's makeshift crown, the imagery of the coat of arms functioned not only as a Portuguese-inspired emblem but also as a full-fledged Kongo metaphor that expressed conceptions of regal power honed in its foundation myth.[14]

Pedro IV invoked in his hat the story of the miraculous advent of Christianity under the Kongo's first great Catholic king, Afonso, in a multivalent effort to legitimate his own claim to the throne. Using the coat of arms on his crown, Pedro positioned himself in the lineage of Kongo Christian monarchs. As other incumbents to the kingdom's throne before him, he drew a parallel between the establishment of his reign in troubled times and Afonso's beginnings in the midst of similar strife. The nature of Pedro's gesture is profoundly historical. Formulated at a time of political, social, and symbolic unrest, the visual and symbolic discourse of his coronation regalia mobilized and recast elements of the past to legitimize his present reign. This move not only borrowed Afonso's story and imagery, but it to a large extent repeated the early king's gesture of reinvention, demonstrating once more the profound significance and lasting influence of the original reformulation.[15]

Pedro IV did not evoke the past only in his hat. He made every effort to receive the crown according to the centuries-old tradition of Kongo Christian coronations. He hiked with his followers to São Salvador to receive the crown in the ancient, if then abandoned, capital of the Kongo and site of the early divine miracles at the very foundation of Kongo Christianity. He also insisted on the presence and involvement in the ceremony of a Catholic priest. Because the clergy that once officiated at the capital had dispersed after its destruction, and priests now looked to Luanda rather than the Kongo for a successful central African career, the new king had to bring the vicar Luis

14. Chronicler Rui de Pina describes the Soyo cap; see the transcription in Brásio, ed., *Monumenta*, I, 61.

15. Álvaro I had performed a similar gesture in the late sixteenth century. See the discussion below in Chapter 4.

de Mendonça to the scene against his will. Pedro's efforts followed a primar-
ily political and strategic logic. He rose to the throne during a period often
qualified as "general anarchy" in which, since 1641, the centralized kingdom
had descended into decades of civil wars, and he needed to establish his le-
gitimacy to a disputed crown. Yet, the means by which he hoped to achieve
this goal are significant. His insistence on the presence of the priest, his con-
spicuous recourse to the coat of arms, and his long journey to São Salvador
for a single day all highlight the vivid currency of the symbolism and imagery
derived from Afonso's time. Known as the restorer of the kingdom, albeit one
irrevocably transformed by decades of unrest, Pedro called upon the Kongo
Christian creation myth and asserted its continued relevance for the political
organization of the realm. In turn, he did not hesitate to adapt insignia and
rituals in response to altered circumstances. He creatively found new possi-
bilities encapsulated in the makeshift crown and in the redesigned ceremony
to assert and herald Kongo Christian might and legitimacy.[16]

This episode allows us to understand that the political and symbolic
changes that unfolded throughout the history of the kingdom did not ad-
here to a teleological pattern of acculturation or appropriation, in particular
with regard to the kingdom's relationship to European ideas and objects. The
kings of Kongo did not adopt the gilded European crown or other items of
regalia only to emulate European rulers. And neither were the foreign objects
fully taken over by local worldviews. Rather, they were part of a sophisticated
reflection about the nature of power and legitimacy in the Kongo in the face
of altered religious and material circumstances. And this reflection was one
of correlation, transforming local logic and foreign input into intrinsically
interrelated parts of a new whole. That a gilded crown may be used as a mpu
and that later a locally crafted object may equally serve in place of an im-
ported gilded crown showcases well the contingent, strategic, iterative, and
cumulative path that Kongo Christianity followed from its advent circa 1500
through centuries of dense history.

The mpu in Figure 52 (Plate 24) functioned in a manner similar to the
coronation hat. It combined motifs in low relief typical of Kongo textiles with
crosses in high relief, visibly distinct from the main pattern as the silver-
colored swords were from the rest of Pedro's hat. The *X*-shaped cross, as
discussed in Chapter 2, was a central motif in the visual and symbolic conver-
sation between Kongo and Christian religious thought. In tombstones, cru-

16. Marcellino d'Atri, "Giornate apostoliche," 1690–1708, 131, published with original pagination in
Toso, *L'anarchia congolese nel sec. XVII*, 65. For the clergy's new orientation, see John K. Thornton,
The Kingdom of Kongo: Civil War and Transition, 1641–1718 (Madison, Wis., 1983), 90–91.

cifixes, and medals, this sign, often combined with the Latin cross, brought together Christian and central African notions of life, death, and immanence. Yet the crosses on the Copenhagen mpu also functioned as the swords on Pedro's hat or the claws on the other mpu, as emblems qualifying the nature and origins of their wearers' prestige. In this case, the distinct hollow branches of the crosses linked the noble cap wearer to the Order of Christ.

The Order was introduced to central Africa in the first moments of contact with Europe and soon became a staple of the kingdom's political life. Although in principle only the king of Portugal could bestow the distinction, Kongo rulers routinely knighted their own nobles and even, on occasion, Europeans. Portuguese authorities repeatedly denounced the practice to no avail. The Order enjoyed great popularity and respect in the region. The desecration of the emblem of the Order, for instance, incurred a severe financial penalty. For the most modest transgressors, the fine could even mean the loss of their freedom, since they could only produce such a sum by being sold into the Atlantic slave trade. Early modern depictions and archaeological evidence placed the Order's insignia, a cross with hollow branches of equal length, among the most prominent regalia of the central African elite. Medallions made of precious metals (such as the one recovered at the eighteenth-century cemetery of Ngongo Mbata or the one depicted on the chest of the Kongo king painted by Portuguese chronicler Cadornega in the 1680s), embroideries on the coats of the rulers as seen in the vignettes in Bernardino d'Asti's "Missione in prattica," wax seals and signatures in the autograph correspondence of the elite, rock paintings, and engravings all heralded the emblem of the Order. The high-relief crosses of the Copenhagen mpu recall the insignia, rendered in raffia fiber and rotated forty-five degrees to fit with the rhythm and patterns of the textile. Attached to the cap, the crosses turned the mpu into an emblem of Christian nobility while they also served as metaphors of the power and legitimacy that the cap's wearer derived from the ability to call upon Christianity's numinous realm. Here again, in successive, cumulative strokes, ideas and motifs linked to both Kongo and European religious and political thought met, blurred, and, eventually, redeployed into a single, cohesive object.[17]

17. For a history of the Order of Christ in the Kongo, see André L'Hoist, "L'ordre du Christ au Congo," *Revue de l'Aucam,* VII (1932), 258–266. For the penalty, see Brásio, "Informação de Raimondo de Dicomano," *Studia,* XLVI (1987), 303–330 (fol. 14). Afonso's 1517 seal is in Corpo Cronológico, parte I, maço 21, doc. 109, Arquivo Nacional da Torre do Tombo, Lisbon. See the insignia in Cadornega, "Historia geral das guerras Angolanas," 1680, Manuscrito Vermelho 77, frontispiece. For rock painting, see Paul Raymaekers and Hendrik van Moorsel, *Lovo: Contribution à l'étude de la protohistoire de l'Ouest centrafricain* ([Léopoldville], 1964). The signature of the ruler of Soyo appears in "Receipt from D. António Mani of Soyo to the Pilot of the Ship Conceição Bernardo Corço for 3 Oufits," in Corpo Cronológico, parte II, maço 92, doc. 142.

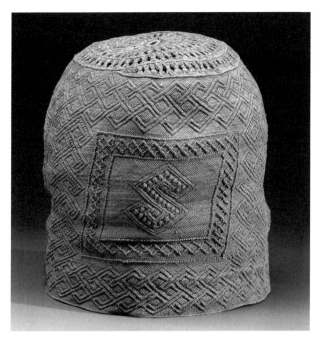

FIGURE 53 Mpu Cap of Status.
Kongo kingdom, before 1876, likely
eighteenth century. Raffia palm
or pineapple fiber, height 21 cm.
Museo Preistorico Etnografico "Luigi
Pigorini," Rome, inv. no. MPE 5423.
Photograph © S-MNPE, "L. Pigorini,"
Roma-EUR, by permission of the
Ministero per i Beni e le Attività
Culturali

Medals and crucifixes pinned on other zimpu during the Christian period
conveyed a similar association. They recast a once wholly central African
marker of status into insignia of Christian nobility, a practice that might
have inspired the maker of the Copenhagen cap. In tomb VII at Ngongo
Mbata, five brass medals and three small crucifixes found around a skull,
along with "fragments of a mat made of woven plant fiber," indicate a mpu
richly adorned with Christian paraphernalia. In another instance, Marcellino
d'Atri reported seeing a brass cross proudly pinned on a cap. Unlike these last
examples, the Copenhagen mpu rendered the insignia with the same material
as the rest of the hat and demonstrated a sophisticated reflection on the pos-
sibilities of different forms of artistic representation. The Copenhagen cap as
well as the one in Figure 53 from the Museo Nazionale Preistorico Etnografico
"Lugi Pigorini" in Rome are remarkable for the way in which their makers
challenged their medium in order to find a formal solution that would render
European emblems both seamlessly and conspicuously in Kongo textiles. A
spiraling top and intricate interlacing geometric patterns form the basis of
the elegant, finely worked Pigorini mpu. A frieze of interlocking geometric
patterns cinch the cap's top and bottom. Four square frames of knotted lines
feature between them on the vertical part of the cap. Decorative *S* figures
emerge from the plain background of these decorative quadrangles. They
resemble initial letters found in European printed or manuscript texts. The
cameos are clearly distinct from the other patterns on the cap, including the

vertical endless knots alternating with them. Like the crosses on the Copenhagen cap, they also seem to function as objects pinned to the mpu and as foreign motifs translated in textile form.[18]

These enigmatic figures could have been the emblem of a prominent family emulating the Kongo royalty's practice of wearing its coat of arms on its crown. The cameos are in some regard even more intriguing than the crosses on the Copenhagen mpu. If the crosses suggest three-dimensional objects pinned on the caps in a manner that echoes established local practices of attaching claws, fangs, or even crucifixes to the hats, the cameos instead emulate two-dimensional European graphic signs and suggest alphabetic literacy. Written documents often served in the Kongo as emblems of power. A bull with indulgences the pope sent to Diogo I (r. 1543–1561), kept in a brocade bag called *Sanctissimo Sacramento* worn around the neck of the king, was one of the principal royal insignia. The medallion of the Order of Christ unearthed at Ngongo Mbata also held in between its two articulated sides a piece of paper, likely an attestation of its owner's induction into the Order. The letters or pages pinned on the Pigorini mpu probably evoked such documents and turned them into emblematic signs. This transposition demonstrates a careful engagement on the part of the cap maker with the differences in artistic representation across media and across cultures. The letters also take part in the same kind of appropriation demonstrated in Álvaro VII's letter to the king of Loango, discussed below, in which writing—once a European import—serves as a medium for the expression of central African thoughts and values. Here, textile techniques bridge the gap between two modes of visual expression but also endow the European alphabet with the status and significance of a local emblem of power.[19]

Foreign Cloths, Local Habits

Power and elite regalia encompassed not only a political and religious dimension but also a social and economic one. The prominent role that textiles played in regalia formed a space of correlation that drew together wealth, power, and devotion. Textiles heralded in the Kongo, as in the wider

18. Vandenhoute, "De Begraafplaats van Ngongo Mbata," 63; Toso, *L'anarchia congolese nel sec. XVII*, 42. The collection date of the Pigorini mpu is unclear. Although it was recorded for the first time in 1876, it likely belonged to the Musaeum Kircherianum collection as early as the eighteenth century. See Bassani, *African Art and Artefacts*, ed. McLeod, 166.

19. See Jesuit Mateus Cardoso's description of the bag in 1622 in Brásio, ed., *Monumenta*, XV, 491–492. See also G. Schellings, "Importante découverte au Bas-Congo: Les ruines de la première église congolaise construite au XVIe siècle, à Mbanza Mbata dia Madiadia," *Le Courrier d'Afrique*, nos. 19–20 (August 1950), 13.

central African area, essential ideas of wealth and prestige. In addition to their prominent role in political insignia, they circulated as currency, served as construction material for palatial architecture, and inspired the decoration program of objects of luxury and status. Olfert Dapper's depiction of the textile-rich environment of central African courts in Figure 73, below, fleshes out the ubiquitous presence of textiles in elite spaces at all levels. In the Atlantic context, these ideas extended to the imported fabrics the kingdom's elite acquired from the foreign traders active in the region in exchange for copper and ivory but also for enslaved men and women. Cloth, metals, precious beads, and coral formed the main means of exchange on the central African coast, where they served as a visual expression of prestige. Girolamo Merolla da Sorrento insists, for instance, on the use of *missangas,* imported red glass beads, "coralli di vetro, portitali da Portoghesi," as both currency and personal ornament in Benguela, a coastal settlement in Angola; the same held true for the Kongo. Velvet cushions, European carpets, and silver crosses graced the royal court of the Kongo in the same manner that central African raffia cloth or ivory horns entered the treasure rooms of European rulers.[20]

Foreign traders paid careful attention to the central African elite's tastes and recorded their discriminating demand for foreign imports in a range of documents. For example, the ledgers of the Luanda-based Portuguese merchant Antonio Coelho Guerreiro, active between 1684 and 1692, provide detailed lists of what he deemed the most profitable items on the central African markets. Guerreiro brought into the region thin red-and-white-striped linens, Indian blue-striped cotton fabric, dark cotton cloth produced specifically for the African trade as well as thicker wools made in Portugal and fine taffetas, lamés, and silks. This inventory complements the one that Dutch merchant F. Cappelle left in a report to Johan Maurits van Nassau and the Oud West Indiche Compagnie around 1640, listing the merchandise that in his opinion the inhabitants of the Kongo and the neighboring kingdom of Loango most desired. Textiles, beads of coral or glass, and objects made of brass rank high on the list.[21]

All three categories that prominently featured on the merchants' lists—

20. Merolla and Piccardo, *Breve, e succinta relatione,* 69.

21. Joseph C. Miller, "Capitalism and Slaving: The Financial and Commercial Organization of the Angolan Slave Trade, according to the Accounts of Antonio Coelho Guerreiro (1684–1692)," *International Journal of African Historical Studies,* XVII, (1984), 1–56. See the French edition of Cappelle in Louis Jadin, "Rivalités luso-néerlandaises au Sohio, Congo, 1600–1675: Tentatives missionaires des récollets flamands et tribulations des capucins italiens, 1670–1675," *Bulletin de l'Institut Historique Belge de Rome,* XXXVII (1966), 229–230, 236–237. Alcohol and weapons also figured prominently in the overall exchange, in particular in the eighteenth century.

beads, copper alloys, and textiles—occupied a social and economic function at the intersection of currency and regalia in central Africa. As part of elite outfits or individually, they expressed closely interrelated ideas of wealth and power. In the Bantu linguistic zone to which the Kongo belongs, the lexica for wealth and power specifically share a strong etymological and symbolic bond. The social context of textile production and use further materialized this lexical connection. The finest central African cloths were the creation of high-ranking men who acquired the specialized technical skills necessary for their creation through exclusive training. Formal rules also directed the use and ownership of different categories of textiles according to social and political rank. The prestige associated with high-status local textiles then transferred to the imported cloths that entered the country through the hands of its elite. Foreign textiles thus became prized not only for their exotic origins and relative scarcity but also because of their association with the local elite, who controlled access to the most-prized local types and, by extension, conferred status to the newly available imports they eagerly sought and conspicuously wore.[22]

Wealth, then, and its interrelated attributes of political power and social prestige manifested themselves in the sartorial practices of the Kongo in terms that correlated the innovations a broadening world brought to the kingdom's shores with deeply rooted local views and practices. The social trajectory of checkered cloth in central Africa, an inexpensive European trade good, illustrates this correlation. The Kongo elite singled out and transformed this very recognizable import into an item of regalia that graced, for instance, the belt of the ambassadors in Figures 45 (Plate 18) and 47 (Plate 20), where it is shown alongside the animal pelt and the bright red sash, a juxtaposition that inscribed the foreign import into visual expressions of power rooted in central African thought. This articulation of local and foreign finery showcases an understanding of prestige that grew to rely on the ability to access Atlantic networks and to acquire imported goods.

The incorporation of foreign imports into local elite sartorial practices tells us much about the open attitude of the inhabitants of central Africa vis-à-vis novelties but also about their involvement in the slave trade, the main avenue through which foreign luxuries became available in the region. At

22. For the links between ideas of wealth and power, see Jan Vansina, *Paths in the Rainforests: Toward a History of Political Tradition in Equatorial Africa* (Madison, Wis., 1990), 73–74, 100. For textile making, see Andrew Battel, *The Strange Adventures of Andrew Battell of Leigh, in Angola and the Adjoining Regions; Reprinted from "Purchas His Pilgrimes,"* ed. E. G. Ravenstein, Works issued by the Hakluyt Society, 2d Ser., no. 6 (London, 1901), 10. See sumptuary laws described, for example, in J[ean] Cuvelier, *Relations sur le Congo du père Laurent de Lucques (1700–1717)* (Brussels, 1953), 56.

the outset, the Kongo rulers' early gestures of correlation that used foreign emblems and textiles as keys to shaping and heralding their new identity as a cosmopolitan, Christian elite contributed to establishing their status as an independent land and a valued diplomatic interlocutor for European powers. The adoption of foreign emblems, however, would also have a pernicious effect. The symbolic power of these insignia did not fade even in the context of intense competition for local control between elite lineages and warlords in the late seventeenth century and for much of the eighteenth century. On the contrary, to assert their power, contenders relied on the regalia that graced the great rulers of the past, creating a strong demand for foreign goods paid for chiefly in slaves, the region's predominant international currency. That demand and its cost in captives became an increasingly important factor of strife and instability in the weakened kingdom, fueling feuds and violent competition between potentates.[23]

The central Africans' involvement with Atlantic networks would seem to imply they were "Atlantic creoles," individuals or groups for whom contact with these networks brought change in a process that was directed outward toward greater commonality with Europeans and measured with the yardstick of Europeanization. They inhabited a space that functioned at the intersection of the three worlds connected by the ocean: Africa, Europe, and the Americas. They used European languages, professed Christianity, and promoted ecological changes with the introduction of new plants. Two crops imported from the Americas, in particular, corn and tobacco, quickly grew to be staples. Corn became central to the local diet, and tobacco was smoked "incessantly." Giovanni Belotti da Romano, among others, described the popularity of tobacco in the Kongo, unkindly concluding that central Africans would rather starve than give up smoking. These innovations went hand in hand with changes in daily life that to some extent brought Africans closer to their European interlocutors.[24]

However, although the Kongo elite embraced with enthusiasm some of these novelties, they did so on their own terms and managed the changes in a way that the concept "Atlantic creole" does not appropriately describe.

23. Joseph C. Miller discusses how "African consumers" occasionally "singl[ed] out a single color or pattern" according to their own taste rather than European values; see Miller, *Way of Death: Merchant Capitalism and the Angolan Slave Trade, 1730–1830* (Madison, Wis., 1988), 70. For a description of the role of the slave trade in the Kongo, see Linda M. Heywood, "Slavery and Its Transformation in the Kingdom of Kongo: 1491–1800," *Journal of African History,* L (2009), 1–22.

24. Ira Berlin, "From Creole to African: Atlantic Creoles and the Origins of African-American Society in Mainland North America," *William and Mary Quarterly,* 3d Ser., LIII (1996), 251–288; Linda M. Heywood and John K. Thornton, *Central Africans, Atlantic Creoles, and the Foundation of the Americas, 1585–1660* (Cambridge, 2007); Belotti, "Giornate apostoliche," 1680, AB 75, 146.

For them, novelties took part in a generative process of correlation through which they reinvented notions and expressions of prestige in the new Atlantic context. The once-foreign white-and-blue-checkered cloth did signify access to foreign trade and links to European trade routes, but it also worked in tandem with local regalia and eventually came to herald new notions of power. The cloth served as a space of correlation. Used in conjunction with animal pelts and other locally significant insignia, it recast the entire regalia of the Kongo elite as an expression of status that functioned within this broader Atlantic context. Yet the cloth simultaneously inscribed the novelties and the changes it encapsulated firmly within the realm of tradition as it became one of several modes of expressing might and prestige.

The new significance of the white-and-blue-checkered cloth as a central African emblem of power may seem trivial, but its enduring presence reveals otherwise. A century and a half after it appeared around the waist of the ambassadors to Recife, the checkered cotton continued to feature in nineteenth-century power figures created by the heirs to the Kongo kingdom (Figure 14 [Plate 7]). Wrapped around the bodies of *minkondi* as around those of powerful men in centuries past, combined with furs and raffia cloth, and knotted around nails and shards stuck into the figures' flesh to spring them into action, the checkered cloth continued in the eighteen and nineteen hundreds to signify and demonstrate might in awe-inspiring visual displays. The singular power that imported cloth was believed to yield in the region may also be measured in the short-lived prohibition by the kings of neighboring Kakongo in the eighteenth century to own or even touch foreign fabric or to give audience to courtiers dressed in them.[25]

Foreign items from near and far became indispensable necessities for the expression of prestige, power, and wealth. In 1666, Álvaro VII of Kongo (r. 1665–1666) appealed to his counterpart north of the Kongo River, the ruler of Loango, to obtain the imported fabrics he needed as he attempted to assert his authority during a time of civil war and aggression from Portugal. This exceptional letter, written in Portuguese, documents a transaction between two African kings whose realms functioned within overlapping local and long-distance networks of trade, diplomacy, and cultural norms. The note, which must have been intercepted by the Portuguese and is now in Lisbon, goes straight to the point: "Here comes my boy *[mosso]* so that Your Majesty, as my brother, may send me what is written in here and I trust that Your Majesty as a friend will send this." The king of Kongo here used the first person

25. [Liévin-Bonaventure] Proyart, *Histoire de Loango, Kakongo, et autres royaumes d'Afrique; rédigée d'après les mémoires des préfets apostoliques de la mission françoise; enrichie d'une carte utile aux navigateurs: Dédiée à monsieur* (Paris, 1776), 145.

and direct address so that the text would function as a record of his own spoken words. It was a distinctive use of writing technology, a doubling of the oral message surely also entrusted to the mosso. Álvaro VII—perhaps inadvertently in the course of his dictation, perhaps intentionally—acknowledges the unusual format of the request by mentioning the written medium within the body of the text. A palpable awkwardness appears from the situation, but Álvaro nonetheless deemed it useful, and probably the most efficient method for presenting a royal plea to his worldly colleague. Both the writing and the purpose of the letter highlight local uses of once-foreign but eventually wholly integrated materials and practices. The main part of the brief records a list of the items Álvaro sought: blue, red, and black velvet and silk cloth of the same colors. The Kongo ruler intended to "cut three capes" in each of these luxurious imported fabrics, crafting cloaks in the local fashion, the kind shown on the shoulders of the many high-ranking men pictured here.[26]

The overall language of the letter is Portuguese with varying degrees of Kikongo flavor. Álvaro describes the foreign merchandise in European terms. Qualitative ideas, however, come in turns of phrase typical of the two dialects of the Kikongo language he and his intended reader spoke. The quality of the fabrics clearly mattered. Álvaro insisted that the textiles "be beautiful" or, in his exact phrase in creolized Portuguese, "that they be things [each] with its perfection" ("couzas com a sua perfeição"). The Portuguese words here transpose not only Kikongo grammar but also larger Kongo aesthetic considerations. The phrase "with its" conveys the widely used Kikongo attributive *kia*. "Perfection," in turn, translates the idea of *mbote*, the Kikongo term for beauty understood in terms of strength, goodness, and wholeness. The text of the letter illustrates the linguistic, cultural, but also aesthetic diglossia of these early worldly kings, who, for all their reveling in imported luxuries, still judged them according to a local system of taste and used local turns of phrase to express quality, value, and beauty.[27]

In addition to overseas wares, Álvaro also asked for "different colors of the most excellent cloths that are in your lands," indicating that textiles circulated in kind from one region of central Africa to the other. Specifically, he asked for "escarlate vermelha," possibly the *dimba tukula* that Cuénot translates as "drap rouge" a century later. He also mentions "grão fino," literally "fine grain," maybe another type of cloth or possibly small corals or red beads. Finally, he asked for gunpowder and reveals why he needed the help of his neighbor to secure these items; he had ordered the closing of the roads in

26. "Carta do Rei D. Álvaro 7º do Congo ao Rei de Loango," Mar. 1, 1666, Arquivo dos Marqueses de Olhão, Núcleo Ultramarino, Angola, maço 40 A, doc. 30, Arquivo Nacional da Torre do Tombo.
27. Ibid.

his kingdom, presumably because of his continuing conflict with the Portuguese or one of his rivals from inside the Kongo. Álvaro's words portray a worldview that fully integrates once-foreign and once wholly local practices, semantics, and aesthetic values. Material and immaterial imports such as cloth and language enriched the central African region with an increasingly complex and multivalent material and cultural frame. Clearly, a single set of adjectives could refer to and qualify both cloth from Loango and imported silks, because the fabrics all took part in a single reality within which they enjoyed commensurate status and expressed similar ideas of prestige. Álvaro's letter demonstrates how his relationship to European novelties makes him more than an Atlantic creole. Its combination of different languages is not used as a tool of communication between the African interior and Europeans; rather, it is an inward-looking demonstration of the possibilities foreign technologies and merchandise afforded within a worldview anchored in local conceptions—albeit one rapidly changing in response to its interactions with a widening world.[28]

The Look of Sainthood

In addition to power and prestige, sartorial practices among the Kongo elite also reflected ideas of religious affiliation essential to their social and political standing. In Friar Giuseppe da Modena's colorful words, "All the blacks here are like as many Saints, with staffs on the end of which they put erected the Holy Cross, and with chaplets around the neck, so that they all look like Anchorites." Albert Eckhout's images of the Kongo ambassadors and the drawing of Garcia II in Figure 5 captured this enthusiastic adoption of medals, rosaries, and crosses by fortunate men in spectacular displays of wealth and religious affiliation. On one level, the religious paraphernalia functioned similarly to other imports, as precious rarities alluding to privilege, wealth, and power. The possession of medals and crucifixes proved one's access to the European missionaries who imported them or it denoted an ability to own the precious metals used in local creations, to mobilize the labor of artists trained in the exclusive technologies of metalworking, and to collect prototypes from which to access the wide but limited catalog of motifs. It is likely that many of the Kongo Christian objects were created with imported metal. The brass objects featured in the merchants' lists discussed above reappeared in the medals, chains, and crosses of elite outfits. The transformation of imported metal into Kongo objects illustrates once

28. Ibid.; Cuénot, "Dictionnaire françois et Congo," 1773, MS 525, 642, s.v. "rouge."

more the complex, nonlinear processes through which Kongo Christian visual culture emerged. Central African metalworkers transformed European brass trade items into Kongo objects such as crucifixes and figures of saints; these Kongo objects drew their form from earlier operations of religious and artistic correlation that had naturalized Christ and the saints into local characters. In this circular and cumulative operation of transformation and appropriation, ideas of wealth and power and also visual manifestations of prestige and Christianity were mutually reinforced.[29]

Brass saints worn as pendants were a common part of elite outfits in the Christian Kongo. Objects made from precious metals collected in the twentieth century, about three inches tall and distinguished by a suspension loop at their back, offer exquisitely detailed depictions of richly dressed figures understood to represent Saint Anthony of Padua, patron saint of Portugal, and the Virgin Mary on iconographic grounds as well as in light of twentieth-century identifications. Both figures are likely seventeenth- and eighteenth-century objects passed down through generations or more recent creations carefully recast from older prototypes. The pendants identified as Saint Anthony display the attributes of the Portuguese saint, Franciscan habit, often with the pointed hood of the Capuchin order, a cross, and an infant. The female figures are richly dressed and stand in a modest prayer pose, in the manner of the Marian images on Kongo crucifixes (Figures 54 [Plate 25] and 55 [Plate 26]). Both Saint Anthony and the Virgin enjoyed great popularity in the Kongo since its first contact with the Iberian kingdom, and particularly after 1650 under the impetus of the Capuchins, who were great promoters of both devotions.[30]

The popularity of the figures not only demonstrated the interest of the Kongo elite in Christian devotional objects but also materialized the connection between Christianity and social and political prestige. The Saint Anthony in Figure 54 (Plate 25), now in the Metropolitan Museum of Art in New York, stands hieratically on a pedestal; he holds in his right hand a cross

29. Monari, "Viaggio al Congo," Manoscritti Italiani 1380, Alfa N. 9–7, 148. See an example of a list of objects imported by the Capuchins in the Kongo in Scritture originali riferite nelle congregazioni generali, vol. 250, fol. 528r, Archivio Storico de Propaganda Fide, the Vatican. Metallographic analysis under way may confirm or disprove the hypothesis that crucifixes were made with imported brass.

30. For descriptions of pendants in the early modern period, see, for example, Luca da Caltanisetta's description in "Relatione del viaggio e missione di Congo fatta per me Fra Luca da Caltanisetta, missionario apostolico, olim lettore e predicatore cappuccino della provincia di Palermo nella Sicilia, nel 1689 sino al . . .," 1701, MS 35, 69r, Biblioteca Comunale di Caltanisetta, published with original pagination in Bontinck, ed. and trans., *Diaire congolais;* Romain Rainero, *Il Congo agli Inizi del Settecento nella relazione di P. Luca da Caltanisetta,* La Nuova Italia (Florence, 1974). For a discussion of the pendants in the twentieth century, see Rob L. Wannyn, *L'art ancien du métal au Bas-Congo,* Les Vieilles civilisations ouestafricaines (Champles par Wavre, Belgium, 1961), 40–41.

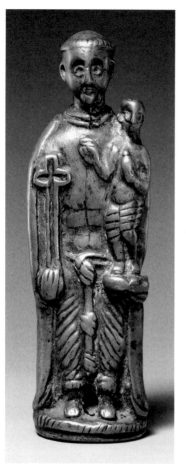 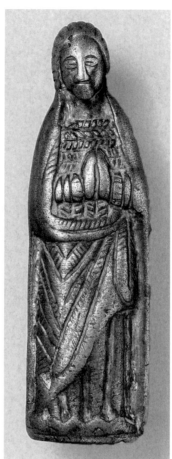

(left) FIGURE 54 Saint Anthony Pendant. Kongo kingdom, possibly seventeenth to eighteenth century. Brass, height 10 cm. The Metropolitan Museum of Art, Gift of Ernst Anspach, 1999, inv. 1999.295.1. Image © The Metropolitan Museum of Art

(right) FIGURE 55 Female Figure. Kongo kingdom, possibly seventeenth century. Brass, 9 × 3 cm. Private Collection. From Julien Volper, *Ora pro nobis: Étude sur les crucifix bakongo* (Brussels, 2011), 95, plate 24. Photograph, P. Louis, © P. Louis and J. Volper

and in the other, the child Christ, who is standing on a book. His tonsure, the carefully molded hood on his otherwise bare back, and the knotted cord he wears as a belt make him a convincing representation of the Franciscan saint. But the folds of his habit fall around his shoulders as a cape and drape around his legs as a wrapper. Incisions on his chest also suggest a muscular, bare torso. Is he Saint Anthony or a Kongo noble in full regalia that could readily join the ranks of the sangamento dancers in Figure 2 (Plate 1)? Is not the bicolored cross he holds that of the Order of Christ? Maybe his tonsure is a mpu, his knotted belt a red sash. The child Christ himself, who wears a wrapper and stands with his shoulders covered by a fold of the larger figure's coat, would easily blend into the ranks of other Kongo Christians dressed in their regalia.

Figurines of the Virgin invite even more ambivalent readings. The Virgin in the brass pendant in Figure 55 (Plate 26) wears large lengths of cloth, art-

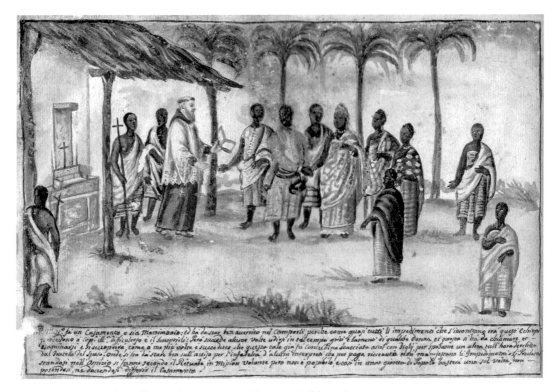

FIGURE 56 Bernardino d'Asti, *The Missionary Blesses a Wedding.* Circa 1750.
Watercolor on paper, 19.5 × 28 cm. From "Missione in prattica: Padri cappuccini ne
Regni di Congo, Angola, et adiacenti," MS 457, fol. 12v, Biblioteca Civica Centrale,
Turin. Photograph © Biblioteca Civica Centrale, Turin

fully draped and arranged in overlapping layers, enhanced with wavy lace at
her feet, and accessorized with stacks of necklaces and bracelets. Her resem-
blance to the elite women depicted in the watercolor in Figure 56 (Plate 27),
from the "Missione in prattica," is striking. In the painting, richly dressed
men and women gather around a priest in an outdoor chapel for a wedding
in the Kongo, or possibly in Angola, in the mid-eighteenth century. The
bride and her attendants are exquisitely wrapped in extravagant lengths of
imported textiles, dark wools and checkered and flowery cottons and linens.
Layers and patterns artfully enclose their bodies in a mix of vertical flounces
and sweeping diagonal drapes that closely echo the swooping lines of the
female brass figure. The makers of the figurine painstakingly molded and
etched the metal to evoke the different folds of light and heavy fabric and
to capture details of textures and patterns, including lacy hems rendered in
the metal with a wavy border. Elaborate coiffures enhanced with cloth and
ribbons, stacks of bracelets, and necklaces appear on both the metal figurine

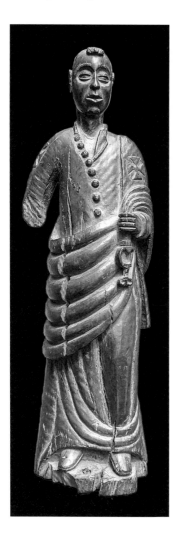

FIGURE 57 Saint Figure, Kongo
kingdom. Possibly eighteenth century.
Wood, height 50 cm. Private collection,
Brussels. Photograph, Cécile Fromont

and in the painting. The brass Virgin could join the women of the wedding
party. In addition to the metal pendants, other statues of the Virgin dressed in
rich local styles and textiles encompassed even more vividly the multivalent
connections between wealth, prestige, and Christianity in seventeenth- and
eighteenth-century central Africa.[31]

 The groom's outfit in the watercolor also echoes to some extent the brass
figure of Saint Anthony, but it offers an excellent parallel to another enigmatic
piece also collected in the twentieth century but in many regards linked to the
early modern period (Figure 57). The figure, almost fifty centimeters high, is

31. For dressed Virgin figures, see Louis Jadin, "Le Congo et la secte des Antoniens: Restauration du
royaume sous Pedro IV et la 'Saint Antoine' congolaise (1694–1718)," *Bulletin de l'Institut Historique
Belge de Rome,* XXXIII (1961), 499. Capuchins also brought to the Kongo papier-mâché heads and
hands to be clothed locally; see Bontinck, ed. and trans., *Diaire congolais,* 169, 209.

often described as Saint Peter because of the key-like object it holds in its left hand. The wooden figure as well as the groom of the watercolor wear tailored jackets and buttoned shirts in the European style juxtaposed with draped wrappers and cloaks. The man in the painting sports a gold chain across the chest as a sash and holds a black European hat in his left hand, possibly a beaver hat. The wooden figure displays the emblem of the Order of Christ on the right sleeve of his jacket and on the coat draped over his left arm. If the tonsure and facial features of the wooden piece point to the representation of a European, the articulation of clothing and regalia also links the figure to the Kongo elite. The wooden figure, the watercolor, the pendants, but also medals and crucifixes featuring similar imagery all captured the remarkable fluidity that existed between the appearance of the elite and representations of their saints. The ambiguity certainly contributed to making the distant holy men and women more familiar figures. Yet the presence of the same regalia also made manifest the three-way connection between social prestige, political might, and attachment to the Catholic Church. This link, in turn, encompassed a physical, bodily dimension as elite men and women wore the brass figurines, medals, and crucifixes as part of their finery. Figures and wearers visually echoed each other, a *mise en abyme* that further reinforced the interrelation between power, wealth, and Christianity.

Staffs and Mestres

Regalia and personal adornment expressed and enacted social status for the political elite but also for another category of prominent figures, mestres. Mestres, or church masters, were members of the elite who had received since childhood a Catholic education from European clergy or older mestres in schools attached to local churches. At the beginning of the sixteenth century, the first generation of Kongo elites received a European education in Portugal, where they resided as envoys of their central African king. The emblematic persona of this early practice is Henrique, the son of Afonso I, who studied in Lisbon and became bishop *in partibus infidelium* of Utica in 1513. Influenced by returnees and European missionaries, local centers of instruction soon emerged in the Kongo in the early sixteenth century and continued to thrive throughout the Christian era. The kingdom, commented Portuguese vicar Rui de Aguiar in 1516, "has schools, and they teach our holy faith to the people and [they have] also schools for girls taught by [the king's] sister." The Kongo crown and elite supported some of the schools, while missionaries founded and maintained others. Serafino da Cortona in 1660 reported on such a local school, the structures and organi-

zation of which remained independent of Europeans. The Jesuits attempted to found a college in 1548 during their short-lived early mission and finally succeeded during their second stay in the region. Their college opened in 1626 and enrolled the sons of the local elite and the Portuguese living in the capital of São Salvador. The Capuchins, in turn, instituted more modest schools at each of their missions that offered catechism as well as advanced instruction to a broader population. European schools as well as local structures that could continue to function without foreign instructors for decades formed an elite with fluent knowledge of Catholic catechism, of Portuguese as well as other European languages, of reading and writing, and, for the most advanced students, of Latin and rhetoric. The education system, at least in São Salvador, created a group of well-educated men, some of whom were able to matriculate to the Collegio di Propaganda Fide in Rome, as several protégés of the Capuchins did in the seventeenth century.[32]

Mestres came from these educated circles. They enjoyed great prestige, and only the highest of the elite could assume the role. Rulers often previously held the position, as did António II Barretto da Silva, *mani* of Soyo at the turn of the eighteenth century. Such a privileged situation created much competition, the "candidates being always more numerous than the positions." In addition to prestige and political opportunities, mestres also benefited from a range of privileges. They were exempt from tribute, from civil responsibility, and from military duties. They had the enviable right to be buried in the church, at an honored location, alongside the ordained priests. The mestres' responsibilities consisted of taking care of the church buildings and adjoining monumental crosses, educating and catechizing the people,

32. Specific references to mestres in the Kongo can be found as early as 1607 in MS Vat. Lat. 12516, fols. 26–35, 108v, Biblioteca Apostolica Vaticana. The Kikongo catechism of 1624, written before the arrival of the Capuchins, was composed with the help of the mestres; see François Bontinck and D. Ndembe Nsasi, *Le catéchisme kikongo de 1624: Réédition critique* (Brussels, 1978), 22. For the story of Henrique, see "Os Primeiros Missionários do Congo (1490-1508)," in Brásio, ed., *Monumenta*, I, 96. On local schools and curriculum, see "Carta do Vigário Rui de Aguiar a El-Rei D. Manuel (25-5-1516)," ibid., 361–363; Serafino da Cortona, quoted in Louis Jadin, "Le clergé séculier et les capucins du Congo et d'Angola aux XVIe et XVIIe siècles; Conflits de juridiction, 1700–1726," *Bulletin de l'Institut Historique Belge de Rome*, XXXVI (1964), 223. For the Jesuit college, see Bontinck and Ndembe Nsasi, *Le catéchisme kikongo de 1624*, 34; Franco, *Synopsis annalium Societatis Jesu*, 1625, paragraph 15, 245. For Capuchin schools, see Belotti, "Giornate apostoliche," 1680, AB 75, 179; Giovanni Belotti da Romano, "Avvertimenti salutevoli agli apostolici missionari, specialmente nei regni del Congo, Angola e circonvicini," 1680, MS 45, 93, Biblioteca del Clero, Bergamo; Juan de Santiago, "Breve relacion de lo sucedido a doce religiosos cappuchinos de la santa sede apostolica enbio por missionarios apostolicos al reyno de Congo; recopilada por uno y el mas minimo indigno totalmente de tan sublime ministerio; dedicada a Nr. Rm. Pe. Fr. Inocencio de Catalagirona, Ministro General de los frailes menores cappuchinos de Nr. Serafico Pe. S. Francisco," circa 1650, II/772, 104, Real Biblioteca del Palacio, Madrid. For Kongo students in Rome, see Giacinto da Vetralla in Scritture originali riferite nelle congregazioni generali, vol. 250, fols. 192–201, Archivio Storico de Propaganda Fide.

and transmitting their knowledge and function to the next generation of the elite who would ensure the continuation of the character and structure of Kongo Christianity over time.[33]

Mestres could exercise their office independently from ordained clergy. Christian prayers, rituals, and devotions survived for decades thanks to them, even in the absence of priests. This capacity played a crucial role in the Kongo, where a significant local clergy never emerged. Several attempts to create seminaries and promote the development of a local priesthood failed for reasons ranging from international conflicts between Portugal, Spain, and the papacy over *padroado* rights; internal resistance on the part of the elite to Episcopal authority over religious matters; and the often deplorable behavior of the clergy, who sometimes used their position to profit from alms or trade rather than to promote and organize the church. In spite of the endemic lack of priests, who were sometimes absent for decades, observers admired the ability of the inhabitants of the Kongo to continue to practice at least some of the Christian rituals, owing in large part to the teachings of the mestres. The Portuguese Franciscan visitor Rafael Castelo de Vide, for example, upon visiting the Kongo in 1780, marveled that, in places without a priest for eighteen years, he could "hear at night or in the early morning the prayers to Mary said at the bottom of a cross" or see "people kneel and start singing the Terce of Our Lady" at the prescribed hour, leaving behind any of their other business.[34]

If the mestres acted independently of ordained clergy, the missionaries, in contrast, depended heavily upon the mestres as linguistic as well as social translators. Although many of the Capuchin friars active in the seventeenth

33. For references to the prestige and competitive nature of the position of mestres, see Cuvelier, *Relations sur le Congo,* 68; Louis Jadin, "Andrea de Pavia au Congo, à Lisbonne, à Madère: Journal d'un missionnaire capucin, 1685–1702," *Bulletin de l'Institut Historique Belge de Rome,* XLI (1970), 446. On the privileges of mestres, see Bernardino d'Asti, "Missione in prattica," fol. 43, Biblioteca Apostolica Vaticana. "Vi sono alcuni maestri della terra che insegnago alla gioventú à leggere e scrivere e la dottrina christiana"; see Rosario del Parco "Informazione della Missione del Regno di Congo, e delli Stati di Conquista di Angola, e Benguella," circa 1760, Scritture riferite nei congressi, Congo, Angola, V, fol. 307r, published in Louis Jadin, "Aperçu de la situation du Congo et rite d'élection des rois en 1775, d'après le P. Cherubino da Savona, missionnaire au Congo de 1759 à 1774," *Bulletin de l'Institut Historique Belge de Rome,* XXXV (1963), 360.

34. The rights of padroado conferred by the papacy to the crown of Portugal in the fifteenth century gave authority over church affairs in overseas territories to the Iberian kingdom. For a discussion of secular clergy, see Jadin, "Le clergé séculier," *Bulletin de l'Institut Historique Belge de Rome,* XXXVI (1964), 186–483; Rafael Castelo de Vide, "Reino do Congo; Relação da Viagem, que fizeram os padres missionarios, desde a cidade de Loanda, d'onde sahiram a 2 de agosto de 1780, até á presença do rei do congo, onde chegaram a 30 de junho de 1781," *Annaes do Conselho Ultramarino; parte não official,* 2d Ser. (1859), 64–65. See also, in the nineteenth century, *Narrative of an Expedition to Explore the River Zaire, Usually Called the Congo in South Africa, in 1816 under the Direction of Captain J. K. Tuckey, R. N.; to Which Is Added, the Journal of Professor Smith* . . . (London, 1818), 79.

and eighteenth centuries learned to speak Kikongo and acquired a level of sophistication in the idiom that allowed them to participate in the redaction of dictionaries and grammars, they also univocally agreed on the difficulty of the task. Girolamo de Montesarchio, for example, despite his industrious efforts to learn the language, copying "a vocabulary, the rules of the language, the elements of catechism to prepare adults to baptism, and a method to hear confession," did not master Kikongo until, he believed, God himself finally intervened and gave him the gift of the language.[35]

Beyond the language barrier, mestres served as cultural interpreters. In sharp contrast to their colleagues who officiated in Latin America as part of a colonial project, European missionaries worked in the Kongo as guests of the kingdom's elite and could not work, in friar Giuseppe da Modena's own words, "without the consent of the people, and the secular arm of the Prince." Missionaries also had to learn and adapt to local variations in the conduct of pastoral work, liturgy, and sacraments with the help of the mestres. "The Blacks are distrustful of the white Europeans," Friar Belotti remarked in 1680 about the inhabitants of Congo and Angola, "so that with the presence of men from their nation as interpreters, and almost as witnesses and advocates in their defense, thus reassured, they remain more content in particular in the act of the sacramental confession." The role mestres played in the sacrament of confession illustrates their pivotal importance in the shaping of Kongo Christianity. In the vignette describing the method of confessing in the "Missione in prattica," a friar and an interpreter sit side by side, and a penitent addresses his confession to the mestre while the priest overlooks the conversation (Figure 58 [Plate 28]). According to the accompanying text, the arrangement is "the custom of the land" and remains valid even in the absence of a language barrier. Already in the 1580s, Carmelites reported the use of local middlemen in confession. The author of the "Missione in prattica" even warned that, no matter his proficiency in the language, "the missionary should not risk hearing confession in this country, without the help of the interpreter." Mestres not only structured the religious experience of the Kongo in the absence of European clerics; they formed the backbone of the organization of Christianity in the country within which foreign missionaries had to inscribe their apostolate. In the Capuchin watercolors, mestres often shadow the friars in the position of enablers rather than helpers. Descriptions of ceremonials such as the coronation mentioned in Dapper's 1668 *Naukeu-*

35. A discussion of the linguistic competence of the Capuchins can be found in Adalbert de Postioma, "Méthodologie missionaire des Capucins au Congo-Matamba-Angola, 1645–1834," *Revue du clergé Africain*, XIX (1964), 368–371. See J. Cuvelier and O. de Bouveignes, *Jérôme de Montesarchio, apôtre du vieux Congo*, XXXIX, Collection Lavigerie (Namur, 1951), 52.

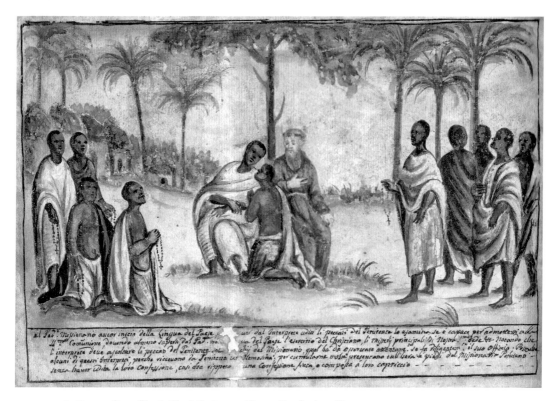

FIGURE 58 Bernardino d'Asti, *The Missionary Hears Confession*. Circa 1750.
Watercolor on paper, 19.5 × 28 cm. From "Missione in prattica: Padri cappuccini ne
Regni di Congo, Angola, et adiacenti," MS 457, fol. 8v, Biblioteca Civica Centrale,
Turin. Photograph © Biblioteca Civica Centrale, Turin

rige beschrijvinge also record their presence at the side of ordained clerics
even during the most solemn occasions.[36]

Holders of the prestigious office of mestre wore characteristic regalia
that signaled their position. A large piece of white cloth draped on the left
shoulder lends them a specific, recognizable look that makes them stand
apart from other characters depicted in the Capuchin watercolors. The white
textiles leave the mestre's right hand free to hold a staff, often topped with a

36. Monari, "Viaggio al Congo," 1723, Manoscritti Italiani 1380, Alfa N. 9–7, 172; Belotti, "Avverti-
menti salutevoli," 1680, MS 45, 93, 73; Bernardino d'Asti, "Missione in prattica," fols. 43–44, Biblioteca
Apostolica Vaticana; Dapper, *Naukeurige beschrijvinge,* 582. I have discussed confessions elsewhere
in "Collecting and Translating Knowledge across Cultures: Capuchin Missionary Images of Early
modern Central Africa," in Daniela Bleichmar and Peter C. Mancall, eds., *Collecting across Cultures:
Material Exchanges in the Early Modern Atlantic World* (Philadelphia, 2011), 134–154. See the Carmel-
ite history and description of Kongo in Vat. Lat. 12516, fols. 103–125, Biblioteca Apostolica Vaticana,
translated in J. Cuvelier and L. Jadin, *L'ancien Congo d'après les archives romaines (1518-1640)* (Brus-
sels, 1954), 119.

cross (Figures 18 [Plate 10], and 56 [Plate 27]). Some mestres, as members of the ruling elite, also wear a mpu cap. In addition, their outfits often include quantities of medals, rosaries, and other devotional objects, ostentatious signs of dedication to the church as well as of elite status. Overall, the mestres' attire formed a variation on the sartorial practices of the political elite. They wore similarly arranged rich lengths of draped cloth and devotional objects, both locally crafted and imported, as markers of wealth and social distinction. Parallel to the recombination of local and originally foreign attributes of political rule, mestres' outfits also reframed and juxtaposed attributes of local significance, such as the mpu, with emblems of prestige derived partly from Europe, such as processional, confraternity, and pilgrim staffs. The attire of the mestres and the political elite conveyed commensurate ideas of prestige, wealth, and power anchored in a Christian, worldly outlook. The significance of the white or light-colored cloth is difficult to interpret, and little more has been recorded than its appearance. The staffs, in contrast, offer a rich terrain to investigate the operations of combination and redefinition observed in the outfits at large. They encoded ideas of prestige, power, and attachment to Christianity with designs and motifs that echoed the reformulations observed in other genres of Kongo Christian visual culture.[37]

None of the numerous staffs collected in the nineteenth and twentieth centuries in regions that once answered to the Kongo crown can be directly attributed to the Christian period. Among this large corpus, however, are specific examples, the formal traits of which illustrate practices of the Kongo Christian era known through textual and visual descriptions. The cane in Figure 59 from Lisbon's Museu Nacional de Etnologia and the one in Figure 41, for instance, encapsulate many of the characteristics of mestre staffs. The first of these traits are the prominent knobs spaced along the length of the shaft. A long wooden stick used as a processional object in one of Giovanni Antonio Cavazzi's 1650s watercolors, for instance, provides a direct comparison and places this feature in a seventeenth-century context (Figure 78 [Plate 35]). The staff in the watercolor, here used as a candlestick, is directly reminiscent of turned wood, a technique common in Europe, examples of which the Ca-

37. For the uniforms of mestres, including their staffs, see Bernardino d'Asti, "Missione in prattica," fol. 43, Biblioteca Apostolica Vaticana. Dapper also describes the white outfit in *Naukeurige beschrijvinge,* 582. For textual references to staffs, see Monari, "Viaggio al Congo," 1723, Manoscritti Italiani 1380, Alfa N. 9–7, 148: "All the blacks, in the outside, as I said, they look all saintly, with staffs on which top they carry the Holy Cross, with rosaries around the neck so that they look like as many anchorites." See also Rafael Castelo de Vide, "Descricao da Viagem que fiz Para Angola e Congo o Missionario Fr Rafael de Castelo de Vide," 1780, Reservados 2, maço 4, doc. 74, 64, Sociedade de Geografia de Lisboa; Bernardino d'Asti, "Missione in prattica," fol. 43, Biblioteca Apostolica Vaticana: "Since they have a saintly vanity to be Christians and to baptize their kids, and to carry around the neck large Crosses and Crucifixes, others carry a Cross at the end of a walking sticks."

FIGURE 59 Mestre Staff, Kongo kingdom. Possibly sixteenth to nineteenth century. Wood, 118 cm. Museu Nacional de Etnologia, Lisbon, Portugal, inv. AI 206. Photograph, José Paulo Ruas, 2013. Photograph courtesy of Direção-Geral do Património Cultural / Arquivo e Documentação Fotográfica

puchins as well as Portuguese secular clergy could easily have introduced to central Africa in various forms of liturgical apparatus. Kongo artists also used the technique, mentioned in nineteenth-century documents as well as shown on several objects of wood and ivory collected in the twentieth century but of apparent antiquity. In the twentieth century, inhabitants from regions once part of the Kongo kingdom continued to associate this type of staff with the Portuguese- or Latin-derived name *santu spilitu,* or Holy Spirit, an appellation that could have emerged in the Christian period.[38]

In the case of many mestre staffs, however, central African artists created objects that replicated the formal effect of turned wood rather than directly used the technique. The Lisbon staff, for instance, displays round knobs and a shaft of varying thickness that recall the use of the technique. Yet its five parts do not connect on a common axis and lack the symmetry of objects created with the mechanical process. Instead, intricate hand carving created a plain elongated cone at the bottom, and a main, middle part was decorated with intricate textile-like low-relief motifs separated in three registers, each topped by a rosette-shaped bulbous knob. Finally, the top spirals into a vertical cylinder intersected by a plain rectangular transversal branch, together suggesting a cross. The knobs, the cross, and the textile motifs in the staff encoded ideas of prestige closely linked to the combinations articulated in Kongo Christian regalia at large. Appropriated foreign style in the knobs and partly adopted European emblems in the cross enter into dialogue with the intricate textile decorations of profound local significance to express ideas of prestige and power that are typical of the Kongo Christian era. As a space of correlation, the staff may be read as a Catholic object wrapped in central African empowered textile designs and, reciprocally, as a Kongo staff that summoned European formal features and Christian emblems in its discourse of prestige.[39]

38. The double-page vignette, *Funeral Procession of Queen Njinga,* is in the front matter of the first volume of Giovanni Antonio Cavazzi, "Missione evangelica al regno del Congo: Araldi Manuscript," 1665–1668, Araldi Collection, vol. A, book 2, chap. 16, between 210 and 211, Modena. For wood turning, see Marc Leo Felix, ed., *White Gold, Black Hands: Ivory Sculpture in Congo* (Qiquhar, Heilungkiang, China, 2010), 125–127. For *santu spilitu,* see Wannyn, *L'art ancien du métal au Bas-Congo,* 45.

39. Other mestres' staffs are housed in the collections of the Afrika Museum, Berg en Dal, Netherlands, and others are known merely through photographs; see Rob L. Wannyn, *Les Arts au Congo Belge et au Ruanda-Urundi* (Brussels, 1950), fig. 75.

Other correlations called upon figures of saints as finials, as seen in Figure 41, bringing the image of blessed men and women into the transactions of central African social relations. The crosses and images of saints not only referred to political and social prestige but also brought great power to the staffs, derived from the belief that they could conjure the invisible forces responsible for success, failure, ailments, and cures. The profuse number of objects produced in the Kongo that incorporated Christian motifs amply demonstrates their status as emblems of prestige but also as respected power objects. Crosses and saints provided trustworthy shields even in matters of life and death—in battle, for instance, where they provided soldiers with protection against wounds and defeat. They also brought comfort to their owners at the moment of passage from life to death, accompanying the deceased to the otherworld in their burials, as observed in Ngongo Mbata.[40]

Among the treasures unearthed at the eighteenth-century cemetery of Ngongo Mbata, a small pendant based on a coin imported from Portugal and reworked into a medal of Saint Anthony further illustrates the correlation operating in Kongo regalia (Figure 60). Like the sartorial practices of the Kongo Christian elite generally, the pendant challenged and to a large extent blurred distinctions between local and foreign. It creatively appropriated and reformulated central African and imported elements to form an entirely new object emblematic of Kongo Christianity. The current location of the pendant is unknown, but a photograph of it appeared in Victor Tourneur's 1939 study of medals from the Kongo. In 1947, Olivier de Bouveignes published a second, almost identical medal that had emerged in Luanda shortly before the excavation (Figure 61). The main part of each of the two pendants is a brass coin of twenty *réis* (sing: *real*), a Portuguese unit of currency. The coins were minted in Porto in 1697 and 1698 respectively for use in Africa, particularly Angola. On the obverse of each coin, a skilled metalworker delicately welded a low-relief depiction of Saint Anthony in Franciscan garb, holding a cross in his right hand and a child in his left. Above the head of the saint, the craftsman attached a suspension loop and, in one of the two pieces, a transversal cartouche bearing the Latin acronym INRI, a detail often observed on crucifixes crafted in the Kongo. He also cunningly placed the saint over the Portuguese coat of arms, in the middle of the coin, so that the decorative volutes that once framed the European escutcheon now brace the blessed man with glowing rays. In the Luanda pendant in Figure 61, the saint

40. See Felix, ed., *White Gold, Black Hands,* fig. 127 a, b. For the apotropaic role of crucifixes in battle, see Franco, *Synopsis annalium Societatis Jesu,* nos. 15–17, 217–273. See the discussion on crosses in Chapter 2, above.

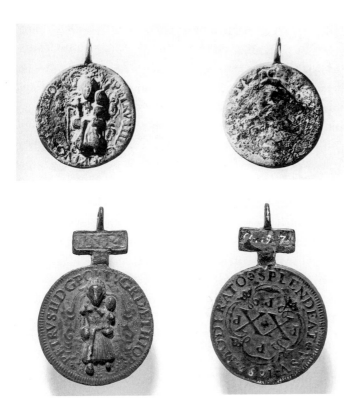

(top) FIGURE 60 Medal of Saint Anthony. Kongo kingdom, eighteenth century. Silvered copper, 3.6 cm. Excavated from Ngongo Mbata cemetery, Democratic Republic of Congo. Current location unknown. Image from Victor Tourneur, "Médailles religieuses du XVIIIème siècle trouvées au Congo," *Revue Belge de Numismatique et de Sigillographie*, XCI (1939), 21–26, plate II, 1. Photograph by the University of Chicago Visual Resources Center, courtesy of the Royal Numismatic Society of Belgium, Brussels

(bottom) FIGURE 61 Medal of Saint Anthony. Kongo kingdom, eighteenth century. Copper, 3.6 cm. Royal Museum for Central Africa, Tervuren, Belgium, inv. HO.1954.19.7. Photograph, J. Van de Vyver, Royal Museum for Central Africa, Tervuren ©

appears upside down from the alignment of the original designs and stands on the Iberian crown turned on its head. In the Ngongo Mbata example, the crown of Portugal graces the head of the holy man. The glorified, almost sarcastically anti-Portuguese position of the saint in both examples may link the medals to the Antonian movement, which peaked in the years surrounding the minting of the coins and promoted similar anti-European ideas. The reverse, only readable on one of the two examples, displays two *X*s, indicating the denomination of twenty réis in Roman numerals. The designs of this side remain formally untouched but in effect participate in a broad Kongo religious and political discourse of status, power, and legitimacy visually encoded in the figure of the *X*-shaped cross.[41]

41. Olivier de Bouveignes found the medal in an exhibition catalog published in Luanda; see Bouveignes, "Saint Antoine et la pièce de vingt reis," *Brousse: Organe trimestriel des "Amis de l'art indigène" du Congo Belge,* nos. 3–4 (1947), 17–22. See also Victor Tourneur, "Médailles religieuses du XVIIIème siècle trouvées au Congo," *Revue Belge de Numismatique et de Sigillographie*, XCI (1939), 21–26; Alberto Gomes and António Miguel Trigueiros, *Moedas portuguesas na época dos descobrimentos, 1385–1580 / Portuguese Coins in the Age of Discovery, 1385–1580* (Lisbon, 1992). The Antonian movement was a prophetic movement that emerged in the era of the civil war; see Chapter 4, below.

The medals embodied a gesture of appropriation that, far from a simple recasting of local and foreign, followed the cumulative logic of correlation typical of other Kongo Christian objects. The artists used two motifs essentially of European origins as means to transform the foreign coin into a central African medal. The image of Saint Anthony of Lisbon transforms the Portuguese coin into an object that called upon central African forms of devotion in which the saint and his visual characteristics played a central, evocative role. The Roman numeral for twenty, XX, similarly places the image of the Christian saint into the new context of Kongo religious thought. The numeral of foreign origin casts the pendant into a specifically Kongo visual and symbolic realm in which the *X*-shaped cross encodes multivalent notions of power, legitimacy, and the supernatural. It then enters into dialogue with crucifixes, monumental crosses, emblems of the Order of Christ and, with them, takes part in the layered and cumulative process of correlation through which Kongo Christianity emerged and evolved.

Heralding Kongo Christianity Abroad

The correlation operating in Kongo Christian regalia also contributed to elevating the status of the Kongo in the early modern Atlantic world. The slave trade factored heavily in the visibility of the kingdom on the global scene, but the close relationships the kingdom cultivated with the ruling elite of Europe—from Portugal and Rome to the Low Countries—through correspondence and diplomatic representations also shaped how it was perceived from Europe. A rich visual archive remains of these activities. Images of elegantly attired Kongo diplomats in paintings, prints, medals, and exquisite objects of wondrous form and exotic flair sent from the kingdom document how the Kongo presented itself on the international scene and chronicle the reception of its efforts in European courts. Yet, although the diplomatic efforts of the kingdom met with some success, the images and objects associated with them soon lost their original significance and faded into more prominent genres of European visual culture and their associated epistemological realms. Diplomatic gifts entered cabinets of curiosity where they became exotic specimens often without acknowledged links to Africa, and portraits of Kongo ambassadors were interpreted as generic representations of exotic peoples or grouped alongside images of black servants. The 1674 inventory of the Royal Danish Kunstkammer in Copenhagen, for example, described the portrait in Figure 67 (Plate 31), below, generically as "a moor with a hat with a red feather." Because of this trend, many impor-

tant early modern depictions of the central African elite have not received scholarly attention as documents of African history.[42]

A striking example is the reworking of Albert Eckhout's portraits of the Kongo ambassadors to Brazil, discussed above, into cartoons for tapestries by the French Gobelins factory. Works such as *Le roi porté par deux Maures (The King Carried by Two Moors)* (Figure 62 [Plate 29]), manufactured after the cartoons between 1687 and 1740, feature some of the most precise depictions of Kongo dress and regalia of the period. The image of the so-called king in the hammock draws from the portrait of the ambassador in Figure 47 (Plate 19) and presents his regalia in even more detail. He wears a tall red-and-white mpu adorned with shells and triangular decorations in alternating white and black. A golden cross, perhaps of the Order of Christ, and two rows of coral beads falling beyond his waist hang from his neck. A red sash, white fur, and blue-checkered cloth cinch at the waist a rich yellow loincloth. A bow, arrows, and a quiver complete his look. The two men carrying the hammock also showcase detailed Kongo finery derived from Eckhout's paintings of the two junior envoys. Both wear nkutu nets over the shoulder and animal pelts around the legs. Tucked at the waist of the left bearer is a cloth depicting the geometric motifs common on Kongo textiles, as illustrated in Figure 72, below. The fringed border of the carrier to the right also hints at a finely worked raffia cloth. Yet the tapestry's detailed renderings, in their new context as palatial decoration in Europe, carried for their viewers little or no connection to the Kongo. Upon their arrival in France in 1679, the paintings sent from ex-governor of Dutch Brazil Johan Maurits van Nassau to Louis XIV that served as the basis for the tapestry cartoons described the scene as "representing how the Principal Negroes in Angola are carried in a hammock." A 1690 inventory of the cartoons, however, described the tableau as merely "a black King carried by two slaves, said King carrying an arrow."[43]

Research on images of Africans in early modern European art have endeavored to sort the portraits from the types, the eyewitness documents from

42. On the generic classification of African objects, particularly in Italian collections, see Ingrid Greenfield, "A Moveable Continent: Collecting Africa in Renaissance Italy" (Ph.D. diss., University of Chicago, forthcoming). The inventory appears in P. J. P. Whitehead and M. Boeseman, *A Portrait of Dutch 17th Century Brazil: Animals, Plants, and People by the Artists of Johan Maurits of Nassau* (Amsterdam, 1989), 173.

43. "Le tableau representant, comme les Principaux Nègres en Angola se font porter dans une hamaque"; see Whitehead and Boeseman, *A Portrait of Dutch 17th Century Brazil*, 129; "Un Roy naigre porté par deux esclaves, lequel Roy tiens une flèche"; see M. Maurice Fenaille, *État général des tapisseries de la Manufacture des Gobelins depuis son origine jusqu'à nos jours, 1600–1900* (Paris, 1903), II, 372. For the Gobelins cartoons, see ibid., 371–378.

FIGURE 62 *The King Carried by Two Moors (Le roi porté par deux maures),* Anciennes Indes series. Eighteenth century. Manufacture des Gobelins tapestry, France, wool and silk, 384 × 355 cm. After cartoons by Albert Eckhout. Photograph courtesy of Instituto Ricardo Brennand—Recife—PE—Brasil

the fanciful allegories and have greatly refined our knowledge of Europe's understanding of race and difference in the rapidly expanding early modern world. Looking at this visual archive with a clearer understanding of Kongo Christian visual culture allows us not only to understand better European views of the African realm but also to recognize the Kongo elite's own agency in fashioning their image and staking out a presence abroad. As the central African ruling class transfigured itself into a Christian aristocracy, it also brought to Christendom through its ambassadors the new and in some regards influential figure of the Kongo Catholic noble.[44]

Throughout the early modern period, the Kongo crown implemented an active diplomatic agenda, corresponding with and dispatching ambassadors to European courts. The emissaries sometimes were Europeans whom the king entrusted to use knowledge of their native lands to conduct his affairs. Yet Kongo men also often confidently set off for Europe to carry out their monarch's business with a keen understanding of the status that their conversion to Christianity should ensure them among other Christian princes. Except for the intriguing figure of the "Manicongo" king in the 1558 "Queen Mary Atlas," there are no extant European depictions of Kongo elites from the sixteenth century before the publication of the influential *Relatione del reame di Congo et delle circonvicine contrade* in 1591, which was based on the testimonies of Portuguese-born ambassador of the Kongo, Duarte Lopes (see Figure 43). Only luxury objects kept in cabinets of curiosities, such as the carved ivories and similar items found in the Medici collection, seem to have represented the Kongo in the Italian territories of the cinquecento (see Figure 21). The many central Africans residing in Portugal in the sixteenth century did not become the subject of known visual representations either. In contrast, the next half century saw a proliferation of depictions of Kongo nobles in European visual culture, reflecting the African realm's invigorated diplomatic agenda. Through correspondence, embassies, and gifts, the rulers of the Kongo endeavored to position themselves advantageously in relation to the events and shifting allegiances that rocked the geopolitical landscape of the troubled global scene in the seventeenth century. In parallel, Europe's overseas interests also intensified at that time and spread rapidly beyond the Iberian sphere; the post-Tridentine church became increasingly involved in extra-European evangelization. The visit of António Manuel, envoy of the

44. See, for example, the discussions of Africans in Renaissance art in Joaneath A. Spicer et al., eds., *Revealing the African Presence in Renaissance Europe* (Baltimore, 2012). See also the series edited by David Bindman and Henry Louis Gates, Jr., *The Image of the Black in Western Art,* new ed. (Cambridge, Mass., 2010–).

king of Kongo to Portugal, Spain, and Rome between 1604 and 1608, engendered, in this context, an unprecedented reception and artistic celebration.[45]

The beginning of the seventeenth century marked a particularly delicate period for the Kongo and its relationship with Europe, owing in large part to the incorporation of Portugal into the Spanish crown between 1580 and 1640 and to the heightened conflict between Dutch and Iberian interests both in Europe and in the southern Atlantic. This era was also one of increased pressure on Kongo territories from the colony of Angola, strategically founded by the Portuguese in 1575, at the kingdom's southern frontier. Under such circumstances, the Kongo launched into a range of diplomatic negotiations with Holland, Spain, and Rome, seeking alliances and political support that would buttress its position as an independent, Catholic realm and keep Portuguese ambitions in check. António Manuel's visit was part of these efforts. The goal of the trip, according to extant archival records, was to ensure the standing of the Kongo king among Christian princes and to establish a direct relationship between the kingdom and Rome. The Kongo demanded recognition as a direct vassal of the pope, a strategic move that would effectively end the oversight that Portugal enjoyed over the central African church under the padroado, or patronage rights, on overseas religious affairs bestowed by the papacy to Lisbon in the course of the fifteenth century. This demand responded to the shortcomings of the preceding embassy of Duarte Lopes, during which the pope invoked the padroado and refused to consider the requests of the king of Kongo. Direct allegiance to Rome and the recognition it conferred on the kingdom as an independent, Catholic land would also help protect the realm against territorial invasion by Portugal through Angola. António Manuel had convincing arguments to sway the pope. As overlord, the papacy would receive part of the kingdom's precious ore; it would also be associated with the crusading efforts of the Kongo monarchs, who had already succeeded in converting several of their neighboring rulers. These proselytizing efforts were particularly important because they seemingly forged a path toward the realm of Prester John, Europe's legendary

45. Homem, "Queen Mary Atlas," 1558, Department of Manuscripts, Add. MS 5415A, fol. 14r. See the images included in [Lopes and Pigafetta], *Relatione*. A good summary of António Manuel's visit is published in Luis Martínez Ferrer and Marco Nocca, *"Coisas do outro mundo": A missão em Roma de António Manuel, Príncipe de N'Funta, conhecido por "o Negrita" (1604–1608), na Roma de Paulo V: Luanda, exposição documental* (Vatican City, 2003). African objects in early modern Italian collections have been discussed, for example, in Ezio Bassani, "Oggetti Africani in antiche collezioni Italiane, 1," *Critica d'Arte*, XLII, no. 151 (1977), 151–182; Bassani, "Oggetti Africani in antiche collezioni Italiane, 2," ibid., no. 154 (1977), 187–202. See the essay on António Manuel in Paul H. D. Kaplan, "Italy, 1490–1700," in David Bindman and Henry Louis Gates, Jr., eds., *The Image of the Black in Western Art from the "Age of Discovery" to the Age of Abolition: Artists of the Renaissance and Baroque* (Cambridge, Mass., 2010), 93–190.

Christian ally beyond Muslim territories. Indeed, the ambassador cunningly sought permission from the pope to start building a road from the Kongo to Prester John's lands.[46]

The ambitious visit in reality suffered from disastrous travel conditions, difficulties made by the disdainful king of Spain, Philip III, and simple ill fortune. António Manuel died only days after reaching Rome and never officially appeared in front of Paul V. Symbolically, however, the visit had a deep impact on the Roman imagination and contributed to shaping the papacy's visual vocabulary of cosmopolitanism. In the years following the short-lived embassy, a range of artwork was created that featured the figure of the Kongo Christian noble drawn from the image of António Manuel. These works demonstrate the keen interest that the ambassador elicited in Rome; they also illustrate how his image as a metonymy for the Christian Kongo was strategically put to work in politically driven papal artistic commissions.

That the pope took a personal interest in the visit of António Manuel is clear. He hosted him in his palace, visited him on his sickbed, and, upon the envoy's passing, financed his funeral and ordered his death mask to be taken. António Manuel's visit aligned with papal interest in overseas evangelization. Kongo Christianity had recently been on the minds of Romans with the visit of Lopes as envoy of the king of Kongo in the 1580s, the publication in the city of Lopes's account of central Africa in 1591, and the closely related elevation of the Kongo's capital, São Salvador, to bishopric in 1595–1596. The visit of the

46. For an analysis of the geopolitical situation in this period that centers on Kongo, see John Thornton and Andrea Mosterman, "A Re-interpretation of the Kongo-Portuguese War of 1622 according to New Documentary Evidence," *Journal of African History,* LI (2010), 235–248. See also Jadin, "Rivalités luso-néerlandaises au Sohio," *Bulletin de l'Institut Historique Belge de Rome,* XXXVII (1966), 137–337. A summary of the instructions to António Manuel written in São Salvador, June 29, 1604, are found in Vat. Lat. 12516, fols. 47–49, Bibiblioteca Apostolica Vaticana, and another Letter from Álvaro II to Clement VIII, written in São Salvador, July 3, 1604, is in Miscellanea Armario I (91), fol. 200r–v, Archivio Segreto Vaticano; these documents are published in Brásio, *Monumenta,* V, 121–122. The other petitions are listed in Misc. Arm. XV (101), 51–52v, Archivio Segreto Vaticano, published ibid., 369–371. For Lopes's earlier diplomatic mission, see [Lopes and Pigafetta], *Relatione,* book II, chap. 6, 60–66. Álvaro I had already offered some mines to Clement XIII via the embassy of Duarte Lopes in 1583–1591; see Teobaldo Filesi, *Le relazioni tra il regno del Congo e la Sede apostolica nel XVI secolo* (Como, 1968), 150–151. For a discussion of the *padroado régio,* or royal patronage, see António Da Silva Rego, *Le Patronage Portugais de l'Orient: Un aperçu Historique* (Lisbon, 1957); Isabel dos Guimarães Sa, "Ecclesiastical Structures and Religious Action," in Francisco Bethencourt and Diogo Ramada Curto, eds., *Portuguese Oceanic Expansion, 1400–1800* (New York, 2007), 257–259. Although there is no mention of the road to Prester John's realm in the papers concerning the visit of António Manuel, a 1620 document mentions that "opening the road from Congo to Prester John" was "one of the most important things that the ambassador D. Antonio Manuele, who died in Rome, had to discuss with Pope Clement"; see "Relazione data a Monsignrore Accorambono . . . circa la strada . . . ," in Brásio, *Monumenta,* VI, doc. 143, 492 (quotation). Among Europeans, the perceived location of Prester John's lands moved over time from China to India and eventually, in the seventeenth century, was placed in Abyssinia. At the time, the Congo River and the Nile River were thought to flow from a common source.

ambassador from the African Christian kingdom was, therefore, cause for celebration. The fortunate coincidence of his visit with the epiphany, the day on which his official reception should have occurred but on which his funeral took place instead, offered a convenient theme for the ceremonials, which would echo the arrival of the faraway magi, or three kings, to Bethlehem. In spite of the premature death of the ambassador, Paul V and, after 1623, Urban VIII used the visit as an illustrative cameo of their foreign-policy ambitions. A lavish funeral for António Manuel brought his remains to Santa Maria Maggiore, a church known for its *presepe,* or crèche, and where a monument marked his tomb, later enhanced in 1629 with a polychrome marble bust by Francesco Caporale (Figure 63 [Plate 30]). A 1608 papal medal portrays the apocryphal reception of the ambassador by the pope (Figure 64), a 1610–1611 fresco in the Sala Paulina of today's Vatican Library shows Paul V at António's deathbed, and a 1616–1617 depiction of a Kongo ambassador is among the figures of the Quirinal Palace's Sala Regia. Finally, several engravings created shortly after the events also contribute to the *fama* of the visit (Figures 65 and 66).[47]

Many of the pages written about these images of António Manuel focus on the proportion of savagery and civilization lent to him by the artists in view of the peculiar mix of European and exotic attributes displayed in his portrayals. Although these discussions are important for exploring the European perspective on Africans at the time, they understandably suffer from a lack of knowledge about Kongo sartorial practices. As a consequence, they pay little heed to the part that the ambassador and his retinue played in the construction of their own image. The above discussion of Kongo elite regalia, however, allows for different interpretations. The portrait bust of António Manuel, for instance, carved from his death mask in a polychrome marble, provides a detailed depiction of not only the physiognomy of the ambassador but also his regalia (Figure 63 [Plate 30]). Francesco Caporale, almost twenty years after the death of António, minutely carved the nktutu net, the coat loosely draped over the shoulders in the Kongo fashion as well as arrows and quivers, and he elegantly transitioned the red belt and wrapper into the bust's pedestal. Similarly, the papal medal struck in 1608 portrays the short-haired, bearded ambassador apocryphally kneeling in front of Paul V, clad in the nkutu, a wrapper covering his legs, and a coat loosely hanging from

47. Black magi were not as common in Roman art as they were in artwork from other regions of Europe, but the date was propitious for the arrival of an exotic envoy. For a discussion of black magi in Italian art, see Kaplan, "Italy," in Bindman and Gates, eds., *The Image of the Black in Western Art,* 93–190. Kaplan also describes papal ambitions against secular powers, in particular the Holy Roman Empire, and discusses these artworks.

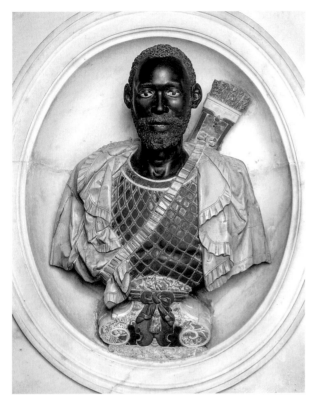

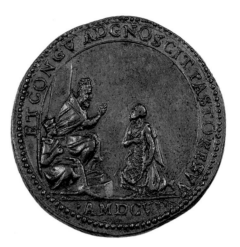

FIGURE 63 Francesco Caporale, *Bust of António Manuel ne Vunda*. 1629. Polychrome marble. Santa Maria Maggiore Baptistry, Rome. Photograph, Mario Carrieri, Milan / The Menil Foundation

FIGURE 64 Commemorative Medal of the Embassy of António Manuel ne Vunda (ambassador of Álvaro II, king of Kongo) to Paul V Borghese. 1608. Bronze, 3 cm. Biblioteca Apostolica Vaticana, Vatican City, Medaglie papali, nn. 1435, 1436. Photograph © 2013 Biblioteca Apostolica Vaticana, reproduced by permission of the Biblioteca Apostolica Vaticana, with all rights reserved

his shoulders (Figure 64). These artworks, in other words, do not depict the ambassador in clothing vaguely evocative of exotic lands; they represent the specific details of Kongo Christian elite insignia.[48]

Two prints preserved together in the exemplar of Duarte Lopes's *Relatione del reame di Congo* in the Biblioteca Angelica in Rome gives the measure of the political moment invested in the trip of António Manuel and outlines the reception of the image that the Kongo diplomats projected of themselves (Figures 65 and 66). Both prints were published in 1608 by the Roman publisher Giovanni Antonio de Paoli, who was closely linked to the pope. They each present the likeness of António Manuel in an elaborate architectural

48. For an analysis of the artworks, see Kate Lowe, "'Representing' Africa: Ambassadors and Princes from Christian Africa to Renaissance Italy and Portugal, 1402–1608," Royal Historical Society, *Transactions*, 6th Ser., XVII (2007), 101–128. For a discussion of the medal and a bibliographical summary, see Martínez Ferrer and Nocca, *"Coisas do outro mundo,"* 111–114.

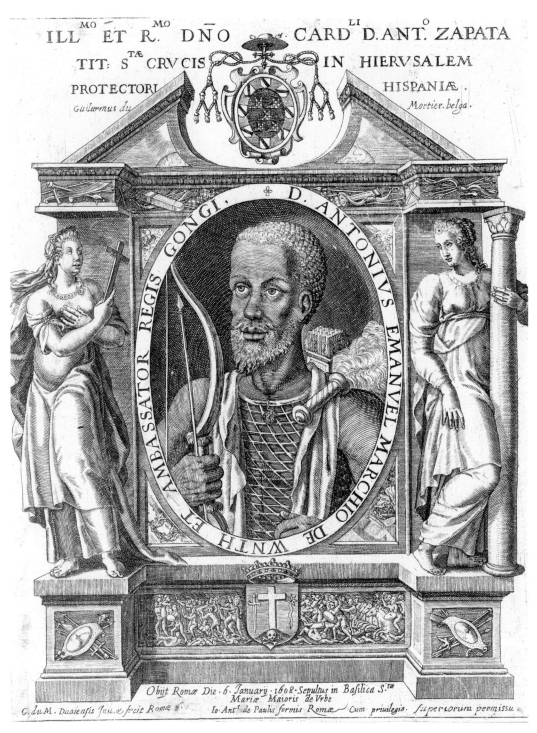

FIGURE 65 Guillermus du Mortier, *Don Antonio Manuel, marquis of Wnth, and Ambassador of the King of Kongo*. Rome: Giovanni Antonio di Paoli, 1608. Engraving, 25.3 × 19.4 cm. Private Collection, London

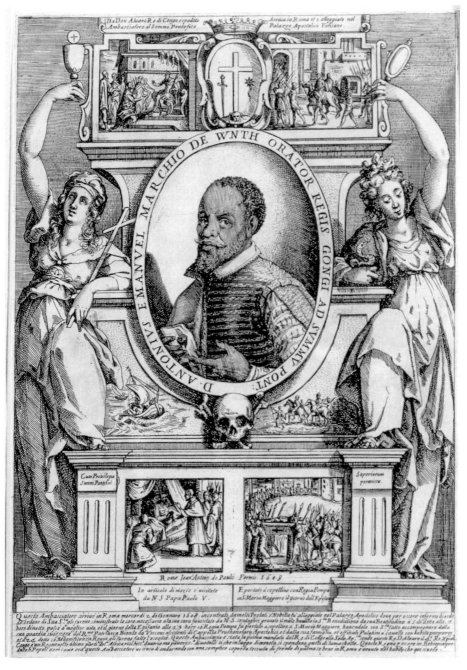

FIGURE 66 Attributed to Raffaello Schiaminossi (Italian, 1572–1622), *Don Antonio Manuele de Funta, Ambassador of the King of the Kongo to the Pope*. Rome: Giovanni Antonio di Paoli, 1608. Etching and engraving, 27.5 × 19.7 cm. The Baltimore Museum of Art: Purchased as the gift of Lorraine and Mark Schapiro, Baltimore, and Print & Drawing Society Fund, inv. BMA 1997.155. Photograph courtesy of the Baltimore Museum of Art

frame enhanced with allegorical figures and small scenes from the journey of the ambassador. The first, authored by Guillermus du Mortier, was commissioned by the Spanish cardinal Antonio Zapata y Cisneros, since 1606 cardinal-priest of Santa Croce in Jerusalem and soon to serve as the official representative of Spain in Rome. The portrait of António at the center of the print is encircled by a Latin inscription, "D. Antonius Emanuel Marquis of Wnth [sic] and Ambassador of the King of Kongo." Allegorical figures of Faith and Fortitude frame the cameo. Directly under the bust, a coat of arms is surrounded by a battle scene in which men using bows and arrows retreat under the assault of sword-bearing troops and cavalry. The escutcheon resembles that of the Spanish Inquisition, which Zapata led, but could also have derived from the coat of arms that António, as a prominent Kongo noble, would have possessed. The iconography of the escutcheon could echo known Kongo heraldic emblems, such as the prominent sword, the large cross, and, to the right, possibly a representation of a celestial apparition. The battle scene juxtaposed with the coat of arms would then make sense as a depiction of the battle in the story of the founding of the Christian Kongo.[49]

The ambassador appears here in indigenous Kongo regalia, with his muscular arms and chest bare under a fine nkutu net decorated at the neck with a medal and with a long span of fabric draped over his shoulders under a fly whisk. The martial iconography suggested by the battle scene and the weaponry shown in the architectural frame echoes the attributes António carries, bows and arrows in his tightly clenched right fist and a quiver on his back. His travels to Rome are suggested in the four triangular vignettes around the cameo, showing clockwise from the top right his journey by sea, his trek on horseback, the visit of the pope to his deathbed, and his body carried on a pall. Overall, the print presents António as a strong and exotic warrior whose might is literally and metaphorically framed by his Faith and Fortitude. The Kongo man represents just the kind of powerful, Christian ally that Rome sought in support of its project to expand its direct influence overseas. The pope's interest in António Manuel seems to have quickly changed Spain's attitude toward the ambassador. No longer was he disdainfully dismissed by the king as he had been before in Madrid; instead, as depicted in the print, he was positioned as an important figure within the orbit of Spain and under the auspices of one of its most prominent cardinals.

The second print, attributed to Raffaello Schiamiossi, presents, in con-

49. For the volume containing the two prints, see inv. II 7. 24, Biblioteca Angelica, Rome. The illustrations used here are not from the Biblioteca Angelica but are from better-preserved prints in other collections. The word "Wnth," or "Vunth," in the title of the two prints refers to "Vunda," a part of the Kongo name and title of António Manuel.

trast, António Manuel clad in European garb with the attributes of his role; he holds a folded and sealed letter in his right hand and points his left index finger in the attitude of speech toward the missive. The allegorical figures framing the central portrait evoke the diplomatic virtues of Faith and Prudence. The Latin inscription around the cameo also insists on the diplomatic mission of the African man, "Don Antonio Emanuel Marquis of Wnth *[sic]* Envoy of the king of Kongo to the Sovereign Pontiff." The four vignettes above and under the cameo present the eventful story of the embassy. At the top left, António kneels in front of Álvaro, king of Kongo, who gives António his benediction. To the right, the envoy arrives at the papal palace on horseback. At the bottom left, Paul V visits the ambassador on his deathbed, and, to the right, a large funerary cortege brings his body to rest in Santa Maria Maggiore "with regal Pomp . . . on the day of the Epiphany." Directly under the portrait, a ship at sea and men traveling on horseback evoke the rest of the voyage. These two scenes as well as the ones at the bottom are also the episodes included in the first print. The same coat of arms features above the bust, and under it is a skull and bones as a fitting *memento mori*. A text at the bottom of the print tells the story of António's travels and death and provides information on the Kongo, ruled by its "fourth Christian king," located in "the furthest part of Africa," and "very rich in ivory but very poor in metals." It also explains the appearance of the ambassador in the portrait. The people of the Kongo are all black like him, it notes, and "there is the custom to go naked with a simple cover of palm-frond cloth, but he [António] came to Rome in the clothing seen here."[50]

The ambassador's appearance clearly was a concern for contemporary observers. A detailed description of António in the Papal Ceremonial Diaries entry for January 2, 1608, stressed, in terms similar to the prints, his "noble appearance" and his "black face and flesh" and characterized him as "pious, devout, and very zealous of the Catholic Church" as well as "very prudent." The two prints depict the central African envoys in rich and specific detail. Far from token, formulaic representations of black men as servants or savages, these images captured the likeness of the Kongo man dressed as a European gentleman or in his impressive regalia of African Christian nobles. It is significant that António Manuel would be represented in his Kongo regalia in the presence of the pope when cermonies at the papal court were regulated by exacting sumptuary laws. In highlighting the foreign, exotic

50. For the print's attribution, see Spicer et al., eds., *Revealing the African Presence in Renaissance Europe*, 135. A broadsheet showing António Manuel, after Figure 66, appeared in the year of the ambassador's death in northern Europe with a German-language gloss; see John Roger Paas, *The German Political Broadsheet, 1600–1700* (Wiesbaden, 1985), 201.

features of the ambassador and, through him, the Kongo Christian kingdom, these images suggest a larger strategy by the papacy to showcase the span of its influence in an age marked by competition among European powers to encompass the world. This strategy is perhaps best illustrated in the frieze in the reception room of Rome's Quirinal Palace; a Kongo man is conspicuously placed among other envoys from faraway lands of particular missionary interest, including Japan and Persia. But, beyond the European perspective on António's visit, these images provide strong evidence for Kongo agency. They demonstrate that António and his entourage of Kongo men arrived in Rome prepared to make a full display of their African Christian regalia and, indeed, modeled it on subsequent occasions during the trip in displays from which Roman artists derived their images.[51]

The Sala Regia of the Quirinal Palace—in which frescoes painted between 1616 and 1617 form a visual manifesto of Paul V's foreign interests—also included a portrait of a Kongo ambassador probably inspired from António. There he appears among other distant envoys, but he alone wears European garb. An attendant standing close to him holds a large sword, which may be a reference to Kongo regalia in general, and possibly to António Manuel's coat of arms in particular. Directly facing the Kongo ambassador, across the ceremonial hall, is another African man wearing, notably, a large yellow cloak draped over his shoulders and a netted shirt reminiscent of the Kongo nkutu. This figure, generally understood to be an ambassador from the Christian kingdom of Ethiopia, thus appears in recognizably central African clothing, a revealing sign that the image of the Kongo Christian noble served at the time as the template for representations of African Christianity.

A comparison of the Roman visit with the one to Dutch Brazil in the 1640s, discussed above, helps us better understand how Kongo diplomats displayed their two looks. On May 12, 1642, Dom Garcia II of Kongo sent a letter to Johan Maurits van Nassau, the governor of Dutch Brazil, reaffirming his dedication to their alliance against Portugal while sternly stating his refusal to receive in his realm the protestant preachers the Dutchmen offered to send. "The evil of the Portuguese," Garcia warned Nassau, "is not enough to abandon the Catholic Faith." After the creation of the West India Company (West-Indische Compagnie, WIC) in 1621, the large Dutch commercial and war fleet occupied the Brazilian captaincy of Pernambuco in 1630, and,

51. See the diaries in Fondo Borghese, Serie I, vol. 721, Archivio Segreto Vaticano, published in Brásio, *Monumenta*, V, 393–403. Lowe explains that European clothing was usually required in papal receptions in "'Representing' Africa," Royal Hist. Soc., *Trans.*, 6th Ser., XVII (2007), 119–120. For a discussion of the Quirinal paintings, see Laura Laureati and Ludovica Trezzani, *Pittura antica*, 2 vols., Il patrimonio artistico del Quirinale (Rome, 1993).

from there, the Dutch expanded their presence in Brazil. Dutch interests then turned to Angola, the source for the enslaved manpower necessary to run their Brazilian plantations. They seized the opportunity offered by the time lag between the signing and the ratification of the Treaty of The Hague, which decreed a ten-year armistice between Holland and Portugal, to take control of a number of Portuguese ports, including Luanda in August 1642. The conquest of the capital of Angola took place as Portuguese troops were engaged with the army of the Kongo in the interior, executing a long-planned strategy the two allies had designed decades earlier. Brought together by a common enemy, the Kongo and the Dutch had shortly before renewed their decades-long alliance against Portugal.[52]

Following proper diplomatic custom, Garcia II sent along with his letter luxurious presents to Nassau. He mentions them at the end of his letter: a gold necklace, precious stones, and "a large silver plate." For this generous gesture, Garcia chose from his royal collection a gold-plated silver basin that had been sent to the Kongo from Peru in the preceding decades. Ironically, Nassau later presented the basin, which signified the proud claim of Garcia's grandeur and attachment to the Catholic Church, to the Reformed Saint Nicholas Church in Siegen, Germany, where it was reworked into a baptismal font. It can still be seen there today, bearing on its back an inscription describing its provenance: "The Prince Johan Maurits van Nassau dedicates this gift, which he received from the king of the Africans in Congo, to be used as holy baptism fount, to the Reformed Church of Siegen, 1658." The platter, produced around 1586 in Potosí, probably made its way to the Kongo through the illegal but well-traveled road linking the Peruvian altiplano to La Plata and Brazil, a clandestine trade route for the exchange of Peruvian silver for African slaves. The elegant and precious plate then entered the royal treasury of Kongo, where it sat alongside a range of precious diplomatic gifts bestowed to the Christian rulers by various European leaders and merchants.[53]

52. Garcia II's letter to Johan Maurits van Nassau, May 12, 1642, is in inv. 171 Z 4306, Hauptstaatsarchiv Hessen, Wiesbaden, Germany. For the role of the Kongo-Dutch alliance in the conquest of Angola, see Thornton and Mosterman, "A Re-interpretation of the Kongo-Portuguese War," *Journal of African History,* LI (2010), 235–248.

53. The gifts appear in an added paragraph alongside the signature in 171 Z 4306, verso, Hauptstaatsarchiv Hessen. See a description of the plate in Siegen in Friedrich Muthmann, "Die silberne Taufschale zu Siegen: Ein Werk der spanischen Kolonialzeit Perus," *Abhandlungen der Heidelberger Akademie der Wissenschaften, Philosophisch-historische Klasse,* I (1956), 17. Latin American silverwork specialist Cristina Esteras Martín summarized the historiography on the platter. She is mistaken in dismissing the voyage of the platter to Kongo. Dom Garcia, who signed the letter, was indeed the king of Kongo and wrote from "Sam Salvador," the capital of his realm, not the homonymous Brazilian city, as she suggests. See "Basin," in Elena Phipps et al., eds., *The Colonial Andes: Tapestries and Silverwork, 1530–1830* (New York, 2004), 211–212. I am grateful for Dr. Esteras's generous help in clarifying some of the sources on which she based her argument.

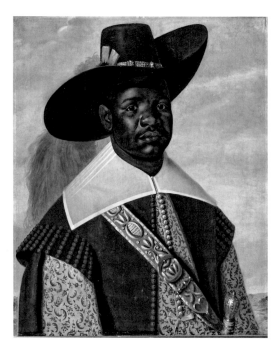

FIGURE 67 Jaspar Beckx,
*Don Miguel de Castro, Emissary
of Congo*. Circa 1643–1650.
Oil on panel, 72 × 60 cm.
National Gallery of Denmark,
Copenhagen, inv. KMS 7.
Photograph by permission of the
National Gallery of Denmark,
Copenhagen, © SMK Photo

The details of this exchange between Kongo king and Dutch governor shed new light on other visual traces of the diplomatic encounters between the Dutch and the Kongo, paintings produced on both sides of the Atlantic in which, as in the Roman case, Kongo ambassadors appear in both African and European attire. Court artist Albert Eckhout, as discussed above, painted Kongo envoys from Soyo during their stay in Brazil in a series of oil studies that depict them in full Kongo Christian regalia, which they wore to impress their host in an official reception and during the acrobatic sangamento they staged for the occasion. Ambassador Miguel de Castro and two of his attendants, Pedro Sunda and Diego Bemba, perhaps the younger men in Eckhout's oil studies, also posed for another series of portraits, now in Copenhagen, during their subsequent stay in the Low Countries (Figures 67 [Plate 31] and 68 [Plate 32]). Inscriptions at the back of the canvases identify the three men, represented in contemporary European clothing of varying sophistication according to their rank. Each of the two attendants present to the viewer one or more objects emblematic of the diplomatic exchanges between the Kongo and the Low Countries. One holds a woven box, and the other, an ivory tusk, prized gifts that the central African envoys offered to their European interlocutors. The tusk and the box are similar to known examples deposited in cabinets of curiosity during the period—that is, they are identifiable, coveted, and much-admired Kongo items. The ambassador, in contrast, does not carry presents but rather displays the gifts he received earlier from the

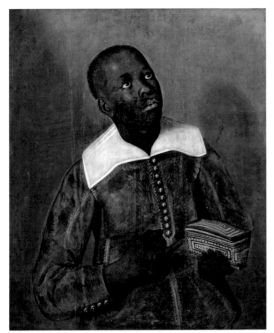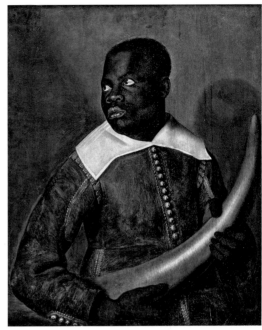

FIGURE 68 Jaspar Beckx, *Pedro Sunda and Diego Bemba, Attendants to Don Miguel de Castro*. Circa 1643–1650. Oil on panel, each 72 × 59 cm. National Gallery of Denmark, Copenhagen, inv. KMS 8 and KMS 9. Photograph by permission of the National Gallery of Denmark, Copenhagen, © SMK Photo

Dutch authorities while in Brazil, a black beaver hat enhanced with metal chains and red feathers and a sword the hilt of which peeks out at the lower right corner. The three canvases thus capture a reciprocal gift exchange between the Dutch and the Kongo, two allies whose mutual support was the key to their standing in the southern Atlantic in the mid-seventeenth century. They are not, as later inventories soon assumed, innocuous genre scenes displaying generic exotic objects and bodies for the entertainment of European viewers. On the contrary, they contain a political claim similar to the one the papacy formulated with its conspicuous heralding of images of António Manuel around Rome. The three canvases are a visual statement with which the Dutch made manifest their connections with the Kongo, an important ally who chose to support them rather than Portugal in their expansionist claims in the southern Atlantic.[54]

54. The men painted in Brazil could have been members of another diplomatic mission from the Kongo rather than Soyo, but they are likely the same people as in the Copenhagen canvases. These three paintings might have been painted by Albert Eckhout or by Jasper Becx; see Whitehead and Boeseman, *Portrait of Dutch 17th Century Brazil*, 173–174. Rebecca Parker Brienen mentions another existing version of Castro's painting in a private collection in Brazil; see Brienen, *Albert Eckhout:*

Dom Miguel de Castro, in fact, almost certainly took an active role in the composition of the paintings. While in the Low Countries in 1643, he asked the WIC for his portrait as well as a mirror to take home with him, demonstrating an intriguing interest in both his likeness and its representation. This interest—which perhaps emerged from seeing Eckhout's studies in Brazil—continued, and he later posed for artists in Europe. The WIC indeed commissioned six portraits of Castro and his men from painter Jasper Becx. One fulfilled the wish of the ambassador to bring home his likeness. Three others, intended as a gift to the count of Soyo and described as featuring Castro and his two attendants, could be the ones now in Copenhagen whose attribution remains debated; they may easily have failed to reach their intended destination. Finally, two canvases remained with the WIC in Zeeland, showing the sitter in both Portuguese and African dress. These representations of the diplomats in both European and Kongo finery underline how the African men put forward a public image that captivated Europeans with its flexible use of elite European dress as well as stunning and exotic African regalia—staged, on occasion, in spectacular performances such as the Recife sangamento.[55]

Literate, polyglot, and worldly, Kongo ambassadors successfully took up the visual challenges of diplomatic representation and furthered the cause of their homeland. In the reception hall of the Quirinal or at the seat of the WIC, images of Kongo Christians stood for their allies' belief in the kingdom as a potent asset for the realization of their overseas endeavors. In the case of António, his visit, even though it was cut short, would have as a direct effect a promise from the pope to send missionaries to central Africa. Indirectly, the visit also yielded the nomination of Spaniard Juan Bautista Vivès as permanent ambassador for the Kongo in Rome. He initiated plans for the Capuchin mission to central Africa and played an active role in the creation and early years of the Congregation of the Propaganda Fide, the papal agency dedicated to global evangelization programs. Both the Capuchin mission and the Propaganda Fide answered the insistent requests of Kongo kings for a Christian clergy that would function outside the realm of the Spanish and Portuguese padroado. Embassies to Dutch Brazil and the Low Countries similarly advanced the Kongo's diplomatic agenda to distance itself from Portugal. Eventually, even if the images and objects linked to these visits

Visões do paraíso selvagem: Obra completa, trans. Julio Bandeira (Rio de Janeiro, 2010), 317. For the gift from Nassau, see Clarival do Prado Valladares and Luiz Emygdio de Mello Filho, *Albert Eckhout: A presença da Holanda no Brasil, século XVII* (Rio de Janeiro, 1989), 126. See the 1674 inventory describing the portraits in Whitehead and Boeseman, *Portrait of Dutch 17th Century Brazil,* 173.

55. About the canvases, see Whitehead and Boeseman, *Portrait of Dutch 17th Century Brazil,* 173–174.

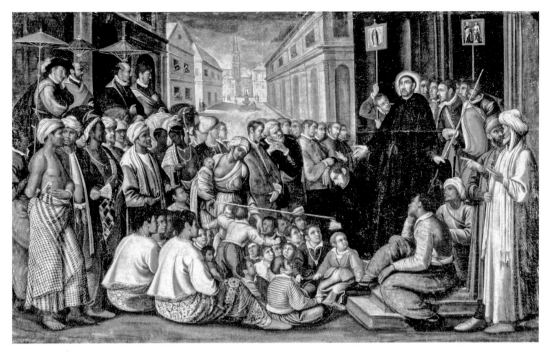

FIGURE 69 André Reinoso, *Saint Francis Xavier Preaching in Goa*. 1619. Oil on
canvas, 96 × 162 cm. São Roque Museum, Sacristy of the Church of São Roque,
inv. 96. Photograph, Júlio Marques, courtesy of the Santa Casa da Misericórdia de
Lisboa / Museu de São Roque

soon lost their potency, these two episodes tell an important story about the
Kongo's partly successful engagement with the diplomatic networks of the
Atlantic world.[56]

The evocative use of the figure of the Kongo noble to illustrate global
missionary ambition was not limited to Rome. In the cycle celebrating the
life of Saint Francis Xavier in Lisbon's Jesuit church of São Roque executed in
1619, Portuguese painter André Reinoso called upon a figure whose attributes
closely connect to images of Kongo Christian elites (Figure 69 [Plate 33]).
In an image of the saint preaching in Asia in front of a cosmopolitan con-
gregation, Reinoso included two men dressed in the manner of the Kongo.
Standing in front of a white horse to highlight their dark skin, both men wear
strings of red beads around their necks and golden bracelets. The man in
front also sports a loosely draped coat on one shoulder and a wrapper, and a

56. New missions for the Kongo are discussed in Misc. Arm., XV (101), 43–45, Archivio Segreto
Vaticano, published in Brásio, *Monumenta*, V, 408–409. See also F. Bontinck, "Jean-Baptiste Vivès:
Ambassadeur des Rois de Congo auprès du Saint Siège," *Revue du clergé Africain*, VII (1952), 262.

cross hangs from a coral string. Another painting in the cycle also depicts a similarly attired black man among a crowd of various nationalities gathered around the saint in a naval scene. This series of paintings was commissioned in the context of the renewed interest of the Jesuits in the Kongo. After an early mission to central Africa that lasted from 1548 to 1555, the members of the Society of Jesus returned to the kingdom in 1619, a date that coincides with the commission of Reinoso's cycle. The figure of the Kongo Christian, which in Lisbon would have been inspired by the presence of envoys from Africa—including António Manuel himself, who traveled through the city a decade earlier—is used here again as a metaphor for missionary success and the expansion of the church. Decades later, another painting, created in 1655 under Jesuit auspices for the Propaganda Fide and representing Gregory XIII's founding of "seminaries and colleges in and out of Europe," included among a crowd of foreign supplicants, directly to the left of the pope, a black man whose pose and costume closely echo Reinoso's figure.[57]

The ambassadors from the central African kingdom were thus successful in heralding Kongo Christianity abroad, partly fulfilling the goal of their mission to ensure the standing of their land as an independent member of Christendom. In the first half of the senventeenth century, their image, and the idea of a faraway Christian land, found fertile ground in Europe and prominently figures in the visual and political agenda of European powers for a short but notable moment.

Conclusion

More than a combination of mix-and-match pieces, Kongo Christian regalia formed a cohesive whole in which the symbols of prestige borrowed from Europe, as well as Christianity in general, entered into a complex and evolving dialogue with preexisting local visual expressions of might and prestige and their concomitant mythological and religious base. The conceptions, imagery, and symbolism that were brought together in the regalia outlined correlations that were cross-cultural but also historical, writing and rewriting Kongo history. The Kongo elite correlated in cumulative and interlacing streams objects and ideas that expressed their status as Christian nobles and participants in the Atlantic world while making sense of change according to their own worldview. Clothing and regalia offered one of the spaces of

57. The painting of Gregory XIII is published in Nobuo Watanabe, *Sekai to Nihon: Tenshō Keichō no shisetsu: Shinkan kaikan 10-shūnen kinen tokubetsuten / The World and Japan: Tensho and Keicho Missions to Europe 16th–17th Centuries* (Sendai-shi, 1995).

correlation within which this sophisticated conversation between Kongo religious, political, and historical thought and the novelties brought to their shore by an expanding world unfolded. Central African caps becoming an emblem of Christian elite status, a wrapper of Indian cotton transforming the Virgin Mary into a wealthy Kongo noblewoman, and even a European saint and Roman numerals recasting a Portuguese coin into a central African object of status and devotion all showcase the ways in which Kongo Christianity emerged and endured throughout the early modern period.

In turn, the correlation of local and foreign regalia formulated by the Kongo elite as a reflection on their own history of conversion endowed the kingdom's elite with a defined image that, as it traveled to Europe, contributed to the promotion of the kingdom and became a motif in European imagery of overseas Christianity. The image of the Kongo elite, if only for a few decades in the early seventeenth century, functioned in European missionary circles as a metaphor for the expansion of the church in Africa and in the world.

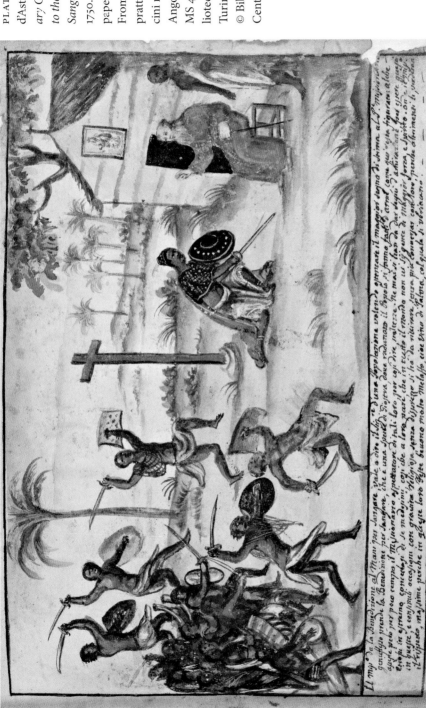

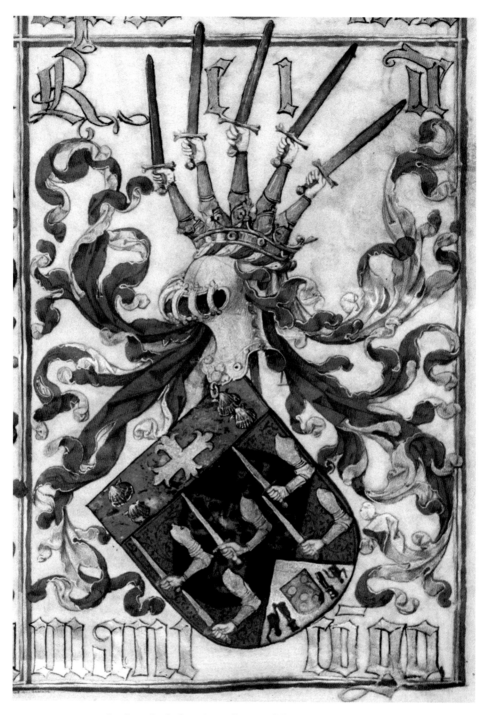

PLATE 2 António Godinho, *Coat of Arms of the Manicongo Kings*. 1528–1541. Ink on parchment, 43 × 32 cm. (full page). From "Livro da nobreza e da perfeição das armas dos reis cristãos e nobres linhagens dos reinos e senhorios de Portugal," Arquivo Nacional da Torre do Tombo, Lisbon, fol. 7, PT/TT/CR/D-A/001/20. Photograph courtesy of the Arquivo Nacional da Torre do Tombo

PLATE 3 Giovanni Antonio Cavazzi, *First King of Dongo*. Circa 1665–1668.
Watercolor on paper, 17 × 23 cm. (page), 13 × 15 cm. (watercolor). "Missione evangelica
al regno del Congo," circa 1665–1668, Araldi Collection, vol. A, book 1, fol. XXI.
Photograph by V. Negro, courtesy of the Araldi Collection, Modena

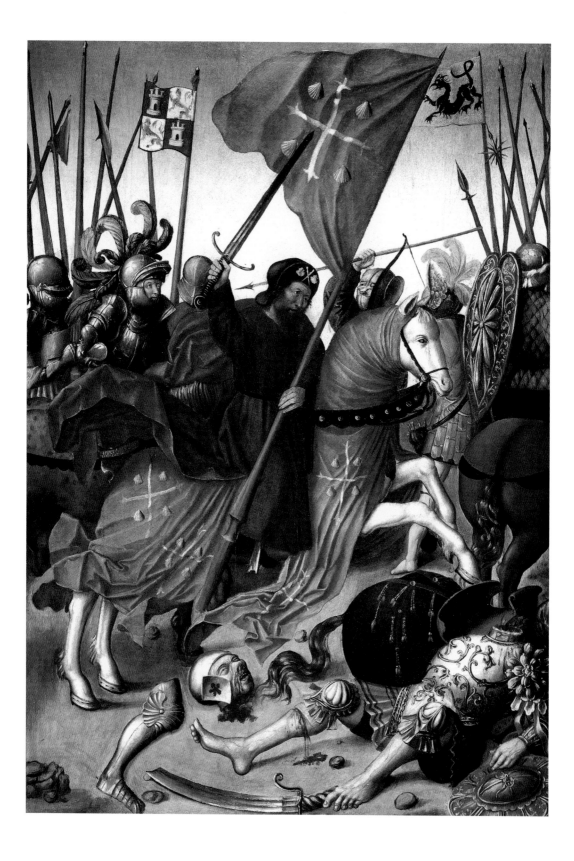

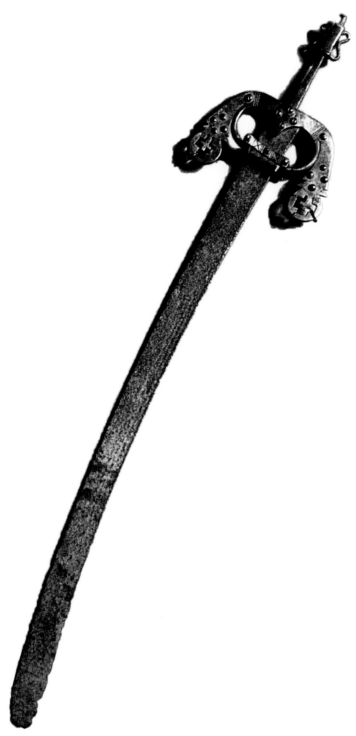

PLATE 5 Sword of Status. Kongo kingdom, sixteenth to nineteenth century. Iron, height 55 cm. Ethnological Museum—Staatliche Museen zu Berlin, inv. III C 44945. Photograph courtesy of the Staatliche Museen zu Berlin

(opposite) PLATE 4 School of Juan de Flandes, *Saint James Matamoros at the Battle of Clavijo*. Early sixteenth century. Oil on panel, 96.5 × 68.3 cm. Museo Lázaro Galdiano, inv. 3025. Photograph courtesy of the Fundación Lázaro Galdiano, Madrid

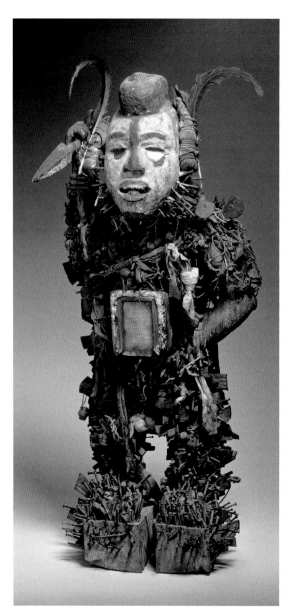

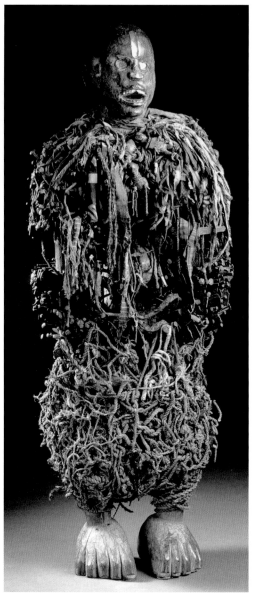

PLATE 6 Nkisi Nkondi. Bakongo, Democratic
Republic of the Congo, before 1914. Wood, metal,
cloth, shell, other material, height 85 cm. Royal
Museum for Central Africa, Tervuren, Belgium,
inv. EO.0.0.22438. Photograph by Schneebeli,
Royal Museum for Central Africa, Tervuren ©

PLATE 7 Nkisi Nkondi. Bakongo, Democratic
Republic of the Congo, before 1878. Wood, metal,
fabric, pigment, fibers, glass, 115 × 45 × 33 cm. Royal
Museum for Central Africa, Tervuren, Belgium,
inv. EO.0.0.7943. Photograph, R. Asselberghs,
Royal Museum for Central Africa, Tervuren ©

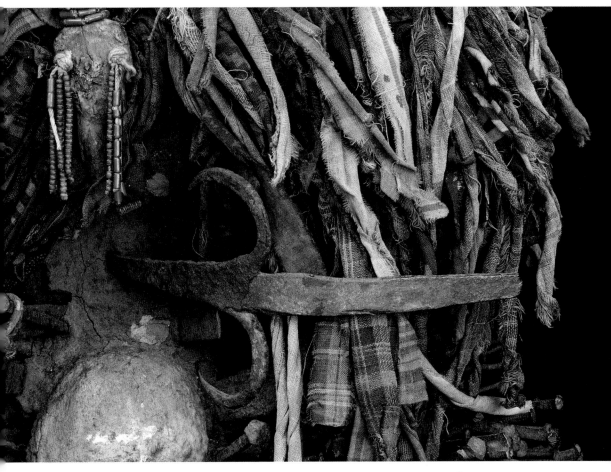

PLATE 8 Detail of a Sword of Status in the Chest of an Nkisi Nkondi. Bakongo,
Democratic Republic of the Congo, before 1878. Wood, metal, fabric, pigment, fibers,
glass, 115 × 45 × 33 cm. Royal Museum for Central Africa, Tervuren, Belgium, inv.
EO.0.0.7943. Photograph, J. M. Vandyck, Royal Museum for Central Africa, Tervuren ©

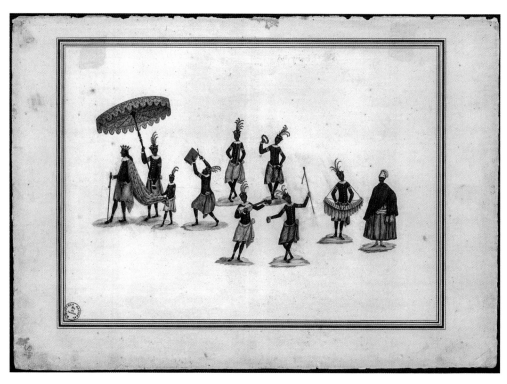

PLATE 9 Carlos Julião, *Black King Festival*. Last quarter of the eighteenth century. Watercolor on paper, 45.5 × 35 cm. (album). Iconografia C.I.2.8, drawing 49, Collection of the Fundação Biblioteca Nacional—Brazil

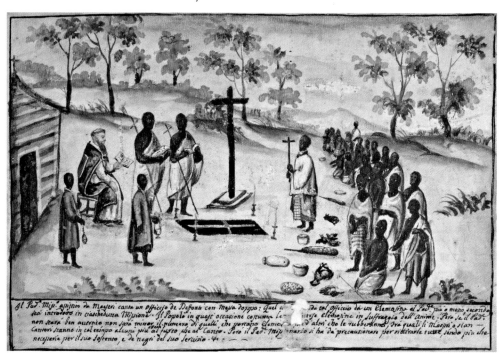

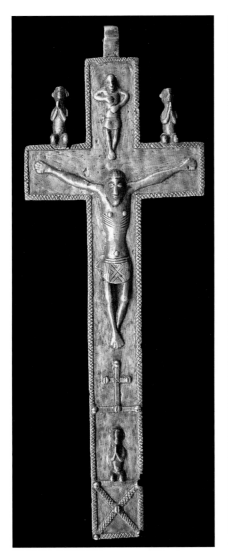

PLATE 11 Kongo Crucifix. Kongo kingdom, possibly eighteenth century. Brass, 40 × 15 cm. Collection Albert Cochaux, Ohain. Photograph, Cécile Fromont

PLATE 12 Cross of the Order of Christ on the first page of a 1504 printed Rule of the Order. From "A Regra et Diffinções Da Ordem Do Mestrado De Nosso Senhor Ihū Xp̄o," circa 1504, RES 127 V. fol. 1, Biblioteca Nacional de Portugal, Lisbon. Photograph courtesy of the Biblioteca Nacional de Portugal

(opposite) PLATE 10 Bernardino d'Asti, *The Father Missionary Helped by the Mestres Sings an Office of the Dead.* Circa 1750. Watercolor on paper, 19.5 × 28 cm. From "Missione in prattica: Padri cappuccini ne Regni di Congo, Angola, et adiacenti," MS 457, fol. 8r, Biblioteca Civica Centrale, Turin. Photograph © Biblioteca Civica Centrale, Turin

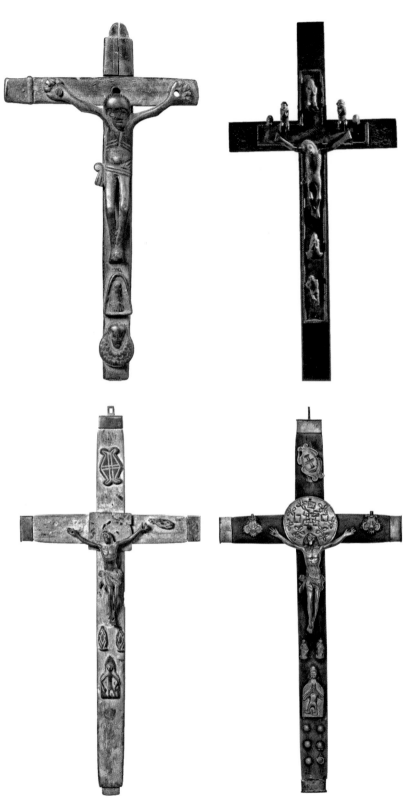

(top left) PLATE 13
Kongo Crucifix. Kongo kingdom, likely second half of the seventeenth century or eighteenth century. Wood and copper alloy, 20 × 11 cm. Afrika Museum, Berg en Dal, Netherlands, inv. 29-381. Photograph, Studio Herrebrugh, © Afrika Museum, Berg en Dal

(top right) PLATE 14
Kongo Crucifix. Kongo kingdom, possibly seventeenth to nineteenth century. Brass and wood, 64 × 27 cm. Current location unknown. Image from Josef Franz Thiel, *Christliches Afrika: Kunst und Kunsthandwerk in Schwarzafrika* (Sankt Augustin, 1978), plate 87. Photograph courtesy of the Anthropos Institute, Sankt Augustin, Germany

(bottom left) PLATE 15
Kongo Cruxifix. Kongo kingdom, possibly seventeenth to nineteenth century. Wood and copper alloy, 54 × 26 cm. Afrika Museum, Berg en Dal, Netherlands, inv. 29-377. Photograph, Studio Herrebrugh, © Afrika Museum, Berg en Dal

(bottom right) PLATE 16
Kongo Crucifix. Kongo kingdom, possibly seventeenth or eighteenth century. Wood and brass, 52 × 25 cm. Museu de Arte Sacra e Etnologia, Missionários da Consolata (Fátima Portugal), inv. SMP 601. Photograph, Ana Paula Ribeiro, 2012 Museu de Arte Sacra e Etnologia, Fátima, Portugal

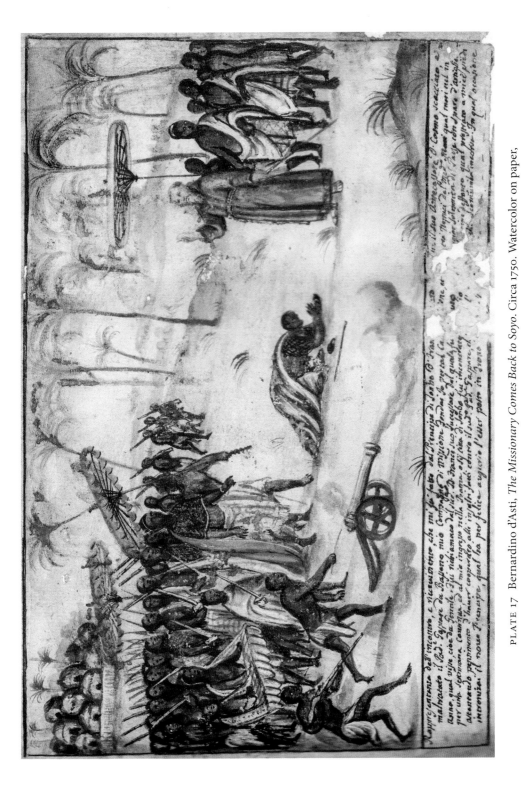

PLATE 17 Bernardino d'Asti, *The Missionary Comes Back to Soyo*. Circa 1750. Watercolor on paper, 19.5 × 28 cm. From "Missione in prattica: Padri cappuccini ne Regni di Congo, Angola, et adiacenti," MS 457, fol. 9r, Biblioteca Civica Centrale, Turin. Photograph © Biblioteca Civica Centrale, Turin

PLATE 18 Albert Eckhout, *Portrait of a Kongo Ambassador to Recife, Brazil.* Circa 1637–1644. Oil on paper, 30 × 50 cm. Libri Picturati A 34, fol. 3, Jagiellonian Library, Krakow. Photograph courtesy of the Jagiellonian Library Photographic Services

PLATE 19 Albert Eckhout, *Portrait of a Kongo Ambassador to Recife, Brazil*. Circa 1637–1644. Oil on paper, 30 × 50 cm. Libri Picturati A 34, fol. 1. Jagiellonian Library, Krakow. Photograph courtesy of the Jagiellonian Library Photographic Services

(left) PLATE 20 Albert Eckhout, *Portrait of a Kongo Ambassador to Recife, Brazil.* Circa 1637–1644. Oil on paper, 30 × 50 cm. Libri Picturati A 34, fol. 5. Jagiellonian Library, Krakow. Photograph courtesy of the Jagiellonian Library Photographic Services

(right) PLATE 21 Albert Eckhout, *Portrait of a Kongo Youth in Recife, Brazil.* Circa 1637–1644. Oil on paper, 30 × 50 cm. Libri Picturati 34, fol. 11, Jagiellonian Library, Krakow. Photograph courtesy of the Jagiellonian Library Photographic Services

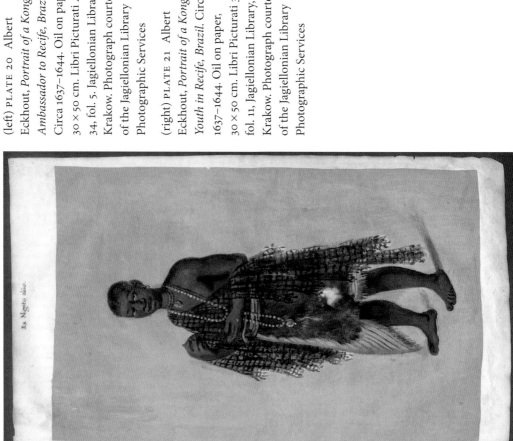

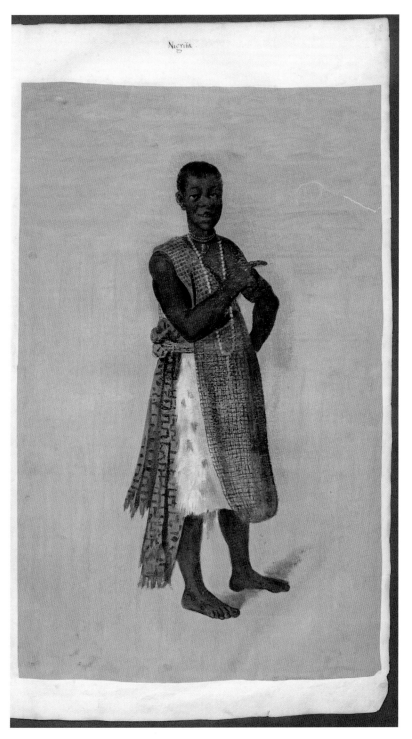

PLATE 22 Albert Eckhout, *Portrait of a Kongo Youth in Recife, Brazil*. Circa
1637–1644. Oil on paper, 30 × 50 cm. Libri Picturati 34, fol. 9, Jagiellonian Library,
Krakow. Photograph courtesy of the Jagiellonian Library Photographic Services

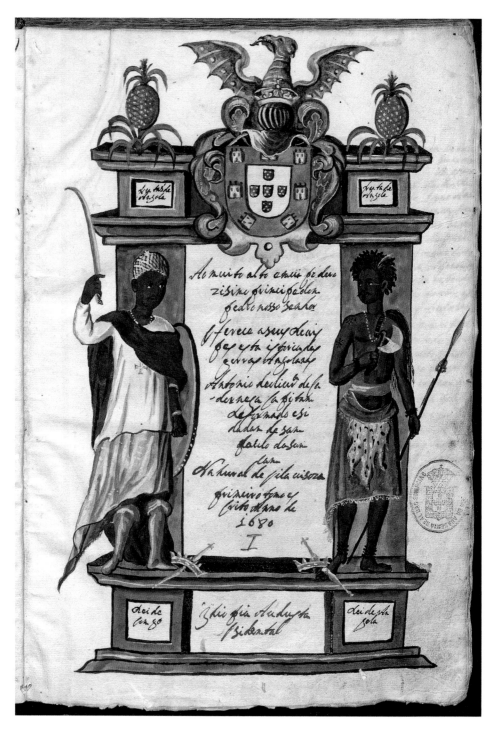

PLATE 23 António de Oliveira de Cadornega, *King of Congo and King of Angola*. 1680. Watercolor on paper, 30 × 20.5 cm. (manuscript). Manuscrito Vermelho 77, frontispiece, Academia das Ciências de Lisboa, Portugal. Photograph courtesy of the Academia das Ciências de Lisboa

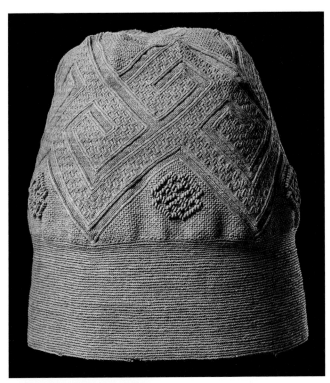

PLATE 24 Mpu Cap of Status.
Kongo kingdom, before 1674.
Vegetal fibers, height 18 cm.
The National Museum of
Denmark inv. no. Dc. 123 Hat.
Photograph © The National
Museum of Denmark,
Ethnographic Collection

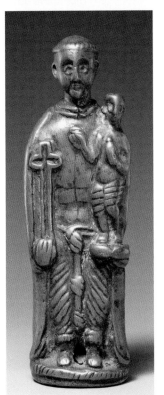

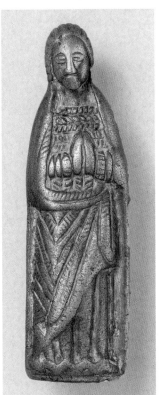

(left) PLATE 25 Saint Anthony
Pendant. Kongo kingdom, pos-
sibly seventeenth to eighteenth
century. Brass, height 10 cm.
The Metropolitan Museum of
Art, Gift of Ernst Anspach, 1999,
inv. 1999.295.1. Image © The
Metropolitan Museum of Art

(right) PLATE 26 Female Figure.
Kongo kingdom, possibly seven-
teenth century. Brass, 9 × 3 cm.
Private Collection. From Julien
Volper, *Ora pro nobis: Étude
sur les crucifix bakongo* (Brus-
sels, 2011), plate 24. Photograph,
P. Louis, © P. Louis and J. Volper

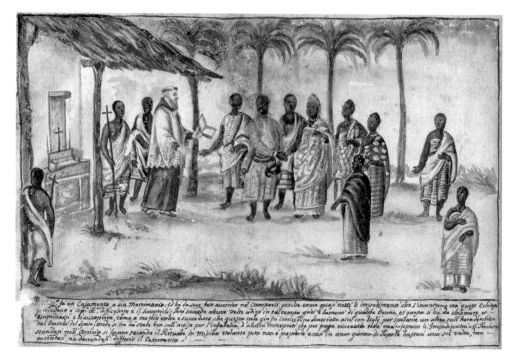

PLATE 27 Bernardino d'Asti, *The Missionary Blesses a Wedding*. Circa 1750.
Watercolor on paper, 19.5 × 28 cm. From "Missione in prattica: Padri cappuccini ne
Regni di Congo, Angola, et adiacenti," MS 457, fol. 12v, Biblioteca Civica Centrale,
Turin. Photograph © Biblioteca Civica Centrale, Turin

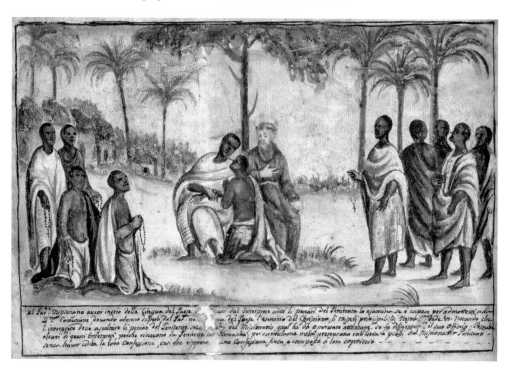

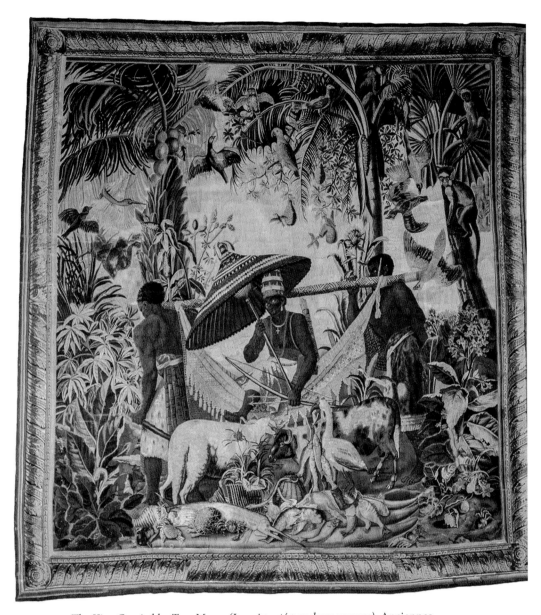

PLATE 29 *The King Carried by Two Moors (Le roi porté par deux maures)*, Anciennes Indes series. Eighteenth century. Manufacture des Gobelins tapestry, France, wool and silk, 384 × 355 cm. After cartoons by Albert Eckhout. Photograph courtesy of Instituto Ricardo Brennand—Recife—PE—Brasil

(opposite) PLATE 28 Bernardino d'Asti, *The Missionary Hears Confession*. Circa 1750. Watercolor on paper, 19.5 × 28 cm. From "Missione in prattica: Padri cappuccini ne Regni di Congo, Angola, et adiacenti," MS 457, fol. 8v, Biblioteca Civica Centrale, Turin. Photograph © Biblioteca Civica Centrale, Turin

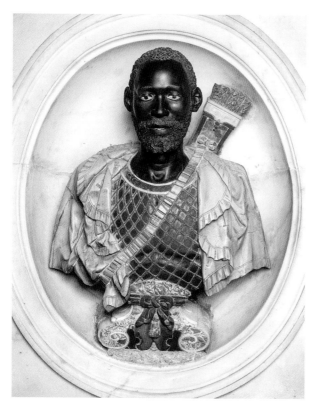

PLATE 30 Francesco Caporale, *Bust of António Manuel ne Vunda*. 1629. Polychrome marble. Santa Maria Maggiore Baptistry, Rome. Photograph, Mario Carrieri, Milan / The Menil Foundation

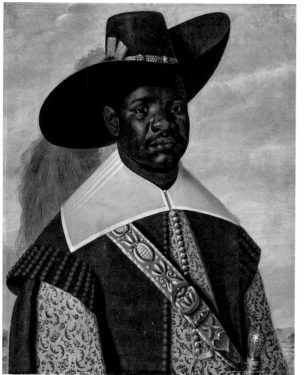

PLATE 31 Jaspar Beckx, *Don Miguel de Castro, Emissary of Congo*. Circa 1643–1650. Oil on panel, 72 × 60 cm. National Gallery of Denmark, Copenhagen, inv. KMS 7. Photograph by permission of the National Gallery of Denmark, Copenhagen, © SMK Photo

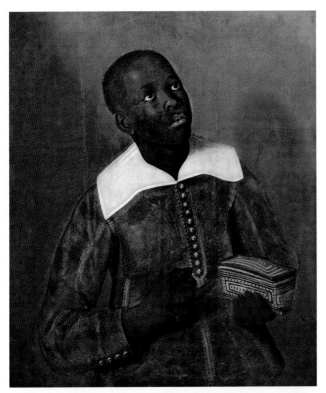

PLATE 32 Jaspar Beckx, *Pedro Sunda and Diego Bemba, Attendants to Don Miguel de Castro*. Circa 1643–1650. Oil on panel, each 72 × 59 cm. National Gallery of Denmark, Copenhagen, inv. KMS 8 and KMS 9. Photograph by permission of the National Gallery of Denmark, Copenhagen, © SMK Photo

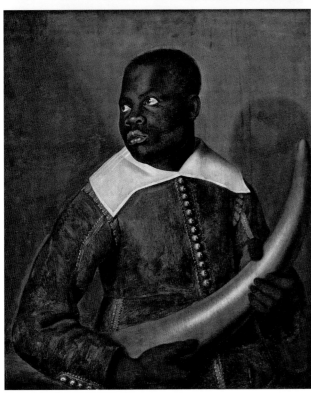

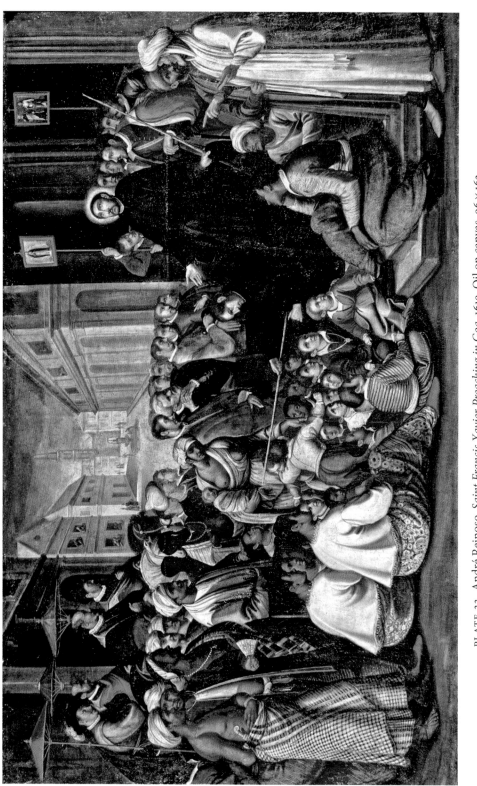

PLATE 33 André Reinoso, *Saint Francis Xavier Preaching in Goa*. 1619. Oil on canvas, 96 × 162 cm. São Roque Museum, Sacristy of the Church of São Roque, inv. 96. Photograph, Júlio Marques, courtesy of the Santa Casa da Misericórdia de Lisboa / Museu de São Roque

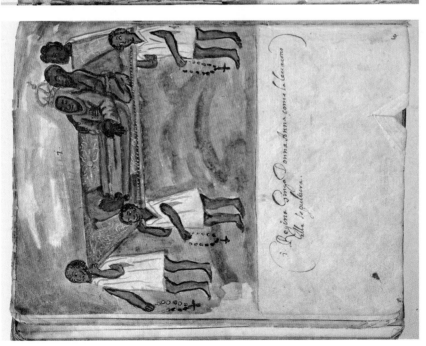

(left) PLATE 34 Giovanni Antonio Cavazzi, *Queen Njinga Dona Ana Being Brought to Her Sepulcher.* Circa 1665–1668. Watercolor on paper, 17 × 23 cm (page). "Missione evangelica al regno del Congo," circa 1665–1668, Araldi Collection, vol. A, book 2, between fols. 210 and 211. Photograph, V. Negro, courtesy of the Araldi Collection, Modena

(right) PLATE 35 Giovanni Antonio Cavazzi, *Catholic Procession in Angola.* Circa 1665–1668. Watercolor on paper, 17 × 23 cm (page). "Missione evangelica al regno del Congo," circa 1665–1668, Araldi Collection, vol. A, book 2, between fols. 210 and 211. Photograph, V. Negro, courtesy of the Araldi Collection, Modena

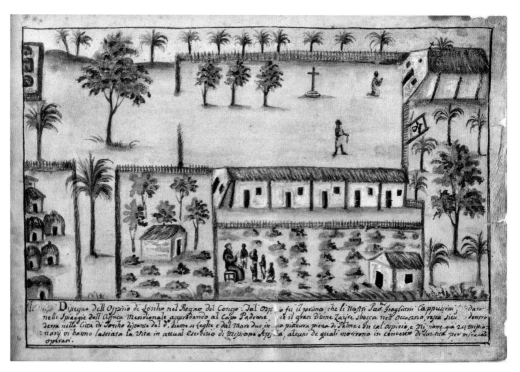

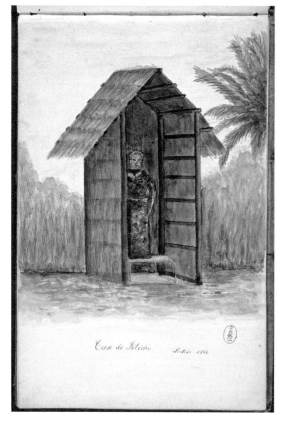

(above) PLATE 36 Bernardino d'Asti, *Plan of the Convent of Soyo in the Kingdom of Kongo*. Circa 1750. Watercolor on paper, 19.5 × 28 cm. From "Missione in prattica: Padri cappuccini ne Regni di Congo, Angola, et adiacenti," MS 457, fol. 4r, Biblioteca Civica Centrale, Turin. Photograph © Biblioteca Civica Centrale, Turin

(left) PLATE 37 Charles Callewaert, *Fetish Hut in Lutele 1883*. Watercolor on paper, 29 cm. × 19 cm. Royal Museum for Central Africa, Tervuren, Belgium, inv. HO.0.1.3114. Photograph Royal Museum for Central Africa, Tervuren ©

Negotiating Time and Space

Architecture, Rituals, and Power
in the Christian Kongo

Dance, regalia, objects of devotion, liturgy, and mythology come together in the *sangamento* and the funeral ceremony vividly recorded in Bernardino d'Asti's vignettes in the "Missione in prattica" (see Figures 2 [Plate 1] and 18 [Plate 10]). Framed in a space that a church and a monumental cross render visibly Christian, they enact correlations that defined the Catholic Kongo. The religious, political, and social changes embedded in the visual and symbolic manifestations of Kongo Catholicism unfolded in an environment that itself had been transformed by the kingdom's conversion. Churches and towering crosses created a politically and religiously charged landscape that monumentalized the history of the advent of the new faith, heralded the legitimacy it conferred to the new political order, and represented a new understanding of the nexus between the visible and the invisible worlds.

Cross as Nexus

The central plazas of Kongo towns, large open spaces called *mbazi,* served as the venue for the kingdom's political and religious rituals. The plazas extended in front of the rulers' residences and, in the Christian era, were next to the principal church and monumental cross erected in each locality. The monumental crosses and the churches were grand and permanent visual manifestations of the mythological and religious ideas on which the kingdom's political organization relied. They directly celebrated and memorialized the victory of Afonso over his heathen opponents and the ensuing conversion of the kingdom to Catholicism. Immediately after his triumphant advent to the throne of the Kongo in 1509, Afonso erected a towering cross in front of the church his father had built in the kingdom's capital, Mbanza Kongo. The gesture, as reported in sixteenth-century oral traditions, commemorated the momentous apparition of the sign of the cross during the fateful battle, after which the young prince became king and ensured a Christian future for the Kongo. The new monarch then ordered

each of his provincial governors to follow his lead by building a church and erecting a cross in their own principal towns. All over the kingdom, markers rose celebrating Afonso's advent as legitimate king and memorializing the miraculous arrival of Christianity in the realm. Hovering over towns and buildings, they turned the kingdom's territory into a triumphal landscape, lending to the foundational myth concrete visual and material dimensions. Judging from the watercolors, contemporary descriptions, and twentieth-century ruins, the size of the crosses matched the significance of their message. They ranged between six and ten meters high, easily rising above the rooflines of single-level Kongo architecture.[1]

Early in the Christian era, the erection of a monumental cross became a quintessential gesture of Kongo rulership. Only decades after the death of Afonso, Álvaro I (r. 1568–1587) re-conquered the Kongo's capital city from the grip of the Jaga, a group of foreign, non-Christian invaders. To proclaim his victory and give material form to his success, he reconstructed the monumental cross that had graced the square of one of the oldest churches in Mbanza Kongo. The reconstruction allowed him to inscribe his reign within the symbolic and political terms defined by his illustrious predecessor, casting his victory as a repetition of Afonso's Christian foundation of the kingdom. The late-sixteenth-century ruler also contributed to the perpetuation of the narrative of Christian triumph, for instance by referring for the first time to the city of Mbanza Kongo by the Portuguese name of São Salvador, after the church in front of which the first cross stood.[2]

These large crosses served a political function as emblems of power and as political monuments encoding a history willed by kings and projected on the public space of the mbazi to frame their subjects' everyday expe-

1. For descriptions of the monumental crosses, see, for example, Louis Jadin, "Les missions du Congo à la fin du XVIIIe siècle," *Congresso Internacional de história dos descobrimentos*, V (Lisbon, 1961), 211. See also François Bontinck, "Les croix de bois dans l'ancien royaume de Kongo," *Dalla chiesa anticha alla chiesa moderna: Miscellanea per il cinquantesimo della facoltà di storia ecclesiastica della Pontificia Università Gregoriana*, Miscellanea Historiae Pontificiae, no. 50 (Rome, 1983), 199–213. Friars often mentioned the monumental crosses; see, for example, Giovanni Antonio Cavazzi and Fortunato Alamandini, *Istorica descrizione de' tre' regni Congo, Matamba, et Angola sitvati nell' Etiopia inferiore occidentale e delle missioni apostoliche esercitateui da religiosi Capuccini* (Bologna, 1687), 319, 322, 449. The oral tradition is reported in [Duarte Lopes and Filippo Pigafetta], *Relatione del reame di Congo et delle circonvicine contrade: Tratta dalli scritti e ragionamenti di Odoardo Lopez Portoghese per Filippo Pigaffetta . . .* (Rome, 1591), 53. In 1974, Shaje Tshiluila photographed the cross in Mbata Kulusu. The images are in the Institut des Musées Nationaux du Congo, negatives IMNZ 5131, 5141. I thank Geoffroy Heimlich for calling these photographs to my attention.

2. According to Linda M. Heywood and John K. Thornton, the first mention of the new name of the city appears in a 1575 letter by Álvaro I to Father Garcia Simões, published in António Brásio, ed., *Monumenta missionaria africana: África ocidental*, 15 vols. (Lisbon, 1952–1988), III, 127–128. See Heywood and Thornton, *Central Africans, Atlantic Creoles, and the Foundation of the Americas, 1585–1660* (Cambridge, 2007), 172.

rience, imagination, and, eventually, memory. But they also encompassed a religious dimension linked to their multivalent association in Christian and non-Christian Kongo thought with beliefs in transitions from life to death—and back. The connection, discussed previously, between cruciform motifs, objects, and locales and the notion of permeability between life and death not only stemmed from a semantic association between the sign and the idea. Crosses in the early modern Kongo also literally materialized and located specific points in space as a nexus between the visible and the invisible worlds. Early modern texts describe this vivid connection at length, most clearly in passages on the reliance of central African rituals on the potency of spaces defined by crosses or crossroads. In the preface to his 1624 bilingual catechism, the Jesuit Mateus Cardoso remarked on the use of the word *iquetequêlo* in Kikongo as the term for "cross." The idiom, he lamented, literally "means *forca,* and one can easily see that this term does not mean cross." In fact, it comes from the word *keteka* ("to hang," "to hang up") and denoted a conception of the cross as a concrete object existing in space. The word *forca* is Portuguese for both "fork," as in a bifurcated branch, and "gallows," the structure used in deadly hangings. This form of capital punishment did not exist in the Kongo, however, and Cardoso's translation should be read primarily as a reference to notions of structural intersection, as in the joining of two branches from which something could hang. In the opinion of the European priest, this material and spatial definition of the cross fell short of properly describing the iconic function of the sign as an image linked to the story of the Passion of Christ.[3]

The cross, understood broadly in the Kongo as "intersection," defined empowered spaces. Accordingly, the meeting of two paths—that is, topographical embodiments of the cross—formed a privileged locus for ritual practices. Friar Lorenzo da Lucca, for example, related a ceremony he observed around 1700 at such a location. He saw a widow, shortly after the death of her husband, walk over to a crossroad *(un crociale di strade)* to grieve. There, a woman who was her closest kin helped her shave her hair and perform the prescribed rituals of mourning. The space that the intersection of the two roads defined served as a frame for the execution of the transformative gestures required at a critical moment when the world of the living and the world

3. [Mateus Cardoso], *Doutrina Christaã . . . de novo traducida na lingoa do reyno do Congo* (Lisbon, 1624), Prologo ao Leitor; for a modern edition, see Marcos Jorge, François Bontinck, and D. Ndembe Nsasi, *Le catéchisme kikongo de 1624: Réédition critique,* Mémoires—Académie royale des sciences d'outre-mer (Brussels, 1978), 16. The "Vocabularium" also translated *crux, -cis* as "iquetequelo": "Vocabularium Latinum, Hispanicum et Congense," [1652], MSS Varia 274, Fondi minori 1896, Biblioteca Nazionale Vittorio-Emmanuele II di Roma.

of the dead entered into contact and redefined each other. Ritual practitioners also believed that, because of this connection, crossroads lent power to their practices and brought strength to their ceremonies. There, they initiated new *banganga* (sing. *nganga*) in their role as intermediaries between the ailments suffered in this world and the invisible causes that underlie them. Banganga also activated their *kiteke,* or images and other power objects at the efficacious spaces offered by crossroads and, on occasion, by monumental crosses.[4]

In the Christian context, monumental crosses as well as their smaller counterparts, crucifixes, also manifested in space the idea of a passage from life to death. The importance of the notion of intersection, understood at its most essential level as a one-dimensional point in space that may be conveyed by objects of any scale, appears in small and large Kongo crosses through formal aspects of their composition. In the crucifixes, round or diamond-shaped metal plates exalt the point of intersection of the two branches, drawing attention to that crucial point on the object (see Figures 28, 29 [Plate 13], 31 [Plate 15], and 84). A similar visual marker emphasized the point of junction on at least one monumental cross, which stood, according to historian François Bontinck, from the 1650s to the 1940s. In spite of the monumental scale of the cross (or several crosses reconstructed in the same place), a single nail connected the two-meter-long transversal bar to the ten-meter-high vertical post. A round copper plate, in turn, decoratively covered that connector. The single nail, enhanced by the metal plate, perfectly echoes details observed in many crucifixes. This central element defined the crosses as material and visual embodiments of the abstract idea of the intersection. Large and small crosses not only conveyed religious beliefs as icons and symbols but also reconfigured their surroundings as spatial markers of intersection. Just like standing at the foot of a monumental cross, holding or wearing a crucifix located one's body in relation to a material point of connection between this world and the world of the dead. The crosses sketched a cosmological to-

4. Friar Lorenzo da Lucca's relation is from Lorenzo da Lucca and Filippo da Firenze, "Relazioni d'alcuni Missionari Capp:ni Toscani singolarmente del P. Lorenzo da Lucca che due volte fù Miss:io Apotol:co al Congo; parte seconda," 1700–1717, fol. 185, Archivio Provinciale dei Frati Minori Cappuccini della Provincia di Toscana, Montughi Convent, Florence. See also the modern French edition with original pagination in J[ean] Cuvelier, *Relations sur le Congo du père Laurent de Lucques (1700–1717)* (Brussels, 1953), 138. For initiations of banganga, see Giuseppe Monari da Modena, "Viaggio al Congo, fatto da me fra Giuseppe da Modena Missionario Apostolico e predicatore Capuccino, incomentato alli 11 del mese di Novembre del anno 1711, e terminato alli 22 di Febraro del anno 1713 etc. . . . ," 1723, Manoscritti Italiani 1380, Alfa N. 9–7, fol. 243, Biblioteca Estense, Modena, published in Calogero G. Piazza, "Una relazione inedita sulle missioni dei Minori Cappuccini in Africa degli inizi del Settecento 2," *Italia Francescana,* XLVII, no. 6 (1972), 364. See also the similar report by Lorenzo da Lucca in Cuvelier, *Relations sur le Congo,* 136. For the activation of power objects, see François Bontinck, ed. and trans., *Diaire congolais (1690–1701) de Fra Luca da Caltanisetta,* Publications de l'Université Lovanium de Kinshasa (Leuven, 1970), 172.

pography over the Kongo, defined and oriented by the intersection of their branches. The political landscape that the large crosses created in celebration of Afonso's triumph thus also functioned as a spiritual geography. The crosses memorialized both the mythological and the religious correlations that Afonso formulated to legitimize his rule. Catholic ideas of death and resurrection as well as related or unrelated central African beliefs in the junction of the visible and invisible worlds at the intersection of cruciform motifs met and merged in the crosses to form a Kongo Christian spiritual and political topography.[5]

A New Place for the Dead

The link between life and death that the crosses conveyed manifested itself in concrete terms. As individual objects worn about the body, small crucifixes strongly echoed funerary bundles that encased and preserved bodily relics of venerable ancestors. At the scale of the community, large crosses marked the location of cemeteries. The monumental crosses as well as churches had replaced in the kingdom, by order of the newly converted kings, the earlier burial grounds dedicated to the elite. In a 1526 letter to the king of Portugal, Afonso reported on the progress of his church constructions. Several churches, he wrote, were under way,

> in particular one for Nossa Senhora da Vitória, which we began in
> a very thick forest, where in the past the Kings were buried, according to their ancient idolatry. We cut and broke it entirely, which was
> a difficult task, not only because of the roughness of the place, but
> also because We doubted that the great [men] of our kingdom would
> consent to it. [But] These were so agreeable and diligent about it that
> they cut those tall and thick trees with their own hands, and carried
> on their backs the stones for the construction, which seemed to be
> divine intervention.[6]

The Jesuit Cristóvão Ribeiro described the completed transformation in 1548. The "church called (ambiro)," he explained, stood "where before they were Christian the [Kongo elite] were buried with the money of the land

5. Bontinck, "Les croix de bois dans l'ancien royaume de Kongo," *Dalla chiesa anticha alla chiesa moderna*, 201–203. The cross is described in G. Schellings, "Importante découverte au Bas-Congo: Les ruines de la première église congolaise construite au XVIe siècle, à Mbanza Mbata dia Madiadia," *Le Courrier d'Afrique*, nos. 19–20 (August 1950), 13.

6. For the link between crucifixes and bundles and crosses and cemeteries, see Chapter 2, above. For the conversion of funeral grounds, see Cavazzi and Alamandini, *Istorica descrizione,* 117. See Brásio, *Monumenta*, I, 479–480: "Prinçipalmente hũma de nossa Senhora da Vitoria, que começamos

and their tusks and with other superstitions; on this location a church was built, destroying the old ambiro." The building of a Christian church on the location of a site of local, pre-Christian significance was a classic strategy of religious conversion, famously formalized in the sixth century by Gregory the Great in his guidelines regarding the evangelization of England. Examples of this practice in the Christian world abound—from early medieval structures overlaying or repurposing Roman temples in Europe, such as the Pantheon in Rome, to the church of Santo Domingo in the Peruvian city of Cuzco, which Spanish Dominican friars built on top of the Qorikancha, the most sacred building of the Inca Empire, as a gesture of spiritual conquest and political domination.[7]

The Kongo elite's adoption of Christianity was in many regards dramatic, and their imposition of a new Christian order on their people forceful. Yet, the elaborate efforts of Afonso to recast Christianity as a Kongo phenomenon indicate that the conversion did not follow a simple pattern of imposition. Rather, the central African elite used visual and narrative spaces of correlation to mold together Christian and local thought, history, and symbols. The redefinition of the cemetery into a Christian church should be read as part of this operation of combination and reformulation. Afonso himself ordered the transformation of the *ambiro* into a Christian church. He likely learned of the practice in Europe—where the upper class enjoyed the privilege of burial inside churches—and recast it within the realm of preexisting Kongo customs. The word *ambiro* refers to the Kikongo for "tomb" and both names and defines the new church. Contrary to Ribeiro's statement, the "old ambiro" was not destroyed by the erection of the church. Rather, it was reframed through architecture as part of the emerging Kongo Christian reorganization of the kingdom. The elite burial ground turned Christian space brought the ancestors within the bounds of the new religion; simultaneously, it endowed the newly built church with the venerable presence of the current elite's mighty predecessors, for whom rich and elaborate tombs enhanced with precious

em hũma muy forte mata, honde antigamente se os Rex enterravam, segundo sua antigã jdolatria; a quall toda rompemos e cortamos, que era coussa muy difyçill de fazer, asy polla aspareza do lugar, como pollos grandes de nosso Reyno, ẽ que tynhamos duujda o quererem comsentir. Os quães foram a jso tam cõformes e deligentes que cõ suas proprias mãos, cortauam as grandes e grossas aruores e leuauam a pedra pera a obra aas costas, o que pareçeo ser por graça deuina."

7. Ribeiro, quoted in Brásio, *Monumenta*, XV, 161. In a letter to the missionaries in England, Gregory the Great advised not to destroy the pagan temples but rather to transform them into churches by purifying them with Holy Water after having destroyed the idols. See Gregory the Great, *Register of Epistles*, 11.56, accessed Mar. 26, 2014, http://www.newadvent.org/fathers/360211076.htm. For Santo Domingo, see Carolyn Dean, *Inka Bodies and the Body of Christ: Corpus Christi in Colonial Cuzco, Peru* (Durham, N.C., 1999), 213.

ivories and textiles had once been constructed. In the transformation, the social and political function of the cemetery as marker of prestige and as monument to past rulers remained mainly unchanged. The practice inaugurated with the ambiro expanded to the entire kingdom. By the seventeenth century, burial in and around churches was common practice for the elite in the capital and in the provinces alike. Formalized donation-fee schedules and precedence charts determined the attribution of burial spots. The great desirability of entombment in a church even spurred a form of funerary stealth in which local men and women surreptitiously buried their deceased inside the buildings either unbeknownst to European priests or against their express prescriptions.[8]

The tombs erected within the churches were imposing constructions of stone and mortar, earth, or stone alone. They rose above the ground like raised biers. As seen on the grave shown in Figure 18 (Plate 10), the tombs were dressed with black palls, regularly renewed on the anniversary of the buried person's death and on All Souls' day. Capuchin friars described the tombs of the rulers of the Bamba province, for example, as mounds of dyed red earth molded in the shape of what looked to them like Italian catafalques. Gravestones, such as the ones in Figure 24, made prominent use of the sign of the cross as a space of correlation that brought together ideas about life and death drawn and transformed from both European Catholicism and central African cosmology. The designs on the stones also featured references to the Order of Christ, the order of knighthood conferred by the king to selected vassals that was one of the foremost markers of prestige in the kingdom. Crucifixes and devotional images of saints completed the sepulchers' outfit. In addition to chapels dedicated to burials, churches used for Mass also housed tombs, located mainly along their lateral walls. There, Christian rituals took

8. *Ambiro* in the European sources refers to the Kikongo *mbiro,* or *mbila,* and derives from the Bantu root *bídá,* or "tomb"; António de Oliveira de Cadornega translates the word in 1680; see Cadornega, *História geral das guerras Angolanas, 1680[–1681],* ed. José Matias Delgado ([Lisbon], 1940), 263. The practice of burials within churches in Europe that started with saints and then expanded to include bishops and rulers by the late Middle Ages extended further to a large public of wealthy patrons; see A. Martindale, "Patrons and Minders: The Intrusion of the Secular into Sacred Spaces in the Late Middle Ages," in Diana Wood, ed., *The Church and the Arts: Papers Read at the 1990 Summer Meeting and the 1991 Winter Meeting of the Ecclesiastical History Society* (Oxford, 1992). My thanks to Douglas Brine for advising me of this source. For the atribution of burial places, see Giuseppe Monari da Modena in Calogero G. Piazza, "Una relazione inedita sulle missioni dei minori Cappuccini in Africa degli inizi del Settecento," *Italia Francescana,* XLVII, nos. 4–5 (1972), 240. About the burial stealth, see Marcos Jorge, François Bontinck, and D. Ndembe Nsasi, *Le catéchisme kikongo de 1624: Réédition critique,* Mémoires—Académie royale des sciences d'outre-mer (Brussels, 1978), 14. See also Bontinck, ed. and trans., *Diaire congolais,* 220; Louis Jadin, "Le Congo et la secte des Antoniens: Restauration du royaume sous Pedro IV et la 'Saint Antoine' congolaise (1694–1718)," *Bulletin de l'Institut Historique Belge de Rome,* XXXIII (1961), 560.

place in the midst of the deceased who, like their living counterparts, entered the church in the full regalia of Kongo Christian nobility, adorned with a wealth of medals, crosses, and devotional objects. The presence of prestigious ancestors lent to the churches the aura of potency that burial grounds possessed in central Africa outside Christian contexts while channeling the invisible potency of the deceased into the frame of Catholic practices. Burial grounds and the monumental crosses or churches that marked their presence materialized and localized the nexus between the living and the dead, just as the tombs of saints in Judeo-Christian tradition formed, in the words of historian Peter Brown, "the *loci* where Heaven and Earth had met."[9]

The connection appeared often in the accounts of the Capuchins, an order whose notorious devotion to the deceased was spectacularly illustrated in their famous bone chapels, elaborate *memento mori* made of decoratively arranged skeletons in the crypt of several of their churches, such as Santa Maria della Concezione in Rome and São Francisco in Évora, Portugal. The friars, like central African elites, showed a keen interest in keeping vivid the presence of the dead in the world of the living. "When [he] discovered so much pity towards [the dead]" in Soyo, Friar Andrea da Pavia created a confraternity dedicated to the care of their souls in the 1680s. He gathered the bones of the deceased and built a chapel to host them, under the watchful eye of a statue of Our Lady of the Suffrages, the Marian devotion dedicated to intercession in favor of the souls. The inhabitants of Soyo, not unfamiliar with practices of delayed or secondary burial of the elite, received the initiative well. No one, Friar Andrea noted, for example, would ever pass in front of the chapel without saying "an *Ave Maria* for the poor souls."[10]

The practice of devoting entire churches or chapels to the cult of the deceased was an old habit in the Kongo inaugurated in the early sixteenth century with the ambiro church, but it thrived in the eighteenth century. The

9. Peter Brown, *The Cult of the Saints: Its Rise and Function in Latin Christianity* (Chicago, 1981), 10. Descriptions of tombs and their upkeep appear in Gio[vanni] Francesco da [Roma], *Breve relatione del successo della missione de Frati Minori Cappuccini del Serafico P. S. Francesco al regno del Congo e delle qualitá, costumi, e maniere di vivere di quel regno, e suoi habitatori* (Rome, 1648), 180; Cavazzi and Alamandini, *Istorica descrizione,* 117. For the Bamba tombs, see Michele Angelo Guattini and Dionigi Carli, *Viaggio del P. Michael Angelo de Guattini et del P. Dioniggi de Carli, predicatori nel regno del Congo descritto per lettere* (Reggio, 1672), 192. For outfits in elite burials, see J. Vandenhoute, "De Begraafplaats van Ngongo-Mbata (Neder-Zaire)" (licentiate's thesis, Rijksuniversiteit Gent Hoger Instituut voor Kunstgeschiedenis en Oudheidkunde, 1972–1973), 56.

10. For interment practices in the Kongo, see Jadin, "Les missions du Congo à la fin du XVIIIe siècle," *Congresso Internacional de historia dos descobrimentos,* V (1961), 223. See also Andrea de Pavia, "Viaggio apostolico alle missioni dell'Africa del P.re Andrea da Pavia Pred.re Capuccino, 1685–1702," 1692–1702, MS 3165, 88–88v, Biblioteca Nacional de Madrid, trans. with original pagination in Louis Jadin, "Andrea de Pavia au Congo, à Lisbonne, à Madère: Journal d'un missionnaire Capucin, 1685–1702," *Bulletin de l'Institut Historique Belge de Rome,* XLI (1970), 444–445.

church of Saint James in São Salvador, which served as a burial place for kings in the mid-seventeenth century, may be an early example of the practice. Another church, Saint Michael, first mentioned in the 1640s, probably became a royal funerary chapel under Álvaro VI (r. 1636–1641), who, according to Bernardo da Gallo's 1710 report, inaugurated a new royal lineage that must have warranted a burial place separate from that of the old dynasty. Lorenzo da Lucca visited Saint Michael in 1706 and saw in the badly weathered chapel a king's tomb, at the time erroneously identified as that of Afonso, in front of the main altar in the sancta sanctorum as well as other royal graves in the destroyed church of Saint Anthony. During his visit, Bernardo da Gallo also recorded oral histories that linked the church of Saint Michael to the location of Afonso's matricide, a newly formulated variation within the Kongo Christian foundation myth. According to that story, Afonso buried alive his idolatrous mother in front of Saint Michael—that is, in front of the chapel dedicated to the burial of the kings of Álvaro VI's lineage—thus linking the new dynasty to Afonso himself. The disjointed testimonies that the two contemporaneous friars recorded, in which several so-called royal chapels competed for prominence, reflect the troubled times of civil wars through which they lived and in which rivalries between lineages played a crucial role. Far from the capital in 1702, the princes of Soyo similarly emulated the royal practices of São Salvador to assert their independence from central Kongo rule with the dedication of a church also called Saint Michael, which was devoted to the cult of their local past rulers.[11]

11. For the church of Saint James, see the 1622 Jesuit report in Louis Jadin, "Relations sur le Congo et l'Angola tirées des Archives de la Compagnie de Jésus, 1621–1631," *Bulletin de l'Institut Historique Belge de Rome*, XXXIX (1968), 374. Friar Francisco do Soveral, bishop of Kongo and Angola, mentioned the church of Saint Michael Archangel in 1640; see Brásio, *Monumenta*, VIII, 443. Rafael Castelo de Vide reports the church of Saint Anthony as the sepulchre of the kings circa 1780; see "Viagem do Congo do Missionário Fr. Rafael Castello de Vide, Hoje Bispo de S. Tomé (1788)," 1780–1788, MS Série vermelha n.o 396, 132, Academia das Ciências, Lisbon. Francisco das Necessidades in 1782 reports the church of Saint Michael as the sepulchre of kings; see Necessidades, "Memoria de como veio a nossa christianidade de Portugal (1844)," *Factos memoraveis: Boletim oficial da provincia de Angola*, no. 642 (1858), 2. See Bernardo da Gallo in Scritture originali riferite nelle congregazioni generali, 1711, t. 576, fol. 331r, Archivio Storico de Propaganda Fide, the Vatican, published in Jadin, "Le Congo et la Secte des Antoniens," *Bulletin de l'Institut Historique Belge de Rome*, XXXIII (1961), 474. For Lorenzo da Lucca's visit to Saint Michael, see Teobaldo Filesi, *Nazionalismo e religione nel Congo all'inizio del 1700: La setta degli antoniani*, Quaderni della rivista "Africa," 1 (Rome, 1972), 109. In this period of civil wars, the identification of the different churches and of the tombs they hosted in the abandoned city of São Salvador seemed to have been difficult. The oral histories, including the matricide, are discussed in Jadin, "Le Congo et la Secte des Antoniens," *Bulletin de l'Institut Historique Belge de Rome*, XXXIII (1961), 472. For Soyo, see Giuseppe Monari da Modena in Piazza, "Relazione inedita," *Italia Francescana*, XLVII, nos. 4–5 (1972), 235–236. Cuvelier also suggests that Saint Michael was the funerary chapel of the Prince of Soyo, albeit with an uncharacteristically imprecise reference, in J[ean] Cuvelier, "L'ancien Congo d'après Pierre van den Broecke (1608–1612)," *Extrait du Bulletin de l'Académie Royale des Sciences Coloniales*, XLII (1955), 185.

The Reconfiguration of Ritual Time

The three-way connection between political power, Christianity, and devotion to the ancestors present in the funerary chapels also manifested itself in the ritual calendar. The most prominent holidays in the Christian Kongo were the feast of Saint James on July 25, in commemoration of the victory of Afonso thanks to the Warrior Saint and of the advent of Christianity in the kingdom, and All Souls' Day, honoring the deceased. Saturdays, which in the Latin church were reserved for remembering the burial of Christ and, by extension, for the commemoration of the dead in general, also held special status in the kingdom. The festival of All Souls occasioned particularly elaborate celebrations during which worshipers gathered around tombs to light candles and recite prayers throughout the night. The Capuchin Marcellino d'Atri described the commemoration of the festival in royal circles in São Salvador around 1700. On that day, he reported, the living ruler visited the tombs of the kings; accompanied by the chimes of handheld bells, he made generous offerings to the church in exchange for the priest's prayers for his departed predecessors. Following the king, each member of the court in order of precedence presented their own donation. The living king and the priest then moved on to a nearby church that hosted the tombs of nonroyal elite, where they enacted the same ceremonial.[12]

That year, 1700, Friar Marcellino contributed an allegorical tableau of his own to the spectacular festival. He constructed for the occasion an altar on the main plaza of São Salvador outfitted "with a figure of death, portrayed as a skeleton, with the sickle in one hand and the hourglass in the other." The memento mori, wielding an iron blade and, given the Capuchins' reputation, probably constructed with a real skeleton, must have formed a striking display. It might have directly recalled for its central African viewers the weapon-yielding, life-size anthropomorphic figures that existed in and around the Christian realm, such as the one illustrated on the coat of arms of the Kongo in 1548, which preceded the equally awesome *minkisi minkondi* of

12. Marcellino d'Atri in Carlo Toso, *L'anarchia congolese nel sec. XVII: La relazione inedita di Marcellino d'Atri,* Studi di storia delle esplorazioni, 15 (Genoa, 1984), 289. For the special emphasis given to Saturdays, see, for example, Rafael Castelo de Vide, "Descricao da Viagem que fiz para Angola e Congo o Missionario Fr Rafael de Castelo de Vide," 1780, RES 2, maço 4, doc. 74, fol. 217, Sociedade de Geografia de Lisboa; Jadin, "Les missions du Congo à la fin du XVIIIe siècle," *Congresso Internacional de história dos descobrimentos,* V (Lisbon, 1961), 223. For All Souls' Day festivals, see Bernardo da Gallo in Jadin, "Le Congo et la Secte des Antoniens," *Bulletin de l'Institut Historique Belge de Rome,* XXXIII (1961), 483; Louis Jadin, "Le clergé séculier et les capucins du Congo et d'Angola aux XVIe et XVIIe siècles: Conflits de juridiction, 1700–1726," ibid., XXXVI (1964), 247; Anne Hilton, *The Kingdom of Kongo,* Oxford Studies in African Affairs (Oxford, 1985), 96; Jadin, "Andrea de Pavia au Congo," *Bulletin de l'Institut Historique Belge de Rome,* XLI (1970), 440–441.

the nineteenth and twentieth centuries (see Figures 13 [Plate 6] and 16). Like these power figures, Friar Marcellino's reaper stood menacingly, clenching an iron blade. These weapons evoked in the Kongo ideas of power and might through their shape, material, and use in rituals such as the *sangamentos*. The skeleton, in turn, linked the multivalent ideas of power cast in the iron blade to equally broad conceptions of death and ancestral prestige. The allegorical skeletal figure could be easily associated with central African practices of conservation and display of the bodies of prominent rulers after their death, often positioned as if alive, and often outfitted in the Christian context with swords of status. Giovanni Antonio Cavazzi's watercolor of Queen Njinga propped up for her funeral in 1663 gives us an image of a central African dead ruler staged in a lifelike position (see Figure 77 [Plate 34]). Marcellino's figure of death, in any case, did not fail to capture the interest of the Kongo king, who decided to keep it for display in his personal oratory.[13]

Around the same time, a letter from the electors of the prince of Soyo to the prefect of the Capuchin mission dated 1702 outlined further the significance of the Christian celebration of the dead in Kongo discourses of political power and legitimacy. The letter asked the prefect to authorize a biyearly celebration of the dead in the province. The first one would occur on the feast day of Saint James in the Capuchin hospice "in suffrage of the poor souls of our dead ones," and the second celebration, on another unspecified day, would take place in the funerary chapel of Saint Michael for "the soul of the defunct princes [of Soyo]." This request resulted from the powerful province's rise to independence from the weakened central Kongo crown. In the second half of the seventeenth century, the rulers of Soyo became more and more powerful thanks in part to their advantageous location on the coast, at the nexus of the kingdom's foreign trade, including the flourishing export of people captured as slaves in the wars of the interior. Soyo rulers gradually affirmed their independence in a series of gestures that culminated in the civil war during which they fought against several pretenders to the central Kongo crown between 1665 and 1709. In that context, the provincial leaders instated new celebrations that emulated and competed with those of the weakened Kongo crown. In addition to the festival dedicated to their own departed princes mentioned above, they created a new celebration, on October 18, the feast day of Saint Luke, to commemorate the victory of Soyo over the allied Kongo and Portuguese troops in a 1670 battle. The holiday directly replicated

13. Marcellino d'Atri in Toso, *L'anarchia congolese nel sec. XVII*, 289–290. For the treatment of dead bodies, see Gio[vanni] Francesco da [Roma], *Breve relatione*, 202. For swords in funerary regalia, see Vandenhoute, "De Begraafplaats van Ngongo-Mbata," 56.

the ceremonies on the feast day of Saint James, during which Kongo kings were feted with the most important sangamento of the year in celebration of the victory of Afonso and of the Christian founding of the kingdom. On the feast day of Saint Luke, the leaders of the coastal province, now sporting the title "great prince of Soyo," emulated the pageantry that surrounded the kings of Kongo in a move with clear political aims and symbolism. By the early eighteenth century, the rulers of Soyo had also procured a painting of Saint Luke that they processed around town. In other words, the Christian celebration of deceased rulers, the celebration of a festival marking the date of a foundational military victory, and the dedication of a funerary chapel to host the remains of rulers all strategically participated in the construction of Soyo's claim to sovereignty. These moves by a rising polity in search of autonomy highlight the significance and manifestations in space and time of the three-way link between political power, Christian ritual, and devotion to the dead in the conception of legitimacy and of the nature of political power in the kingdom of Kongo at large.[14]

The Spectacle of Architecture

Monumental crosses and churches stood as standards of rulership and markers of burial grounds. They interchangeably symbolized the link between political legitimacy, devotion to the deceased, and Christianity, and they located the source of power in the nexus between the world of the living and the world of the dead. Visually, both types of monuments stood out from other central African buildings. The crosses that towered over rooflines and the churches that stood on the central plaza of towns, like the cathedral in Mbanza Kongo, or within the palace compounds of rulers both endowed central African lands with a distinct Kongo Christian character.

14. The petition is published in Piazza, "Relazione inedita," *Italia Francescana*, XLVII, nos. 4–5 (1972), 235–236. This period is best described in John K. Thornton, *The Kingdom of Kongo: Civil War and Transition, 1641–1718* (Madison, Wis., 1983); Thornton, *The Kongolese Saint Anthony: Dona Beatriz Kimpa Vita and the Antonian Movement, 1684–1706* (Cambridge, 1998). On the feast day of Saint Luke, see Cuvelier, *Relations sur le Congo*, 53. Celebrations of the feast of Saint James are described in Girolamo Merolla da Sorrento and Angelo Piccardo, *Breve, e succinta relatione del viaggio nel regno di Congo nell' Africa meridionale, fatto dal P. Girolamo Merolla da Sorrento . . . Continente variati clima, arie, animali, fiumi, frutti, vestimenti con proprie figure, diversità di costumi, e di viveri per l'vso humano* (Naples, 1692), 159–161. The "gram principe de Sonho" ("great prince of Soyo") also acquired his own seal that consisted of a simple cross, emulating the use of the cross as a symbol of the origins of Kongo Christian kingship. See the signature of the prince in Richard Gray, "'Come vero Prencipe Catolico': The Capuchins and the Rulers of Soyo in the Late Seventeenth Century," *Africa: Journal of the International African Institute*, LIII, no. 3 (1983), 44. For the painting of Saint Luke, see Cuvelier, *Relations sur le Congo*, 58.

The most prominent trait that distinguished the buildings used as churches in the Kongo was their abrupt and unmediated presence in public spaces. In contrast to domestic architecture, in which inhabited quarters remained removed from public view behind several walls, churches stood in town squares, their facades open to the direct gaze of all. This feature is striking since enclosures defined the Kongo built environment. Fences of human height bounded towns, palaces, or even remote ritual meeting grounds and separated inside from outside spaces with a physical and visual barrier. The earliest European reports already noted the fences, such as the 1491 description of Mbanza Kongo, the capital of the king of Kongo, as "encircled with a wall and towers." A detail from a drawing from the 1650s, now in the Museo Francescano in Rome, depicts this feature in two different contexts (Figure 70). In the image on the left, small trees or pickets planted at regular intervals and joined together to form an opaque wall create a rectangular enclosure for a modest building. This "house surrounded with a fence" is a small orthogonal structure with a low door and no windows. The second image, to the right, depicts the "house of the king with more fences." A modestly sized building stands at the center of the inner courtyard of this larger compound, alongside smaller constructions. Three concentric rectangular fences surround this central space. The height of the fences increases from the inside to the outside. Full-grown trees serve as the vertical poles for the outermost hedge. In both examples, the door of the outside fence and that of the main building face different directions, allowing no direct line of sight between the outside and the inside.[15]

The use of large trees in labyrinthine walls to bound elite compounds also appears in the print of a "noble house" published in Girolamo Merolla da Sorrento's 1692 *Breve relatione del successo della missione de'frati minori Cappuccini* (Figure 71). Here, several small circular thatched houses built closely together are protected with three circular fences, each with a gate facing a blind wall. As the two images suggest, both circular and quadrangular structures existed in the early modern Kongo, but it is unclear whether the different shapes had particular social meanings. On occasion, a single town grouped quadrangular and round buildings. Fences, however, played a better-known role. Capuchin friar Francesco da Roma insisted on the significance of the enclosures in the architecture, linking the number of inner fences to the social standing of the compound's owner. The king's palace, for instance, even

15. The 1491 report reads: "Et tene dicto re una terra circundata de muro e torre"; see Potenze estere 649 (Misc. in cartolina "Guinea"), Archivio di Stato di Milano, transcribed in Kate Lowe, "Africa in the News in Renaissance Italy: News Extracts from Portugal about Western Africa Circulating in Northern and Central Italy in the 1480s and 1490s," *Italian Studies*, LXV (2010), 327.

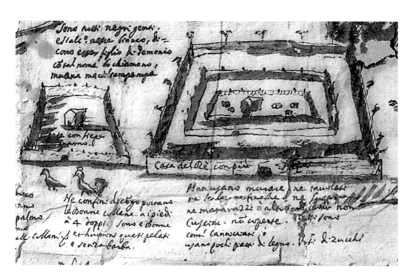

FIGURE 70 Kongo Enclosures. Detail of Anonymous, *People, Victuals, Customs, Animals, and Fruits of the Kingdoms of Africa*. Circa 1652–1663, 73 × 40 cm. MF 1370, Franciscan Museum of the Capuchin Historical Institute, Rome. Courtesy of the Capuchin Historical Institute, Rome

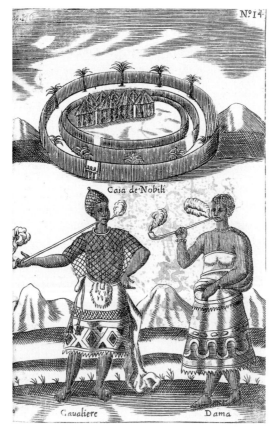

FIGURE 71 Elite Couple and Compound from the Kongo. From Girolamo Merolla da Sorrento and Angelo Piccardo, *Breve, e succinta relazione del viaggio nel regno di Congo nell' Africa meridionale, fatto dal P. Girolamo Merolla da Sorrento . . . Continente variati clima, arie, animali, fiumi, frutti, vestimenti con proprie figure, diversità di costumi, e di viveri per l'uso humano* (Naples, 1692), plate 14. Photograph courtesy of The Warden and Fellows of All Souls College, Oxford

in the temporary settlement described by Friar Lorenzo da Lucca circa 1700 at the height of the civil war, counted "many wall enclosures." The maze-like walls separating inner courtyards from the central plaza of the town defined palatial architecture in the Kongo from the sixteenth to the late nineteenth century. In the 1580s, the Discalced Carmelites commented on the palace of the king and the "many palisades and paths" that led to its entrance that formed "something like a labyrinth of Crete." Three hundred years later, in 1858, Portuguese civil servant Zacharias da Silva Cruz described the entire capital as a maze; he lamented that the various compounds "hardly had a passage between one and the other, and with such twists and turns, it is difficult to find one's way in a labyrinth of the sort."[16]

Eyewitness accounts from travelers and missionaries provide detailed descriptions of the architecture and construction techniques of the Kongo. The fences and house walls deservedly receive particular notice. They consisted of artfully woven vegetal material that created double-sided designs. Kongo architecture, basketry, and textiles were intimately related expressive genres. Similar creation techniques for all three produced common motifs that graced the built environment, the movable furniture that outfitted it, and the bodies of its dwellers. Rui de Pina reported the impressions of the first visitors to the Kongo in 1491 who saw the large structures of the king's palace. These houses were "beautiful and all decorated and woven of diverse loops *(laços)* made of palms of many colors."[17]

Two centuries later, Merolla described similar sophisticated designs on the facade of the ruler of Soyo's palace and that of the dwellings of a few members of the local elite that received permission to make use of the privileged decorations. A complex arrangement of small wood planks of various hues produced, in the words of the friar, a "quadratura." In the context of seventeenth-century Italy, the word *quadratura* referred to "illusionist architectural painting aimed at extending real architecture into an imaginary space." In other words, Merolla described the effect that the wall decoration

16. W. Holman Bentley also remarked on trees used in the structure of fences in 1879; see Bentley, *Pioneering on the Congo* (New York, 1900), 141. Diversely shaped structures appear in figure 5 of Bernardino Ignazio da Vezza d'Asti, "Missione in prattica: Padri cappuccini ne' Regni di Congo, Angola, et adiacenti," circa 1750, MS 457, Biblioteca Civica Centrale di Torino. Merolla also mentions the variety of house shapes in Ngoyo, north of the Congo River, in Merolla and Piccardo, *Breve, e succinta relatione,* 278. For the significance of enclosures, see Gio[vanni] Francesco da [Roma], *Breve relatione,* 186. Lorenzo da Lucca mentions the enclosures in 1706 in Filesi, *Nazionalismo e religione nel Congo all'inizio del 1700,* 99. For the Carmelite report, see J. Cuvelier and L. Jadin, *L'ancien Congo d'après les archives romaines (1518–1640)* (Brussels, 1954), 132. On the capital as maze, see Zacharias da Silva Cruz, "Relatório sobre a sua viagem à San Salvador do Congo," *Boletim official de Angola,* no. 695 (1859), 3. Bentley also describes "the labyrinth" fences at the entrance of the king's compound in 1879; see Bentley, *Pioneering on the Congo,* 123.

17. Rui de Pina, in Brásio, *Monumenta,* I, 114.

produced as trompe l'oeil. Although other observers did not provide such an explicit description of the wall decorations, they did note the colorful effect of facades in preceding centuries. Merolla himself elsewhere admired the house of the governor of Ngoyo, north of the Congo River, which was "covered with vines woven in delicate designs and embellished with diverse colors." The play of colors on juxtaposed woven planks created illusionistic three-dimensional motifs on the walls of the prestigious buildings. The geometric motifs of Kongo textiles and ivories from the period easily suggest the effect of similar designs produced at a larger scale on walls. The interlacing of geometric patterns on a cloth that arrived in Europe in the early eighteenth century, for example, showcases the sort of trompe l'oeil effects that Merolla experienced looking at the walls of palaces in Soyo (Figure 72). Dark and light geometric designs interlace at right angles, suggesting the light and shadow of three-dimensional objects. Similar treatment of colors and shapes also decorated movable objects from textiles to ivory tusks (see Figure 21) and basketry (depicted in Figure 7 [Plate 3]), all well-known types of objects documented by examples in early modern European collections.[18]

The friar's characterization of the architectural decoration is a precious addition to our scant knowledge of central African architecture before the nineteenth century. In particular, it allows us to grasp that elite structures of the Kongo not only provided a physical frame for the people and the activities they hosted but also created a dazzling visual environment. Walls, clothing, and objects of status echoed one another in palatial spaces in a concert of geometric patterns of varying scales, colors, and shapes. The intricate designs of *mpu* caps, decorated ivory horns, woven boxes, and textiles moved each at their own pace and along their own path on a background of equally intricate motifs deployed on the palaces' facades, palisades, and walls. The juxtaposition of patterns of different dimensions, hues, and textures—some staying still, others moving in varying rhythms and trajectories—created an opulent visual experience. A print depicting the king of Loango in Olfert Dapper's 1668 *Naukeurige beschrijvinge der Afrikanensche Eylanden* aptly captures the dizzying spectacle (Figure 73). The printmaker for the Dutch compiler com-

18. Merolla and Piccardo, *Breve, e succinta relatione,* 168–169, 278; Lorenzo da Lucca and Filippo da Firenze, "Relazioni," 1700–1717, fols. 96–97, in Cuvelier, *Relations sur le Congo,* 80. For wall construction techniques, see Calogero Piazza, *La missione del Soyo (1713–1716) nella relazione inedita di Giuseppe da Modena OFM Cap.* (Rome, 1973), 228. See the definition of *quadratura* in Rudolf Wittkower, Joseph Connors, and Jennifer Montagu, *Art and Architecture in Italy, 1600–1750,* 6th ed., 3 vols. (New Haven, Conn., 1999), I, 35. A 1580s document also reports the use of polychrome woven walls of "good appearance"; see Cuvelier and Jadin, *L'ancien Congo d'après les archives romaines,* 120. See the Kongo objects in early modern collections catalogued in Ezio Bassani, *African Art and Artefacts in European Collections, 1400–1800,* ed. Malcolm McLeod (London, 2000), object nos. 394, 436, 451.

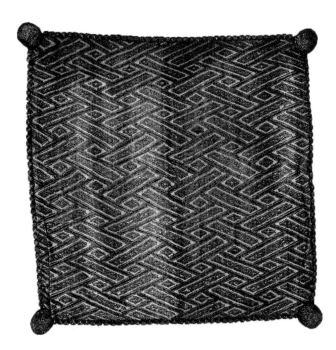

FIGURE 72 Kongo Double Pile Cloth with Geometric Decoration and Tassels. Kongo kingdom, seventeenth or early eighteenth century. Raffia-palm fiber, 55 × 55 cm. The National Museum of Denmark inv. no. Dc. 106 Textile. Photograph © The National Museum of Denmark, Ethnographic Collection

posed a view of a central African courtly scene. He compellingly rendered the effect that the juxtapositions and overlaps of motifs, textures, and patterns produced in the royal ceremonial. Although the print is in black and white, it vividly suggests the rich spectacle created by the colorful animal pelts, striped imported cloth, local textiles as well as white ivories, bright feathers, beads, shiny metals, and carved woods packed together inside a walled enclosure in front of a thatched building. Other prints in Dapper also capture the lavish show of patterns and textures of central African courts—for example, the depiction of the coronation scene in the Kongo discussed previously and below (see Figure 6). Photographs of the Kuba royal court, eastern neighbors of the Kongo since the seventeenth century, illustrate well the rich visual effects orchestrated in the pomp of the early modern Kongo elite.[19]

Although Portuguese masons and carpenters introduced European building techniques to the kingdom around 1500, the inhabitants of the Kongo showed little interest in these innovations, except for the building of churches. Palaces and other residential structures generally did not make use of masonry or wood-plank construction. In São Salvador, only the Portuguese quarter included houses that followed European footprints and used

19. For photographs of the Kuba royal court, see, for example, Suzanne Preston Blier, *The Royal Arts of Africa: The Majesty of Form* (New York, 1998), 200, 243.

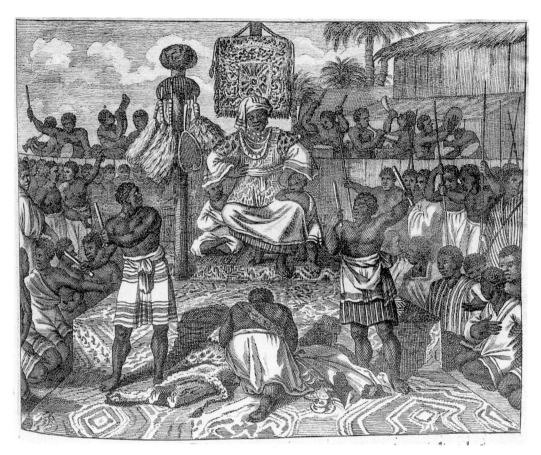

FIGURE 73 *Court Scene from Loango.* From Olfert Dapper, *Naukeurige beschrijvinge der afrikanensche eylanden: Als Madagaskar, of Sant Laurens, Sant Thomee, d'eilanden van Kanarien, Kaep de Verd, Malta en andere, vertoont in de benamingen, gelegentheit, steden, revieren, gewassen . . .* (Amsterdam, 1668), 539. Photograph courtesy of the Melville J. Herskovits Library of African Studies, Northwestern University

either stonework or white-plastered straws and earth walls. Among all the buildings, only the king's palace rose to a second story. A confined and walled section of the city encompassed all of its stone constructions, including the circular tower prominently featured in seventeenth-century depictions of the city, such as Dapper's view in Figure 74. The wall, between four and six meters high and about one meter thick, as well as the tower was still standing in the mid-nineteenth century, according to Baptist missionary W. Homan Bentley. Churches, bell towers, and the monumental crosses that could reach as high as ten meters thus conspicuously rose above the skyline of the city. The large crosses also often stood ostentatiously on hills or other visible landmarks. The rest of the town's architecture, in sharp contrast to these Christian landmarks,

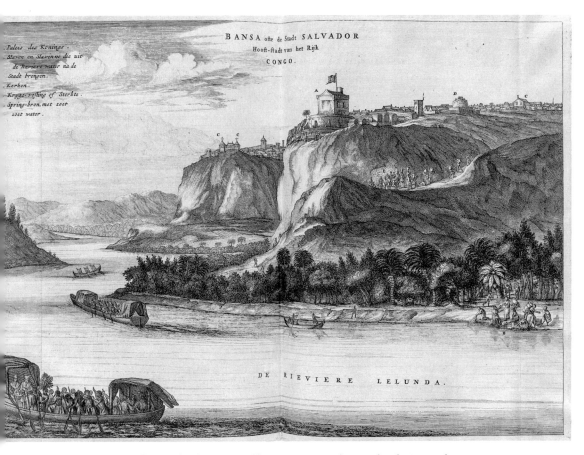

FIGURE 74 *View of São Salvador*. From Olfert Dapper, *Naukeurige beschrijvinge der afrikanensche eylanden: Als Madagaskar, of Sant Laurens, Sant Thomee, d'eilanden van Kanarien, Kaep de Verd, Malta en andere, vertoont in de benamingen, gelegentheit, steden, revieren, gewassen . . .* (Amsterdam, 1668), 562–563. Photograph courtesy of the Melville J. Herskovits Library of African Studies, Northwestern University

followed an almost opposite pattern, presenting monotonous exteriors that set the stage for the sometimes extravagant visual spectacle of the interiors. The fences that bounded each compound not only defined individual plots but also served as paths between them, narrow and blind passageways that enclosed the passersby's gaze.[20]

20. Afonso of Kongo to Manuel I, Oct. 5, 1514, June 13, 1517, in Brásio, *Monumenta*, I, 294–323, 410–411. For the king's palace specifically, see Gio[vanni] Francesco da [Roma], *Breve relatione*, 188. The circular tower and the pleasing effect of the arrangement of the passageways is mentioned in [A. J. de Castro], "O Congo em 1845: Roteiro da Viagem ao Reino do Congo, por A. J. de Castro, major da Provincia de Angola, em junho de 1845," *Boletim da Sociedade de Geographia de Lisboa*, 2d Ser., II (1880), 63, 64. Bentley describes the wall as it stood in 1879 in *Pioneering on the Congo*, 141. Cavazzi mentions crosses in prominent locations in Cavazzi and Alamandini, *Istorica descrizione*, 844.

Kongo Church Architecture

The view of São Salvador in Dapper's 1668 *Naukeurige beschrijvinge,* al-
though a second-hand European creation, captured the overall effect of
the royal palace and churches rising above the generally low-profile houses
of the hilltop city (Figure 74). As always in Dapper's illustrations, it is dif-
ficult to distinguish between details that might have been accurately derived
from the documentary sources at the disposal of the engraver and fanci-
ful ideas about Africa elaborated by an artist who likely never left Europe.
Here, however, as with other illustrations of central Africa in this work,
the images prove more accurate than the text and point to the existence of
sources of great accuracy from which the engraver drew. In the coronation
scene, for example, the coat of arms of the kings of Kongo appears on the
back of the chair but is not mentioned in the text. Similarly, the enclosure
described in the text as a "wall of chalk and cement" appears to the left of
the image as a dutiful description of these words but morphs on the right
side into a more ambiguous and almost certainly more accurate depiction
of a woven vegetal enclosure, structured by a series of palm trees, as seen
on the far right corner. The different treatment of the wall derives from the
depiction of light and shadow in the print, but the palm tree detail suggests
a visual source for the image in which the enclosure resembled that in the
Museo Francescano drawing (see Figure 6 and Figure 70). In Figure 74, the
depiction of the freshwater source, the walled quarters of the city, and its
cliff-top location are all convincing details that make the print a satisfy-
ingly evocative view of the Kongo capital in the mid-seventeenth century. In
the image, the towering churches and crosses lend to the town a distinctly
Christian appearance in keeping with the written descriptions and material
evidence that have survived to our time. In particular, it conveys the great
visibility of the churches in the Kongo landscape. Their size, the crosses
attached to their roofs, and their presence in public spaces without fences
or enclosures gave them great visual impact and presence in the central
African environment.[21]

 Height and often also construction techniques differentiated the churches
from other types of buildings. Churches regularly used European or European-

21. A painting in the collection of the Musée Dapper in Paris presents a closely related view of the
city probably inspired by the print in Olfert Dapper, *Naukeurige beschrijvinge der afrikanensche eylan-
den: Als Madagaskar, of Sant Laurens, Sant Thomee, d'eilanden van Kanarien, Kaep de Verd, Malta
en andere, vertoont in de benamingen, gelegentheit, steden, revieren, gewassen . . .* (Amsterdam, 1668),
562–563 (Figure 74, above); see Christiane Falgayrettes-Leveau and Musée Dapper, *Le geste kôngo*
(Paris, 2002), 134–135. For a larger discussion on the evidentiary potential of Dapper, see Adam Jones,
"Decompiling Dapper: A Preliminary Search for Evidence," *History in Africa,* XVII (1990), 171–209.

inspired materials such as wood planks or stone and mortar with occasional thatched additions for the sacristy or the living quarters of visiting missionaries. The images from the Turin "Missione in prattica" suggest a differentiation between secular buildings, temporary shelters for portable altars, and dedicated churches. The latter, seen in Figures 2 (Plate 1), 18 (Plate 10), and 56 (Plate 27), seem to be made of wood planks; they are often plastered and conform in their shape and proportions to European constructions. The sixteenth-century parish church later elevated to the Cathedral of Kongo in 1596 is a testament to the use of European-inspired techniques and materials for the construction of important churches. The building suffered greatly through the centuries, yet it still partially stands today.[22]

The history of the cathedral's partial destruction and conservation can be traced from the beginning of the seventeenth century. According to Francesco da Roma, the cathedral, dedicated to São Salvador, was around 1645 one of three stone-and-mortar churches in the capital, along with Our Lady of the Immaculate Conception and Saint James. In 1694, it was one of the few surviving churches in the ruined capital that Luca da Caltanisetta visited at the height of the era of civil wars. It still stood whole, although damaged by the roots of overgrown trees. By 1705, Bernardo da Gallo judged the building to be destroyed. His assessment might have been pessimistic, or renovations might have taken place during the eighteenth century, since in 1781 the once more abandoned cathedral stood with some of its side chapels intact. In 1845, António Joaquim de Castro found the principal chapel and its altar on a stepped platform, the chapel of the Sacrament and the sacristy standing. A decade later, in 1858, Portuguese lieutenant Zacharias da Cruz reported that the church was in a similar state, as did Bentley in 1879.[23]

A 1914 photograph by Portuguese military officer José Veloso de Castro shows the remains of the massive stone-and-mortar walls of the sacristy and sanctuary that endured through the centuries (Figure 75). At the center, two

22. Merolla and Piccardo, *Breve, e succinta relatione,* 168. See the description of churches in the capital in Gio[vanni] Francesco da [Roma], *Breve relatione,* 179–181. Straw or light-material constructions adjoining churches are mentioned in Jadin, "Les missions du Congo à la fin du XVIIIe siècle," *Congresso Internacional de historia dos descobrimentos,* V (Lisbon, 1961), 213. For the cathedral, see António Brásio, "Quarto centenário da Sé do Congo," *Portugal em Africa,* 2d Ser., V, no. 26 (1948), 91–99.

23. Gio[vanni] Francesco da [Roma], *Breve relatione,* 181; Bontinck, ed. and trans., *Diaire congolais,* 36; Bernardo da Gallo, in Filesi, *Nazionalismo e religione nel Congo all'inizio del 1700,* 79. For the 1781 assessement, see Jadin, "Les missions du Congo à la fin du XVIIIe siècle," *Congresso Internacional de historia dos descobrimentos,* V (Lisbon, 1961), 213. For the nineteenth-century descriptions, see [Castro], "O Congo em 1845," *Boletim da Sociedade de Geographia de Lisboa,* 2d Ser., II (1880), 63; Cruz, "Relatório sobre a sua viagem à San Salvador do Congo," *Boletim official de Angola,* no. 695 (1859), 2; Bentley, *Pioneering on the Congo,* 141.

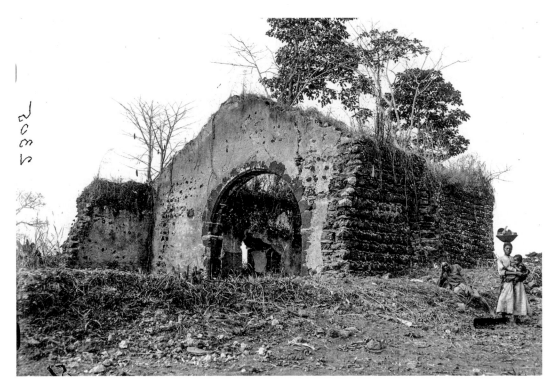

FIGURE 75 José Veloso de Castro, *Cathedral of São Salvador*. Circa 1914. Photograph. PT/AHM-FE-CAVE-VC-A10-2305, Archive of the Arquivo Histórico Militar, Lisbon, Portugal

square, engaged columns with decorative capitals support a round masonry arch with chiseled edges that separates the nave from the sanctuary, as António Joaquim de Castro, Cruz, and Bentley had described decades earlier. The stones are plastered, and the structure was once covered with a simple gable roof. A smaller doorway on the far wall opened to the bishop compound or, according to Cruz, to one of two lateral chapels. The photograph fits well not only with Castro's notes but also with Eustachio da Ravenna's 1711 drawing of the bishopric of the Kongo, now missing from the Propaganda Fide archives in Rome but published by Louis Jadin in 1964 (Figure 76). The drawing was part of a project for reorganizing the cathedral and its surroundings that would elaborate upon existing structures. The cathedral appears in the drawing as a rectangular church with a single nave, a gable roof, and a large arched entrance that stood in the axis of the other archway linking the nave to the choir, which is visible in the photograph. Windows on the front and the side walls bring light to the interior. A choir and sacristy of diminishing height complete the building, which is topped by two crosses, a flag, and a small bell tower. The simple facade articulates a square window in the

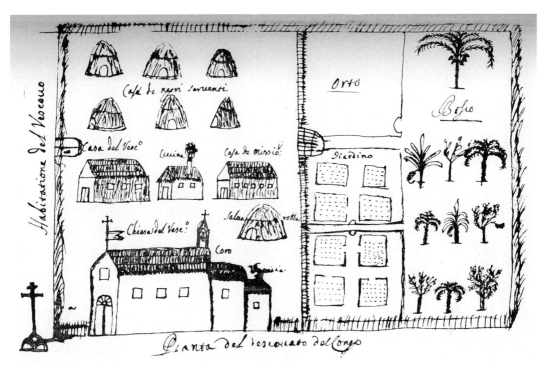

FIGURE 76 Eustachio da Ravenna, *Plan of the Bishopric of Congo*. 1711. From Louis
Jadin, "Le clergé séculier et les capucins du Congo et d'Angola aux XVIe et XVIIe
siècles: Conflits de juridiction, 1700–1726," *Bulletin de l'Institut Historique Belge de
Rome*, XXXVI (1964), 260. Photograph, the University of Chicago Visual Resources
Center, courtesy of the Belgisch Historisch Instituut te Rome—Institut historique
belge de Rome (BHIR-IHBR)

upper tier and a large arched doorway composed of a fanlight opening at the
top and a two-door gate at the bottom. According to Castro, the cathedral
measured about 31 by 15 meters, with the choir about 7 by 6 meters. In Friar
Eustachio's drawing, the cathedral stands directly on the public square, next
to a monumental cross. It opens on its side through the door seen in the 1914
ruins to the proposed private enclosure of the bishop's residence. The friar
envisioned the bishopric as a compound in the central African style, with a
palisade enclosing a series of buildings. The bishop's house and sleeping quar-
ters for missionaries would follow European plans, and servant houses would
use local construction patterns. A fruit and vegetable garden would complete
the complex. The actual construction followed an even more ambitious plan,
according to Castro's observations of the remains of the bishop's palace in
1845. He described four exterior walls that outlined a grand building, the
facade of which opened with a large central gateway flanked by two smaller

doors; all three openings were constructed in full masonry arches. Cruz, in turn, judged that the entire compound, consisting of the stone-and-mortar sixteenth-century cathedral as well as the eighteenth-century bishop's palace, measured around 250 meters.[24]

The provincial church of Ngongo Mbata, excavated in the twentieth century, provides an example of a provincial structure with a similar plan, but on a smaller scale. The church stood prominently on a small hill, on a platform six steps above the ground. It measured about twenty-five by ten meters, about half the size of the cathedral, and faced west with the altar at the eastern end. Boulders set in earth formed the walls and the steps leading to the building. The simple, rectangular single-nave plan is similar to that of São Salvador in the kingdom's capital. It contained more than thirty tombs and probably was a dedicated funerary chapel, as was São Salvador and Saint Michael in Soyo, rather than a structure meant to accommodate primarily the liturgy of the Mass. Echoing Giuseppe Monari da Modena's description of the relative prestige of tomb locations, with the friars' resting places at the front and center, the graves at the center of the Ngongo Mbata church were larger, more elaborate, and outfitted with richer burial material. With each elaborate grave erected within its walls, the interior of the church grew denser. The tumuli themselves must have offered a striking sight with their red earth, somber black palls, and the numerous movable devotional objects, figures, and images placed in their midst as suffrage for the deceased.[25]

Built under the impetus of local rulers, European-style religious buildings participated in making the kingdom's territories a Christian landscape. Ambitious buildings such as the cathedral as well as more modest constructions in smaller localities such as Ngongo Mbata testify to the great resources mobilized to implement and sustain the kingdom's conversion. The churches served as monuments of the new political and religious order ushered in by Afonso and enlivened through the centuries by his successors.

24. The drawing appeared in Jadin, "Le clergé séculier," *Bulletin de l'Institut Historique Belge de Rome*, XXXVI (1964), 260. António Joaquim de Castro's measurements, at about 22 centimeters for a palm, are 141 by 69 palms, or 31 by 15 meters, for the full church, 33 by 27 palms, or about 7.26 by 5.94 meters, for the choir, and 108 by 42 palms for the nave, or 23.76 by 9.24 meters. I use here the concordances in J. F. G. Palaiseau, *Métrologie universelle, ancienne et moderne, ou, Rapport des poids et mesures des empires, royaumes, duchés et principautés des quatre parties du monde présenté en tableaux par ordre alphabétique de pays ou ville* . . . (Bordeaux, 1816), 160. See [Castro], "O Congo em 1845," *Boletim da Sociedade de Geographia de Lisboa*, 2d Ser., II (1880), 63; Cruz, "Relatório sobre a sua viagem à San Salvador do Congo," *Boletim official de Angola*, no. 695 (1859), 2.

25. Giuseppe Monari da Modena, in Piazza, "Relazione inedita," *Italia Francescana*, XLVII, nos. 4–5 (1972), 240. A short description of the Nongo Mbata site, including the plan of the church and markings of the location and size of the tombs, appeared in G. Schellings, "Oud Kongo: Belangrijke Ontdekking uit de eerste beschaving," *St. Gerardusbode: Maandschrift der paters Redemptoristen*, LIII, no. 8 (1949), 10–13.

Devotional Furnishings

Churches spectacularly built in stone and mortar or otherwise visibly emulating European architecture might have been the most striking type of building dedicated to Kongo Christian practice, but they were not the only ones. Other structures used local construction techniques or were wholly integrated into palatial compounds. Regardless of their outside appearance, funerary chapels as well as liturgical churches all hosted numerous devotional paraphernalia within their walls. This assortment of objects allowed European observers to recognize without hesitation diverse types of buildings as Christian temples, whether, in Friar Giovanni Francesco da Roma's words, they were made "with sticks and straw, large and small according to the number of inhabitants."[26]

Many of the devotional objects and images that defined the Christian spaces originated from abroad. Imported devotional images flowed into the Kongo since the kingdom's first contact with Europeans. Early chroniclers such as Rui de Pina in the sixteenth century commented on the size, properness, and ornamentation of even the earliest churches built in the kingdom. Inquisition inquiries conducted in the kingdom between 1596 and 1598 brought to light the commercial networks from which buyers in the Kongo obtained foreign objects of devotion. In the market of the provincial capital of Mbata around 1595, for example, Portuguese and African traders offered for sale crucifixes and images of saints but also masks (*carrancas feitas de pastilha com fio de seda and alchimia*), puppets or articulated figures (*bonifrates*) advertised as relics, "bones of saints" (*ossos de sanctos*), and "sons of God" (*filhos de Deus*). Moreover, these devotional objects entered and traveled within the country through close-knit rather than occasional commercial relationships. One of the Portuguese men who appeared in the Inquisition documents, for instance, could claim knowledge of the final destination of his merchandise, asserting that one of his crucifixes resided in "the house of the king of Kongo, in the chapel of the Manibunho."[27]

26. For descriptions of other types of churches, see Brásio, *Monumenta*, III, 502. See also Necessidades, "Memoria," *Factos memoraveis*, no. 642 (1858), 12; Bontinck, ed. and trans., *Diaire congolais*, 9; Gio[vanni] Francesco da [Roma], *Breve relatione*, 181.

27. "Construção da Primeira Igreja Do Congo (6-5-1-6-1491)," in Rui de Pina's chrónicas, livro C, cap. LXI, in Brásio, *Monumenta*, I, 130. The Inquisition inquest is in Tribunal do Santo Oficio, Inquisição de Lisboa, processo 776, fols. 66–66v, 82r, 103v2r, Arquivo Nacional da Torre do Tombo, Lisbon, and has been discussed in José da Silva Horta, "Africanos e Portugueses na documentação Inquisitorial de Luanda a Mbanza Kongo (1596–1598)," *Actas do Seminário "Encontro de Povos e Culturas em Angola,"* Luanda, Apr. 3–6, 1995 (Lisbon, 1997), 309, 311.

When the Capuchins arrived in the region fifty years later around 1650, they praised the wealth of embellishments and images that graced local churches. In their descriptions, they rarely remarked on the local manufacture of works except to mention the use of local material such as ivory or indigenous seeds used as rosary beads. In contrast, they did make a point to note objects of foreign provenance, a practice that highlights the probable predominance of locally crafted Christian art. Juan de Santiago, chronicling the first Capuchin voyage to the Kongo, reported his and his fellow friars' delight in discovering several pious objects at the church of the port city of Pinda in 1645. They saw "on the worn altar a devout statue of large size of the Immaculate Conception *[purissa conçepçion]*, and another statue of Saint Anthony of Padua and a medium sized painting, very old, yet well painted, of our seraphic Father Saint Francis, in Capuchin habit and hugging a cross." The Capuchins soon added images of their own to the churches. Their missions included European painters, such as the lay brother Félix del Villar, active in the Kongo in the late 1640s, who traveled to central Africa with their materials and painted pious images on site. Around 1700, they also offered to the Confraternity of the Rosary of nearby Soyo a statue of Saint Anthony of Padua—which had been carved in Brazil and brought from Luanda—of "very good facture" and fit to be put on the main altar and used in processions.[28]

The capital of São Salvador counted the greatest number of churches and devotional art objects. Our Lady of the Conception hosted in the 1640s a "very old" statue of the Virgin brought from Spain to the Kongo before 1583 by Diego del Santissimo Sacramento, a member of the short-lived Discalced Carmelite mission. The same church also had a statue of Saint Anthony of Padua. The paintings and sculptures that adorned the churches of São Sal-

28. See chaplets made of plant seeds in Bontinck, ed. and trans., *Diaire congolais*, 36. Merolla saw an ivory crucifix on an ebony cross in the late seventeenth century; see Merolla and Piccardo, *Breve, e succinta relatione*, 319. See also Juan de Santiago, "Breve relacion de lo sucedido a doce religiosos cappuchinos de la santa sede apostolica enbio por missionarios apostolicos al reyno de Congo . . .," circa 1650, II/772, MC/791, fol. 55, Real Biblioteca del Palacio, Madrid. It was, of course, the Capuchin Franciscans who adopted the medieval habit of Saint Francis as an antiquarian gesture rather than the reverse; see also Cavazzi and Alamandini, *Istorica descrizione*, 322. For the Soyo Saint Anthony, see Lorenzo da Lucca and Filippo da Firenze, "Relazioni," 1700–1717, fols. 75–76, in Cuvelier, *Relations sur le Congo*, 57. See Félix del Villar to the Propaganda Fide, Jan. 20, 1650, in Brásio, *Monumenta*, X, 474–475. Statues from Brazil in central Africa included one of Saint Anthony, which was still extant in the twentieth century in the church of Muxima, in the northern part of Angola. See Santos Furtado, "Uma imagem de Santo António em Angola (Santo António da Muxima): Breve estudo e apontamentos," *Boletim do Instituto de Angola*, no. 14 (July–December 1960); Marcellino Canzani d'Atri, "Giornate apostoliche fatte a me Fra Marcellino d'Atri predicatore Cappucino nelle missioni de regno d'Angola e Congo, nella Etiopia inferiore parte occidentale nell'Africa 1690," 1690–1708, 110, Convento Santi Francesco e Chiara, L'Aquila, published with original pagination in Toso, *L'anarchia congolese nel sec. XVII*, 49–50.

vador received diligent care and survived through decades of disorder and several destructions of the city. At the height of the civil wars, around 1700, one of the pretenders to the throne of Kongo, exiled in the mountain outpost of Kibangu, outfitted the main church of his camp with statues of the Madonna dressed in local textiles, of Saint Francis, and of Saint Anthony. Meanwhile, another pretender settled in the partly ruined capital itself and kept in his palace a painting of the Virgin along with other objects of devotion. Both men collected and preserved devotional images, and they made sure to maintain close control over them because such prestigious objects buttressed their claim to the throne. As with the textiles, swords, and medals that the Kongo elite eagerly collected and wore, the ability to own and display devotional paintings and sculptures conferred social prestige and political weight at the highest echelon of Kongo society.[29]

Christian imagery entered into the Kongo through a variety of routes. It arrived through the secular clergy via Angola, through diplomatic relations with Christian rulers from Europe, or through the missionary orders active in the kingdom. Painting workshops in nearby Luanda also produced Christian works about which much can be imagined but little said as no examples have been identified yet. Locally produced objects joined the imported ones seamlessly. Regardless of their origins, Christian images lived a rich, eventful life in the Kongo. They were prized possessions of their community, carefully kept and maintained in churches over decades, processed around town several times a year, and sometimes proudly displayed with tributes of war, such as, on one occasion, the crown of a foreign leader defeated by a community's home ruler. Some of the Christian images even became miraculous and acquired their own local histories. Late-seventeenth-century traditions, for instance, told of the miracles of Our Lady of Muxima, an image that a small town in northern Angola felicitously imported from the heart of the Kongo.[30]

29. Giovanni Francesco da Roma saw the statue of Our Lady in 1645 and correctly assessed its age as well as that of the statue of Saint Anthony; see Gio[vanni] Francesco da [Roma], *Breve relatione*, 179–180. The statue is also mentioned in "Lettera delli Padri Carmelitani Discalzi del Convento della Madonna della Concettion di Congo in Etiopia alli Padri et Fratelli della sua provincia scritta alii 14 Decembre 1584," *Il Carmelo*, I, nos. 3–9 (1902), 109. For a short study of the Carmelite mission to the Kongo, see Graziano Saccardo, *Congo e Angola con la storia dell'Antica missione dei Cappuccini*, 3 vols. (Venice-Mestre, 1982–1983), 63–66. The three statues of the Kibangu church are described by Bernardo da Gallo in his report to the pope dated 1710, published in Jadin, "Le Congo et la Secte des Antoniens," *Bulletin de l'Institut Historique Belge de Rome*, XXXIII (1961), 499, 511. For artworks in São Salvador, see the report of Lorenzo da Lucca in 1707, ibid., 548.

30. For paintings in Luanda, see Toso, *L'anarchia congolese nel sec. XVII*, 281. On the crown, see Antonio Zucchelli da Gradisca, *Relazioni del viaggio e missione di Congo nell'Etiopia Inferiore Occidentale del P. Antonio Zucchelli da Gradisca, predicatore Capuccino della Provincia di Stiria, e gia missionario apostolico in detto Regno . . .* (Venice, 1712), 198. For evidence of locally produced Christian objects in the Kongo, see Chapter 2, above. Marcellino d'Atri talks about the miraculous image of Muxima in Toso, *L'Anarchia congolese nel sec. XVII*, 49–50.

Although the large paintings and statues received the attention of visitors, modest figures, medals, and prints deposited on tombs and altars or brought into the buildings on the bodies of devotees also graced the churches' inner space. Inventories of devotional objects brought with the Capuchins in the Propaganda Fide archives give some idea of the volume of Catholic paraphernalia that entered the Kongo. A 1666 document lists, for example, the items sent in a single shipment:

> Items of devotion provided by the Sacred Congregation of Propaganda
> Fide to the Capuchin Fathers missionaries of Congo and Angola
> Medals, large and small, 14240 *[sic]*
> Stamped medals, 200
> Large stamped medallions, 15
> Small Caravaca crosses 215
> Venetian glass chaplets 6
> Small rings 344
> Decorated enamel chaplets, 12
>
>
> Small decorated reliquaries, 400
> [etc.]

Only a small number of these objects have survived through the centuries, but a few examples collected in the early twentieth century and in the Ngongo Mbata excavations give some indication of the original corpus of Catholic devotional objects present in seventeenth- and eighteenth-century central Africa. Alongside local productions and items of Portuguese origin such as medallions of the Order of Christ, a large number of objects were of Italian provenance and likely arrived in the region in the hands of the Capuchins.[31]

Christian images, large and small, were housed in the churches but also appeared in public spaces in spectacular processions, marched along with soldiers in military camps, and circulated in networks of patronage. Their highly visible presence shaped the visual environment of the Christian Kongo. Conspicuous church architecture and ostentatiously displayed Catholic devotional images framed daily life in the Kongo and brought a Christian character to the spaces in which they functioned. The same images and landmarks,

31. Toso, *L'anarchia congolese nel sec. XVII*, 98; Scritture originali riferite nelle congregazioni generali, vol. 250, fol. 528r (the list appears twice, once on a floating page and once on folio 528r). See the discussion of the medals unearthed at Ngongo Mbata in Victor Tourneur, "Médailles religieuses du XVIIIème siècle trouvées au Congo," *Revue belge de numismatique et de sigillographie*, XCI (1939), 21–26.

however, also entered into a larger conversation among the inhabitants of the Kongo about the shape of rituals, the definition of spaces of worship, and, eventually, the nature of devotion. If the spread and visibility of Christian visual apparatus in central Africa clearly demonstrated the deep presence and significance of Christian practices and ideas, it also served as a node for practices outside that religious realm. The confrontation of central African and European religious and historical thought produced the prominent phenomenon of Kongo Catholicism but also engendered other correlations that functioned outside the Christian framework and often competed with it.

Contingent Correlations

The impact that Christian and central African religious thought and artistic form had on one another surpassed the single frame of Kongo Christianity. Social and religious phenomena outside the new religion, such as the *kimpasi,* an exclusive association of initiated members chosen among elite men and women, also evolved as a result of the cross-cultural confrontation of local and foreign ideas about social organization, religious rituals, and the supernatural. Churches in the Christian Kongo, whether built according to European standards or following local construction practices, reflected conceptions of ritual space that, by the end of the seventeenth century, underlay the organization of both Christian and non-Christian places of worship. The correlation of imported and indigenous conceptions of ritual and devotional space also domesticated foreign religious practices and transfigured local—including otherwise non-Christian—forms of worship. The observable result of this correlation was a palpable similarity between spatial and liturgical expressions of worship within and outside Christian contexts. In the seventeenth and eighteenth centuries, the church and the kimpasi association, for example, followed rituals that enacted similar correlations within parallel, if competing, institutions.

Friar Marcellino d'Atri visited a kimpasi meeting ground around 1700. In a semicircular enclosure, he found an altar erected on a platform raised a few steps from the ground and outfitted with "two great idols," a cross, tiger's claws, lion's teeth, animal tails, a red-dyed horn, charcoal, an incensory, and an asperser similar to that used to sprinkle holy water. Friar Marcellino deduced from his observation of the structure and the objects arranged within it that a close connection existed between the spaces and rituals of the kimpasi and those of the church. "They use these things," he wrote, "in imitation of the true [that is, Christian] priests, I do not know whether [they do it] to despise holy ceremonies or to vie with them because they give competition

to their false deities." Indeed, kimpasi enclosures and their inner structures were similar to churches and Christian altars of the same period. Raised a few steps from the ground, both altars displayed figures, images, and liturgical objects that practitioners regularly bathed with fragrant smoke and sprinkled with empowering liquids. Kimpasi and Christian temples not only coexisted in the Kongo; they also deployed similar liturgical and devotional artifice in the form of cult figures, pious objects, and multisensory ceremonies. What is more, these formal similarities enacted the belief in the permeability of the divide between life and death that the two cults shared. Yet, the two groups remained distinct and functioned separately. It is unclear whether the kimpasi predated the advent of Christianity in the region or emerged simultaneously with it. But it is clear from their coexistence that Christianity did not supersede the kimpasi and that the central African institution did not take over the once-foreign faith. Rather, both existed, competed, and drew from each other. They became concomitant expressions of the innovations that emerged from the confrontation of central African and European religious, social, and visual forms throughout the early modern period.[32]

The altars and meeting places of the two groups had social pendants: the selective membership association of the kimpasi and Christian confraternities. Lay sodalities enjoyed great popularity in early modern southern Europe and spread rapidly in the Kongo from the sixteenth century under the impetus of the Iberian clergy active in the region. In 1595, São Salvador counted six confraternities, devoted to the Corpus Christi, the Virgin Mary, the Immaculate Conception, the Rosary, the Holy Spirit, and Saint Anthony, respectively. Each brotherhood observed devotion on a particular day of the week, when they sponsored a Mass for their members and benefactors and in suffrage for the souls of the dead. In the seventeenth and eighteenth centuries, under the influence of the Capuchins, confraternities continued to multiply. Patron saints were drawn from popular Portuguese, then Franciscan, devotions, especially the Immaculate Conception, Saint Anthony, and, by special dispensation from the Dominicans, the Rosary, a devotion also dear to Franciscans.[33]

32. Marcellino d'Atri in Toso, *L'anarchia congolese nel sec. XVII*, 201–202.

33. On confraternities in the Kongo, see Lorenzo da Lucca and Filippo da Firenze, "Relazioni," 1700–1717, fol. 75, in Cuvelier, *Relations sur le Congo*, 57. Other references include Mateo de Anguiano, *Misiones Capuchinas en Africa*, Biblioteca "Missionalia Hispanica," VII (Madrid, 1950), 296, 349. See also Mukuna Mutanda, "L'institution et le rôle des confréries dans la mission capucine du royaume du Kongo et de l'Angola de 1645 à 1765," *Revue Africaine de théologie*, no. 19 (1995), 37–51; Brásio, *Monumenta*, V, 612, XV, 162. Confraternities in São Salvador are noted ibid., III, 502–503. In 1603–1604, there were four or five confraternities in Mbanza Kongo; see ibid., V, 78. For the practices of confraternities, see ibid., III, 502–503. For the development of sodalities under the Capuchins, see Giovanni da Romano Belotti, "Avvertimenti salutevoli agli apostolici missionari, specialmente nei

Confraternities were organized around selective membership, peer emulation, and ostentatious displays of piety. They were governed by a set of rules, known as constitutions, that laid out the modes of devotion, regulated participation according to gender, social status, and age, and defined the obligations and privileges of members. In the Kongo, belonging to one or several confraternities conferred great prestige. With few exceptions, membership was a privilege of the elite who closely monitored and actively intervened in their organization. When the Dominicans created the confraternity of the Rosary in 1610, for example, the king himself chose one of his cousins as the secretary and the duke of Bamba as administrator of the group. Members of the brotherhoods also enjoyed formal, institutionalized benefits. According to Giuseppe-Maria da Busseto, writing in 1674, only a member of the Saint Francis brotherhood, for instance, could become ruler of Soyo.[34]

Confraternities organized intense and spectacular devotional practices during which they staged the objects and artworks they owned in lavish performances. On the first Sunday of the month, the members of the confraternity of Our Lady of the Pietà of Soyo in the early eighteenth century, for example, took their statue of the Madonna on a procession. School pupils marched first in pairs, each holding a cross, then the brothers followed with their own crosses just before the *mestres,* or church leaders, and the friars. The local ruler marched to the immediate right of the Madonna. The order of the procession, opening with the schoolboys and culminating with the ruler, publicly enacted social precedence within the church and Kongo society alike. Processions often culminated with the administration of self-discipline, an activity in which the brothers of the fraternities participated with a zeal that

regni del Congo, Angola e circonvicini," 1680, MS 45, 87, Biblioteca del Clero, Bergamo; Cavazzi and Alamandini, *Istorica descrizione,* 343. About the derogation from the Dominicans, see ibid. See also Lorenzo da Lucca and Filippo da Firenze, "Relazioni," 1700–1717, fol. 75, in Cuvelier, *Relations sur le Congo,* 57. The Franciscan-specific devotion to the Rosary dates back to the fifteenth century with the creation of the practice of the "Franciscan Crown," or "Seraphic Rosary," that introduced meditation on the mysteries of the life of the Virgin.

34. A manuscript example of a constitution redacted by Georges de Gheel can be found in the "Vocabularium," [1652], MSS Varia 274, Fondi minori 1896, ii–iv. On confraternities for youth, see the example of the city of Mbata in Bontinck, ed. and trans., *Diaire congolais,* 24. For the institution of female sodalities, see Belotti, "Avvertimenti salutevoli," 1680, MS 45, 85: "For [women] are instituted particular congregations with the name of the Immaculate Conception of the Very Blessed Virgin or of the Very Holy Rosary, or also of Saint Claire, or others, according to the devotion of the Fathers and the people." On the creation of the confraternity of the Rosary, see Mateo de Anguiano, *Misiones capuchinas en Africa,* 110; and Brásio, *Monumenta,* V, 612–613. For the link between membership and rulership in Soyo, see Giuseppe-Maria da Busseto to the Propaganda Fide, Apr. 18, 1674, Scritture originali riferite nelle congregazioni generali, 1676, t. 464, fol. 379, in Louis Jadin, "Rivalités luso-néerlandaises au Sohio, Congo, 1600–1675: Tentatives missionaires des récollets flamands et tribulations des capucins italiens, 1670–1675," *Bulletin de l'Institut Historique Belge de Rome,* XXXVII (1966), 290.

the Capuchins endlessly admired. On many occasions, the friars reported in vivid words the impressive spectacle of brothers self-flagellating around the monumental cross, the great streams of blood flowing from their backs to the ground.[35]

The organization of the confraternities closely matched the structures of the kimpasi, with the notable exception of the secrecy and discretion of the latter's rituals. In the eighteenth century, Capuchins José de Pernambuco and Francisco de Veas "destroyed idols and set fire to what [central Africans] call *kimpasi* [quinpaces] which are some places or houses away from the main roads where men and women used to join in the form of a confraternity." Both brotherhoods and kimpasi ritual associations were based on selective membership and the acquisition of a body of esoteric knowledge. As noted previously, kimpasi initiation involved the symbolic death and resurrection of the initiate, a cognate of the central narrative of the Christian dogma. Beyond this fundamental similarity with Catholicism at the level of religious thought, kimpasi and confraternities shared a similar social dimension through their role in the redefinition of kinship and their involvement in funerary rites.[36]

Kimpasi groups are best known through the testimonies of the Capuchins, who described their ceremonies as manifestations inspired by the devil in which the participants were led to idolatry and abominations. Among the traits of the association they denounced most vehemently was the "pernicious" mixing of men and women in its membership and rituals. Mateo de Anguiano, Capuchin chronicler writing in Spain from the accounts of his colleagues, described kimpasi meeting grounds as "isolated places or houses where men and women . . . commit thousands of turpitudes without taking into account gender or parentage." Kimpasi membership indeed redefined relationships of kinship so that the social responsibilities of the members

35. Giuseppe Monari da Modena describes the festival in Piazza, "Relazione inedita," *Italia Francescana*, XLVII, nos. 4–5 (1972), 243. See also the directions for the leading of such processions in Belotti, "Avvertimenti salutevoli," 1680, MS 45, 86. See also Jadin, "Andrea de Pavia au Congo," *Bulletin de l'Institut Historique Belge de Rome*, XLI (1970), 445–448. On self-punishment, see Jadin, "Rivalités luso-néerlandaises au Sohio," *Bulletin de l'Institut Historique Belge de Rome*, XXXVII (1966), 290; Mateo de Anguiano, *Misiones capuchinas en Africa*, 105–106; Santiago, "Breve relacion," II/772, MC/791, fol. 105, Real Biblioteca del Palacio, Madrid.

36. José de Pernambuco and Francisco de Veas, in Mateo de Anguiano, *Misiones capuchinas en Africa*, 256. Mateo de Anguiano is an eighteenth-century Spanish Capuchin historian that compiled the reports of various missionaries to the Kongo from his order, including those of Antonio de Teruel and Francisco de Pamplona. His writings are important because some of his sources are now lost. I used references to the kimpasi in early modern sources to build this argument, but a modern description of the association can be found in Joseph van Wing, *Études Bakongo: Sociologie, religion, et magie*, 2d ed., Museum Lessianum, Section missiologique, no. 39 (Bruges, 1959), 420–489. On kimpasi rites, see J[ean] Cuvelier and Olivier de Bouveignes, *Jérôme de Montesarchio, apôtre du vieux Congo*, XXXIX, Collection Lavigerie (Namur, 1951), 157.

within the association differed from the ones they inherited from birth. In this respect, the confraternities, or brotherhoods and sisterhoods, with their rules of mandatory solidarity between members, functioned similarly. Within the lay sodalities, new sets of prescriptions and obligations superseded familial duties, in particular with rules of mutual support that formed the core of most constitution contracts.[37]

The new social configuration that both categories of associations engendered fully expressed itself on the occasion of the death and funerary rites of a member. With the exception of marriage, death was the life event in which formal relationships of kinship and family solidarity mattered most for both Christianity and the kimpasi. When one of their members passed away, kimpasi associates staged elaborate funeral rites, which are described at length by Cavazzi. Similarly, one of the privileges of belonging to a Christian confraternity was the right to be buried inside a church or on a church's grounds and the insurance of receiving donations from other members to finance the burial and necessary prayers. Confraternity constitutions included such stipulations as, "When a member of the congregation dies, the others assist to his burial and obsequies, recommending his soul to God."[38]

The most significant similarity between the kimpasi and the confraternities is the way in which the two organizations simultaneously, but with different results, reckoned with the changes and novelties brought about in central Africa with the advent of Christianity and the region's involvement in Atlantic networks. New objects, practices, and ideas did not function exclusively within the Kongo Christian realm but also entered into dialogue with other circles of central African society. Examples abound of local practitioners who enthusiastically adopted as part of their own rites Christian objects, spaces, and styles of liturgical celebration. Capturing these different manifestations of the cross-cultural encounter between central Africans and Catholicism enables us to understand the correlation that brought about Kongo Christianity without falling into the trap of teleological interpretation. The development of the new thought system was contingent, historically defined, and politically motivated. At the periphery of the Kongo Christian discourse that the elite embraced and promoted as a legitimizing narrative, other correlations

37. Bontinck, ed. and trans., *Diaire congolais,* 39; Cuvelier and Bouveignes, *Jérôme de Montesarchio,* 156; Mateo de Anguiano, *Misiones capuchinas en Africa,* 256. See also the description of Buenaventura della Corella in Scritture originali riferite nelle congregazioni generali, vol. 249, fols. 336r–336v.

38. Cavazzi and Alamandini, *Istorica descrizione,* 86. See the description of the rules for the confraternities in São Salvador in Antonio de Teruel, "Descripcion narrativa de la mission serafica de los padres Capuchinos y sus progressos en el Reyno de Congo," circa 1640, MS 3533, 37–40 (quotation on 38), Biblioteca Nacional de Madrid; Jadin, "Le Congo et la Secte des Antoniens," *Bulletin de l'Institut Historique Belge de Rome,* XXXIII (1961), 454.

of central African, Catholic, but also Kongo Christian thought and visual forms occasionally emerged. The Antonian movement that challenged the dominant Kongo Christian narrative became the best known among them.[39]

Antonianism

Around 1700, at the height of the civil wars waged between pretenders to the throne of Kongo, a prophetic movement swept the region. A young woman of elite extraction who presented herself as an incarnation of Saint Anthony led the movement that became known as Antonianism after the claim of its main protagonist. The beliefs and activities of the sect are exceptionally well documented through several contemporary European eyewitness accounts, but, unfortunately, almost no African sources mention the movement. John Thornton has outlined the intricacies of the political and historical context that saw the emergence, growth, and eventual dispersion of the movement. As several royal pretenders claiming legitimacy from different descent groups and based in different regions of the Kongo fought over the throne in civil wars that had devastating consequences for the people of the kingdom, several prophetic movements appeared. Each claimed to have access to invisible forces that would illuminate a path toward peaceful times. Antonianism, the most successful of these movements, was led by Beatriz Kimpa Vita, who had received a rigorous Christian education as a member of the ruling Kongo upper class and had undergone initiation as a non-Christian ritual practitioner. Kimpa Vita claimed to be Saint Anthony and to have direct access to the Christian God, whom she visited weekly upon her death on Fridays. Resurrecting on Sundays, she could report to the dwellers of the visible world the answers she obtained during her otherworldly stay. Her main goal consisted in the reunification and pacification of the kingdom and the overall restoration of social harmony, a popular agenda, indeed, that won her massive support. Overall, her teachings advocated a fiercely anti-European, anti-Capuchin stance. She claimed, in particular, that Jesus was an African from the Kongo and that Europeans purposefully ignored African saints. Yet her dogma and the organization of her sect were deeply anchored in Christian imagery, rituals, and narratives.[40]

 The core of Kimpa Vita's message as well as the visual and material manifestations of her movement both reacted against and directly drew from the

39. Bontinck, ed. and trans., *Diaire congolais,* 172; Lorenzo da Lucca and Filippo da Firenze, "Relazioni," 1700–1717, fol. 178, in Cuvelier, *Relations sur le Congo,* 130.
 40. Thornton, *The Kongolese Saint Anthony.*

narratives, imagery, and institutions of the Kongo Christian elite. Most notably, she rejected the cross, a stand that carried great political significance because the sign stood at the core of the legitimizing narrative of Kongo Christian kingship; that position would be one of the causes of her downfall. The different pretenders to the throne all carefully weighed the political advantage that joining the movement could afford them, but eventually most of them turned their back on Kimpa Vita and rallied around the sign of the cross. In a spectacular gesture, the duke of Bamba, for instance, literally "seized a large cross" as he embarked upon a crusade-like fight against the Antonians. Another of the pretenders and his entourage finally rejected Antonianism after Kimpa Vita ill-fatedly demanded the uprooting of the monumental cross on the main plaza of his town. The epilogue of the story features King Pedro IV's victory on the battlefield against his rival for the throne and Antonian sympathizer, Kibenga, another triumph secured thanks to the miraculous protection of a crucifix. The story of the battle, which took place on the first Friday of Lent, February 15, 1709, reestablished the kingdom, echoing Afonso's narrative exactly two hundred years earlier. The Capuchins, who actively advocated against Kimpa Vita, acutely perceived the potential for Afonso's foundation narrative to rally the kingdom against the Antonians and around the tenets of Kongo Christianity. The Capuchins tirelessly suggested to the Kongo elite throughout the episode that they should turn to the early king as an inspiration and example to emulate. With or without intervention by the Capuchins, the elite repeatedly reached for the cross at key junctures during the episode.[41]

The Antonians' choice of Saint Anthony as the alternative to Christ and the cross derived from the popularity of the saint in the Kongo. The Portuguese had successfully promoted the devotion to their own patron saint since the early days of contact, and interest in the Franciscan holy man was renewed with the arrival of the Capuchins in the mid-seventeenth century. Not only did the friars champion Saint Anthony—a central figure of Franciscanism—in their catechization, they also, and most strikingly, channeled his appearance visually with their garbed bodies. The friars, dressed in habits emulating the medieval attire of the thirteenth-century saint, closely resembled the paintings and sculptures that heralded the image of Saint Anthony across central Africa. Indeed, the Capuchin garb itself held great evocative power, and prominent people endeavored to channel that power for themselves. When the fearsome and apostate Angolan queen Njinga died reconciled with the church in 1663, she piously and spectacularly decided in her last

41. Filesi, *Nazionalismo e religione nel Congo all'inizio del 1700*, 67–68, 95, 108–109.

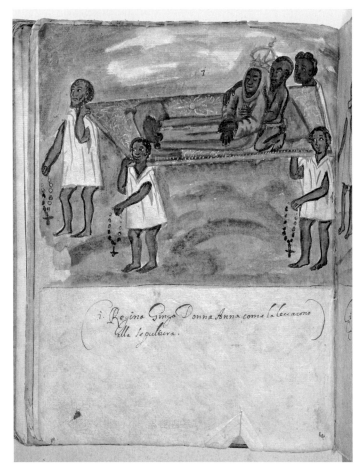

FIGURE 77 Giovanni Antonio Cavazzi, *Queen Njinga Dona Ana Being Brought to Her Sepulcher*. Circa 1665–1668. Watercolor on paper, 17 × 23 cm (page). "Missione evangelica al regno del Congo," circa 1665–1668, Araldi Collection, vol. A, book 2, between fols. 210 and 211. Photograph, V. Negro, courtesy of the Araldi Collection, Modena

moments that she wanted "to be clothed after her death with the Capuchin Habit" in demonstration of her dedication to Catholicism. Thus clothed and graced with a golden European crown, her body appeared at her funeral propped up in the local custom, as if still animated, by a red cushion and an attendant.[42]

Cavazzi, the priest present at Njinga's deathbed, captured the scene in a watercolor that also appeared in the published edition of his work (Figure 77 [Plate 34]). The painting, simply glossed "Queen Njinga Donna Anna; how they took her to the sepulcher," presents the lifeless queen, crowned and dressed in the Franciscan habit, seated with the help of red cushions and an attendant on a platform decorated with a colorful carpet. Four men dressed in simple white European shirts, each holding a chaplet in his left hand, carry the dais on their shoulders. A second vignette depicting a pious procession

42. Cavazzi and Alamandini, *Istorica descrizione*, 718.

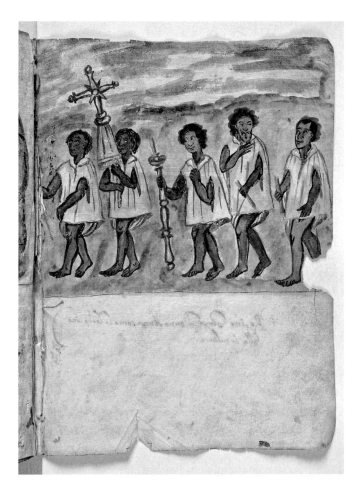

FIGURE 78 Giovanni Antonio Cavazzi, *Catholic Procession in Angola*. Circa 1665–1668. Watercolor on paper, 17 × 23 cm (page). "Missione evangelica al regno del Congo," circa 1665–1668, Araldi Collection, vol. A, book 2, between fols. 210 and 211. Photograph, V. Negro, courtesy of the Araldi Collection, Modena

led by Cavazzi himself in the company of eight candle- and cross-bearers precedes the painting in the manuscript (Cavazzi stands on the facing page; Figure 78 [Plate 35]). Two years later, Dona Barbara, who succeeded her famous sister Njinga on the throne of Matamba, also asked on her deathbed for a similar treatment, and "her cadaver, covered in a Capuchin Habit (as she had requested) was buried with ecclesiastical rites." Cavazzi hurriedly sketched the scene in his manuscript on the page facing the representation of Njinga's body. On another occasion in 1706, Friar Lorenzo da Lucca met a widow of the king of Kongo who lived a devout life and chose to wear the Franciscan garb in sign of her dedication to Catholicism. The pious queen even developed facial hair, a detail that furthered her resemblance to the friars, famed for the beards they wore in imitation of Saint Francis and of Christ and that gave them the nickname *barbadinhos,* or "little bearded ones," in Portugal as well as all over Europe. This last detail makes even more salient the cross-gender dimension of central African women's adopting the garb

of European men. All three queens mentioned above had reached old age, and their reproductive ability no longer defined their position in society. Perhaps they saw in the similarly barren friars a fitting cognate for their own ambiguous gender identity as women beyond their fertile years. Kimpa Vita's impersonation of Saint Anthony similarly hinged on her childlessness, and a pregnancy helped to precipitate her downfall.[43]

At the height of her influence, however, Kimpa Vita found inspiration from the friars as she endeavored to convincingly become Saint Anthony. Embodying the saint entailed a point-by-point imitation of the Capuchins' look, lifestyle, predication methods, and imagery. She vowed poverty and chastity and burned non-Christian devotional objects and crucifixes, just as the friars destroyed what they considered idols. She staged processions and liturgies in churches and relied on mestre-like figures and other helpers in pseudo-clerical positions, thus mimicking friars, bishops, and priests. Her followers and opponents alike recognized her emulation of the friars, comparing, for instance, her achievements toward the reunification of the kingdom to what they perceived as shortcomings of the Capuchins in this regard.[44]

Kimpa Vita also responded to the artistic forms that the Capuchins endorsed and imported into the country. She amply demonstrated in one of her conversations with the friars a keen interest and deep knowledge of the iconography and significance of saint figures. She even conceived of herself as a living version of these images. Her outfits, characteristic headdress, and theatrical behavior approximated her to the holy figures. Her peculiar gait is particularly telling in this regard. Bernardo da Gallo described the disconcerting sight of "that woman" gliding "on tiptoes," her hips and body slithering "like a snake," while she carried her head straight and "her neck stretched." She appeared to be floating above the ground rather than walking, evoking the movement of statues in procession, carried on platforms and smoothly gliding across space. Her notorious wide-open eyes also lent her the white and bright clairvoyant gaze that later became characteristic of anthropomorphic power figures in central Africa. In addition to these visual links, specific practices contributed to further blur the line between her body and figural representations. For instance, she invited infertile women to tie threads around her wrists and ankles to cure their ailments, a practice usually

43. On Dona Ana, see ibid., 738. The image of Dona Barbara is published in Ezio Bassani, *Un Cappuccino nell'Africa nera del seicento: I disegni dei "Manoscritti Araldi" del Padre Giovanni Antonio Cavazzi da Montecuccolo,* Quaderni Poro, 4 (Milan, 1987), 31. For the pious queen, see Lorenzo da Lucca and Filippo da Firenze, "Relazioni," 1700–1717, fol. 263, in Cuvelier, *Relations sur le Congo,* 216.

44. Filesi, *Nazionalismo e religione nel Congo all'inizio del 1700,* 64, 65, 78, 79, 80.

directed toward inanimate figures that she transposed to her own body, now turned into a devotional image.[45]

Eventually, as a means to end the civil wars, Kimpa Vita proposed an alternative to the legitimizing discourse inaugurated by Afonso, the authority of which wavered in the midst of the internal conflicts. The pretenders to the throne carefully considered the two options. One of the candidates, Kibenga, for example, hosted the Antonians in his town but also simultaneously staged, in the presence of the Capuchins, an impressive showcase of his ability to embody Kongo Christian kingship in the tradition of Afonso. He received the friars in his palace to the sound of iron bells and royal whistles, outfitted as a knight of the Order of Christ. He displayed around him on imported carpets and chairs a crucifix, a painting of the Virgin, a ceremonial bow and arrows, a Rosary, a Caravaca cross, and a book. Two other chairs for the friars to sit on completed the tableau with the validating presence of Catholic priests among the other royal regalia.[46]

The Antonian movement provides another example of the extent to which the people of the Kongo drew from Christian imagery and stories to make sense of their changing reality. Put into historical perspective, Antonianism can be understood as a further correlation of the centuries-old tenets and symbols of Kongo Christianity with the novelties introduced by, on the one hand, Capuchin Franciscanism and, on the other hand, the troubled circumstances of civil wars. Here, again, as with the kimpasi, the visual and religious discourses of Christianity proved integral to the formulation of a social phenomenon that functioned outside and in many regards in opposition to Christian orthodoxy. The Antonian movement offered an alternative to the dominant Christian dogma at a moment when the old narrative failed to ensure the legitimacy of a single king. Yet, the worldview that Kimpa Vita proposed remained intimately linked to Christianity and its specific Kongo form. Antonian imagery, stories, conceptions of the invisible world, and ideas of a typical Kongo sacred landscape conformed to those Afonso once established. For Kimpa Vita as for Afonso, the center of the kingdom was Mbanza Kongo / São Salvador, the ritual center within the capital was

45. Bernardo da Gallo, ibid., 63 ("sopra le punte delle dita de piedi," "à modo de biscia," "il collo teso"); Thornton, *The Kongolese Saint Anthony,* 133.

46. Lorenzo da Lucca, in Filesi, *Nazionalismo e religione nel Congo all'inizio del 1700,* 106. The Caravaca crosses have two horizontal bars, imitating the reliquary containing a piece of the True Cross in the Spanish town of Caravaca. The cross also recalls the legendary conversion of a Muslim king to Christianity in 1232 upon the miraculous apparition of the cross carried by two angels. The story associated with the Caravaca cross thus echoed that of Afonso. See W. L. Hildburgh, "'Caravaca' Crosses and Their Uses as Amulets in Spain," *Folklore,* LI (1940), 241–258.

the cathedral, and life and death were connected through the possibility of death and resurrection.

In other words, despite its anti-European stand and proudly local claims, Antonianism was not a revivalist movement attempting to arch back to a pre-Christian, pre-European past. The equally short-lived Andean movement of Taki Onqoy, or "Disease of the Dance," that developed in Peru in the aftermath of Spanish colonial rule in the 1560s offers a point of comparison and contrast. The Andean movement claimed that the *huacas,* the innumerable landscape-embedded Andean divinities the Spanish once defeated, had risen back to life to fight and defeat the Christian God, as the Indians would vanquish the Spaniards. Like the Antonians, the followers of Taki Onqoy rejected the cross, directly responded to Christian proselytism in their discourse, and sometimes called themselves after saints; but, unlike the central Africans, they also denounced all ideas and products foreign to the Andes as dangerous and harmful, calling for a return to a pre-European order. The Taki Onqoy movement did emerge in the early decades of contact with Europe, however, whereas the Antonian movement formed more than two hundred years after the Kongo's first interactions with Portugal. Yet, the real difference between them is that the central African prophetic movement functioned within the Kongo Christian worldview itself. In contrast to other examples of politico-religious resistance movements in colonial contexts, such as the Taki Onqoy, the Antonians did not wholly reject the once-foreign religion but rather proposed an alternative hermeneutics of its tenets.[47]

Conclusion

Buildings, monuments, and movable objects created a distinctly Kongo Christian landscape in west central Africa from the sixteenth through the eighteenth century. The ostentatiously Christian architecture and visual environment of the Kongo kingdom not only manifested a political discourse of triumph and legitimacy for the ruling class but also encompassed a profound religious and cosmological dimension. Churches, crosses, and burial places together defined a nexus between the world of the living and the world of the dead that structured the ritual, political, and religious life of the people of the Kongo. A closer look at descriptions and depictions of

47. Sabine MacCormack, *"Pachacuti:* Miracles, Punishments, and Last Judgment: Visionary Past and Prophetic Future in Early Colonial Peru," *American Historical Review,* XCIII (1988), 984–985. See also Jeremy Mumford, "The Taki Onqoy and the Andean Nation: Sources and Interpretations," *Latin American Research Review,* XXXIII (1998), 150–165.

the built environment of the kingdom brings to life the visual and material context in which Kongo Christianity emerged and endured.

The reconfigurations of ritual, social, and political time and space documented in the period also highlight how Kongo Christian redefinitions coexisted with competing or outlying correlations in which central Africans reckoned with sociohistorical change and cross-cultural encounters. Simultaneous conversations took place between central African religious thought and the novelties generated by the advent of Christianity and Atlantic trade in the region. Afonso's narrative remained the most prominent among them, but others existed and persisted in parallel to it. It is important to consider these alternative correlations and to understand Kongo Christianity as a contingent phenomenon, the path and durability of which was all but predictable. Christianity played a central, formative role in the religious, political, and social life of west central Africa between the sixteenth and the eighteenth century, but it is equally important to note the existence and influence of other responses to the novelties and disruptions brought about by the entrance of the region into the networks of the Atlantic world. Just as it is easy to overlook non-Christian phenomena in the era of the Kongo kingdom, studies of central Africa in the following age of rising and triumphant European imperialism often underplay the persistent role of Kongo Christianity in the formation of nineteenth- and twentieth-century colonial central Africa. We now turn to manifestations of Christianity in nineteenth-century central Africa that bridge the gap between our knowledge of the Kongo kingdom and our understanding of the cultures of the Congo in the colonial era.

From Catholic Kingdom to the Heart of Darkness

The Fate of Kongo Christianity in the Nineteenth Century

In 1866, Joseph Poussot, missionary of the French Congregation of the Holy Spirit under the protection of the Immaculate Heart of Mary (C.S.Sp.), known as the Spiritans, visited the region of Soyo as his order initiated its Congo mission. The Spiritans took up the apostolic prefecture the Capuchins had left vacant since their forced departure from Luanda in the 1830s in the wake of the abolishment of regular religious orders in Portugal. This symbolically momentous event for the history of Portugal and the overseas regions under its clerical influence formally ended the Capuchin mission to central Africa, already in crisis since the end of the eighteenth century. Poussot described his ventures in a report in which he notably mentioned his visit to a chapel still outfitted with liturgical furnishings and animated by a group of devoted caretakers. A decade later, in 1877, another Spiritan, Antoine-Marie-Hippolyte Carrie, followed in Poussot's footsteps and set off to explore the Kongo province of Soyo—or, as Europeans conceived of it by then, the surroundings of the European trading post of Santo Antonio—eager to see "all the religious mementos attached to the ancient church of Saint Antoine." The original report he redacted and dutifully illustrated with photographs is now lost or misplaced, but, fortunately, it partially appeared in print in *Les missions Catholiques,* the weekly publication of the French missionary organization l'Oeuvre de la Propagation de la Foi, and simultaneously in the Italian serial *Missioni Cattoliche.* The detailed articles, published in installments throughout 1878, follow Carrie's visit step by step.[1]

On April 2, 1877, the French priest embarked from Banana on the north shore of the Congo to Santo Antonio, known in the past as Soyo's port of

1. [R. P.] Carrie, "Une visite à Saint Antoine de Sogno (Congo)," *Les missions Catholiques,* nos. 487–489 (October 1878), 472–474, 485–486, 496–498; Carrie, "Una visita a Sant'Antonio di Sogno, Congo," *Missioni Cattoliche,* VII, nos. 42, 49, 51 (1878), 500–502, 586–588, 609–611. See Poussot's report in Brásio, *Angola,* Spiritana monumenta historica: Series Africana (Pittsburgh, Pa., 1966), I, 514–525.

Pinda, across the river. The former province, now an independent polity, then functioned around two centers, Mbanza Soyo, heir to the old capital and seat of the "king of Soyo," and Santo Antonio—formerly Pinda—under the purview of the *gente da igreja,* an influential group who claimed descent from the Capuchins' entourage of the previous century. Landing on the southern shore, Carrie first encountered the *mambouc,* the king's official in charge of managing relations with foreigners since at least the eighteenth century. The great man wore a red cloak with golden galloons and a red *mpu* cap topped with a golden tassel, in keeping with the elite sartorial practices of earlier centuries. The French trader who accompanied Carrie introduced the priest to the mambouc as a "ganga nzambiampongou," the Kikongo phrase for a Catholic priest, which was used in the region since at least the seventeenth century, to the great surprise and obvious delight of their hosts. The mambouc then took Carrie to Mbanza Soyo, where the king organized a grand reception in his honor. It was staged, as it would have been in centuries past, on the central plaza, decorated for the occasion with carpets and equipped with a throne for the king and armchairs covered in rich fabrics for the guests. Dom João, the king, soon appeared in a hammock, surrounded by courtiers and shaded by a large umbrella. He wore a mix of European- and local-style regalia: a colorful wrapper, a black tailored jacket, and a brigadier hat with a round golden cockade. As his ancestors had done many times before, he provided the visiting Catholic priest with a house under a *nsanda* tree and assigned to him an attendant and translator, Miguel, son of the former king.[2]

Carrie's enthusiastic reading of his Capuchin predecessors' relations, namely those of Girolamo Merolla da Sorrento, Giovanni Antonio Cavazzi, and Antonio Zucchelli da Gradisca, certainly framed his experience and shaped his tale. The visual and material evidence he encountered, however, did not disappoint his expectations. The sartorial spectacle and pageantry he witnessed closely matched those of the previous two centuries. This visible presence of the past in the priest's account, the historical dimension palpable in his observations, contrasts sharply with other writings on the region in the decades surrounding the "scramble for Africa." The competition between European states for imperial control over the largest possible swathes of territory on the African continent, formalized in the 1885 Berlin Conference, unilaterally negated local sovereignty and set the path toward colonial rule.

2. For the mambouc, or mambuka, see Kajsa Ekholm Friedman, *Catastrophe and Creation: The Transformation of an African Culture,* Studies in Anthropology and History, V (Philadelphia, 1991), 51–52. See also Phyllis Martin, *The External Trade of the Loango Coast, 1576–1870: The Effects of Changing Commercial Relations on the Vili Kingdom of Loango,* Oxford Studies in African Affairs (Oxford, 1972), 97–98.

Explorers that set off to map and take possession of the continent, and the European governments that sponsored them, buttressed their claims with a new form of discourse about Africa and Africans that served as an ideological primer and preamble to imperialism and colonial hegemony. The area once famous in Europe for being part of the cosmopolitan kingdom of Kongo became in explorers' tales and in the minds of their avid European and American readers the "heart of darkness," "le pays des ténèbres," the land of "the primitive Bakongo" and "the Congo cannibals," characterizations that would lastingly influence the perception of the region. The area's past as a Christian realm had no place in these accounts.[3]

The selective blindness of the nineteenth- and early-twentieth-century sources are challenged here with evidence—sometimes drawn from these very same sources—of Christianity's continued, if changing, role in the region in the wake of modern colonialism. The powerful ideological apparatus that enabled and sustained nineteenth-century colonization eventually destroyed the remaining structures and obscured the memory of the Christian Kongo. The nineteenth-century kingdom, of course, was a strikingly different entity from what it was in its heyday in the mid-seventeenth century. The erosion of the king's central authority, which began during the era of the civil wars of the later sixteen hundreds, continued into the nineteenth century. Rivalries between lineage groups, competition from elite traders, and a shrinking territory of direct influence reduced the political relevance of the king and kingdom as power-yielding institutions. Yet, the kings in the eighteen hundreds continued to hold an enviable position for which pretenders fiercely competed, and their traditions, such as Afonso's legitimizing story and Christian regalia, still commanded respect. Further, in spite of treaties of vassalage the African monarchs signed throughout the century, the kingdom remained effectively independent from Portugal until the 1910s. The architecture, devotional paraphernalia, political regalia, and rituals that central African artists and patrons had forged since the late fifteenth century continued to play an influential role in the cultural and religious development of central Africa in the eighteen hundreds and beyond. Visible artistic,

3. Carrie mentions the authors of the relations in his report; see Carrie, "Une visite à Saint Antoine de Sogno," *Les missions Catholiques*, nos. 487–489 (October 1878), 473. Joseph Conrad's 1902 novella *Heart of Darkness* first appeared as a magazine series in 1899; see Joseph Conrad, "The Heart of Darkness," *Blackwood's Edinburgh Magazine*, CLXV (January–June 1899), 193–220, 479–502, 634–657. See also R. Saillens, *Au pays des ténèbres: Histoire de la première mission chrétienne au Congo* (Paris, 1889); John H. Weeks, *Among the Primitive Bakongo: A Record of Thirty Years' Close Intercourse with the Bakongo and Other Tribes of Equatorial Africa, with a Description of Their Habits, Customs, and Religious Beliefs* (Philadelphia, 1914); Herbert Ward, *Five Years with the Congo Cannibals,* 3d ed. (London, 1891).

religious, and social vestiges of Kongo Christianity endured throughout the period, and emblematic objects of central Africa as "heart of darkness," such as nail figures or carved ivory tusks, owe aspects of their form and significance to the Kongo Christian era.

Kongo in the Nineteenth Century

Since Pedro IV's restoration of the Kongo crown and of the capital of São Salvador (r. 1696–1718), the kingdom had functioned as a decentralized entity over which the kings exercised limited power, in contrast to their predecessors from earlier periods. By the mid-eighteenth century, Soyo to the northwest and Nsundi to the northeast of the realm, both on the shore of the Congo River, had become effectively independent, drawing wealth and influence from their location and the access it gave them to profitable international trade in slaves and commodities. Even in its diminished state, the Kongo throne continued to yield enough prestige to warrant fierce competition between legitimate and illegitimate pretenders during the eighteenth century and first half of the nineteenth century. Candidates to the position buttressed their claims with a mix of arguments about genealogical precedence and the military and economic might they drew from the areas under their direct control. Wars and political negotiations, sometimes lasting for decades, decided the outcome. Wealthy leaders from rich regions thus became powerful kings, while resource-poor monarchs yielded nominal power over the provincial rulers who plotted to install them. In 1764, for example, the incumbent king, Álvaro XI, before receiving the insignia of kingship arching back to Afonso's reign, had to sit at the center of a circle of standing lords and promise to remain humble, respect their power, and protect tradition. In spite of these changes, the symbolism surrounding the office of the king was similar to that of the earlier centuries, especially with regard to the prominent status it gave to Christianity.[4]

Only in the second half of the nineteenth century did Portugal begin to truly threaten the Kongo's independence. The European country's interference started in a battle for the throne in which one of the pretenders, who became Pedro V (r. 1860–1891), sought alliance with Portugal to garner strength against his rivals, making a formal act of vassalage to Portugal in 1859. This formal act had no immediate consequences, however, other than

4. See the 1775 report of Friar Cherubino da Savona in MS Borgiano Latino 269, 47–49v, Biblioteca Apostolica Vaticana, published in António Brásio, "O Problema da eleição e coronação dos reis do Congo," *Revista Portuguesa de história,* XII (1969), 380.

Pedro's victory over his rivals in 1860, thanks to the assistance of Portuguese troops. By 1870, the European forces had left São Salvador, unable to sustain their occupation in a region that remained too distant from their colonial center of Luanda. When Pedro V renewed his vassalage in 1885, however, new cash crops and the rubber boom made Portuguese settlement in the Kongo financially viable, and the Berlin Conference's rule of effective occupation rendered the active presence of Portugal in the region a political imperative should the Iberian realm defend its colonial claims over the area against other European powers. But it was only later, under the long and efficient tenure of José Heliodoro de Faria Leal as colonial administrator of the "Portuguese Congo" between 1896 and 1912, that the kingdom effectively became integrated with colonial Angola. Several revolts in the following years would not reverse the takeover.[5]

Meanwhile, a parallel transition took place for the Kongo church. From the end of the eighteenth century to the 1830s, the Propaganda Fide–sponsored Capuchin mission, which had animated congregations all over the kingdom since around 1650, dwindled and ceased in the face of the continued conflict between Rome and Portugal over the application of patronage rights and, eventually, over the 1820 Portuguese liberal revolution and the 1833 dissolution of the male regular orders. In the decades preceding and following the end of the Capuchin presence, only a small number of clerics from Luanda visited the old kingdom. In 1865, the Propaganda Fide transferred the apostolic prefecture of the Kongo to French Spiritans, who, in response to Portuguese opposition, established themselves at the northern end of the old kingdom—in Soyo—rather than attempting to operate closer to São Salvador within Portuguese-claimed territories. In 1888, Rome created the apostolic vicariate of the Congo Free State, which was entrusted to the Belgian Congregation of the Immaculate Heart of Mary, better known as the Scheut Fathers, who replaced the Spiritans on their northern missions. Protestants such as the Baptist Missionary Society also settled in the region in 1878 and soon after boldly chose to center their mission in São Salvador itself. Portugal, for its part, created its own secular Catholic Congo Mission (Missão do Congo) under the leadership of António Barroso in 1881. Effectively, very few clerics officiated in the Kongo during the nineteenth century

5. José Heliodoro de Faria Leal, "Memórias d'África (Part 1)," *Boletim da Sociedade de Geographia de Lisboa*, XXXII (1914), 299–330, 343–362, 383–410, and "Memórias d'África (Part 2)," XXXIII (1915), 15–30, 64–79, 113–128, 162–173, 214–231, 357–380. For a study of the gradual takeover of the Kongo kingdom by the Portuguese, see René Pélissier, *Les guerres grises: Résistance et révoltes en Angola, 1845–1941* (Orgeval, 1977), 110–112, 119. See also Jelmer Antoon Vos, "The Kingdom of Kongo and Its Borderlands, 1880-1915" (Ph.D. diss., School of Oriental and African Studies, University of London, 2005).

until the later decades. Yet, some central aspects of Kongo Christian visual, material, and political culture honed in the earlier centuries not only endured in the period but also contributed to the shaping of west central Africa in the aftermath of colonization.[6]

Gente da Igreja

The day after his visit to the king of Soyo, Antoine-Marie-Hippolyte Carrie set off for Santo Antonio, a short distance from the king's settlement. There, he met the gente da igreja, or "people of the church," who ruled the town. The gente da igreja regularly featured in nineteenth-century accounts of west central Africa. According to these documents, they formed distinct communities that dwelled at the periphery of towns. They claimed descent from the *muleques,* the enslaved men and women once attached to the service of churches in the old kingdom. The existence of such an institution in the orbit of the church may seem surprising, but it nonetheless played a central role in the organization of Christianity in the Kongo. As early as the late sixteenth century, Carmelite missionaries remarked on enslaved laborers working in fields to support the church. Like the Catholic ecclesia at large—who, with the exception of a few individuals, did not denounce the slave trade until the nineteenth century—most clerics active in central Africa did not oppose slavery. Secular and regular priests even participated in the trade, some with the pragmatic goal of supporting their apostolic work in the region, others for their own profit. Some did raise their voices, however, such as Capuchin Giacinto da Vetralla, who denounced the trade in his long account of the Kongo to the Propaganda Fide in 1658, claiming the slave trade drained human resources from the land and incited wars.[7]

6. François Bontinck, "La mission spiritaine de Boma (1880–1890)," *Zaïre-Afrique*, no. 136 (June 1979), 363–375; Bontinck, *Les missionnaires de Scheut au Zaire, 1888–1988* (Limete-Kinshasa, 1988). The later decades of the Capuchin mission and the overall clerical presence in nineteenth-century Kongo is discussed in Louis Jadin, "Les survivances chrétiennes au Congo au XIXème siècle," *Etudes d'histoire Africaine*, I (1970), 137–185. For a period history of the beginnings of the Baptist mission, see John Brown Myers, *The Congo for Christ: The Story of the Congo Mission* (London, [1895]). See also the short outline of Kongo's missionary history of the period in Françoise Latour da Veiga-Pinto, *Le Portugal et le Congo au XIXème siècle: Étude d'histoire des relations internationales* (Paris, 1972), 81–86. The documents surrounding Barroso's activities appeared in António Brásio, ed., *D. António Barroso: Missionário, cientista, missiólogo* (Lisbon, 1961).

7. See the discussion of the term *muleque* and its widespread use in central Africa in Joseph Calder Miller, *Way of Death: Merchant Capitalism and the Angolan Slave Trade, 1730–1830* (Madison, Wis., 1988), 68 n. 43. See the Carmelite 1584 account by Diego del Santissimo Sacramento in António Brásio, ed., *Monumenta missionaria africana: África ocidental*, 15 vols. (Lisbon, 1952–1988), IV, 362–363. Alphonse Quenum provides a good outline of the position of the church vis-à-vis the trade as well as specific examples of clerical slave trading in Quenum, *Les Églises chrétiennes et la traite atlantique du XVe au XIXe siècle*, Collection "Hommes et sociétés" (Paris, 1993), 95–154. On the Capuchin involve-

The Capuchins in general, whose rules of poverty contradicted the notion of slaveownership, relied on enslaved labor and drafted elaborate legal arguments to justify the presence of "escravos da igreja," or "church slaves," in their convents. Instead of renouncing or denouncing the practice, they would claim, for example, that, although they employed muleques, ownership lay in the hands of the Holy See through the intermediary of the apostolic syndic. The friars, indeed, depended on the labor of enslaved men and women, whom they also occasionally traded and castigated. If, for the most part, they did not purchase the enslaved directly, they accepted them as gifts from the elite of the kingdom or as payment for fines incurred in trespassing against the church.[8]

Bernardino d'Asti, in his circa 1750 practical guide to the central African mission, "Missione in prattica," described the use of muleques in the most benign light he could, presenting them as necessary to the mission and outlining the benefits the enslaved men and women derived from their position. He also professed pragmatic admonitions on the topic to future missionaries. He advised that friars should rely principally on children for domestic service; once grown, the children should be married and settled on a *senzala,* or slave quarter, near the convents. There, they would continue to contribute to the church by cultivating fruits and vegetables and raising livestock. Bernardino also awkwardly attempted to justify the institution with claims that enslaved men and women in the service of members of the elite often sought to become muleques for the church, but he did not elaborate on the reasons for this stated desire. It is plausible that, because the Capuchins did not participate in the slave trade to the same extent as members of the kingdom's elite, muleques in the service of the church enjoyed some enviable level of

ment, see Mukuna Mutanda wa Mukendi, "La méthode missionaire des PP. Capucins de la 'Missio Antiqua' dans les royaumes du Congo, de l'Angola et de Matamba (1645–1835)" (excerpt from Ph.D. diss., Université Pontificale Grégorienne, 1979); Mukuna, "La question des 'esclaves d'église' détenus par les pères capucins au Kongo et en Angola (1645–1835)," *Revue Africaine de théologie,* XV, no. 30 (October 1991), 163–179. Capuchin father Dieudonné Rinchon wrote on the slavery in the Kongo, tiptoeing around the role of the church and the Capuchins in Rinchon, "Notes sur le marché des esclaves au Congo, du XIVème au XIXème siècle," *Congo,* II (1925), 388–409; Rinchon, *La traite et l'esclavage des congolais par les Européens* (Brussels, 1929). See also Kabolo Iko Kabwita, *Le royaume Kongo et la mission catholique, 1750–1838: Du déclin à l'extinction,* Mémoire d'églises (Paris, 2004), 141–178. See Giacinto Brugiotti da Vetralla's report in Scritture originali riferite nelle congregazioni generali, vol. 250, 198r, Archivio Storico de Propaganda Fide, the Vatican, cited in part in Violante Sugliani, "P. Giacinto Brugiotti e la sua Missione al Congo," *L'Italia Francescana,* IV, no. 6 (1929), 535. Other friars made references to the slave trade, yet in a matter of fact, descriptive tone, such as Marcellino d'Atri, in Carlo Toso, *L'anarchia congolese nel sec. XVII: La relazione inedita di Marcellino d'Atri,* Studi di storia delle esplorazioni, 15 (Genoa, 1984), 4, 78–79, 334. On the Capuchins and slavery, see also Carlo Toso, "I Cappuccini e il problema della schiavitù in Africa," *Italia Francescana,* LXVIII, no. 2 (1993), 9–21.

8. Mukuna, "La question des 'esclaves d'église,'" *Revue Africaine de théologie,* XV, no. 30 (October 1991), 165.

stability and protection, not least from the possibility of being sold into the networks of the Atlantic slave trade. The frequent absence of the priests from the convents would have also certainly contributed to their independence and security.[9]

Later in his manuscript, Friar Bernardino returns to the topic with a story describing the Capuchins' role as protector of the slaves' religious, if not physical, integrity. The account, presented as an anecdote, hovers between edifying tale and gospel-worthy parable. "One man had sent me a piglet that I kept next to the Convent," starts the fable. One night, the friar hears the precious animal screech and runs to it just in time to save it from the knife of some ill-intentioned intruder. Inquiring about the matter the next morning, he learns that two boys, ten and twelve years old, had tried to kill the animal, a crime that, according to Kongo laws, would make them slaves of the pig's owner. The boys planned the attack, they explain, to avoid being sold by their current owners to "heathens" *(gentili)*. Bernardino, the story continues, moved by the boy's religious zeal, scolds their master, reminding him that Catholic slaves should never be sold "to gentiles or to Dutch or English heretics." Finally, the guilty but repentant owner promises never to commit such a crime again; he gives the older boy to the convent and resolves not to sell the younger.[10]

Most Capuchins who took a strong stance on the subject of the slave trade did not denounce the trade itself but rather the practice of sending enslaved Catholics, or even recently baptized men and women, to Protestant countries. Friar Girolamo Merolla da Sorrento, who arrived in Soyo in the 1670s, deplored this "very pernicious abuse of selling slaves, even if they are Christian to heretics." Some of his colleagues even actively served as intermediaries between French Catholic slave traders and the ruler of Soyo around 1700. On one occasion, one of them even climbed on board a slave ship anchored nearby and negotiated with the merchant to arrange for the enslaved men and women sold from Soyo to sail to a Catholic destination.[11]

If proximity to the friars did not afford muleques full protection against

9. Bernardino Ignazio da Vezza d'Asti, "Missione in prattica de RP cappuccini italiani ne regni di Congo, Angola, et adiacenti," circa 1750, MS Borgiano Latino 316, fols. 33–34, Biblioteca Apostolica Vaticana.

10. Ibid., fols. 69–70.

11. Girolamo Merolla da Sorrento and Angelo Piccardo, *Breve, e succinta relatione del viaggio nel regno di Congo nell' Africa meridionale, fatto dal P. Girolamo Merolla da Sorrento . . . Continente variati clima, arie, animali, fiumi, frutti, vestimenti con proprie figure, diversità di costumi, e di viveri per l'uso humano* (Naples, 1692), 202; Lorenzo da Lucca and Filippo da Firenze, "Relazioni d'alcuni Missionari Capp:ni Toscani singolarmente del P. Lorenzo da Lucca che due volte fù Miss:io Apotol:co al Congo; parte seconda," 1700–1717, fols. 81–83, Archivio Provinciale dei Frati Minori Cappuccini della Provincia di Toscana, Montughi Convent, Florence.

deportation into the Atlantic slave trade, it did give them privileged access to Christian rites and objects, a close connection only the elite otherwise enjoyed. The so-called church slaves' status also positioned them as intermediaries between foreigners and the rest of the population. They could speak European languages and had access through the priests to imported goods and devotional objects that were prized items of status. Even in the absence of missionaries, they continued to live and work around the convents. They did not leave the premises of their own accord, and, more tellingly, they did not find themselves taken away by other potential owners either, hinting at the real protection that their position lent to them vis-à-vis further exploitation in general and the Atlantic slave trade in particular. In 1777, for example, eighteen years after the last visit of a priest, Stefano Maria da Castelletto found in his accounting four hundred to five hundred men, women, and children attached to the Soyo hospice, still ready and eager to welcome him. In the course of the two preceding decades, he learned, the group had sent thirteen messengers to Luanda to request a new cleric for their convent. When Zacharias da Cruz and two priests visited the Kongo from Angola in 1858, a team of escravos da igreja worked for them, led by Pedro Luiz, who proudly presented to the travelers the written nomination letter as mestre he had obtained in the past from one Friar Bernardino. As a symbol of his role, the old man proudly wore a worn red wrapper embroidered with crosses. A generation later, the gente da igreja of São Salvador were still ready to welcome visiting clerics; when the priest Boaventura dos Santos visited the capital of Kongo in 1876–1877, the king offered him a house in the "part of S. Salvador inhabited by those who are called slaves of the Church."[12]

Muleques thus formed stable, lasting, and closely knit social groups whose members strongly identified with a role and position that they reproduced independently across generations. The institution led to a form of ethnogenesis that engendered by the nineteenth century identifiable and influential groups known as gente da igreja. Around the mid-eighteen hundreds, the gente da igreja of the capital of São Salvador formed an independent, organized, and powerful group that played a prominent role in the power struggles for control of the Kongo crown. In 1845, for example, the king of Kongo, Henrique II, talked about the gente da igreja as slaves *(escravos)* "*of* the Convent of Santo

12. Bernardino d'Asti, "Missione in prattica," circa 1750, MS Borgiano Latino 316, fol. 45; Stefano Maria da Castelletto, Letter of May 6, 1777, on the state of the missions, in Scritture riferite nei congressi, Africa: Angola, Congo, V, fol. 383v, Archivio Storico de Propaganda Fide, the Vatican; Zacharias da Silva Cruz, "Relatório sobre a sua viagem à San Salvador do Congo," *Boletim official de Angola,* no. 696 (1859), 1; L[ouis] Jadin, "Recherches dans les archives et bibliothèques d'Italie et du Portugal sur l'Ancien Congo," *Bulletin des séances de l'Académie Royale des Sciences Coloniales,* II, no. 6 (1956), 974.

Antonio [that is, the Capuchin convent] and *of* the Cathedral" in São Salvador who gave their support to an opponent to the king in a challenge to his reign. Because their position entailed primary allegiance to the church rather than to any of the lineages competing for political prominence, they could claim independence from lay authorities and from opposing factions of the elite. They made political use of this position, lending their support to one or the other side. In addition, as custodians of the churches, they had in their possession the Christian objects that incoming rulers still needed for their coronation and thus held great sway in the political affairs of the lay powers, at least in São Salvador and Soyo where political rituals of the Christian Kongo endured the longest.[13]

Safekeeping Chapels and Saints

Naturally, then, "people of Pinda known as people of the church" welcomed Carrie and his colleague Mathias Schmitt in their 1877 visit to Santo Antonio of Soyo. The gente da igreja, some of whom "served the function of priests," introduced Carrie to the building and the objects in their custody. It is unclear whether the chapel in question stood on the site of the former Capuchin convent of Soyo or on the location of the old church of Nossa Senhora de Pinda. Measures of distance in various documents from both the late nineteenth century and earlier are imprecise and difficult to compare; moreover, the spatial organization of the region's built environment revolved around loose, extensive groupings of constructions that extended over several kilometers, the locations of which changed over time. Carrie describes Mbanza Soyo, for example, as "an area" *(un espace)* two kilometers long and eighty meters wide, "some distance away" from the historic town of Soyo. The Capuchin convent itself changed location from Pinda to Mbanza Soyo at least once in the preceding centuries. The site the Europeans described in the late eighteen hundreds, regardless of its exact situation, bore the signs of Capuchin occupation. Landscaping, in particular, including orderly plantations of tamarind, coconut, and acajou trees, visibly marked the location of the chapel as one of the locales that friars had once groomed with fruit trees both as decoration and as a food source. The gente da igreja thus chose one of the Capuchin sites and consolidated there objects that once belonged to the many churches of the wider Soyo region, from Nossa

13. Cruz, "Relatório sobre a sua viagem à San Salvador do Congo," *Boletim official de Angola,* no. 696 (1859), 1; Letter of Henrique II, king of Kongo, to the Angola governor general, in António Brásio, *Angola,* I, 26 (quotation, emphasis mine); Jelmer Vos, "Child Slaves and Freemen at the Spiritan Mission in Soyo, 1880–1885," *Journal of Family History,* XXXV (2010), 74.

Senhora de Pinda to the various other chapels in use in Soyo during the seventeenth and eighteenth centuries.[14]

Carrie's detailed report and Schmitt's more circumspect unpublished notes on their 1877 visit complement Poussot's earlier impressions of the Santo Antonio chapel in 1866. The notes of Portuguese administrator Francisco Antonio Pinto, who saw the chapel in 1882, complete the tableau. Together, these documents sketch a comprehensive description of the form, state, and use of the church and devotional objects at Santo Antonio. As they approached the chapel, Carrie and Schmitt heard with emotion the sound of a bell the gente da igreja rang to welcome them. The heavy relic of the past, dated 1700 and appropriately labeled "si Deus pro nobis quis contra nos," hung from a small wooden frame one meter and a half above the ground. In 1645, a similar construction had stood near the church of Pinda. Ten meters away from the bell, they discovered the chapel itself, a thatched cabin with cob walls. According to Carrie, it was the second reconstruction of the church the Capuchins built on the site. The new building closely followed the plan of the Soyo convent that Friar Bernardino depicted in "Missione in prattica" on which the bell, hanging on a modest frame by the church, was featured (Figure 79 [Plate 36]). The nineteenth-century cob church measured five by ten meters and closed with a European-style wooden door outfitted with a keyed lock. Another door opened to the side that Poussot considered a posterior addition. The rectangular floor plan was divided in two parts with a freestanding wall that separated the nave from the sacristy, leaving two one-meter openings along the sides of the church for people to circulate from one room to the other. Two windows with wooden shutters brought light to the back room. A small blind closed another opening in the front of the church. Friar Bernardino had painted a building, in contrast, with three windows on its facade. Two cannons and a rusted hammered-iron basin that might have served as a baptismal font lay, in 1877, in front of the chapel.[15]

14. Letter by Schmitt, Dec. 8, 1877, 26, 3L1.4b3/109045, Archives Générales de la Congrégation du Saint Esprit, Chevilly-Larue, France ("les gens de Pinda appelés gens de l'Eglise"); Carrie, "Une visite à Saint Antoine de Sogno," *Les missions Catholiques*, no. 487 (October 1878), 473. On changes in the hospice location, see Merolla and Piccardo, *Breve, e succinta relatione*, 87. For Capuchin landscaping in Soyo, see François Bontinck, ed. and trans., *Diaire congolais (1690–1701) de Fra Luca da Caltanisetta*, Publications de l'Université Lovanium de Kinshasa (Leuven, 1970), 6. The Capuchin convent of São Salvador also had an alley of palm and banana trees; see Cruz, "Relatório sobre a sua viagem à San Salvador do Congo," *Boletim official de Angola*, no. 695 (1859), 3. For Capuchin convent gardens, see also Michele Angelo Guattini and Dionigi Carli, *Viaggio del p. Michael Angelo de Guattini et del p. Dioniggi de Carli, predicatori nel regno del Congo* (Reggio, 1672), 190.

15. Francisco Antonio Pinto, "Missão ao Zaire de Francisco Antonio Pinto, Setembro de 1882," in Pinto, ed., *Angola e Congo* (Lisbon, 1888), 351–419. See Poussot's report in Brásio, *Angola*, I, 514–525. The Latin phrase translates as, "If God is for us, who can be against us?" (Rom. 8:31). Juan de Santiago mentions the bell in Santiago, "Breve relacion de lo sucedido a doce religiosos cappuchinos de la santa

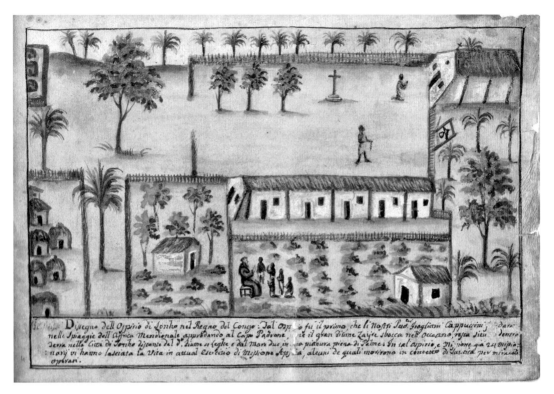

FIGURE 79 Bernardino d'Asti, *Plan of the Convent of Soyo in the Kingdom of Kongo.*
Circa 1750. Watercolor on paper, 19.5 × 28 cm. From "Missione in prattica: Padri
cappuccini ne Regni di Congo, Angola, et adiacenti," MS 457, fol. 4r, Biblioteca Civica
Centrale, Turin. Photograph © Biblioteca Civica Centrale, Turin

Inside, the nineteenth-century travelers found, as they would have in
Kongo churches of preceding centuries, a tamped earth floor and walls lined
with straw mats. At the back of the church, an altar stood against the free-
standing partition between the nave and the sacristy. A large cloth attached
to the ceiling served as dorsal for the altar when Carrie and Schmitt saw it
in 1877 but was replaced with an open European umbrella by the time of
Pinto's visit in 1882. The altar rose half a meter above a step and included a
gradine or shelf as well as an altarpiece *(boca do camarim)*; the gente da igreja
arranged the table in strict adherence with Catholic liturgical requirements,
even without clerical supervision. The step, altar, shelf, and altar screen were,
according to Pinto, made of decorated Brazilian mahogany, probably taken

sede apostolica enbio por missionarios apostolicos al reyno de Congo . . .," circa 1650, II/772, MC/791,
fol. 55, Real Biblioteca del Palacio, Madrid. See the annotated translation of Jean-Paul Welter, *Relation
de la première mission Capucine au royaume du Congo (1645–1648)* (Leuven, 1969–1970), 117–118.

from an older church but now held together with newer indigenous wood pegs. A local carpet, which Carrie described as "[from] Loango," covered the ground and step in front of the altar, as in older churches. The altar and shelf almost disappeared under a wealth of cloths and textiles.[16]

In this remarkable setting, the European observers found an equally amazing collection of Christian liturgical and devotional objects that the gente da igreja gathered, cautiously kept under key in the chapel, and continued to use in carefully staged ceremonies. Six Brazilian dark-wood chandeliers outfitted the altar table itself. A one-meter-high wooden Christ on the cross occupied the middle of the altar on the shelf. Around him, a forty-centimeter-high silver cross on a conical base held a seventeen-centimeter bronze Christ. A smaller wooden crucifix and two others of undetermined material were included in the scene. Also on the shelf, two wooden statues, the Virgin and Saint Anthony, stood on either side of the larger crucifix. They were stick figures meant to be clothed, and only their carved faces emerged from the bundled local textiles wrapped around their bodies. The Virgin, wearing a silver crown, could be the one Giuseppe da Modena saw in 1702 in the compound of the prince of Soyo, who had received it as a present from Andrea da Pavia a decade earlier. It could also be the famous and ancient Virgin of Pinda, revered as a miraculous image since at least the mid-eighteenth century by the inhabitants of Soyo and their unconverted neighbors from Ngoyo, north of the Congo River. Around 1700, the Capuchin convent of Soyo also had a statue of Saint Anthony whose gilded brass crown from Holland the prince of Soyo had taken as a tribute of war from the king of Ngoyo after defeating him on the battlefield. Juan de Santiago also saw in 1645 a wooden Saint Anthony next to the Virgin of Pinda. The ancient paintings that graced the church in the seventeenth century, however, did not survive.[17]

Five smaller wood-and-clay saints and Virgins and two figures of Saint

16. The carpet is mentioned in Carrie, "Une visite à Saint Antoine de Sogno," *Les missions Catholiques,* nos. 489 (October 1878), 497. Giuseppe Monari da Modena mentioned such carpets in his "Viaggio al Congo, fatto da me fra Giuseppe da Modena Missionario Apostolico, e predicatore Capuccino, incomentiato alli 11 del mese di Novembre del anno 1711, e terminato alli 22 di Febraro del anno 1713 etc. . . . ," 1723, Manoscritti Italiani 1380, Alfa N. 9–7, fol. 369, Biblioteca Estense, Modena, published with original pagination in Calogero G. Piazza, "Una relazione inedita sulle missioni dei minori cappuccini in Africa degli inizi del Settecento," *Italia Francescana,* XLVII, nos. 4–5 (1972), 270. See also Bernardino d'Asti, "Missione in prattica," circa 1750, MS Borgiano Latino 316, fol. 74–75.

17. Monari, "Viaggio al Congo," 166, also in Piazza, "Relazione inedita," *Italia Francescana,* XLVII, nos. 4–5 (1972), 242. On the Virgin of Pinda, see Merolla and Piccardo, *Breve, e succinta relatione,* 87. On the crown, see Antonio Zucchelli da Gradisca, *Relazioni del viaggio, e Missione di Congo nell' Etiopia Inferiore Occidentale del P. Antonio Zucchelli da Gradisca, Predicatore Capuccino della Provincia di Stiria, e gia Missionario Apostolico in detto Regno . . . ,* (Venice, 1712), 198. See also Santiago, "Breve relacion," circa 1650, II/772, MC/791, fol. 55; Welter, *Relation de la première Mission Capucine,* 117–118.

Anthony stood between the large statues. A twenty-five-centimeter silver incensory in the shape of an old Portuguese galleon (similar to the one in Figure 80) with its spoon, another silver incensory, a bronze bowl, an ivory asperser in a dish with water, and a number of small bells completed the outfit of the altar. Pinto also noted a Brazilian mahogany tabernacle door sculpted with the figure of Saint John the Baptist, and in 1866 Poussot had found on the altar a stack of old books. On the floor by the altar step, a round stone more than fifty centimeters in diameter served to burn fragrant resins in lieu of incense.[18]

A linear description of the objects cannot do justice to the overwhelming spectacle that the altar must have offered. Statues and objects of every size, made of wood and precious metals, densely populated the shrine. Lengths of textiles enhancing the statues and the shrine completed the display. Locally crafted items and pieces of foreign workmanship grouped together on the platform included examples from every notable category of Kongo Christian visual culture. Crucifixes, of course, featured prominently, along with figures of the Virgin and of the popular Saint Anthony. Fabrics outfitting the large saint figures, the mat gracing the approach to the altar, and the lengths of cloth draped over the table also brought to the space the multivalent associations of wealth and prestige that textiles carried in the region. The incensory still astutely loaded with a local substitute for the holy fragrance, the bronze stoup used for aspersions, local torches, and bells to accompany prayers and songs also encapsulated the gente da igreja's intense and vivid recollection of the minutiae of Catholic liturgy; they clearly continued to reenact with great detail the church's multisensory rites. Between 1877 and 1882, the gente da igreja substituted the old veil over the altar for an umbrella, added a new frontal to the table, and pinned an engraving of Pope Leon XIII to the altar-piece, gestures suggesting that the chapel was the seat of a lively cult whose followers still embraced novelty and welcomed change, rather than a shrine memorializing a bygone era. In the sacristy, Carrie found a worn wardrobe set against the back wall of the nave. Its metal hinges had been replaced with vine ropes. Two plaster statues of the child Christ and an old missal lay on its top, and resting inside it was a consecrated altar stone and three marble slabs. He also found in the sacristy a silver chalice without its paten.

In the ancient kingdom's capital of São Salvador, the images and objects of the old evangelization also continued to receive special treatment. In 1858,

18. Details of the objects also appear in Jayme Pereira de Sampaio Forjaz de Serpa Pimentel, *Um anno no Congo, 1 de maio de 1895 a 1 de maio de 1896: Apreciações sobre o Districto do Congo, coordenação de alguns documentos relativos ao Congo, traços geraes d'uma administração ultramarina* (Lisbon, 1899), 44–45.

Zacharias da Cruz saw Catholic devotional paraphernalia gathered in a small house on the central plaza. Among the items, he noted "images" of São Salvador, or the Holy Savior, standing 125 centimeters high, of Saint Anthony and of Saint Francis, both about 75 centimeters high, and a two-and-a-half-meter monumental crucifix. Although Cruz called all the objects "images," he probably was referring to sculptures, as he also used the word "image" to describe the crucifix, which was almost certainly three dimensional. He also found a large bell, about sixty centimeters in diameter at the opening, and, attached to a gilded cane, a large dossal made of scarlet wool and cotton and lined with fine cotton cloth. All these objects were well preserved. Along with these devotional pieces, Cruz saw what he called "war instruments of the land, some of ivory as well as two battle drums [from Portugal]," similar to the ones used for Kongo pageants depicted in Figures 2 (Plate 1) and 42 (Plate 17). Many more objects, Cruz reported, remained hidden in the possession of the two pretenders to the vacant Kongo throne, who jealously hoarded them to use in their coronation as testaments to their legitimacy as heirs to the ancient crown.[19]

Little is known of the objects that still graced Kongo churches at the beginning of the twentieth century, and their fate since then remains unclear. Some perhaps survived Angola's turbulent twentieth century and might remain in private hands, among descendants of the gente da igreja or of the kingdom's ruling elite. A silver incense boat, now in the Museu Nacional de Soares dos Reis in Portugal, provides a rare glimpse of the contents of central African Christian temples of the early modern period (Figure 80). Crafted in Brazil in the first half of the eighteenth century, the vessel belonged to Our Lady of Muxima, a church in a town in northern Angola with strong links to the Kongo, renowned for its miraculous Virgin. There it joined other devotional items made in Brazil, such as the church's namesake statue and a sculpture of Saint Anthony. Prince Luis Felipe of Portugal, son of Queen Amélia, brought it back to Lisbon in 1907 as a souvenir of his trip to Angola. It is this type of luxury object, heavy and well designed, that we should imagine on the altars of the Kongo.[20]

If many of the pieces described in nineteenth-century texts were old relics

19. Cruz, "Relatório sobre a sua viagem à San Salvador do Congo," *Boletim official de Angola*, no. 695 (1859), 1.

20. Santos Furtado, "Uma imagem de Santo António em Angola (Santo António da Muxima)," *Boletim do Instituto de Angola*, no. 14 (July–December 1960), 41–51. My thanks to Maria de Fátima Pimenta for providing me with the details of the provenance of the incense boat. For the miraculous image of Muxima, see Chapter 4, above, and Marcellino d'Atri in Toso, *L'anarchia congolese nel sec. XVII*, 49–50. According to John Thornton, a handful of objects belong today to the Mbanza Kongo Museum; personal communication.

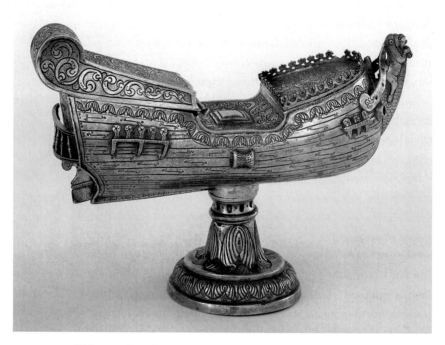

FIGURE 80 Unknown Brazilian artist, *Incense Boat*. Circa 1719– 1755. Silver, 15 × 25 cm. Museu Nacional de Soares dos Reis, Oporto, Portugal, inv. 129 Our MNSR. Photograph, Carlos Monteiro, 1998. Courtesy of Direção-Geral do Património Cultural / Arquivo e Documentação Fotográfica

of the preceding centuries, active workshops also existed in the Kongo at the time that produced objects of Christian or Christian-inspired iconography. In 1866, for example, Portuguese cleric António Barroso noted the continuing manufacture of large brass crucifixes. He described one of them as "a figure of yellow metal, 40 cm, hands and feet nailed to a wooden cross, the loincloth was well draped and belonged to a crucifix but the face, hair, and breast was that of a woman with features of the black race." Barroso immediately interpreted the cross as a "figure of fantasy," a contemporary misunderstanding of the Christian icon; in fact, however, distinctly local Catholic devotional objects had been produced in the Kongo since the sixteenth century.[21]

Remnants from the height of the Christian era were not confined to the main towns. Cruz also came across an old church with a collection of Christian paraphernalia in a small locality called Quinganga, or "town of the priest." There, the relics of the Christian period did not owe their conserva-

21. António José de Sousa Barroso, "Trabalhos em Africa, missão portugueza do Congo," *Boletim da Sociedade de Geographia de Lisboa,* VI (1886), 487.

tion to the will of mighty rulers such as the princes of Soyo or the kings of Kongo who found in them potent political tools. Rather, the continuation of practices and the safekeeping of objects from centuries past derived from a profoundly meaningful local history, expressed in oral narratives, toponyms, and naming traditions and attached to carefully conserved material remains of the past. Dom Simão, the elderly local chief whom Cruz judged to be more than eighty years old, served as the living bridge to the knowledge and practices of the Christian era that the village still celebrated.[22]

The church of Quinganga was a building of average size with, as in Soyo, a European-style wooden door closed with a rope. Inside, an "image" of Our Lady of the Rosary, one meter high, two Saint Anthony figures, one forty centimeters and the other shorter, two crucifixes, one of wood and the other made of silver, and a figure of Saint Lucy graced the altar that faced the door, which was constructed with sticks and covered with yellow wool and cotton cloths. A brass processional cross, a silver incensory, an incense box, a chalice, three monstrances, a paten, an altar stone, small bells, and a wooden box for the hosts also outfitted the altar. In the middle of the church the tomb of a friar named José, one of the last missionaries who visited the place, still remained visible. Dom Simão also preserved two damaged breviaries and several letters; one of the letters dated back to the seventeenth century. The letters, which Cruz unfortunately could not copy, recorded the correspondence between missionaries and past rulers of the locality as well as between prominent local men.[23]

The Portuguese visitor also noted Dom Simão's oral version of the history of Quinganga and its Christian objects. One of his distant predecessors and his namesake, the old man told Cruz, had traveled to Portugal and brought back from there the devotional objects that were in the church as well as many others that had since disappeared. Priests from the Kongo capital, he continued, used to visit the place regularly, and this clerical presence explained why it became known as "town of the priest." In 1858, the village still identified with the epithet, and its people still preciously preserved the church, its treasures, and the stories of Dom Simão.

In fact, another report from visitors to the same town decades earlier further fleshes out the enduring impact of Christianity at the local level from the time of the old kingdom into the era of emergent colonialism. In 1781, the Franciscan missionary Rafael Castelo de Vide journeyed from Luanda to São Salvador. As he arrived in the town then named Budila, in the Bamba

22. Cruz, "Relatório sobre a sua viagem à San Salvador do Congo," *Boletim official de Angola*, no. 712 (1859), 2.

23. Ibid., no. 711 (1859), 1.

province, he rejoiced in hearing the bells toll and in encountering the first Kongo church on his journey to the capital of the Christian kingdom. In the building, he found a "large Image of Our Lady" as well as a good silver incensory and incense box, probably the same ones that Cruz would see there eighty years later. During his stay, Friar Rafael recorded a version of local history, according to which the town was called "banza do Ganga," or "Padre Simão," after the name of a cleric who once officiated in the town. In addition to the church, Budila also had a house for visiting priests, constructed with architectural techniques and features that distinguished it from the rest of the town's buildings; it was "the best house [he] had encountered, for it had wooden doors—while others are made of straw—and earthen walls, but with a roof of straw."[24]

Banza do ganga is the lusitanized version of *mbanza a nganga,* or "town of the priest," the Kikongo phrase from which the name Quinganga also derived. A comparison of the 1781 and 1858 reports sketches the process and means through which the people of Quinganga formulated and transmitted their local history. The multivalent character of Dom Simão featured at the core of the town's traditions and identity. The name already appeared in one of the letters kept in the town's archives, signed by a Dom Simão de Medeiros on December 30, 1603, according to Cruz, probably misreading the year 1653. In fact, other copies of Castelo de Vide's account in the Arquivo Histórico Ultramarino and the Sociedade de Geografia, both in Lisbon, specifically make the connection between Padre Simão and Simão de Medeiros, possibly a mulato cleric active in the mid-seventeenth century, a chronology that would be in keeping with the later date. In later oral histories, the name of Simão remained fluidly attributed to the figure of a visiting cleric and that of a Christian ruler of the town, as suggested in 1858. In any case, the locality's identification with the pious figure took part in a larger set of associations with Catholicism manifested in oral history, toponymy, and the presence and preservation of the church, convent, and Christian paraphernalia over decades. Written, oral, and visual documents came together in the so-called town of the priest to create a deep and enduring tale still vivid in 1858.[25]

24. Rafael Castelo de Vide, "Viagem do Congo do Missionário Fr. Rafael Castello de Vide, Hoje Bispo de S. Tomé (1788)," 1780–1788, MS Série vermelha no. 396, 68–69, Academia das Ciências, Lisbon.

25. Cruz mentions the letter by Simão de Medeiros in "Relatório sobre a sua viagem à San Salvador do Congo," *Boletim official de Angola,* no. 711 (1859), 1. For Simão de Medeiros, see Louis Jadin, "Le clergé séculier et les capucins du Congo et d'Angola aux XVIe et XVIIe siècles: Conflits de juridiction, 1700–1726," *Bulletin de l'Institut Historique Belge de Rome,* XXXVI (1964), 203, 212–213, 219. See the published version of this copy of the account in Rafael Castelo de Vide, "Reino do Congo: Relação da viagem, que fizeram os padres missionarios, desde a cidade de Loanda, d'onde sahiram a 2 de agosto

Moreover, Budila's appellation of Quinganga is not an idiosyncratic example but rather illustrates a widespread practice. *Banza a nganga* was a common toponym for settlements in the core regions of the kingdom, in particular in locations linked to the gente da igreja. Portuguese cleric António José de Sousa Barroso visited several Quinganga towns in his travels between São Salvador and Bembe during 1883–1884. An enthusiastic reception to the sound of a bronze bell welcomed him in one town. There, in a house dedicated to the safekeeping of the treasures of a destroyed chapel, he saw on an altar an image of Our Lady with a silver diadem and dressed in clothing made of local textiles. In front of the figure was a metal crucifix on a wooden cross, and to its left was a beautifully worked processional crucifix of yellow metal, which was more recently manufactured than the rest of the objects. Three figures of Saint Anthony, two clay and one wooden, stood at the center of the altar, and a large wooden crucifix in a poor state of conservation graced the wall above. A "wormy female saint and a metal plate painting of the face of the Lord complete the tableau of images." Barroso also noticed a silver thurible and incense boat as well as a darkened chalice of uncertain metal. The ruler of the town proudly showed the priest two early-eighteenth-century breviaries and some almost illegible manuscripts. Among them the Portuguese man recognized a 1784 letter written by André Couto Godinho, an African priest trained in Coimbra who is also known from other documents as a contemporary and colleague of Castelo de Vide, both active in the Kongo in the 1780s. One of the letters was a certificate for a mestre, authorizing his service in catechization and confession; a similar certificate remains among the personal papers of Kongo ambassador António Manuel, who died in Rome in 1608. Finally, Barroso observed in the town, as Carrie did in Soyo, remains of the landscaping found in Capuchin hospices, in this case plantations of lemon and orange trees rare for the region. In 1908, still, Baptist missionary Thomas Lewis reported that "there are many townships in the present day bearing the name of Kinganga (*i.e.* town of the priests), and the inhabitants consider themselves inherited property of the Catholic priests." Up to the eve of Portugal's colonial takeover of the Kongo, the gente da igreja continued to maintain elements of centuries-old Kongo Christian material culture and tradition.[26]

de 1780, até á presença do rei do congo, onde chegaram a 30 de junho de 1781," *Annaes do Conselho Ultramarino; parte não oficial,* 2d Ser. (1859), 73.

26. See the description of Quinganga in Antonio José de Sousa Brum [Barroso], "No Congo: Trabalhos da missão portuguesa de Salvador; I, Apontamentos de uma viagem ao Bembe," *Boletim da Sociedade de Geographia de Lisboa,* V (1885), 48–49. For Godinho, see Graziano Saccardo, *Congo e Angola con la storia dell'Antica missione dei Cappuccini,* 3 vols. (Venice-Mestre, 1982–1983), II, 374–379. The 1600 certificate is in Miscellaneorum Armaria I, XCI, Collettione di Scritture di Spagna II, 137,

Lived Kongo Christian Traditions in the Nineteenth Century

The objects preciously kept in the custody of the gente da igreja did not merely form dormant collections of a celebrated past's mementos; they also continued to serve in rituals and ceremonies. In Soyo, nineteenth-century visitors had the opportunity to witness the ways in which the spaces devoted to Christian objects came to life as the gente da igreja regularly met in or around the chapels as a congregation under the leadership of their mestre. In 1866, Poussot described one of these gatherings and their elderly leader who had long ago served under the Capuchins and carried with him a crucifix as emblem of his office. In 1878, Carrie probably met the same mestre, an old man in charge of the church keys and reputedly educated under the last Capuchins—that is, before the 1830s. Earlier in the century in 1816, British naval officer James Tuckey had encountered the old man's predecessors, two mestres also educated locally (with the occasional input of clerics visiting from Luanda), devotional objects and diploma in hand. Tuckey, in his usual disparaging tone, reported:

> Several of the Sonio [sic] men who came on board were Christians after the Portuguese fashion, having been converted by missionaries of that nation; and one of them was even qualified to lead his fellow negroes into the path of salvation, as appeared from a diploma with which he was furnished. This man and another of the Christians had been taught to write their own names and that of Saint Antonio, and could also read the Romish litany in Latin. All these converts were loaded with crucifixes, and satchels containing the pretended relics of saints.[27]

A photograph, probably from the first decades of the twentieth century, gives a face to one of the mestres (Figure 81). Sitting on a folding chair, the elderly man holds a crucifix, similar to those buried at Ngongo Mbata in the eighteenth century, and the typical staff of church leaders, of the kind pictured in seventeenth-century watercolors. Staffs and crosses could also serve as emblems of power for a local ruler, but the absence of other insignia, such as a mpu cap, suggests that the image captured the likeness of a mestre.[28]

Vatican Secret Archives, the Vatican. The quotation is from Thomas Lewis, "The Old Kingdom of Kongo," *Geographical Journal*, XXXI (1908), 591.

27. Poussot in Brásio, *Angola*, I, 517; *Narrative of an Expedition to Explore the River Zaire, Usually Called the Congo, in South Africa, in 1816, under the Direction of Captain J. K. Tuckey, R. N., to Which Is Added, the Journal of Professor Smith . . .* (London, 1818), 79–80.

28. The photograph is published as illustration 5.28 in Marc Leo Felix and C. C. Lu Henry, *Kongo Kingdom Art from Ritual to Cutting Edge* (Hong Kong, 2003), 206, with provenance referenced as

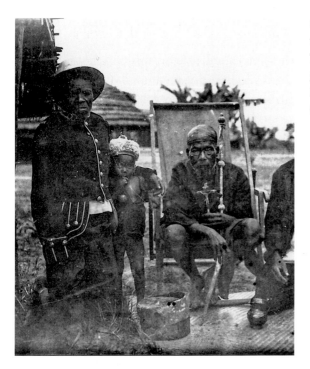

FIGURE 81 Kongo Mestre with Staff and Crucifix. Twentieth century. Photograph courtesy of Congo Basin Art History Research Center, Brussels

On the day of Carrie's visit in 1877, the gente da igreja gathered for communal prayers in the chapel, under the direction of their mestre and his attendants, women to the left of the altar and men to the right. They all knelt behind the religious leader, and, following his cues, made the sign of the cross, recited prayers, and sang responsorial chants in praise of God and the saints in a mix of Kikongo, Italian, and Portuguese. Scented smoke and the sprinkling of holy water that the old mestre had blessed completed the ceremony. Christian objects and practices coined in the preceding centuries continued to function in west central Africa at the dawn of the colonial period.

Power Objects from Kongo to Congo

The gente da igreja, who upheld the heritage of the Christian era in at least some parts of west central Africa, were not living relics of the past carrying on outdated traditions. On the contrary, they adapted the function and use of the Christian objects, images, and architecture in their midst in a way that ensured continued relevance within the changing sociohistorical context of

"archives Pères Jésuites Heverlee." I was not able to locate the photograph in this archive, but I thank Marc Leo Felix for providing me with a digital copy and Hein Vanhee for bringing the image to my attention.

imperial colonialism. They reframed the objects they inherited and crafted new practices that prevented them from becoming obsolete, powerless remains of a bygone era. The large wooden figures in the church of Santo Antonio in Soyo, for instance, received the attention of their keepers in a fashion that left European visitors more than perplexed. Carrie found the large Virgin on the altar covered up to her face with what he called "étoffes," that is, loose fabric rather than clothing. Disconcerted at first, he decided to recognize there an influence of Portuguese Catholic devotion. Pinto came to the same conclusion when he described the statues as stick figures *(de roca)* that, instead of clothing, were wrapped in cloth *(fazenda)*. Both Europeans referred to a genre of devotional statues popular in southern Europe and the Iberian colonies since the early modern period that consisted of schematic frames hidden under rich clothing from which peeked only carefully crafted hands and faces.[29]

The "much older" Saint Anthony, "disfigured with time and mutilated by insects," gave Carrie more pause. It was wrapped in a "mass of fabrics," imported textiles of all sizes, colors, and quality, so it immediately seemed to him suspicious and potentially superstitious. He reproached the gente da igreja for this unorthodox treatment of the statue, qualifying it as "superstition," an ambiguous term that can refer to a range of offenses from the relatively innocuous improper worship of the true God to much more serious charges such as idolatry. The strips of knotted cloth attached to the statue and pinned to the wall with wooden pegs shrouded the entire saint except for his termite-eaten face and the head of the child Jesus he carried. Pinto also found striking the profusion of cloth and textiles cinching the figures and covering the altar and filling the closets of the sacristy. Carrie explained to his readers that the gente da igreja often "asked the European traders for these cloths for the upkeep of their church." He attempted to remove the cloths around the saints but eventually let the gente da igreja persuade him that the coverings merely served to protect and reinforce the ancient statues, without further meaning, superstitious or otherwise.[30]

These wrapped saints, who were also likely pierced with the wooden pegs Carrie noticed, resonate with such an array of central African objects and practices that, despite the French priest's opinion, they cannot so easily be dismissed. On the contrary, the association between saints and textiles is part of a typical seventeenth- and eighteenth-century Kongo Christian tradition

29. Pinto, "Missão ao Zaire," in Pinto, ed., *Angola e Congo,* 367. See "étoffes" in Carrie, "Une visite à Saint Antoine de Sogno," *Les missions Catholiques,* nos. 487–489 (October 1878), 497.

30. Pinto, "Missão ao Zaire," in Pinto, ed., *Angola e Congo,* 367–368; Carrie, "Une visite à Saint Antoine de Sogno," *Les missions Catholiques,* nos. 487–489 (October 1878), 497.

of correlation between local and foreign practices. The Kongo elite, for instance, adorned their bodies with a combination of imported and indigenous cloth and textiles that defined Kongo regalia, as outlined previously. Moreover, funerary practices in the lands associated with the kingdom of Kongo also included wrapping cadavers of prominent men and women in layers of a variety of cloth acquired at great cost by kin and kith. Textiles aggrandized and conserved the remains of deceased members of the elite, including those awaiting Christian burial. Some crucifixes received similar treatment, wrapped in fabric before being buried or stored; others reflected the practice in their iconography, with an etched border reminiscent of textiles enclosing the corpus of Christ (as in Figure 89, below). Funerary bundles continued to mix imported cloth and locally crafted textiles in several regions once part of the Kongo throughout the nineteenth and into the twentieth century. In 1858, Zacharias da Silva da Cruz saw the bodies of a ruler, his wife, and his son, in the process of being smoke dried, "wrapped in a great quantity of money cloth *[fazenda da lei].*" In the Kongo, cloth had also cinched the empowered material core of non-Christian ritual instruments before it was used to wrap the body of Christ and the corpses of rulers. A rare document describing the use of power objects around the time of Kongo's conversion in the first decade of the sixteenth century tells the story of what the Portuguese text called a *feitiço* ("charm") specifically wrapped in cloth. From this perspective, the bundled saints of the Santo Antonio chapel echoed both ancient and contemporaneous practices, the symbolism of which fluidly carried over from Christian to non-Christian contexts.[31]

Minkisi minkondi offer the most striking parallel to the wrapped saints. At the time of Carrie's visit, these large anthropomorphic power figures, characterized by iron nails and metal shards struck into their bodies and by knotted or wrapped pieces of cloth tied about them, watchfully guarded large regions of west central Africa, including Soyo. Little indication exists of the origins of these spectacular objects, which are conspicuously absent in the thousands of pages chronicling life in the Kongo and its neighboring regions from 1491 to the end of the eighteenth century. Travelers, merchants, and missionaries of the sixteenth to eighteenth centuries often commented on large anthro-

31. Gio[vanni] Francesco Borrano da [Roma], *Breve relatione del successo della missione de Frati Minori Capuccini del Serafico P. S. Francesco al regno del Congo e delle qualità, costumi, e maniere di vivere di quel regno, e suoi habitatori* (Rome, 1648), 202. Poussot saw a crucifix wrapped in textiles in 1866; see Brásio, *Angola,* I, 520. See figures illustrated in Alisa LaGamma et al., eds., *Eternal Ancestors: The Art of the Central African Reliquary* (New York and New Haven, Conn., 2007), 310–311. See also José Heliodoro C. R. de Faria Leal, "Congo Portuguez, De S. Salvador ao Rio Cuilo," *Revista Portugueza colonial e marítima,* X, nos. 59–60 (1902), 257; Cruz, "Relatório sobre a sua viagem à San Salvador do Congo," *Boletim official de Angola,* no. 690 (1859), 3; João de Barros, in Brásio, ed., *Monumenta,* I, 142.

pomorphic figures yielding power over unseen forces, but none remarked on the practice of piercing or tying their wooden bodies. Olfert Dapper's secondhand chronicles of the late seventeenth century alone describe on one occasion the powerful effects of nails driven into a wooden anthropomorphic figure in Loango, north of the Congo River. The story, however, places the nailing in the hands of unscrupulous Portuguese sailors repairing the damage made to a local object and, as Volavkova underlined, "reveals that the driving in of nails and stab marks was not at that time a current ritual."[32]

Some descriptions of Kongo anthropomorphic figures from early modern sources include "idols of human face in wood and stone," an "idol in the shape of a man with horns and with a savage look," and an "idol who exactly had the appearance of a mountebank puppet *[verisimile di figura posticcia de' Bagattellieri]* dressed just like them, with a red bonnet on the head." These descriptions, in particular the last comparison to a puppet, suggests bold facial features, colorful textile additions, and dramatic postures comparable to those of the known minkondi of the nineteenth and twentieth centuries. Human-shaped figures in awe-inspiring attitudes in keeping with the aggressive gestures of early modern Kongo soldiers and *sangamento* dancers had also appeared in the sixteenth-century coat of arms of the kingdom (see Figure 16). Yet, the foreboding air of these objects did not revolve around the conspicuous stabbing and piercing of their wooden flesh that became a characteristic feature of "what is undoubtedly the most spectacular and, at the same time, the most distinctively Kongo type, the 'nail fetishes,' *minkondi,*" a prominent category of nineteenth- and twentieth-century central African anthropomorphic and, occasionally, zoomorphic minkisi.[33]

Nkisi (plural *minkisi*), as defined in the detailed ethnographies of the nineteenth and twentieth centuries, is "a personalised force from the invisible land of the dead" who "has chosen, or been induced to submit itself to some degree of human control effected through ritual performances" by an "initiated expert," the *nganga* (plural *banganga*). The term *nkisi,* we recall, was used in early modern Kongo Christian contexts to convey the idea of "holy" and "holiness." Then, as in the colonial period and today, ritual prac-

32. Olfert Dapper, *Naukeurige beschrijvinge der afrikanensche eylanden: Als Madagaskar, of Sant Laurens, Sant Thomee, d'eilanden van Kanarien, Kaep de Verd, Malta en andere, vertoont in de benamingen, gelegentheit, steden, revieren, gewassen . . .* (Amsterdam, 1668), 551; Zdenka Volavkova, "Nkisi Figures of the Lower Congo," *African Arts,* V, no. 2 (Winter 1972), 56.

33. Giovanni Belotti da Romano, "Giornate apostoliche con varii, e dilettevoli successi: Descritte dal P. F. Giovanni Belotti da Romano predicatore Cappucino della Provincia di Brescia, 23 novembre 1680," 1680, AB 75, 149, Archivio Generale Cappuccini, Rome; Bontinck, ed. and trans., *Diaire congolais,* 107; Merolla and Piccardo, *Breve, e succinta relatione,* 281; Wyatt MacGaffey, "Complexity, Astonishment, and Power: The Visual Vocabulary of Kongo Minkisi," *Journal of Southern African Studies,* XIV (1988), 199.

titioners focused the powers of minkisi in material objects, containers endowed with medicines that together became the nkisi, and sometimes took on human or animal form. Among these material manifestations, hunter minkisi, or *minkisi minkondi* (sing. *nksisi nkondi*), captured the imagination of Europeans, first as the very embodiment of the Western idea of the fetish and more recently as masterpieces of African art. Although all minkondi do not include nails and not all minkisi with nails are minkondi, this category best showcases the visual, metaphorical, and performative effects of nailing as a form of activation and empowerment of objects in the broad Kongo area. Nailing a nkondi is a visual metaphor for the injury that set the hunter in motion as well as for the injury it will effect on its intended target. Metonymic apparatus attached to the shards, such as pieces of cloth, hair, or saliva, direct the hunter to the wrongdoer it is asked to catch, the client it should protect, or the signatories of the contract it certifies. Nails and shards serve as visual records of activating gestures, although adjurations need not leave a visual trace.[34]

If early modern sources do not mention the use of nails and shards, they do record the existence of figures activated in a manner similar to twentieth-century minkondi. During Friar Luca da Caltanisetta's visit in 1701 to Nzonzo, an independent and, until his visit, unconverted polity east of the Kongo and north of the kingdom of Matamba, he recorded that "there isn't a house without its idol, because they are pagan; when they loose something or for another reason, they take the idol outside where they throw their diabolical malediction *[diabolica scomunica]* by beating it." Later in his description of the town, he mentions another "idol" solemnly struck in the course of dances *(vadono battando ditto idolo)*. The friar did not indicate whether the beatings left visible traces on the figures, but it is difficult to imagine that he would have failed to mention such a salient feature. In the kingdom itself in Soyo, around the same time in 1705, Lorenzo da Lucca reported the ritual stabbing, not of an image, but of a tree. In the course of a December sowing ceremony involving the entire town, the ruler of the province and his followers each took turns planting rough blades ("coltelli . . . rozzamente fatti") in a tree. Beyond these physical instances, "striking" also appeared in seventeenth-

34. For the European reception of the minkondi, see Pamela McClusky, "The Fetish and the Imagination of Europe: Sacred Medicines of the Kongo," in Pamela McClusky, ed., *Art from Africa: Long Steps Never Broke a Back* (Seattle, 2002). Wyatt Macgaffey synthesizes ethnographic knowledge about minkondi in MacGaffey, *Art and Healing of the Bakongo, Commented by Themselves: Minkisi from the Laman Collection,* Monograph series, no. 16 (Stockholm, 1991), 4. About the continuing use of minkisi in the region of São Salvador in the 2000s, see Bárbaro Martínez-Ruiz, *Kongo Graphic Writing and Other Narratives of the Sign* (Philadelphia, 2013). About minkondi, see MacGaffey, "Complexity, Astonishment, and Power," *Journal of Southern African Studies,* XIV (1988), 199.

century texts as an abstract notion referring to the mobilizing of unseen forces. The 1648 "Vocabularium," for instance, defines a *witch (veneficius)* as "munpanda quissi," one who strikes nkisi, and *witchcraft (maleficium)* as "muquissi ibhandabhanda," one who habitually strikes nkisi.[35]

Anthropomorphic figures in early modern central Africa were also likely to suffer in the hands of the missionaries. So-called idols, of course, felt the wrath of the proselytizing friars, who zealously maimed, struck, and destroyed them. In an exalted episode, the Jesuit Pero Tavares kicked, wrestled, tore down, strangled, dragged on the ground, and then struck with a stick an "idol" he came across in the Angolan locale of Golungo in October 1631. Yet Christian figures themselves received devotions that impaired their physical integrity. Merolla proudly described in 1692 his spectacular stabbing of a Virgin bust "with a dagger in the chest" during a sermon. Luca da Caltanisetta, in turn, satisfyingly noted the bewilderment of the king of Kongo, who stood gaping in front of the "bloody and pitiful" Sicilian crucifix the friar had brought with him.[36]

The striking and stabbing of wooden figures thus existed in seventeenth- and eighteenth-century central Africa abstractly and in practice, but it did not translate into a visually defined form akin to nail-covered minkondi until the very end of the period. Tuckey gave us the earliest description of nail figures in 1816: "Each village has a grand kissey. . . . It is the figure of a man, the body stuck with bits of iron, feathers, old rags, etc. and resembles nothing so much as one of our scare-crows." The British officer's wording suggests a widespread, deep-rooted practice that would have arched back to the preceding century. Yet no other source or precedents ascertain the antiquity of the practice or bring to light a moment of innovation in which ritual practitioners would have transformed the abstract idea of nailing and the ritual practice of striking into a visual metaphor. The era of the nailed minkondi most likely only partly overlapped with the pre-colonial Kongo Christian period, and, similarly, the geographical realm where nail figures occurred only partially

35. Luca da Caltanisetta in Romain Rainero, *Il Congo agli Inizi del settecento nella relazione di P. Luca da Caltanisetta,* La Nuova Italia (Florence, 1974), 365; Lorenzo da Lucca and Filippo da Firenze, "Relazioni," 1700–1717, fols. 159–160. See the location of Nsonso, or Sonso, in Saccardo, *Congo e Angola,* II, 190. For the translation of *veneficius* ("witchcraft"), see "Vocabularium Latinum, Hispanicum et Congense," [1652], MSS Varia 274, Fondi minori 1896, 53v, 113v, Biblioteca Nazionale Vittorio-Emmanuele II di Roma; John K. Thornton, "Afro-Christian Syncretism in the Kingdom of Kongo," *Journal of African History,* LIV (2013), 53–77.

36. Pero Tavares to Jeronimo Vogado, the superior in Luanda, Oct. 14, 1631, *Lusitania,* 55, fol. 79v, Archivum Romanum Societatis Iesu, Rome, published in Louis Jadin, "Pero tavares, missionaire jésuite, ses travaux apostoliques au Congo et en Angola, 1629–1635," *Bulletin de l'Institut Historique Belge de Rome,* XXXVIII (1968), 318; Merolla and Piccardo, *Breve, e succinta relatione,* 148; Luca da Caltanisetta in Rainero, *Il Congo,* 400–403.

intersected with the lands once under the kingdom's rule. The great centers for the creation of nail figures belonged principally to regions north of the Congo River, and only a few areas of the kingdom's core made use of the mighty figures. The greatest number of minkondi appeared far from the heart of the old Kongo.[37]

When John Tuckey visited the Kongo in 1816, he noted, in addition to the nail figure, many other "fetiches" displayed in the compound of the ruler of Mboma, a polity on the northern shore of the Congo River, directly facing and closely related to Soyo. His description of the objects does not mention nails or shards but explicitly describes the gestures of the figures, one arm up yielding a weapon, the other down in the ancient attitude already described in the imagery and interpretation of the sixteenth-century coat of arms of the Kongo. In the compound of the ruler of Mboma, he wrote, "a fetiche was seen in every hole and corner, consisting of sculptured figures in wood and stone, one exactly resembling the figures we see in England of Bacchus astride on a barrel, with the addition of a long pipe in his mouth and a spear on his shoulder." Tuckey's comparison of the figures to the infamous Greco-Roman god is in keeping with his overall disparaging view of the region, but it also draws a vivid parallel between the figures and the pose of Bacchus in one of his canonical representations: "astride on a barrel," one arm akimbo, hand on the hip, the other arm in the air lifting a cup. This pose notably featured in Peter Paul Rubens's version of the theme, which had widely circulated in print form in Europe since the seventeenth century, and would be a commonly understood reference for the gentlemanly readership Tuckey hoped for his report. Bacchus, of course, also allowed the British officer to talk about the nudity and sometimes prominent phallus of anthropomorphic Kongo figures in the euphemistic manner common in his time.[38]

The sketch the author included to illustrate this written description of the Bacchic "fetiches" made the arm gesture equally explicit (Figure 82). The silhouettes, clearly modeled after wall paintings, vessel decorations, or metal-sheet cutouts rather than three-dimensional figures, still present the characteristic pose, one arm up and the other down. The figure on the right, in particular, stands with one fist on the hip, while his other hand sways a

37. *Narrative of an Expedition to Explore the River Zaire,* 180. On the distribution of the figures, see Marc Léo Felix, Charles Meur, and Niangi Batulukisi, *Art et Kongos: Les peuples kongophones et leur sculpture Biteki bia Bakongo* (Brussels, 1995).

38. *Narrative of an Expedition to Explore the River Zaire,* 105–106; Norm Schrag, "Mboma and the Lower Zaire: A Socioeconomic Study of a Kongo Trading Community, c. 1785–1885" (Ph.D. diss., Indiana University, 1985). See, for example, Rubens's 1638–1640 *Bacchus* in the State Hermitage Museum in Saint Petersburg, Russia, accessed Apr. 29, 2014, http://www.hermitagemuseum.org/html_En/03/hm3_3_1_3c.html.

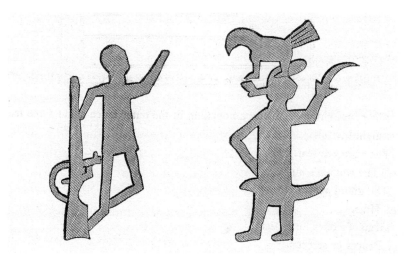

FIGURE 82 Two-Dimensional Designs from the Kongo. From *Narrative of an Expedition to Explore the River Zaire, Usually Called the Congo, in South Africa, in 1816 under the Direction of Captain J. K. Tuckey, R. N.; to Which Is Added, the Journal of Professor Smith . . .* (London, 1818), 116. Photograph courtesy of the Melville J. Herskovits Library of African Studies, Northwestern University

sword high in the air. He also wears a mpu cap drooping atop his head and a knotted wrapper—or perhaps that is a depiction of a prominent phallus—and he has a pipe in his mouth. The animal shadow at the top of his head is not unusual in two-dimensional central African designs, a genre in which distinct motifs often overlap.[39]

Together, Tuckey's written and visual descriptions of anthropomorphic imagery in the Kongo in the early nineteenth century explicitly articulate a visual lexicon in which weapons, arm gestures, iron blades, textiles, and feathers come together in various combinations. These observations flesh out our understanding of the transition between the visual and material environment of the Kongo kingdom in the early modern era and that of the regions once part of the realm in the late nineteenth and twentieth century. Tuckey's visit occurred at a moment in the history of central Africa that hinged between the enduring manifestations of the Kongo Christian period and the early appearance of the features that would define the region in the colonial era. Continuities and changes become apparent in his testimony as well as the lasting coexistence and conversation of Christian and non-Christian imagery and ideas in west central Africa.

39. Rob L. Wannyn mentions the metal cutouts in Wannyn, *L'art ancien du métal au Bas-Congo, Les Vieilles civilisations ouestafricaines* (Champles par Wavre, Belgium, 1961), plate XXVII.

The artistic and spiritual geography of the nail figures did not match that of the kingdom, but they were close neighbors and partial contemporaries. Minkondi and other anthropomorphic figures of the region shared with Kongo Christian objects similarities in form and iconography and commonalities of use. In the period and regions of overlap, the two categories of objects entered into dialogue. Nail figures looked to material and visual practices molded in the Christian era; emblems of power and strength such as textiles, shells, or swords that once endowed Kongo Christian nobles with an aura of prestige and might likewise aggrandized the minkondi. The hilt of a sword of status from Kongo Christian elite regalia pierced the chest of a nail figure collected before 1878. A shell similar to the emblem of Saint James present in several versions of the Kongo Christian coat of arms topped the medicine packet on the head of another nkondi (see Figures 13 [Plate 6] and 15 [Plate 8]). Yet another power figure carried around the neck a full Kongo crucifix, this one in the urban context of Luanda at the turn of the twentieth century, a place and time where people from many regions of central Africa mingled (see Figure 84, below). In a more general observation, Tuckey noted the intriguing mix of crucifixes and "fetishes" he witnessed in the region. Gestures and attitude, in particular, linked anthropomorphic images created in the two contexts. Preceding chapters have considered the shell, the sword, and the crucifixes as spaces of correlation within which Kongo artists and patrons brought together local and foreign visual and symbolic elements and, eventually, created new forms of meaning that illustrated and enacted the novel ideas of Kongo Christianity. In turn, nineteenth- and twentieth-century minkondi build upon these earlier correlations and recast them once more into objects whose significance may not fully be understood without recognizing the common visual and symbolic vocabulary that linked them to earlier central African visual forms.[40]

Worldly Savagery

An 1883 watercolor by Charles Callewaert painted in Lutele offers a visual pendant to the two saint figures wrapped in textiles Carrie found in the Santo Antonio chapel in Soyo (Figure 83 [Plate 37]). The Belgian man came to the region as a member of the Comité d'Etudes du Haut Congo, an entity created by Leopold II with the mandate to take possession of the area

40. *Narrative of an Expedition to Explore the River Zaire,* 165n. The photograph on the postcard in Figure 84 appeared previously as "A Collection of Angolan Fetishes or Gods," in Mrs. Harry A. M. McBride, "My Wanderings in Little-Known Angola," *Wide World Magazine,* XLII, no. 247 (February 1919), 295.

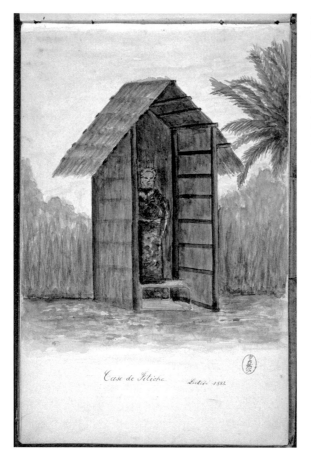

FIGURE 83 Charles Callewaert, *Fetish Hut in Lutele 1883*. Watercolor on paper, 29 cm. × 19 cm. Royal Museum for Central Africa, Tervuren, Belgium, inv. HO.0.1.3114. Photograph Royal Museum for Central Africa, Tervuren

and plan its exploitation. The painting, part of a series of amateur images composed during his stay in central Africa, depicts a near lifesize anthropomorphic figure standing on a platform in a small house. Woven straw on a wooden frame forms the walls and roof of the three-sided house, built to the scale of the figure it enshrines. The little house stands at the edge of an open area, in front of tall grass, a palm tree, and distant fronds. Callewaert titled his view "Case de Fétiche, Lutete, 1882" and sealed the page with his Japanese characters stamp. The "fetish" in the "hut" is a tall human figure, whose body disappears entirely under dark-blue cloth stained with reddish patches on the chest and in front of the legs and cinched with a beige belt. Bright red material crowns its head. Thin black shards pierce the entire surface of the figure, except for its face and the bottom of its legs. If the material ritually empowering minkondi often included textiles, the fully covered figure is exceptional. Here, dark-blue cloth, reminiscent of the imported wools favored in the Kongo since at least the seventeenth century, dresses up the figure in a full robe, including long sleeves visible on the left arm and a

rope-like belt. The ensemble is strongly reminiscent of a friar's garb or of the long robes on statues of Catholic saints. The serene, soft face of the figure, although not unusual in Congo art, also contributes to the identification of the piece with Catholic statuary. Could this figure be another Catholic saint turned minkisi, as the statues in the Soyo chapel seemed to be? The conjunction of abode and figure also echoes some of the variations on the design of the Virgin at the bottom of crucifixes in which the silhouette of the saint becomes the outline of a house and the drapes of her robe the body of a figure inhabiting the small structure, as seen in Figures 28, 29 (Plate 13), 31 (Plate 15), and 32. No matter the exact nature of the Callewaert figure's link to Christian imagery, it defines a visual context within which distinctive features of nail figures and Christian saints coexist even within a single object. The Santo Antonio saints and Callewaert's "fetish" make manifest the intersection between the imagery of the Christian period and that of the colonial era. Contemporaneous and visually related, saint figures with cloths and nails or nail figures clothed as saints demonstrate the overlaps in form and meaning between the two corpuses.

In another example, Mrs. Harry A. McBride, a British woman who traveled to Angola around 1917, illustrated the report she published in the popular *Wide World Magazine* with a photograph of a "collection of Angolan fetishes or gods," an image also published as a postcard by Luanda-based Casa 31 de Janeiro (Figure 84). A calabash filled with fibrous strips and two long antelope horns lay in the foreground of the composition. To the back, three staffs and two anthropomorphic figures face the lens. The first figurine, to the right, is a short piece stylistically linked to works by the Ovimbundu people of central Angola, wrapped in cloth and diverse materials. Three features make the taller figure to the left remarkable. First, its skull is pierced with the point of an antelope horn almost half its height. Second, an equally disproportionate Kongo crucifix hangs from its neck; the cross belongs to the well-documented eighteenth-century type illustrated in Figures 28 and 29 (Plate 13). Finally, dark cloth covers its body, not unlike a friar's garb or a Catholic saint's robe, and dangling sticks hang almost as a veil from the dark material placed on top of its head. Among the objects in front of the group, European bells included in a nkisi bundle also bring a seemingly out-of-place ecclesiastical flair to the ensemble. Here, again, abstract or anthropomorphic minkisi and items linked to Kongo Christianity join forces in objects that form spaces of correlation of a new kind. This assemblage of pieces was staged for the camera lens, but individual objects such as the bundle with bells, a type also documented elsewhere, and the crucifix-wearing figure—if not another invention for the photo shoot—individually illustrate the mix of objects linked

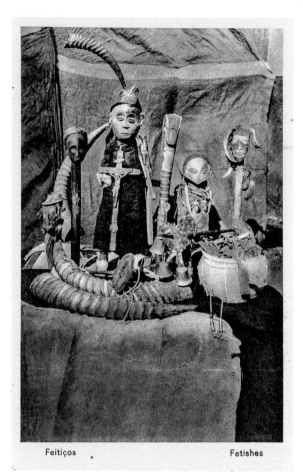

FIGURE 84 Unknown photographer, *Feitiços (Fetishes)*. Circa 1920. Postcard, collotype. Published by Casa 31 de Janeiro, Loanda, Angola. EEPA Postcard Collection, CG-20-75, Eliot Elisofon Photographic Archives, National Museum of African Art, Smithsonian Institution

Feitiços Fetishes

to central African Christianity with fetishes often noted in contemporary relations. The makers of the bell bundle or of the crucifix-wearing figurine brought together the already-composite forms of Kongo Catholicism with objects and symbols that otherwise functioned outside the Christian realm to form minkisi of a new kind.[41]

Similarly, the makers and users of the nail figures performed operations of correlation like those of their predecessors of the Kongo Christian era. They looked to the visual vocabulary of previous centuries for formal and symbolic maneuvers—Christian or otherwise—with which to aggrandize and activate their figures. Nineteenth-century carvers found inspiration in

41. McBride, "My Wanderings in Little-Known Angola," *Wide World Magazine,* XLII, no. 247 (February 1919), 295. The anthropomorphic figure and its attached crucifix also appeared in another photograph in José de Oliveira Ferreira Diniz, *Populações indígenas de Angola* (Coimbra, 1918), 54. A photograph of another empowered bundle that included European bells appears in Postcard Collection, Angola inv. 1985–142105, Eliot Elisofon Photographic Archives, National Museum of African Art, Smithsonian Institution, Washington, D.C.

the large anthropomorphic figures set in mighty poses that their predecessors had produced for centuries in a sustained dialogue since 1500 between deep-rooted local formal idioms and imported artworks from Europe, Brazil, and beyond. The same reflection on local and foreign but also past and present forms and symbolism continued in the colonial era. Nail figures recast novel foreign items and old Kongo forms into visual expressions of a local, contemporary discourse of power and efficacy.

The most prominent features of the figures that have become emblematic of the untouched, "savage" "heart of darkness" are, ironically, imported European objects. Mass-produced iron nails and imported textiles confer to many minkondi a distinctly cosmopolitan flair. Even the mirrors with which the figures attract and deflect the gaze of viewers and spirits alike are imported commodities recognizably linked to overseas sources. Their ultramarine provenance doubtlessly contributed to their metaphorical meaning in nineteenth- and twentieth-century Congo thought, in which they evoked the ocean-like barrier separating the world of the living from the realm of the spirits. Minkondi also often sported European clothing and accessories. Bowler hats, firearms, padlocks, coins, medals, metal trinkets, beads, chains, and screws visibly endowed the figures with a worldly appearance.[42]

Contemporary and neighboring art forms such as Loango-carved ivories and other depictions of *colons* (figures of Europeans) and their local sergeants similarly bridged the gap between foreign forms and local imagery in the visual responses of central Africans to the advances of colonization. Scholarship tends to discuss minkondi predominantly as local, inward-looking creations and Loango carvings principally in relation to their links to global commercial, economic, and visual networks. But we can gain much insight in considering them both as spaces of correlation in which central Africans from different parts of the region created a distinct, nineteenth-century, early colonial discourse. In the carved tusks and the minkondi, central Africans articulated materials and imagery drawn from their changing social and material environment with deep-rooted central African forms and thoughts. They brought together these two strands within single and, to some extent, new objects, recasting the novelties of an abruptly transforming world into icons and symbols of their own, and, in effect, domesticating change. The new forms and imagery broadened their own worldview and allowed them to make sense and participate in the shaping of the new colonial world they now inhabited.

42. See Wyatt MacGaffey, *Religion and Society in Central Africa: The BaKongo of Lower Zaire* (Chicago, 1986), 44.

Loango Tusk

In the mid-nineteenth century, artists from the Loango coast, a long stretch of shore between Cape Lopez in today's Gabon and the north bank of the Congo River that received its name from the historical kingdom and principal town of the area, started creating intricately carved ivories, the majority of which were destined for export. The low-relief designs on the tusks chronicled everyday life in the region with a special focus on the violence engendered by the rise of European colonial imperialism. Vivid scenes of forced labor, tense racial relations, asymmetrical power relationships, and sexual predation formed the paradoxical core of objects primarily intended to decorate European drawing rooms. The imagery of the tusks voiced the concerns and preoccupations of the African populations on the Loango coast, who lived at the intersection of the geographical and cultural domains of European colonizers and those of the local populations on the coast and in the interior.[43]

In the same manner as the makers of minkisi minkondi could evoke in their figures central Africa's Christian past and its colonial present, the creators of Loango ivories, objects firmly anchored in the transactions of nineteenth-century European imperialism, also commented in their works on deep-rooted religious practices and artistic forms in their region, including, on occasion, a centuries-long engagement with Christianity. The kingdoms that occupied the Loango coast before the eighteen hundreds, although distinct polities from the Kongo, shared with their southern neighbor a long and rich history of interaction with Europeans and the church. The king of the historical Loango kingdom turned to the Kongo as early as the 1560s to seek missionaries, and Carmelite friar Diogo da Encarnação commented in the 1580s about how the monarch "wants to become Christian and asks for priests." The inhabitants of the region also sometimes received Christian teachings from European traders. Capuchin friar Bernardino Ungaro even officially, if fleetingly, converted the king of Loango around 1665. Between 1766 and 1775, a French mission briefly operated in the realms of Loango and Kakongo. Networks of trade between the Christian Kongo and the Loango coast also ensured the close circulation of ideas, objects, and images, as il-

43. See Nichole N. Bridges, "Imagery, Carvers, and Consumers: Investigating Carved Loango Tusk Sculptures," in John M. Janzen, ed., *A Carved Loango Tusk: Local Images and Global Connections* (Lawrence, Kans., 2009), 17–33; and Zoë Strother, "Dancing on the Knife of Power: Comedy, Narcissism, and Subversion in the Portrayals of Europeans and Americans by Central Africans," in Nii O. Quarcoopome and Veit Arlt, eds., *Through African Eyes: The European in African Art, 1500 to Present* (Detroit, 2009), 49–59.

lustrated in the epistolary communication about textiles between the rulers of Kongo and Loango discussed previously.[44]

A meter-high ivory tusk in the Chrysler Museum in Norfolk, Virginia, is a striking example of Loango ivory carving (Figure 85). Rows of men, women, and animals involved in a range of mundane occupations walk along the ribbon-like, spiraling back of a snake slithering along the surface of the tusk. The figure of a man in a crucifixion pose stands out among the succession of scenes of everyday life (Figure 86). In contrast to the rest of the figures on the tusk that are pictured in profile (which is typical of Loango ivories) and firmly stand on the etched ground, the man appears in a full frontal position and trespasses the bounds of the spiraling border; his downward-pointing feet, bearing no weight, overlap the snake's skin. Only two other vignettes, a crocodile devouring a man and two ladders leading to a European ship, cross over the barrier. No cross holds his body, nor do nails pierce his limbs, but his position makes him an indisputably Christ-like figure. A woman to his right reads attentively from a book, and a man to his left, head bent, has joined his hands in a gesture that in the region could mean Christian prayer or respectful salutation. The man-Christ himself is alive; he looks absently into the distance, and his bearded face conveys lassitude more than agony. His head turned to the right, his uncrossed feet, and his short loincloth lend him the canonical look seen on Christ figures of Kongo crucifixes. The long etched line of the snake juxtaposed to the crucified body also becomes a close kin to the checkered border of many of the Kongo crosses, such as the one in Figure 19 (Plate 11) or photographed in Figure 89, below. In the register just above Christ, a man wearing the mpu bonnet of the elite wields a large European sword in the precise style of the Kongo Christian elite.

Scenes of animal and human predation, of long caravans of captives, and of handgrips and handshakes sealing deals and transferring power between white and black men form the core of the tusk's imagery. The ivory chronicle casts trade with Europeans, forced labor, and generalized violence as the central shaping forces of life in the region. The crucifixion appears among these scenes, a link in the chain of mundane events within the tusk's long lines of anecdotes. The figure of Christ and the spectacle of devotees paying

44. Brásio, *Monumenta*, III, 279, V, 82. An account of the stay of Friar Bernardino Ungaro, including a copy of his own report, appeared in Giovanni Antonio Cavazzi and Fortunato Alamandini, *Istorica descrizione de' tre' regni Congo, Matamba, et Angola sitvati nell'Etiopia inferiore occidentale e delle missioni apostoliche esercitateui da religiosi Capuccini* (Bologna, 1687), 562–568. For a contemporary account of the French mission compiled from firsthand documents and testimonies, see M. l'Abbé Proyart, *Histoire de Loango, Kakongo, et autres royaumes d'Afrique; rédigée d'après les mémoires des préfets apostoliques de la mission françoise; enrichie d'une carte utile aux navigateurs: Dédiée à monsieur* (Paris, 1776).

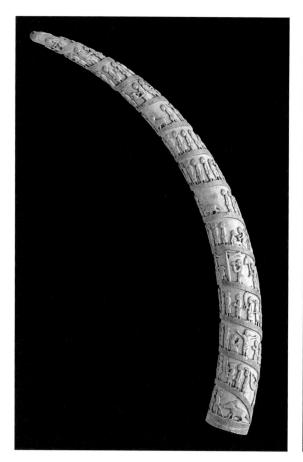

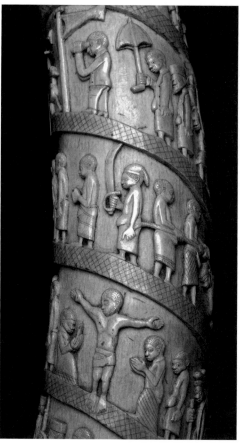

FIGURE 85 Carved Elephant Tusk from the Loango Coast. Kongo peoples. Republic of the Congo or Democratic Republic of the Congo, late nineteenth to early twentieth century. Ivory, 112 cm. Chrysler Museum of Art, Norfolk, Va. Gift of Walter P. Chrysler, Jr., 71.2409

FIGURE 86 Detail of Carved Elephant Tusk from the Loango Coast. Kongo peoples. Republic of the Congo or Democratic Republic of the Congo, late nineteenth to early twentieth century. Ivory, 112 cm. Chrysler Museum of Art, Norfolk, Va. Gift of Walter P. Chrysler, Jr., 71.2409

homage to his image participate in the tusk's chronicling of the quotidian on the central African coast; the visual idioms of Christianity unremarkably join the rest of the figures in this tableau of everyday life. Better, perhaps, than any other testimony, the vignette documents the presence of Christianity in the region through African eyes. And, indeed, missionary activity surged on the Loango coast alongside renewed European trading interest and became a signifcant part of the foreign presence in the region.[45]

45. On missionary activity in the region, see Bontinck, "La mission spiritaine de Boma," *Zaïre-Afrique,* no. 136 (June 1979), 362–375.

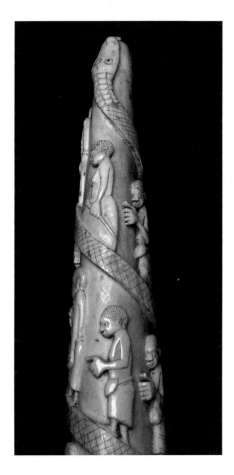

FIGURE 87 Detail of Carved Elephant Tusk from the Loango Coast. Kongo Peoples. Republic of the Congo or Democratic Republic of the Congo, late nineteenth to early twentieth century. Ivory, 112 cm. Chrysler Museum of Art, Norfolk, Va. Gift of Walter P. Chrysler, Jr., 71.2409

Yet the crucifixion does not just stand for another European-imported novelty; it also takes part in the complex arrangement of richly evocative central African symbols that lends the ivory another layer of meaning. The tusk provocatively challenges its own significance as a set of vignettes for the souvenir market. The body of the snake offers along the shaft of the tusk a flat and stable ground for the actions of the protagonists; the etched checkered pattern efficiently and elegantly separates the length of the ivory into different registers. But, at the very top, the geometric pattern that evoked the snake's body morphs into scales, the flat ribbon swells into the rounded neck of a serpent, eyes wide open and tongue hissing out (Figure 87). As ground shifts into animal, the nature of the object changes from chronicle of the everyday to cosmological design. The mundane activities that unfold on the serpentine line, a multivalent symbol of the shifting watery divide between the world of the living and the world of the dead, now take on new meaning. The proces-

sion belongs to the visible world, a world apposed, in the cosmological logic that the presence of the snake suggests, to its invisible pendant, the realm of the ancestors and the spirits. Three figures bridge the two worlds. First, a crocodile devouring a man breaches the bounds of the pictorial space as its tail rests over the body of the snake. Central African folklore considered the amphibious predator, who dragged his victims to their demise below the water's surface, as a literal and mythological intermediary between the land of the living and the land of the dead. The two ladders hanging from the European ship also breach the aquatic divide in an image showcasing the connection central Africans made between seafaring Europeans and spirits dwelling in the otherworld. Finally, the crucifixion breaches the divide between life and death and the boundary of the snake line in a third instance. The crucifixion motif thus appears on the tusk not only as part of imagery that participates in daily life on the Loango coast through missionary activities but also as a symbol imbued, like the reptile or the sea vessel, with cosmological significance. Serpent, crocodile, ship, and crucifixion all have double meanings. They are at one level mundane objects of the everyday, a ground to step on, a dangerous beast, a mode of transportation, and a tool for Christian devotion. From another perspective, they function as multiple metaphors for the multivalent connections between life and death, turning the tusk's chronicle of life into an allegory of cosmological order.[46]

Loango tusks are eminently difficult objects to decipher; the stories they tell are complex, and their meanings are often obfuscated. Here the artist presented Christianity both as a thread woven into the fabric of the daily life he chronicled and as a visual discourse that complemented or functioned in parallel to other local cosmological symbols. Whether the reference to Christianity arched back to the Kongo Christian era or to Loango's own past relations with the church is difficult to gauge, but, regardless of the origins of the design, it is striking that it serves as one of the hinges linking the tusk's matter-of-fact and metaphorical content. In the ivories and in the minkondi, new and old, local and foreign thoughts and forms mix and merge in ways that greatly challenge their perception by European observers as tourist items and fetishes of a backward people. Both genres, on the contrary, reflected their makers' creative reflection on the colonial world in the making and on the role their own worldview could take in shaping this new reality.

46. "The amphibious crocodile," Wyatt MacGaffey explains, "in fact and folklore, carries people to the land of the dead"; see MacGaffey, "Fetishism Revisited: Kongo *Nkisi* in Sociological Perspective," *Africa: Journal of the International African Institute,* XLVII (1977), 175. For the association between Europeans and the underwater land of the dead, see W. Holman Bentley, *Pioneering on the Congo* (New York, 1900), 252.

A Hardening Gaze

As Carrie visited the Santo Antonio church in Soyo in 1877, dozens of minkondi watched over west central Africa, and artists on the nearby Loango coast were busy carving ivory tusks. The visual environment of the region as a whole as well as individual objects participated in a continuing conversation between centuries-old forms and thoughts and the novel circumstances within which they now existed. In that regard, late-nineteenth-century central Africa benefited from the cumulated experiences of correlation over centuries of contact with Europe. Kongo Christian crucifixes, for instance, continued to serve as spaces of correlation in which central African elite brought together conceptions of leadership inherited from the Kongo kingdom with their new political and spiritual role as leaders of a people increasingly under the bough of colonial overlords, as Belgian king Leopold's Congo Free State seized control of the northern part of the kingdom in 1885 and Portugal took over São Salvador in the 1910s. Photographs and ethnographic descriptions of local leaders proudly displaying ancient crosses testify to that role in the nineteen hundreds.

Spiritan father Jan Vissers, who worked in Cabinda in the first half of the twentieth century, left a rare series of photographs showcasing Kongo Christian objects in the hands of the proud men who inherited them from generations of predecessors. In an image now in the Afrika Museum in Berg en Dal, the repository of many objects collected by fathers of the Holy Ghost, an old man sits quietly in front of a small house next to, presumably, his emblems of status (Figure 88). A large sword with its handle pierced with crosses (similar to Figure 11), an iron double bell, a staff decorated with three knobs, a wood-and-metal crucifix (also pictured in Figure 31 [Plate 15]), and a metal ring offer a full collection of Kongo Christian regalia. In another frame, a ruler put on an impressive mpu adorned with many claws and an equally imposing necklace of big-cat teeth to showcase his crucifix for the camera (Figure 89). Vissers took a rare interest in Christian objects in the local visual culture, one that led to the creation of the photograph as well as to the transfer of these objects to Western collections. For more than a century before his time, however, the foreigners who traveled in west central Africa saw the Christian objects they observed from a very different perspective.

The European explorers and travelers who visited central Africa during the nineteenth century sporadically mentioned Kongo Catholicism and its material and visual manifestations. The previously mentioned "Naturalists and Officers" of the Tuckey expedition, for example, described their encounter in Soyo around 1816 with a group of Kongo Christian men. Among

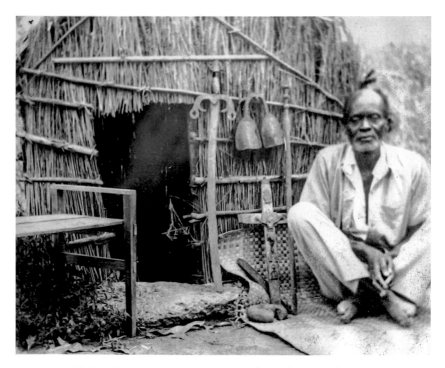

FIGURE 88 Father Jan Vissers, *Domingos Kya Fellie and His Regalia*. Circa 1950.
Photograph. Courtesy of Afrika Museum, Berg en Dal, Netherlands

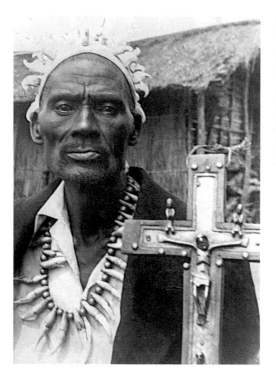

FIGURE 89 Father Jan
Vissers, *Field Photograph of
Kongo Ruler Pedro Bambi,
Yenga (North Angola) Angola
or Cabinda*. Circa 1950.
Photograph. MAS (Museum
aan de Stroom), Ethnographic
Collections, Antwerp, inv.
AE.1959.0051.0001.D

them were a mestre, who held a "diploma" attesting to his function, and his acolyte; both could read "the Romish litany in Latin" and "write their own names and that of Saint Antonio." Fifty years later, in 1879, William Holman Bentley, from the Baptist Missionary Society, recorded his impressions of São Salvador. "In a house in the king's compound," he wrote, "were kept a large crucifix and some images of saints, but they were only the king's fetishes." "If the rains were insufficient, they were sometimes brought out and carried round town." The Kongo monarch himself, he noted after meeting with him, held in his hand a crucifix and a scepter. Christian objects continued to play a conspicuous role in political insignia and to serve as trusted intermediaries between the visible world and the invisible forces holding sway over them.[47]

If Tuckey, Bentley, and their colleagues left important testimonies about the continuous use of Catholic rituals and objects in the Kongo during the nineteenth century, their writings were either dismissive or derisive of their own observations. Prejudice veiled the perception of these European, often Anglo-Saxon visitors, who saw the region and its people through eyes not only trained by the pseudoscience of their era to consider Africans and Africa as inferior in every aspect to Europe and Europeans but also tainted by a profound contempt for Roman Catholicism and its rituals. The central elements of Kongo Christianity—attachment to objects of worship, devotion to saints, and multisensory performances of rituals—were also the aspects of Catholicism in general that were the most decried by Protestants eager to denounce "Romish" abuses. One of Tuckey's reflections provides colorful evidence of his estimation of Catholicism. Central Africans, he wrote, paid to their "fetiches . . . the same worship that a good catholic would do to the *os sacrum* of his patron saint." Profanity joins mockery here, in words playing on the ambivalent meaning of the Latin phrase *os sacrum,* which could be read as both "relic," or "sacred bone," and "tailbone." The irreverent pun used Latin, the ritual language of Catholicism that Reformed churches criticized.[48]

47. *Narrative of an Expedition to Explore the River Zaire,* 80; Bentley, *Pioneering on the Congo,* 35, 123. Other testimonies of Catholic artifacts in the Congo are found in Cha[rle]s W. Thomas, *Adventures and Observations on the West Coast of Africa, and Its Islands; Historical and Descriptive Sketches of Madeira, Canary, Biafra, and Cape Verd Islands; Their Climates, Inhabitants and Productions; Accounts of Places, Peoples, Customs, Trade, Missionary Operations, etc., etc., on That Part of the African Coast Lying between Tangier, Morocco, and Benguela* (New York, 1860). Wannyn also notes, "Vers 1880, d'après le R. P. Van Wing, en certain point de la Côte, le chef avait l'habitude de donner la bénédiction au peuple avec un crucifix datant de la première évangélisation" (Wannyn, *L'art ancien du métal au Bas-Congo,* 39).

48. John Thornton explained that the "hardening of European attitudes towards non-Western cultures in general since the nineteenth century . . . has been most noticeable in Africa, where the increasing cultural chauvinism of nineteenth-century Europe was coupled with the newly devised concepts of pseudo-scientific racism, itself an outgrowth of Africa's peculiar relationship to Europe and the Americas through the slave trade"; see Thornton, "The Development of an African Catholic

Charles Thomas, a Protestant missionary from Georgia in the United States, wrote in the 1860s a telling diatribe denouncing Catholicism and its inability to truly convert central Africans. The attack accurately described the methods of the Capuchins, which he then blamed for their failure to achieve conversion. He deplored that, "in this, the year of grace of 1859, there are no traces of Catholicism to be found among [the Kongo] except here and there a decayed temple, the picture of a saint, or a crucifix." "Roman Catholicism," he explained, "as a religious system has not the power to raise a barbarous people to a high degree of civilization and practical Christianity." In the eighteenth century, Dutch merchant Willem Bosman had expressed similar thoughts about the inadequacy of Catholicism, ironically using the opposite argument. "If it was possible to convert the Negroes to the Christian Religion," he wrote, "the Roman-Catholics would succeed better than we [that is, Protestants] should, because they already agree in several particulars, especially in their ridiculous Ceremonies." William Pietz quoted Bosman in his study of the creation of the concept of "fetishism" to underline the link in Protestants' minds between the Roman Catholic use of ritual objects and images and what they perceived as the irrational practices of African religions.[49]

Also clearly woven into nineteenth-century reports and observations of northern Europeans more generally is the rhetoric of the justification for colonization, which entwined the concepts of civilization and progress with that of Christianity. Decades before the scramble for Africa, in 1816, the Tuckey report had set up the arguments against Portugal's claim for colonial control of the region:

> The vast shoals of Catholic missionaries [that] poured into Congo
> and the neighboring parts of Southern Africa, from Italy, Spain, and
> Portugal, in the sixteenth and seventeenth centuries, appear not to
> have advanced the natives one single step in civilization; and the
> rude mixture of Catholic with Pagan superstitions, which were found
> among the Sognio people on the left bank of the Zaire, close to the
> sea coast, was all that could be discovered of any trace of Christian-
> ity, after the labours of these pious men for three hundred years.

Church in the Kingdom of Kongo, 1491–1750," *Journal of African History,* XXV (1984), 154. The *os sacrum* is the central bone of the pelvis; in Tuckey's text it is meant to be read as a profanity, something to the tenor of the "butt bone"; see *Narrative of an Expedition to Explore the River Zaire,* 63.

49. Thomas, *Adventures and Observations,* 266; William Pietz, "The Problem of the Fetish, II: The Origin of the Fetish," *Res: Anthropology and Aesthetics,* no. 13 (Spring 1987), 39, and "The Problem of the Fetish, IIIa: Bosman's Guinea and the Enlightenment Theory of Fetishism," no. 16 (Autumn 1988), 105–125.

He concluded, revealing the point of his arguments, that "colonization holds out the only prospect of meliorating [the Kongo people's] civil and moral condition." And the colonization on his mind was, without a doubt, one led by enlightened, Protestant Britain.[50]

The context of these observations was the growing competition between European powers for territorial colonization of central Africa, which would culminate in the 1885 Berlin Conference. The nations of the emerging West began to see Africa as a blank expanse of land to be discovered, conquered, and developed, its inhabitants a negligible quantity or, at best, savage yet helpless inferiors whose backward mores required the firm guidance of enlightened metropoles. Portugal offered a weak dissenting voice in this concert of claims from northern Europe and the United States. The Iberian kingdom, mostly left out of the scramble for Africa because of its peripheral position within Europe, fought for recognition of its centuries-old dominion over the region. In particular, it worked at presenting the kingdom of Kongo as an organized country that willingly became Portugal's vassal. The perspective of Portuguese descriptions of the kingdom of Kongo thus differed singularly from that of Anglo-Saxons. If Iberian writers emulated the racist, condescending tone of the likes of Tuckey and his fellow explorers, they gave a much more nuanced account of the Kongo in which many of the traits of the kingdom's organization in the preceding centuries are emphasized rather than systematically eclipsed or derided.[51]

Seeing the Nineteenth Century in Historical Perspective

The inability of many nineteenth-century European observers to acknowledge and perceive traces of central Africa's long-standing visual and material conversation with Europe is striking. The structures and practices that defined the Christian Kongo did not, of course, remain unchanged and unchallenged in the nineteenth century. But evidence suggests that both continuity and change in the Kongo, from the time of its first involvement in the early modern Atlantic system to the period of rising and eventually triumphant European imperialism, can be outlined, defined, and analyzed. Read attentively, and in light of the background sketched above, the elusive and prejudiced texts and images of nineteenth-century travelers can provide

50. *Narrative of an Expedition to Explore the River Zaire*, 370.

51. See, for example, [A. J. de Castro], "O Congo em 1845: Roteiro da Viagem ao reino do Congo, por A. J. de Castro, major da Provincia de Angola, em junho 1845," *Boletim da Sociedade de Geographia de Lisboa*, 2d Ser., II (1880), 53–67. See also the exalted defense of Portuguese missionary endeavors in central Africa in Pinto, "Missão ao Zaire," in Pinto, ed., *Angola e Congo*, 367–370.

the missing link between our knowledge of the Kongo in the early modern period and the anthropological observations that scholars conducted in the twentieth century in the same region of central Africa.

As they visited central Africa, travelers witnessed such age-old ceremonies as the knighting of members of the Order of Christ. In 1881, priests visiting São Salvador continued to participate in such ceremonies *(armar cavalleiros),* in which the king gave the distinction of the habit *(habito)* to deserving men, "turning them into knights" as "kings of Congo" had "always" done. Explorers also often saw the staging of sangamentos, ritual performances that had been central to the definition and enactment of the Kongo kingdom's political rule and social hierarchies. The documentary record attests to the continuous use of these performances throughout the Christian era. In 1781, as Franciscan cleric Rafael Castelo de Vide arrived in a town during an apostolic tour of the Kongo, the people "immediately executed their usual dances of joy *[danças de alegria],* that they called *sangamentos* which are like martial exercises, and they said that they were against the devils that had stopped fathers [that is, priests] from coming to their land, and they all do this in honor of the fathers when they arrive in their towns, as a sign of honor." In 1845, A. J. de Castro, the Portuguese crown ambassador to the Kongo sent from Angola, repeatedly sat through sangamentos staged in his honor. As he reached important localities, rulers quickly organized elaborate receptions in keeping with long-standing Kongo traditions. They received the foreigner in ceremonial courtyards outfitted with elegant European or Brazilian furniture, armchairs or antique mahogany seats made in turned wood in the Manueline style. Soon, men armed with rifles, bows and arrows, or swords joined the rulers in "a sort of military exercise" in which they all leaped and swayed their weapons in the air while shouting. Ivory horns, shells, trumpets, and drums accompanied the dances. In 1879–1880, Bentley also witnessed a sangamento near São Salvador when an elderly "notable chief" visited the king in the capital. The old man sang, "drew a long cavalry sword," and began to dance and skip while twirling his swords above his head and around his legs in acrobatic moves. "As a 'ceremonial,'" Bentley conceded, "this *Sanga* was the most impressive."[52]

An early-twentieth-century photograph published in a 1926 article by Leon Bittremieux captured a sangamento in action (Figure 90). The context

52. Brum, "No Congo," *Boletim da Sociedade de Geographia de Lisboa,* V (1885), 44; Castelo de Vide, "Viagem do Congo," 1780–1788, MS Série vermelha no. 396, 137, Academia das Ciências; Castro, "O Congo em 1845," *Boletim da Sociedade de Geographia de Lisboa,* 2d Ser., II (1880), 56, 59; Bentley, *Pioneering on the Congo,* 201–202. Baptist missionary Thomas Lewis also wrote an admiring description of the sangamento in Lewis, "The Old Kingdom of Kongo," *Geographical Journal,* XXXI (1908), 596.

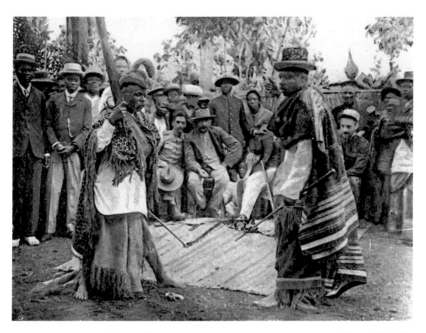

FIGURE 90 *A Popular Gathering 1911–1914.* From Leo Bittremieux, "Overblijfselen van den katholieken Godsdienst in Lager Kongoland," *Anthropos,* XXI (1926), plate following page 804. Courtesy of the Anthropos Institute, Sankt Augustin, Germany

for the event differs greatly from that of the preceding decades. At the time of the photograph, the kingdom had finally come under the colonial rule of Portugal, and the Portuguese administrators who oversaw the sangamento authorized it as a folk festival and an amusing distraction. Bittremieux describes the photograph, "A popular gathering *["volksvergadering"]*: prominent residents and Portuguese authorities. Left: Martins is elevated king; right: Buta." According to the caption, the dance showcases the nominal king of Kongo, Dom Manuel Martins Kiditu, possibly on the occasion of his coronation in 1911, and Álvaro Buta, a prominent member of the Kongo elite who would soon lead a rebellion against the monarch in 1913–1914. Bittremieux is mistaken in identifying the king as one of the dancers. The young, mission-educated titular monarch, known for his Europeanized ways, is instead sitting on the armchair at the center of the carpet in the background. He is clad in a Western suit, but his feet rest on what seems to be an animal pelt, in the traditional fashion; the dancer to the right obscures his face. Álvaro Buta, however, might be one of the two dancers.[53]

53. Leo Bittremieux, "Overblijfselen van den katholieken Godsdienst in Lager Kongoland," *Anthropos,* XXI (1926), plate following 804.

The photograph captured a group of African men dressed in the European style, gathered in an outdoor space enclosed with a man-high fence. They stand in a semicircle around a carpet, looking at the two richly dressed main protagonists, who are holding a dynamic but posed stance. Three Portuguese administrators have joined the group. They sit on European chairs on either side of the king's traditional armchair. The dancer to the left appears in the regalia of the Kongo elite that British traveler John Weeks and Faria Leal both described. He wears a fringed wrapper of local cloth under a white European shirt. His shoulders are covered with a thick coat dotted with flower or star patterns and enhanced with long galloons. He holds a stick in his left hand and raises a large Kongo sword of status (of the kind in Figures 10 [Plate 5] and 11) in his right. A feather decorates the tricorne hat on his head. He stands with his feet wide apart, firmly planted on the ground. The dancer facing him also wears a local wrapper and a long cloth wrapped over his shoulders. He lifts a thinner sword and holds a stick in his left hand. A European hat and shirt complete his look.[54]

The dancers awkwardly pose for the camera, but the scene clearly illustrates the sangamento that accompanied the nominal coronation. The Portuguese administrator in São Salvador, Faria Leal, probably the man sitting to the right of the king in the photograph, described the coronation in his 1914 "Memórias d'África," including details on the regalia and a short description of the "joust or tournament" that the great men of the Kongo performed in celebration of the event "with leaps and wild faces" while holding "old swords." The choreography, objects, and hierarchies displayed in the performance are easily matched with those of centuries past. The photograph illustrates well the status of the Kongo in the early twentieth century, hovering between a strong sense of history and identity inherited from the ancient kingdom and the colonial erasure of the political significance of their traditional ceremonies and practices, which the Portuguese tolerated and lightly considered at best as folklore. The regalia and ceremonial sartorial practices of the Kongo elite sketch a parallel story. Although the mix of local and imported items of clothing expressed deep-rooted conceptions of power, prestige, and legitimacy for the heirs of the Kongo kingdom, the ceremonial outfits in the era of rising and triumphant colonialism elicited comments such as, "His costume convey[ed] the idea of punch in a puppet-show." Precise descriptions of the ceremonial regalia of the elite over the course of the nineteenth century leave

54. Dom Manuel Martins Kiditu wears a hat similar to that of one of the dancers in a photograph in Weeks, *Among the Primitive Bakongo*, following page 40. See also Faria Leal, "Memórias d'África (Part 1)," *Boletim da Sociedade de Geographia de Lisboa*, XXXII (1914), 321.

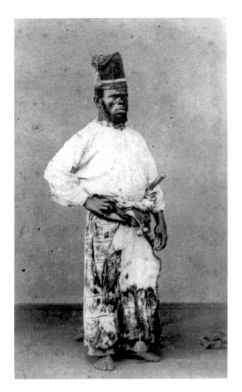

FIGURE 91 Christiano Jr., *African Man in Rio de Janeiro*. Circa 1865. Photograph, 9 × 6 cm. Central Archive of the Instituto do Património Histórico e Artístico Nacional, Section Rio de Janeiro: Collection Christiano Jr.

little doubt, however, that the correlation of local and foreign that defined Kongo regalia in the early modern period continued to inform the sartorial practices of the eighteen hundreds. The mix of European clothing and local insignia that Europeans derided in fact manifested in the Kongo a strong sense of history and prestige evident, for example, when comparing the finery in the photograph with that of the seventeenth-century ambassadors in Figures 45–49 (Plates 18–22). Key items such as the mpu caps, *kinkutu* shoulder nets, coral beads, and crucifixes also continued to be featured in the elite outfits of nineteenth- and twentieth-century central Africa.[55]

That Kongo Christian regalia and its social significance endured through time and changing circumstances is also apparent in a poignant photograph taken in Rio de Janeiro in 1865 (Figure 91). The studio shot composed by Christiano Junior, a Portuguese photographer and businessman, was part of a series of images of Brazilian local color that the entrepreneur hoped to sell as souvenirs to visitors returning to Europe. Among the portraits of presumably enslaved street vendors, artisans, and domestics—the "'black types'" he

55. Faria Leal, "Memórias d'África (Part 1)," *Boletim da Sociedade de Geographia de Lisboa,* XXXII (1914), 321–322; *Narrative of an Expedition to Explore the River Zaire,* 101–102; Cruz, "Relatório sobre a sua viagem à San Salvador do Congo," *Boletim official de Angola,* no. 696 (1859), 1–2; Brásio, *Angola,* I, 522.

was advertising—the stark gaze of a bearded African man captures viewers' attention. Imperiously standing with one hand on his hip, staring the camera down, the unnamed man proudly wears full Kongo regalia. With the means of someone living at the bottom of the social hierarchy of slavery-era Brazil, he turned a high velvet cap enhanced with a tassel into a mpu cap, wrapped a colorful piece of fabric around his legs over his frayed pants and shirts, and cinched a dark, probably red, belt around his waist. The typically central African animal pelt dangling in front of his legs, the necklace, and the pommel of a stick or umbrella rather than a sword at his side complete a look that easily compares to that of his seventeenth-century counterparts, such as the man in Figure 71. The members of the elite Father Carrie met in Soyo around the same time in the 1870s wore similar items of prestige, a "bonnet" of status, "golden braids," a "brightly colored loincloth," and a European-style coat. We know almost nothing of the man in the photograph, but it is possible that he directly came from the Kongo, at a time when the slave trade to Brazil still lingered. His outfit, however, painstakingly put together and covering his modest attire, tells us much about the pride and likely empowerment that claiming his status as a member of the Kongo elite brought him in his new environment.[56]

Kulusu: Enduring Associations outside the Christian Context

A careful analysis of the visual and material culture of the sixteenth to seventeenth centuries not only allows us to pinpoint vestiges of Kongo Christianity in later periods; it also brings new historical perspective to practices outside the Christian context. The intimate association present in the Kongo kingdom era between the idea of the cross and the notion of transition between life and death, for instance, endured into the twentieth century not only in crucifixes and monumental crosses but also in a class of objects known in the ethnographic literature as "hunting fetishes," also called *kulusu, kulunsi,* or *santou.* The last three names derived from the Portuguese words *cruz* and *santo,* meaning "cross" and "saint." Kulusu make manifest in their forms, like crucifixes and monumental crosses, the abstract notion of intersection. Made of wood and metal, they are cruciform objects, the conception and construction of which center on the intersection of

56. Paulo Cesar de Azevedo and Mauricio Lissovsky, "O Fotógrafo Christiano Jr.," in De Azevedo and Lissovsky, eds., *Escravos brasileiros do século XIX na fotografia de Christiano Jr.* (São Paulo, 1988), xii; Carrie, "Une visite à Saint Antoine de Sogno," *Les missions Catholiques,* nos. 487–489 (October 1878), 473. See also Cécile Fromont, "Dancing for the King of Congo from Early Modern Central Africa to Slavery-Era Brazil," *Colonial Latin American Review,* XXII (2013), 184–208.

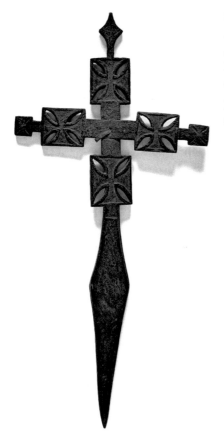

FIGURE 92 Cross. Mbanza Kongo, Angola, nineteenth century. Wood, 48 × 23 × 2.4 cm. Inv. 999.3.30470. Hood Museum of Art, Dartmouth College, Hanover, New Hampshire; purchased through the William B. Jaffe and Evelyn A. Jaffe Hall Fund

two perpendicular branches. The central point of overlap is clearly marked with a hole or a single nail, as in the wooden example in Figure 92 from the Hood Museum in Hanover, New Hampshire. The wood carver responsible for this kulusu placed a square plaque on each of the branches, each at an equal distance from the center. The openwork squares read ambivalently as a four-branch star in the negative or as a Greek cross in the positive. They are close cognates of motifs found in rock paintings and engraved on crucifixes as well as of the insignia of the Order of Christ. Variations of the same design are etched on the two ends of the horizontal bar. At the top of the kulusu, a pointed lozenge loosely echoes the elongated diamond shape of the sharp point at the bottom. Precise geometry and parallel asymmetry defined the conception of this object; simple designs connect and combine into endless variations of the Greek cross and the diamond shape. For example, the two innermost openings of the four plaques trace a large lozenge that shares its center with the larger cross. One can easily include in this new form triangles topping each of its corners to create another common Kongo two-dimensional design, seen in Figure 23.

During his travels in the region of Bamba in the first years of the eighteenth century, Lorenzo da Lucca observed practices that suggest the existence of objects similar to kulusu at the time. On several occasions, he saw a wooden cross along a road, planted in the ground in the midst of wild animal horns and tree branches. He called the ensemble "charm of the Horns [*fattuchieria delle Corna*]," which "is a hunters' superstition that allows to catch many beasts." Lorenzo da Lucca quickly broke and burned the crosses, which he considered an abominable blasphemy. Nineteenth- and twentieth-century ethnographies interpret the formal traits and comment on the uses of kulusu in terms that not only resonate with the friar's account but also with the analysis of other cruciform motifs encountered in the early modern period. John Weeks's informants in the 1880s insisted that the point of intersection of the two branches was the focus of the object, conceived as the "'heart'" of the cross. Ritual activations of the kulusu concentrated on that point. Hunters placed the deadly bullet there to celebrate a successful expedition in a ceremony that connected the cruciform object and its center to the animal's passage between life and death. In some accounts, this observance took place on the grave of a famous hunter whose otherworldly intervention contributed to the favorable outcome. The sharp lower end of the kulusu served to plant the cross in the ground of graves or cemeteries, where large crosses of the early modern period once—and, in some cases, still—stood. The logic of the kulusu ritual mirrored the practices surrounding the monumental cross. Communities brought their dead to the large cross, whereas they brought the kulusu to the dead. Both examples, however, revolve around the strong and clearly enduring connection between the sign of the cross and ideas of death.[57]

A broad common ground thus exists in the visual and conceptual formulations of kulusu and Kongo monumental crosses and crucifixes. The connection functioned both across time and across genres. From the early modern period to the beginning of the twentieth century, from Christian to non-Christian contexts, formal features and ritual practices defined and enacted a strong and enduring link between the cross and ideas of passage from life to death. To fully understand the kulusu, one needs knowledge of the depth and extent of that association and of its visual manifestations in the

57. Lorenzo da Lucca and Filippo da Firenze, "Relazioni," 1700–1717, fols. 463–464; Weeks, *Among the Primitive Bakongo,* 183; John H. Weeks, "Notes on Some Customs of the Lower Congo People," *Folklore,* XIX (1908), 433. On the kulusu, see also Jean-Michel Massing, "Crosses and Hunting Charms: Polysemy in Bakongo Religion," in Jay A. Levenson, Diogo Ramada Curto, and Jack Turner, eds., *Encompassing the Globe: Portugal and the World in the 16th and 17th Centuries: Essays* (Washington, D.C., 2007), 87–96.

region. The example of the kulusu makes apparent how the visual, material, and religious culture of central Africa in the nineteenth and twentieth centuries can be more fully understood when ethnographies are enriched with the insights and nuances of history. Here, as in many other instances, rich archival, ethnographic, visual, and archaeological records afford scholars of central Africa an opportunity—and a rare one for the African context—to approach their topics from a multicentennial perspective.

Conclusion

From the arrival of Europeans on their shores circa 1500 to the unraveling of their kingdom in the late nineteenth century, the people of the Kongo embraced the novelties that a widening world brought to their shores. Eyewitness accounts in written and visual form and locally crafted artworks testify to the sophisticated reflection through which central African men and women brought together and transformed local and foreign thought, materials, and images into the new worldview of Kongo Christianity. In turn, these documents also showcase the active and to a large extent efficacious engagement of the Kongo elite in the diplomatic, commercial, and religious networks of the early modern Atlantic world. Their notable presence on the international scene ensured the status of their kingdom as part of Christendom and guaranteed its independence from European colonial ambitions for centuries.

In fact, Kongo Christianity's impact largely surpassed the bounds of its region of origin. It was a phenomenon that enlivened all corners of the early modern Atlantic world. It reshaped the geographies of Christendom and sparked in Europe fierce competition between rulers, including the papacy, for political and spiritual oversight at a global level. Popes and kings in seventeenth-century Europe invoked the Christian Kongo and its imagery in support of their own prestige and claims to worldwide authority. In central Africa, the newly formulated Kongo Christian religious and political system reshaped people's understanding of the nature of the universe and of their place within it. With the advent of Christianity, central Africans' invisible realm gained new attributes and manifested itself in the visible world with the intercession of new objects, rituals, and miracles.

This broadened spiritual, visual, and political universe also traveled and took root in the Americas. Countless men and women who came from areas in and around the Kongo had lived through or at least witnessed the kingdom's correlation of European and central African religious thought, artistic forms, and expressions of political and social prestige before their forced uprooting to a new continent through the Atlantic slave trade. The singular perspective they had acquired in the Kongo region shaped their experience of enslavement and conditioned their participation in the multicultural societies of North and South America.

Kongo Christianity provides a rich cultural background and a deep historical frame for the practices, images, and objects that enslaved central Africans and their descendants honed on the other side of the Middle Passage. Kongo Christian sangamentos, elite regalia, and confraternities, for example, bring a crucial perspective to the black kings and queens festivals that emerged in the Americas in the era of slavery. Across the continent, men and women, declaring their central African identity, found social power and moral strength in devotions and festivals organized around the elections of leaders chosen in their midst. The form, function, and symbolism deployed in sangamentos and in Kongo elite regalia were central preliminaries to these American ceremonies. In light of this backstory—newly fleshed out in the previous pages—the elections no longer appear as manifestations vaguely linked to an African background shared by their participants but rather as events that drew from specific elements of Kongo Christian pageantry, recast within the new social and cultural environment of life in colonial America.

In seventeenth- and eighteenth-century Brazil, men and women who identified as central Africans formed groups in the orbit of the church that emulated Kongo Christian governing structures, regalia, and ceremonies. During festive events similar to the sangamentos, the members of these associations elected kings and queens, sent off ambassadors, staged mock battles with sticks or fake swords, and collected funds, all activities in keeping with traditions that the Kongo Christian elite honored contemporaneously on the other side of the Atlantic. These organizations and events forged in the era of slavery continue to this day to empower Brazil's Afro-descendant populations, whose confraternities still stage spectacular processions and dances called *congadas* or *congados* during which they honor and pay tribute to their elected kings and queens.[1]

Similar echoes of the Kongo resonated in eighteenth- and nineteenth-century New York. Enslaved men and women of the city of Albany organized in groups they called "fraternities" to observe the Catholic feast of Pentecost during a weeklong festival known as Pinkster. Under the leadership of their chosen "king," often reputed to be born in Angola and clad in a showy and lavishly decorated red coat, they organized dances and staged mock fights similar to the sangamentos, using sticks in lieu of swords, to the sounds of drumming and songs inspired by central African rhythms and tunes.[2]

1. See Chapter 1, above; Marina de Mello e Souza, *Reis negros no Brasil escravista: História da festa de coroação de rei congo* (Belo Horizonte, 2002); and Cécile Fromont, "Dancing for the King of Congo from Early Modern Central Africa to Slavery-Era Brazil," *Colonial Latin American Review,* XXII (2013), 184–208.

2. Jeroen Dewulf, "Pinkster: An Atlantic Creole Festival in a Dutch-American Context," *Journal of American Folklore,* CXXVI (2013), 245–271.

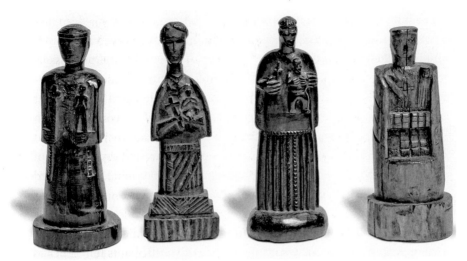

FIGURE 93 Saint Anthony Figures. Southeastern Brazil's Paraíba River valley, nineteenth to twentieth century. Wood, height around 10 cm. Private collection. Photograph, João Liberato

Beyond the realm of performance, the visual forms that emerged in the Christian Kongo informed the creation and use of empowered objects among central African populations in the Americas. Figures of saints made in the Christian Kongo, for example, prefigured the creation of innumerable statuettes in southeastern Brazil's Paraíba River valley in the nineteenth century (Figure 93). Between one and six inches tall, the Brazilian figures are painstakingly carved of metal, bone, or, most commonly, the hardwood from the knots of araucaria pine trees. The iconography of the statuettes varies but generally focuses on the attributes of Saint Anthony. The freestanding figures are garbed in clothing reminiscent of the Franciscan habit, with hoods and knotted belts, and they hold a Latin cross in the right hand and a child in the left. The choice of iconography, the proportion of the body, and the stylized treatment of the saint's features, carved in the hard, shiny material, echo those of the saint figures of the Kongo discussed in Figures 54 (Plate 25) and 57. And, indeed, the diminutive Brazilian objects used as pendants or altar outfits belonged to enslaved communities whose members predominantly and recently originated from central Africa, and often from within regions once under the purview of the Kongo kingdom.[3]

In 1854, observers from the slaveowning class saw José Cabinda, a ritual

3. See Marina de Mello e Souza, "Santo Antônio de nó-de-pinho e o catolicismo afro-brasileiro," *Tempo,* XI (2001), 171–188; and Robert W. Slenes, "L'arbre *nsanda* replanté: Cultes d'affliction Kongo et identité des esclaves de plantation dans le Brésil du sud-est entre (1810–1888)," *Cahiers du Brésil contemporain,* LXVII–LXVIII, part II (2007), 217–313.

practitioner from the Paraíba Valley, using in his ceremonies two pine-knot saints alongside other ritual objects crafted in the tradition of central African minkisi, including an anthropomorphic figure outfitted with a mirror over its stomach and a cow horn empowered with a mirror and tar. The latter two objects follow almost exactly templates from contemporaneous minkisi active in central Africa. The multivalent correlations of Christian and non-Christian thought and visual forms observed in the Kongo are also key precedents for Cabinda's complex power objects and for the ceremonies he led with their help. Ritual practitioners and worshippers in early modern and nineteenth-century central Africa used both saint figures and non-Christian minkisi as empowered intercessors between the visible and the invisible worlds. In some instances, such as in the Kimpasi or the Antonian movement, rituals and imagery inspired from Christian cults were readily called upon outside, and against, mainstream Catholic rituals. José Cabinda's composite cult thus calls for a multifaceted reading in which the tradition of cumulative correlation inherited from central Africa should hold pride of place. His power objects that took on Christian form embodied much more than a syncretic borrowing by Africans of the imagery of the slaveowning class; they broadly belonged to deeply rooted central African practices of correlation, and specifically to the multiform evocative power that Kongo men and women had found in the image of Saint Anthony for centuries before José's time.

The central African background also suggests that the function of ritual groups organized around men such as José Cabinda was as much political as it was religious. Statues of saints in the Kongo indeed did not simply serve as images of spiritual intercessors; they also entered into dialogue with the visual expression of wealth, power, and devotion at the core of the definition of social status and political legitimacy espoused by the Kongo elite. In central Africa, figures of saints or the Virgin mirrored the appearance of the Kongo elite. In Brazil, the pine-knot saints retained a similar visual ambiguity, standing as empowered black figures that operated alongside larger statues of black saints famously designed to echo the skin color of their African worshippers. Around 1880, ex-slaves of the Paraíba Valley expressed the connection they saw between the Saint Anthony figures and reflections on racial identity by replacing the white Jesus held by some larger statues with a black child. Often associated with reports of rebellions in southeastern Brazil, pine-knot Saint Anthony figures thus not only served in religious cults and in the manipulation of invisible forces, but they also participated in the political—and physical—empowerment of their holders.[4]

4. Slenes, "L'arbre *nsanda* replanté," *Cahiers du Brésil contemporain*, LXVII–LXVIII (2007), 274–289 (for José Cabinda), 303 (for the black Jesus).

The visual, cultural, and spiritual universe of Kongo Christianity, then, had an impact well beyond the confines of the central African kingdom where it emerged. In particular, it traveled to the American continent with the enslaved men and women who had witnessed its correlations in central Africa and endured there among their descendants as a source of spiritual and political strength. Kongo Christianity is more than a singular historical occurrence bounded to a defined part of the African continent. It is a phenomenon whose influence has resonated across the early modern Atlantic.

Index

Friars are listed under their first names.